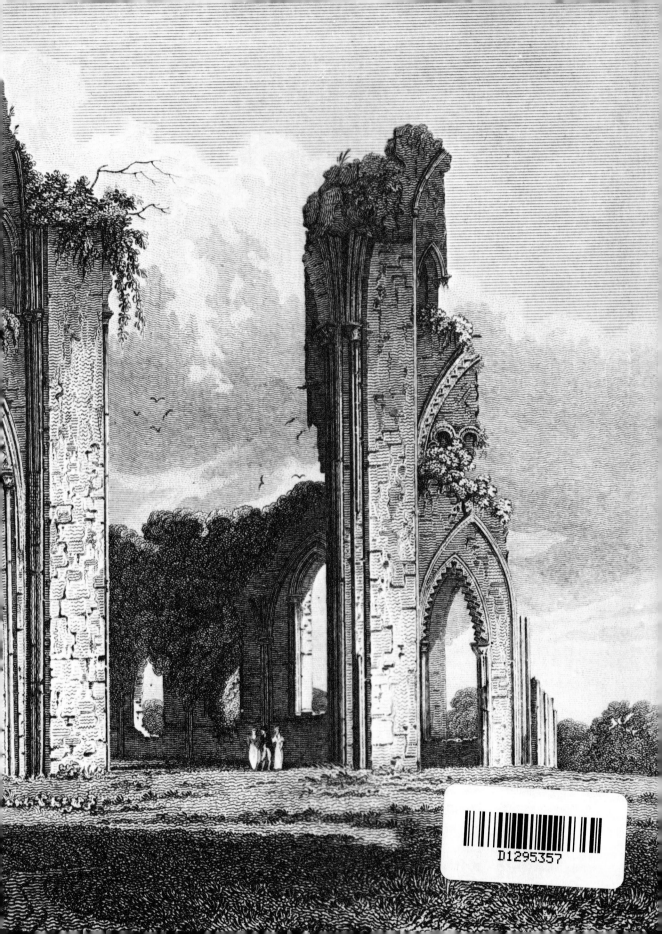

ROMANTIC ENGLAND

ROMANTIC ENGLAND

Writing and Painting 1717–1851

Peter Quennell

THE MACMILLAN COMPANY

Library of Congress Catalog Card Number: 78-119142
First American Edition 1970
The Macmillan Company, 866 Third Avenue, New York, N.Y. 10022. Collier-Macmillan Canada Ltd., Toronto, Ontario
Romantic England was first published in Great Britain in 1970 by Weidenfeld & Nicolson, Ltd., London. Printed in Great Britain.

Illustrations Acknowledgments

Figures in **bold** type indicate pages with colour illustrations.
Arts Council, London, 201; Ashmolean Museum, Oxford, 176, 203, 248, 252; Atheneum of Ohio, St Gregory Seminary, Cincinnati, Ohio, 208; by courtesy of the Duke of Atholl, 57; Bodleian Library, Oxford, 136, 155; British Museum, London (photo John Freeman), **209**, **212a**, 15, 19, 25, 26, 30, 31, 32, 39, 41, 43, 46, 48, 60, 61, 90, 104, 122, 135, 169, 225, 227, 230, 233, 234, 235, 241, 242, 244, 245, 253; Commander Campbell Johnston, Brighton, 17; City Art Gallery, Salford, 29; City Museum and Art Gallery, Birmingham, 103, 147; Eton College (photo Derrick Witty) 54; Fitzwilliam Museum, Cambridge, **237**, 232; Mrs Robert Frank Collection, **210–11**; Goethe Museum, Frankfurt, 217; John Freeman, 263, 265; Keats' House, Hampstead, London (photo Christopher Oxford), 92, 94, 100; Keats-Shelley Memorial House, Rome, 151; A. F. Kersting, 68; Kunsthaus, Zurich, 219, 220; Laing Art Gallery, Newcastle-upon-Tyne, 221; Lady Lever Art Gallery, Port Sunlight, 23; by courtesy of the Trustees of T. C. Loyd Esq., 97; Mansell Collection, London, 13, 64, 71, 73, 81, 83, 100, 102, 107, 109, 111, 116, 118, 119, 122, 123, 128, 152, 153, 156, 164, 166, 167, 181; Paul Mellon Foundation, 261; Mary Moorman Collection, 76–7; by courtesy of Messrs John Murray Ltd, 112, 115; National Building Record, 8; National Gallery of Ireland, Dublin, 225; National Gallery, London, 259; National Gallery of Wales, Cardiff, 259; National Portrait Gallery, Edinburgh, 50; National Portrait Gallery, London, **51**, 53, 54, 65, 69, 79, 85, 87, 95, 172, 180, 205, 215, 247, 261; National Trust (Bearsted Collection, Upton House) **33**, (Egremont Collection, Petworth), **52**; National Trust for Scotland (Brodick Castle), 35; Nottingham City Librarian and Curator of the Newstead Abbey Collections, 113, 124; Piccadilly Gallery, London, 158; Pierpont Morgan Library, New York, 127, 131; Radio Times Hulton Picture Library, London, 105, 140; Royal Academy, London, 194, 195; Georg Schafer Collection, Germany, 218; Science Museum, London, **256b**; Southampton Art Gallery, **238**; Staatliche Museen, Berlin, 250; Mr Peter Summers, 31; Tate Gallery, London, 56, 57, 58, 59, 146, 149, 163, 173, 177, 178, 183, 185, 186, 192, 193, 197, 198, 226, 239, 251, (Photo John Webb) **34**, **141**, **142–3**, **255**, **256a**, 120, 229; by courtesy of Lord Christopher Thynne, 12; Victoria and Albert Museum, London, **144**, 188, 190, 223, (Photo John Freeman) **212b**, 257; Walker Art Gallery, Liverpool, 161.

Contents

Preface

This book has been planned neither as a picture-book with text nor as an illustrated literary essay. Pictures and letter-press are meant to form a whole; and, in combination, I hope that they may throw some light – here and there, perhaps a gleam of new light – on the strange history of the English Romantic Movement. A detailed survey of this large and complex subject was clearly far beyond my range. I have attempted, however, to define the spirit of the movement by pursuing certain general themes – for example, the Romantics' obsession with Youth; their interest in the realms of the Subconscious and the shadowy world of Sleep; their attitude towards Nature and Love; and the cult of extreme sensations – 'where the soul trembles on the verge of the unlawful and unhallowed' – that frequently disturbed their private lives and sometimes brought about their downfall.

Among the modern authors I have consulted I owe a special debt to Lord Clark, whose *Moments of Vision* and *Looking at Pictures* are full of brilliant insights into the background of Romantic painting and poetry; and to Mr Geoffrey Grigson, for his delightful anthology, *The Romantics*, and for his two excellent studies of the work of Samuel Palmer. Some passages of my text have appeared, under a different guise, in *Horizon* and *Life International*; and I am grateful to the editors of those magazines for permission to reprint them here. I must also express my gratitude to the University of Iowa and to the *Philological Quarterly* (where it was first published) for allowing me to reprint part of a new letter from Alexander Pope; and to Professor Willard B. Pope and the Harvard University Press for leave to quote at length from Professor Pope's splendid new edition of the diaries of Benjamin Robert Haydon.

<div align="right">P. Q.</div>

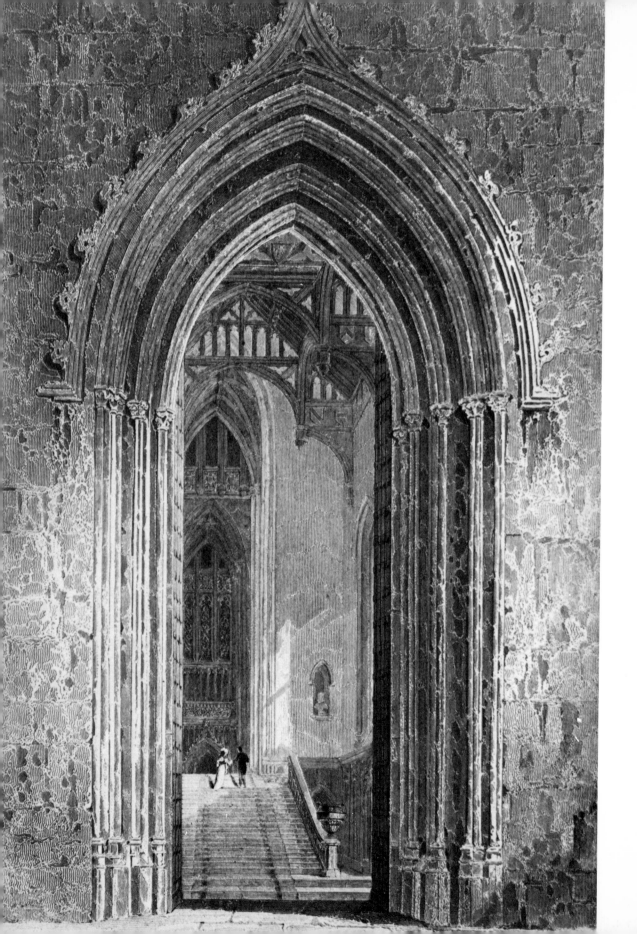

I

The Gothic Background

During the fifteenth century, more than five hundred monastic foundations dignified the English landscape. By the middle of the sixteenth, all were empty and derelict, their inhabitants vanished and their ancient shrines despoiled; while the splendid buildings the monks had left behind them were very often used as quarries, from which Tudor 'new men' prised the cut stone that they needed for their halls and manors. Every district of sixteenth-century England must have been scattered with graceful, ghostly ruins. Yet, although John Leland, our earliest native antiquary, who surveyed the kingdom and its monuments between 1534 and 1543, noted many signs of tragic change, there are few references in Elizabethan verse or prose to the desolation of the monasteries. Like the medieval strongholds, which themselves were doomed, they belonged to an outworn, half-forgotten age; and not until the closing decade of the century, when John Donne wrote of the storm-winds that roar and rumble through 'our ruin'd Abbeys',* did any English poet suggest that they had had a strong effect on his imagination.

The first real hint of a feeling for the Gothic past appeared almost twenty years later. John Webster's masterpiece, *The Duchess of Malfi*, which was written about 1614 and published in 1623, contains an elaborate and impressive scene, where the darkness of the hero's mood is set off by

* . . . Words, words, which would tear
The tender labyrinth of a soft maid's ear,
More, more, than ten Sclavonians scolding, more
Than when winds in our ruin'd abbeys roar.
Satyre II, 1594–5

his gloomy antique background. Delio and Antonio are walking the battlements; and Delio describes the prospect:

> Yond's the cardinal's window. This fortification
> Grew from the ruins of an ancient abbey;
> And to yond side o' the river lies a wall,
> Piece of a cloister, which in my opinion
> Gives the best echo that you ever heard,
> So hollow and so dismal . . .

At which Antonio, oppressed by his fears for his wife and children, whom the wicked Cardinal has already murdered, unfolds a train of melancholy thoughts:

> I do love these ancient ruins.
> We never tread upon them but we set
> Our foot upon some reverend history . . .
> All things have their end:
> Churches and cities, which have diseases like to men,
> Must have like death that we have.

The whole scene is eminently romantic, both in its architectural setting and in the mood it conjures up – the broken cloister, haunted by a mysterious echo that catches and distorts the hero's words; and Antonio's instinctive sympathy with all the associations of decline and death. Here Webster seems to have anticipated the mood of Pope and Gray and Horace Walpole. But he died in 1625; and otherwise Englishmen of the seventeenth century show little affection either for Gothic architecture or for what we now regard as the romantic mode of feeling.

True, *Il Penseroso* includes some celebrated lines on the 'studious cloisters', 'high-embowed' roofs, 'antick pillars' and 'storied windows' of our vast medieval churches; but, after the Civil Wars, even the most perceptive critics, polymaths like Sir Christopher Wren and John Evelyn, found more to blame than to praise in the achievement of the Middle Ages. 'The Goths and Vandals', wrote Evelyn, 'having demolished the Greek and Roman architecture, introduced . . . a certain fantastical and licentious manner of building which we have since called modern or Gothic – of the greatest industry and expressive carving, full of fret and lamentable imagery . . .'[1] At times, where his commission demanded it, Wren himself employed the Gothic style, as did his gifted successors, Nicholas Hawksmoor and Sir John Vanbrugh. But, if they adapted the architecture of the past, they handled the job in the spirit of conscientious artist-craftsmen. There was no close correspondence between their own emotions and the genius of the men they copied.

Oddly enough, it was during the Palladian period that Gothic art returned to favour; and, as often happens in the history of artistic movements, the change occurred with dazzling suddenness. Lord Burlington was the aristocratic leader of the Palladian reformation; Alexander Pope, then twenty-nine years old, but already well known as the author of *An Essay on Criticism*, *Windsor Forest* and *The Rape of the Lock*, had become his

literary adjutant. Both believed that every work of art, whether it were a house, a garden or a poem, should be a judicious blend of art and nature. Both, like their associate William Kent, deplored the 'damned gusto' that, under the influence of Wren and his successors, had recently prevailed in England, insisting that English architects must revert to pure Palladian and Vitruvian principles. In gardening, on the other hand, they were prepared to allow themselves much greater latitude, and recommended the use of natural details – serpentine paths, rustic coppices and artful juxtapositions of light and shade – so arranged as to produce an effect of elegant irregularity. But Burlington's taste was essentially classicist; and thus far Pope had followed suit.

Then, in 1717, he decided to issue a volume of collected verse and prose, among which were two highly original and hitherto unpublished works, *Elegy to the Memory of an Unfortunate Lady* and an Ovidian epistle, *Eloisa to Abelard*. Each poem has a Gothic setting; and, while the first depicts a lonely revenant – the spectre of a woman who has taken her own life, and now haunts the shadows of a deserted garden – the second, derived from the famous series of letters, of which an English translation had appeared in 1713, retells the pathetic story of Peter Abelard and his beloved pupil Eloise. Pope takes considerable liberties with his subject; for, although the Paraclete, where Eloise had been condemned to pass her days, was a fairly recent building – founded, indeed, by Abelard himself – the poet dwells upon its sad antiquity and, to make its situation all the more impressive, throws up a range of gloomy mountains.

These surroundings are attuned to his heroine's mood, just as, in Webster's play, a Gothic background reflects his hero's sorrows:

> The wandring streams that shine between the hills,
> The grots that echo to the tinkling rills . . .
> No more these scenes my meditation aid,
> Or lull to rest the visionary maid:
> But o'er the twilight groves, and dusky caves,
> Long-sounding aisles, and intermingled graves,
> Black Melancholy sits, and round her throws
> A death-like silence, and a dread repose:
> Her gloomy presence saddens all the scene,
> Shades ev'ry flow'r, and darkens ev'ry green,
> Deepens the murmur of the falling floods,
> And breathes a browner horror on the woods.

When he describes the effect of her miserable solitude upon his heroine's imagination, Pope might also be describing the advance of the Romantic Spirit across the English literary landscape. One of the chief functions of creative art is constantly to reinterpret nature; and henceforward the whole universe, viewed through the eyes of poets and story-tellers, began to undergo a subtle change. Its colours deepened, its shadows darkened. Mountains, hitherto regarded as annoying natural obstacles, were now pregnant with 'ideas of religion and poetry'; and Gothic ruins, formerly dismissed as so much architectural rubbish, of interest only to the

(*Left and above*) The Hermit's Cell
at Badminton, built before 1750,
probably by William Kent;
photograph by courtesy of
Lord Christopher Thynne

antiquarian, were voted deeply moving and sublime. 'Horrid' became a poetic keyword; fear, a favourite literary emotion. Every ancient building must have its ghost, just as every gentleman's park required a tame hermit.

Pope's correspondence reveals his devotion to antiquity, and his passionate interest in Gothic architecture. Thus, staying at Stanton Harcourt, while he completed the fifth volume of his *Iliad*, he gathered vivid impressions of 'an ancient country seat', admired the Cyclopean aspect of its huge medieval kitchen, and, in the old hall, gazed up at a 'vast arched window, beautifully darkened with divers scutcheons of painted glass', among which he noticed 'one shining pane' that bore the date 1286. Six years later, he visited Sherburne, where the ruins of the castle in the park struck him as 'inexpressibly awful and solemn'; though, being a good Augustan, he could not help suggesting that they should be duly 'cultivated'. He opined, for instance, that

these venerable walls, some arches almost entire of thirty or forty feet deep . . . might have a prodigious beauty, mixed with greens and parterres . . . and the whole heap, standing as it does on a round hill, kept smooth in green turf . . . Little paths of earth, or sand, might be made, up the half-tumbled walls; to guide from one view to another . . . and seats placed here and there, to enjoy those views, which are more romantic than imagination can form them.'

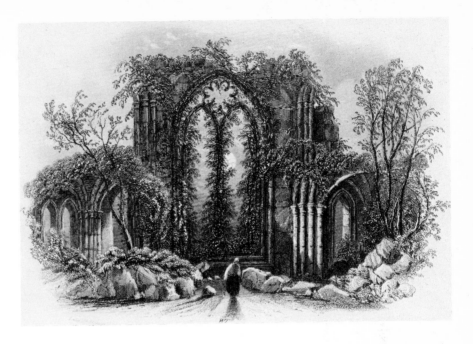

Netley Abbey; an
engraving after Turner

Later still, in 1734, accompanied by his aged friend Lord Peterborough,
he studied and sketched the magnificent ruins of Netley Abbey near
Southampton. They had come well provided with wines, two bottles of
brandy, cold pie, turkeys and pigeons – the Augustans were always
luxurious sightseers; and there, among ivy and rose-trees, they sat down
to eat a comfortable meal:

We had large entire arches over our heads, and gatherd a Salad of Alisander, a
very pretty-tasted herb . . . After dinner, we strolled out again, found . . . the
Shell . . . of a Church . . . the End window over the Altar vastly high, the
whole wrought finely with old Gothic ornaments. One Part of the Roof . . . was
yet standing, but lookd terribly, it was above 60 foot high, hung like Net work,
so thin so fine . . . No part of Westminster abby is more ornamented.

The word 'romantic' had been in circulation since the middle of the
seventeenth century;* but the first important use of the adjective 'pictur-
esque' was made by Pope during the fierce winter of the year 1712, when
he praised a couple of pretty lines, written by a rival poet,† about the
'bright confusion' of a snow-bound prospect glittering beneath the sun-
shine. Like 'romantic' and the associated word 'sentimental', it was to
exert a decisive influence upon the development of eighteenth-century
taste; and it was applied both to Gothic ruins and to the art and archi-
tecture of the Far East, the pavilions, pagodas and flying bridges portrayed
on Japanese screens and Chinese porcelain. But, for Pope and his friends,

* 'I speak especially of that imagination, which is most free, such as we use in romantick
inventions.' Henry More, 1659.
 'There happened this extraordinary case – one of the most romantique that I ever heard of in
my life.' Samuel Pepys, 13 June 1666.
 † Ambrose Philip's lines, he wrote, 'seem to me what the French call very *picturesque*'. In 1703,
Richard Steele had referred to a 'picturesque' circumstance.

13

a truly picturesque scene must include a shade of Gothic gloom. Only in Gothic could they discover the perfect image of their own fantasies and waking visions – of the anarchic impulses that they managed somehow to reconcile with the Augustan cult of law and order.

The English Gothic revival was, above all else, a literary movement; two great champions of neo-Gothic taste were imaginative novelists as well as builders; and the mood that engendered *The Castle of Otranto* and *Vathek* is closely akin to the state of mind that produced Strawberry Hill and Fonthill Abbey. Pope had died in 1744; in 1747 Horace Walpole bought a modest house beside the Thames, which, in 1750, he announced that he was reconstructing to form 'a little Gothick castle'. At the time, some of his friends were dubious. The Gothic vogue, they believed, had already passed its zenith. During its heyday, even Lord Burlington's protégé, the great William Kent himself, had designed a castellated villa. But the style had since fallen into much less gifted hands; and Batty Langley's handbook, *Gothic Architecture improved,** when it appeared in 1742, had encouraged the wild proliferation of every kind of architectural whimsy.

Now that a hundred English parks and gardens could boast some curious antique detail, and the craze had filtered down into the middle class, so that a London merchant and his wife might be seen playing cards or drinking their tea in one of Batty Langley's summer-houses, the movement had become hackneyed; and meanwhile a new fashion – or, rather an old fashion newly revived – was gaining ground among the cognoscenti. 'A few years ago', remarked a journalist in 1753, 'everything was Gothic ... According to the present prevailing whim everything is Chinese ...'† Not only domestic furniture but the most commonplace utensils 'are all reduced to this new-fangled standard: and without doors so universally has it spread, that every gate to a cow-yard is in T's and Z's, and every hovel for the cows has bells hanging at its corners.'

Yet Walpole persevered with his scheme. For him Gothic art was no aesthetic foible, but a serious and deep-rooted passion, which aroused his strongest private feelings. Strawberry Hill, he afterwards declared, 'was built to please my own taste, and in some degree to realize my own visions'.[2] It was an imaginative edifice, rather than a serious attempt to reproduce the features of a genuine Gothic building – a poem, a romance, a secret fantasy transmuted into brick and stone.

Hence the fact that its structure was insubstantial – during his occupancy, he wrote in later life, he had outlived two or three sets of Gothic battlements – caused Walpole not the smallest chagrin. He seems to have welcomed the touch of make-believe – 'pie-crust' battlements imitating solid masonry, fan-vaulting modelled in lath-and-plaster, and wall-paper

* *Gothic Architecture improved by Rules and Proportions In many Grand Designs.* Among the illustrations were eight types of chimneypiece and fourteen types of pavilions, temples and 'umbrellos'. For an appreciation of the author's ideas, see Kenneth Clark, *The Gothic Revival*, 1928.

† The Chinese taste had first reached England during the reign of Charles II, and flourished under Queen Anne.

(Below, left) Batty Langley's suggestion for an 'umbrello'. *(Right)* A 'Gothick Pavilion', one of the architectural whimsies illustrated in Langley's book

(Below) Gothic furniture; an 'Embattled Bookcase'

'painted in perspective' to represent medieval fretwork. Walpole was primarily an enthusiastic amateur; and, although he loved to visit the buildings, scrutinise the manuscripts and turn over the chronicles of the English Middle Ages, his taste was very often faulty, and again and again he failed to distinguish between the genuine and the sham antique. Thus, in 1769, he was at first completely deceived by Thomas Chatterton's transparent forgeries; and, in 1753, he records that he had been highly pleased with the bogus ruins that Sanderson Miller had just raised at Hagley, which, he immediately decided, had 'the true rust of the Barons' wars'.

Beckford eventually tired of Fonthill; for Walpole, more temperate and better balanced, Strawberry Hill was an endless source of satisfaction; and here, one night during the early summer of 1764, he was visited, he tells us, by a peculiarly disturbing dream. That summer, he was feeling gloomy and anxious. His handsome, selfish cousin, Henry Seymour Conway, for whom he cherished a more than cousinly devotion, had recently fallen foul of Court and Government; and Walpole had been struggling to prepare his defence in the form of a bellicose political pamphlet. It was not an easy task; he was evidently over-tired. And that night, he remembered, he had had a dream, 'of which all I could recover was that I had thought myself in an ancient castle . . . and that on the uppermost bannister of a

15

great staircase I saw a gigantic hand in armour. In the evening I sat down, and began to write, without knowing in the least what I intended to say . . .'

For the next two months, as he covered sheet after sheet, he lived through a period of strange excitement, during which he deliberately cut himself off from his usual friends and pastimes. Out of his trance emerged *The Castle of Otranto*, the only book of his, he assured his old confidante Madame du Deffand, that had caused him real pleasure. Published anonymously towards the end of 1764, it enjoyed an immediate popular success; and a second edition, with the author's name, appeared in April 1765. To explain the effect it made on contemporary readers is nowadays a little difficult. Walpole's personages are all of them decorative dummies

(*Above*) Strawberry Hill; 'built to please my own taste and . . . realise my own visions'; from a picture by J. Faringdon. (*Right*) The author of *The Castle of Otranto* in his library at Strawberry Hill

16

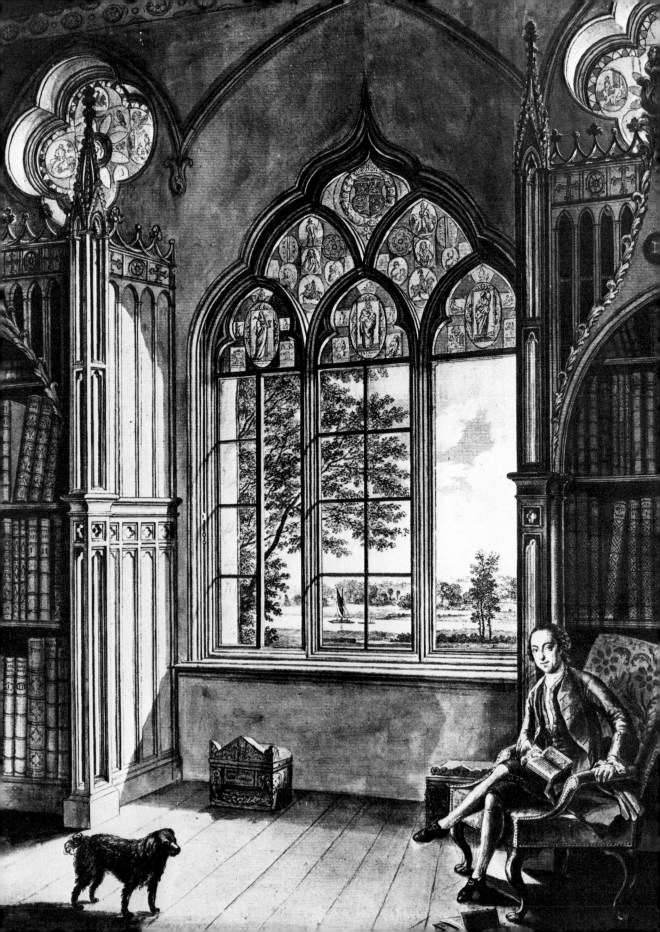

– a haughty tyrant, a brace of innocent maidens, a mysterious knight and an unacknowledged heir.

'Perhaps the dream-like inconsequence of the story', suggests Walpole's able biographer, R.W.Ketton-Cremer, 'constitutes its main charm ...' It sprang from a dream, and retains something of that inexplicable attraction which certain vivid dreams exert. Walpole's fantastic stage-properties leave a particularly deep impression: a sighing portrait that steps from the canvas; the armoured hand; a gigantic sculptural leg; and the prodigious helmet – 'an hundred times more large than any casque ever made for human being, and shaded with a proportionate quantity of black feathers' – that comes crashing down into the castle courtyard.

The symbolism of the tale and its background seems to have been the product of Walpole's unconscious memory. Huge stone-built Otranto is an immensely magnified version of his own small and flimsy Thames-side house; and he also drew on his dormant recollections of a once-familiar Cambridge college. Here Walpole was establishing a pattern that many of the later Gothic novelists followed. They, too, drew up their images from the darkest recesses of their own subconscious; and they, too, would write at breakneck speed, under the pressure of some violent secret emotion.

Soon after his novel had reached the public, Walpole ventured to penetrate an even deeper stratum of repressed feelings; and this time the form he chose was dramatic blank verse.

I have finished my tragedy [he wrote to George Montagu on 15 April 1768], but as you would not bear the subject, I will say no more of it, but that Mr. Chute, who is not easily pleased, likes it, and Gray, who is still more difficult, approves it. I am not yet intoxicated enough with it to think it would do for the stage, though I wish to see it acted; but ... I know nobody could play the Countess; nor am I disposed to expose myself to the impertinences of that jackanapes Garrick, who lets nothing appear but his own wretched stuff ...

This tragedy was *The Mysterious Mother*, which he had begun composing on Christmas Day 1766, and of which the Strawberry Hill Press now issued a private edition limited to fifty copies. Despite his vague hopes that he might one day see it acted, Walpole clearly did not intend that it should have an extensive circulation; for the subject that Montagu could not abide was the incestuous relationship of the Countess of Narbonne and her only son, Count Edmund, and the Count's passionate attachment to the beautiful orphan Adeliza, whom the Countess has brought up from childhood, and whom the Count learns – though not until a wicked friar has already joined their hands in marriage – to be both his sister and his daughter.

The anecdote around which Walpole built his tragedy was based on a tale he had heard when very young, about a confession made by a lady who, 'under uncommon agonies of mind', had once sought the advice of the seventeenth-century Archbishop Tillotson.* In his opening lines,

* Walpole later traced the story back to a far more ancient source, the *Heptameron* of Margaret of Navarre.

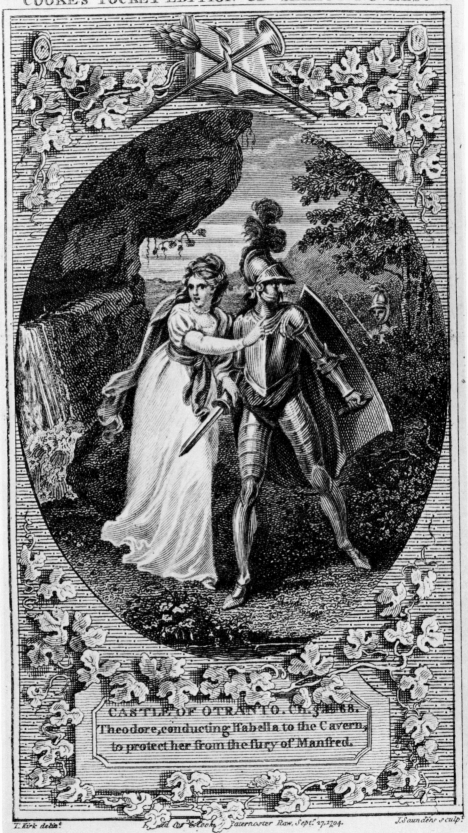

CASTLE OF OTRANTO. Ch. 3 p. 68.
Theodore, conducting Isabella to the Cavern, to protect her from the fury of Manfred.

T. Kirk delin. J. Saunders sculp.

Walpole establishes an appropriate architectural background:

> What awful silence! how these antique towers
> And vacant courts chill the suspended soul,
> Till expectation wears the cast of fear;
> And fear, half-ready to become devotion,
> Mumbles a kind of mental orison,
> It knows not wherefore . . .

So 'horrid' a drama naturally required a Gothic framework; and Walpole would never have considered staging it in the sixteenth or the seventeenth century, still less in the present humdrum period. Why he should have chosen the subject, we do not know. 'A psycho-analyst', writes his biographer, 'might perhaps connect his attraction to the theme of incest with his youthful devotion to his own mother, which exerted so profound an influence on his life. A subconscious urge of this sort would certainly explain both his choice of a theme and the intense feeling with which the theme was handled.'[3]

Walpole's preoccupation, however, may have had a slightly different origin. A sensitive, precocious, effeminate child, he had always idolised his charming mother; but the puissant Sir Robert Walpole and his fashionable wife were well known to lead largely separate lives; and she (reported a London gossip) was thought to have been 'as gallant . . . with men as he with women'. May not the conflict that her son at length resolved by producing *The Mysterious Mother* have originated in some dreadful discovery that, years ago, had left him shocked and wretched? It is the general strength of her passions, rather than a particular liking for her son, that drives the unhappy Countess to her ruin; and, while he imagines that he is embracing a girl he loves, she is battening upon his father's image:

> You know how fondly my luxurious fancy
> Doated upon my lord. For eighteen months
> An embassy detained him from my bed.
> A harbinger announced his near return.
> Love dress'd his image to my longing thoughts
> In all its warmest colours – but the morn,
> In which impatience grew almost to sickness,
> Presented him a bloody corse before me . . .
>
> Thou canst not harbour a foreboding thought
> More dire, than I conceived, I executed.
> Guilt rush'd into my soul – my fancy saw thee
> Thy father's image . . .
> Grief, disappointment, opportunity,
> Rais'd such a tumult in my madding blood,
> I took the damsel's place; and while thy arms
> Twin'd, to thy thinking, round another's waist,
> Hear, hell, and tremble! – thou didst clasp thy mother!

Passion itself is the villain of the piece; and the Countess's inability to

control her appetites, rather than the fact that she entered her son's bed, is the moral essence of her tragedy.

When a popular edition of the drama appeared in 1781, Walpole admitted that the subject was 'disgusting' – he had only allowed it to be published, he wrote, because a surreptitious edition of the work had recently been put on sale; while his publisher was careful to point out that the theme of incest had been treated elsewhere, and that two plays, produced during the previous seventy years, *The Fatal Discovery* and *Innocence Distressed*, had handled it with no less freedom. 'Of the present tragedy', he continues, 'we may boldly pronounce, that for nervous, simple, and pathetic language . . . for striking incidents; for address in conducting the plot; and for consistency of character . . . it is equal, if not superior, to any play of the present century.'

Byron agreed. *The Mysterious Mother*, he asserted, was 'a tragedy of the highest order, and not a puling love-play'. Byron's judgement was obviously prejudiced; and otherwise Walpole's drama has received comparatively little notice. Among its author's literary productions, however, it occupies a special place; for not even in *The Castle of Otranto* did he dive so deep into his own subconscious mind, or translate the feelings he unearthed there into so strange a set of symbols. The Gothic mode was the key he employed to give them imaginative weight and substance. 'Shall I tell you my dreams?' demanded William Beckford in the opening sentence of his first book;[4] and Walpole, too, when he produced his novel and his play, was concerned to tell his dreams, just as, in the fabric of Strawberry Hill, he had sought to realise his own visions. Both Walpole and Beckford set out to build a bridge between the dream-world and the world of everyday experience.

Born in September 1760, William Beckford was a spoiled child; and, as many of his adult characteristics show, he remained a spoiled child all his life. Not only had he inherited, at the age of ten, the enormous fortune built up by his grandfather, a rich Jamaican colonist, and his father, Alderman Beckford, twice Lord Mayor of London, a patriotic merchant-prince; but he had been blessed with great good looks, energy, gaiety, courage, admirable health and an extraordinarily quick and active mind. Nor had his family neglected his education. The boy prodigy, Wolfgang Amadeus Mozart, was engaged to supervise his early musical studies; while Sir William Chambers explained to him the rules of architecture, and Alexander Cozens, subsequently a close friend, taught him how to draw and paint. There was no need to teach him the art of pleasing. As 'England's wealthiest son', he could be sure of a warm welcome in drawing-rooms and country houses; and, thanks to his looks and address and versatile talents – he had a melodious voice, improvised on the piano and was a gifted natural mimic – he cut a particularly dashing figure.

Yet by the autumn of 1784, before he had reached his twenty-fifth birthday, he was already faced with social ruin; and from that moment until he died, an embittered and cantankerous octogenarian, in the year

1844, he never managed to redeem his credit. The catastrophe that so nearly destroyed him was a scandal of his own making. Like many heirs to a splendid estate, he had a tyrannous, possessive mother; and Mrs Beckford alternately flattered her son, and treated him to storms of righteous fury. Thus he had grown up selfish, passionate, irritable, governed by strong feelings and no less violent imagination. Clearly he was headed for some dramatic scrape; and, when he was eighteen, Beckford fell in love – not, however, with a marriageable girl but with an eleven-year-old boy, William Courtenay, the pampered only son of Lord Courtenay, descendant of one of the most ancient families in Europe, and his prolific wife, the former Fanny Clack.

Lord Courtenay's seat was Powderham Castle, which stands beside the River Exe; and on the 'variegated shore' of that 'blue river' Beckford first caught sight, as he afterwards recorded, of 'the object of all my tenderness'. There, at the hour of sunset, when he was paying a visit to the Courtenays, accompanied by his tutor, the Reverend John Lettice, he had noticed the beautiful dark-eyed boy 'sporting among the deer' across his father's park; and the attraction he felt had rapidly assumed the guise of a violent infatuation. William Courtenay had not been unresponsive. He, too, was a spoiled child, surrounded by a dozen adoring sisters, devoted to feminine finery and dressing-up, and evidently experienced beyond his age.

Throughout his whole career, Beckford displayed a strongly paederastic tendency;* but he was one of those homosexuals whom almost every woman finds attractive; and he was not averse from using his power over women, if they were prepared to accept his romantic view of existence, and were gay, intelligent and well bred. Such a conquest was Louisa Beckford, the dissatisfied wife of his fox-hunting cousin Peter, who became his mistress in 1780, soon after his memorable visit to Powderham. Five years older than her fascinating relation, a tall, thin, aquiline young woman, she was already threatened by tuberculosis; and she had the hectic vivacity and feverish appetite for life that very often distinguish a consumptive constitution. Having succumbed to Beckford's spell, she quickly adopted the rôle of fellow adventurer and *âme damnée*; and Beckford proceeded to indoctrinate her with his own peculiar brand of juvenile diabolism.

He and she, he suggested, were fallen spirits, versed in arcane knowledge and mysterious forbidden joys. They were the representatives of the Satanic Sovereign on earth. 'Stay a week', he begged, urging her to join him at his country house, ' – and then, Louisa, we must lie in wait for souls together.' 'William – my lovely infernal!' she exclaimed, 'how gloriously

'How gloriously you write of iniquities . . .' Louisa Beckford sacrificing to the Goddess of the Underworld; portrait by Romney

* Beckford's biographers, however, Dr Guy Chapman and Mr Boyd Alexander, are firmly convinced that his sexual tendencies have been misjudged, or, at least, exaggerated. His link with William Courtenay, writes Dr Chapman, was 'not, I believe, homosexual passion'; while Mr Alexander, despite the evidence of Beckford's letters, which myself I find it difficult to disregard, asserts that 'he wrote obsessively about sex because he was repressed and possibly impotent'.

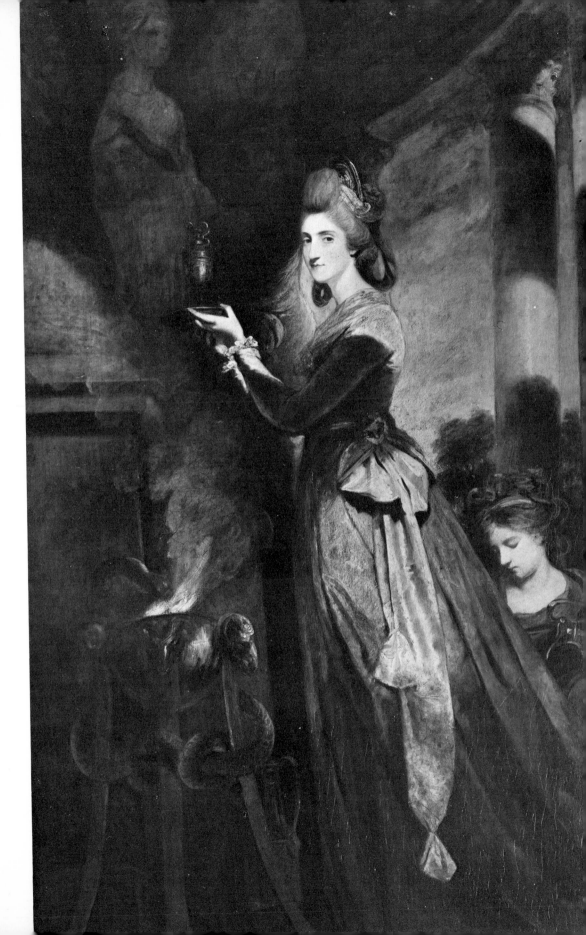

you write of iniquities . . . Like another Lucifer you would tempt angels to forsake their coelestial abode and sink with you into the black infernal gulph. Converts to your faith would crowd from every starry world, and the wide expanse of Heaven be left desolate and forlorn.'

Their dangerous dreams were finally realized during the last days of the year 1781, when Beckford assembled a Christmas party that included both Louisa and William, Louisa's greatest friend, the charming Sophia Musters, and her lover of the moment, Louisa's brother, George Pitt, as well as a literary clergyman, the Reverend Samuel Henley, and the middle-aged artist Alexander Cozens. Fonthill, the house built by Alderman Beckford on the edge of Salisbury Plain, was a huge, and now old-fashioned structure; but Beckford had engaged the celebrated stage-designer Loutherbourg,* 'himself a mystagogue', to arrange bizarre effects of lighting; and a bevy of Italian musicians played and sang behind the scenes. Servants had been banished; but 'at every stage of this enchanted palace [we read] tables were swung out covered with delicious consommations – masked by the fragrance of a bright mass of flowers, the heliotrope, the basil and the rose'; and 'the vapour of wood of aloes ascending in wreaths from cassolettes placed low on the floor in salvers and jars of japan' curled up towards the gilded roof.

Outside, over the fields and downs of Wiltshire, all was 'dark and bleak and howling; whilst the storm was raging against our massive walls and the snow drifting in clouds'. But within doors, beneath the 'soft and pure radiance' devised by Loutherbourg, 'the very air of summer seemed playing around us'; and Beckford and his adventurous friends could explore a paradise of 'uncontrolled delights'. As an elderly recluse, he endeavoured to describe the scene:

Immured we were *au pied de la lettre* for three days following – doors and windows so strictly closed that neither common daylight nor commonplace visitors could get in . . . the great mansion at Fonthill . . . was admirably calculated for mysteries. The solid Egyptian Hall looked as if hewn out of a living rock – Through all these suites – through all these galleries – did we wander and wander – too often hand in hand – strains of music swelling forth at intervals . . . †

Some of the mysteries celebrated at Fonthill were clearly of an amorous kind. Louisa had early resigned herself to the fact that her lover's deepest passion was for William Courtenay, whom in their correspondence they styled 'our lovely Kitty'; and it was then, Beckford remembered, that he had seized Kitty's 'delicate hand' and led him 'bounding . . . to my

* Philip James de Loutherbourg (1740–1812), son of an Alsatian artist, had come to London in 1771, to work for David Garrick at Drury Lane. Later, he launched his *Eidophusikon* or *Representation of Nature*, which showed, for example, with ingenious stage-effects, moonlight on the Mediterranean and a sunset near Naples. Loutherbourg was interested in the occult, and a friend of Cagliostro.

† See *Beckford* by Guy Chapman, 1937. This and the previous description of the Fonthill party are quoted by Dr Chapman 'from an original draft written by Beckford on the fly-leaf of a copy of Waagen's *Works of Art and Artists in England*' now in his possession.

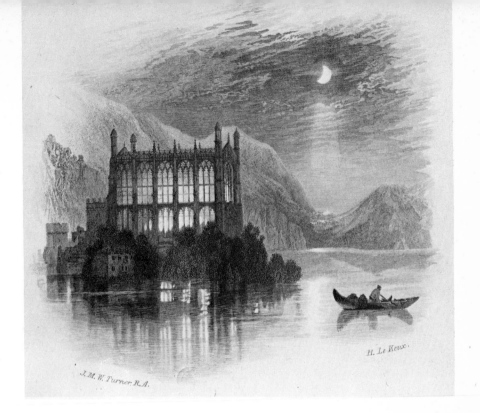

St Herbert's Chapel; from the *Poems* of Samuel Rogers illustrated by Turner

chamber'. Beckford would never forget these Christmas revels. After the lapse of more than fifty years, they continued to trouble his imagination; and at the time they filled him with intense excitement. 'The delirium [he wrote] into which our young and fervid bosoms were cast by such a combination of seductive influences may be conceived but too easily.' And, once he had bidden his guests farewell, he immediately hastened back to London and, in order to relieve the pressure of his feelings, began work on a fantastic Eastern tale.

Beckford was later to claim that 'the fit I laboured under when I wrote *Vathek* lasted two days and a night'. We know, however, that the project as a whole occupied him for some five or six months; and he did not announce the conclusion of the tale until the early summer of 1782. '*Vous avez donc rêvé à Vathek*', he replied in June to a new admirer, Lady Craven, ' – *quel Calife . . . j'avoue que je suis un peu fier de son voyage – je l'ai même damné avec assez de magnificence . . .*' During its composition, he had kept Henley informed of his rapid progress through the narrative; the story, he declared, was 'so horrid that I tremble whilst relating it and have not a nerve in my frame but vibrates like an aspen'. For its author it evidently possessed a powerful symbolic meaning.

Although *The History of the Caliph Vathek* can scarcely be classed among the Gothic novels, since Beckford gave it an Islamic background, which he derived from his study of *The Arabian Nights* and from the Eastern manuscripts he had collected, it shows the same imaginative leaning towards the 'awful' and the 'horrid'. The Caliph himself, a devotee of illicit pleasures, yet a restless seeker after truth, whose occult researches embrace

25

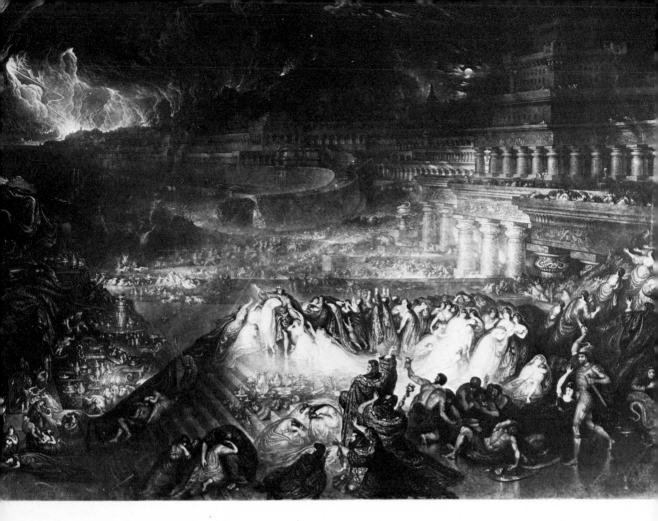

'even sciences that did not exist', and who has built a palace consisting of five pavilions 'destined for the particular gratification of each of his senses', no doubt represents the novelist. Like Beckford, he has a fierce, excitable mother, and, during the course of his adventures, becomes involved with a voluptuous young woman, Nouronihar, and a seductive stripling, Goulchenrouz. But here Beckford seems to have decided to skirt the theme of homosexual love;* and the boy has vanished before Vathek and his mistress descend into the infernal regions, Eblis, 'abode of vengeance and despair'.

At this point, Beckford's narrative, hitherto a web of grotesque and picturesque fancies, reaches a dramatic climax. Eblis is another Fonthill, as Loutherbourg had rearranged it in December 1781:

The Caliph and Nouronihar beheld each other with amazement . . . But their eyes, at length, growing familiar to the grandeur of the surrounding objects, they extended their view to those at a distance; and discovered rows of columns and arcades . . . The pavement, strewed over with gold dust and saffron, exhaled so

The Fall of Nineveh; painted and engraved by John Martin

* The theme is treated by Beckford with greater freedom in his posthumously published collection of stories, *The Episodes of Vathek*.

26

subtile an odour as almost overpowered them. They, however, went on; and observed an infinity of censers, in which, ambergrise and the wood of aloes, were continually burning . . .

As at Fonthill, there are mysterious sounds of music; but, unlike Beckford's Christmas guests, who had been young and gay and carefree, 'a vast multitude was incessantly passing; who severally kept their right hands on their hearts; without once regarding any thing around them . . .' These are the damned, whose hearts are enveloped in flames; and Vathek and Nouronihar and their wretched associates are presently condemned to join the crowd:

At almost the same instant, the same voice announced to the Caliph, Nouronihar, the four princes, and the princess, the awful, and irrevocable decree. Their hearts immediately took fire, and they, at once, lost the most precious gift of heaven: – Hope. These unhappy beings recoiled, with looks of the most furious distraction. Vathek beheld in the eyes of Nouronihar nothing but rage and vengeance; nor could she discern ought in his, but aversion and despair. The two princes who were friends . . . shrunk back, gnashing their teeth with mutual and unchangeable hatred . . .

Such was, and such should be, the punishment of unrestrained passions and atrocious deeds!

Vathek was originally written in French; and Henley, who had been ordered to translate it, published his English rendering, during the author's absence abroad and without his leave, in June 1786. Meanwhile, though Beckford had given form both to his rebellious impulses and to his secret sense of guilt, he had failed to exorcise them. Nor could he escape their ill-effects; rumours of the scandalous party at Fonthill were already circulating among his friends and enemies. His relations were alarmed. He continued to dazzle London society. 'What a strange exotic animal I was in those days,' he recollected during later life, 'abandoned to all the wildness of my imagination and setting no bounds to my caprices. Never was I quiet a single instant. I seemed like the antique Mercury perpetually on tiptoe . . .' But some onlookers, including the elderly George Selwyn, himself an amateur of strange sensations, surmised that, despite his 'very extraordinary talents' and agreeable person and figure, he might eventually find his way into a private madhouse. His family then decided that he must be married off as soon as possible; and in May 1783 he was wedded to Lady Margaret Gordon, a charming and good-natured young woman, whom he treated tenderly and considerately, and for whom he would appear to have felt a warm regard.

At the same time, he did not break off his secret relationship with William Courtenay; and Louisa Beckford, still his favourite accomplice, did her best to encourage that 'strange wayward passion' and the other 'iniquities' and demonic schemes that he and she had loved discussing. In their correspondence she continued to salute him as 'a descendant of the great Lucifer', and prophesied that 'your apartment adorned with the youthful victims you have sacrificed on his altars may perhaps ere long be

sanctified by his presence, where, transformed in the mystic shape of a goat, he will receive . . . our adorations'.

She was always ready, Louisa insisted, to abet his sacrilegious plans: 'Now I really do owe a sacrifice to the Furies, and am ripe for any mischievous undertaking which you, my lovely prompter, may choose to suggest.' She was even willing, she assured him, to sacrifice her own son, and wished to God that he were old enough to become 'a little victim'. The child was growing more beautiful every day, 'and will in a few years answer your purpose to perfection, but what an age it is to look forward. Perhaps before that time one or both of us [will have] sunk into another world . . .'

Louisa Beckford, riddled by tuberculosis, died abroad in 1791; towards the end of her brief, unhappy existence, although she never ceased pleading and importuning, she had lost her hold upon her lover; but there seems no doubt that her machiavellian influence had helped to bring about the Caliph's fall. The final act of hubris was committed at Powderham during the autumn of 1784, when Beckford and his wife were visiting the castle, and he was discovered by William Courtenay's tutor – who immediately reported the discovery to Lord Courtenay and Lord Loughborough,* a stern and self-righteous pillar of the British law, who happened also to be staying at Powderham – locked in the boy's room.

Soon afterwards, with Loughborough's help, the story reached the London newspapers; and thenceforward 'England's wealthiest son' became its greatest moral bugbear. His wife had refused to abandon him – she said that he was a good and gentle husband; but she succumbed to an attack of puerperal fever in May 1786; and for the two daughters she had borne him he felt very little real affection. Now his solitude was almost complete. Fashionable society had cast him off; even humble country neighbours refused to call at Fonthill. During the next twelve years, accompanied by a princely train, he wandered up and down Europe, and wrote his admirable travel-book, *Recollections of an Excursion to the Monasteries of Alcobaga and Batalha.*

On his return, he conceived an ambitious plan – that of building himself a new Fonthill, far larger, stranger and more impressive than his father's stolid mansion. Like Strawberry Hill, it was to be a visionary edifice; and just as Horace Walpole was unperturbed when his battlements began to crumble, so Beckford was entirely undismayed when, owing to faulty design and workmanship – James Wyatt was a negligent architect – his soaring central tower collapsed in ruins. What excited him was the glorious turmoil of the work, and the romantic prospects it afforded. Five hundred workmen were employed, labouring diligently round the clock:

It's really stupendous, the spectacle here at night [he wrote on 18 September 1808] – the number of people at work, lit up by lads; the innumerable torches

* Alexander Wedderburn, a middle-class Scottish lawyer, created first Baron Loughborough and first Earl of Rosslyn; Attorney-General and afterwards Chief Justice of Common Pleas. He had married Lord Courtenay's sister, and was said to hate Beckford because Lady Loughborough had at one time been enamoured of him.

'How tired I am of keeping a Mask on my face . . .' Beckford at the age of forty; portrait by Hoppner

suspended everywhere, the immense and endless spaces, the gulph below; above the gigantic spider's web of scaffolding – especially when, standing under the finished and numberless arches of the galleries, I listen to the reverberating voices in the stillness of the night, and see immense buckets of plaster and water ascending, as if they were drawn up from the bowels of a mine, amid shouts from subterranean depths, oaths from Hell itself, and chantings from Pandemonium or the synagogue . . .

Beckford had moved into the Abbey in 1807, while it was still being built or rebuilt; and he remained there until 1822, when he abandoned

it, moved away to Bath and had the contents of his house put up for sale. His excuse was poverty; in 1797, the yearly income that he derived from his West Indian properties amounted to some £155,000; but, according to his own reckoning, his work on the Abbey had cost him well over a quarter of a million. He may also have tired of his masterpiece once it had achieved final shape. Yet a masterpiece it undoubtedly was. Nothing of the same kind had ever before been seen in England – an enormous pile of Gothic buildings grouped around a towering octagon, from which radiated four extensive transepts. St Michael's Gallery alone was 112 feet long; and it formed part of a 300-foot vista. Proportionately lofty and splendid were the great fan-vaulted roofs. Around these rooms Beckford scattered pictures and bibelots that he had collected on his travels – a nautilus cup designed by Cellini, furniture by Riesener, exquisite objects of crystal, bronze and Sèvres, together with Giovanni Bellini's famous *Doge Loredan* and his incomparable *Agony in the Garden*.

Around his park he threw up a twelve-mile wall, much too high for any

(*Left*) Like Strawberry Hill, a visionary edifice in which the builder realised his own dreams; Fonthill Abbey, from J.Rutter's *Delineations of Fonthill*, 1823. (*Right, above*) Window at the end of the 112-foot vista that Beckford called 'St Michael's Gallery'. (*Below, left*) Fonthill, the Grand Saloon; from *Delineations of Fonthill*. (*Below, right*) A distant view of the Abbey; from a plate that once belonged to Beckford

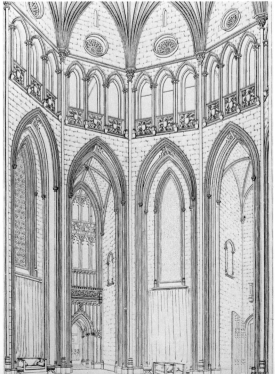

Some of Beckford's most precious objects of art, including the nautilus cup designed by Cellini; from *Delineations of Fonthill*

fox-hunter to jump, which carried a frieze of terrifying iron stakes. At Fonthill no wild creature was ever to be shot or hunted; and, as Beckford's occasional guests drove down the twenty-two miles of pathway, they saw partridges, pheasants and hares running unafraid beside the carriage-wheels. Yet the house itself was uncomfortable, and almost always cold and gloomy. Beckford, in his magnificent seclusion, was not a calm or happy man; and, now that his equals shunned him, he depended more and more on menial company – his agent Gregorio Franchi, a young musician he had picked up abroad, who acted as his homosexual pimp, his pet dwarf and a host of servants and employees, whom he distinguished by outrageous nicknames – 'Nicobuse', 'Coxone', 'Bouffetaut', 'Rottier', 'Bagasse', 'Silence', 'Ghoul', Rhinoceros' and the 'Great Dolt'. Beckford had a passion for inventing fantastic pseudonyms that went with his tortuous and secretive character. Even his poodle, of which he was particularly fond, he had entitled 'Viscount Fartleberry'.

Here our task is not to evaluate Beckford's character (which had its dark and squalid aspect: he was cruel, mean and sour-tempered) but to allot him the place he deserves in the history of Romantic England. Clearly, he was a follower of Horace Walpole – though, in his correspondence, Walpole gave him short shrift – and anticipated many of the excesses of the nineteenth-century Romantic movement. Byron was an enthusiastic reader of *Vathek*, and would have liked to meet the author; but, as Beckford remarked, the meeting, if it had occurred, would no doubt have ended badly: 'We should have both met in full drill – both endeavoured to have been delighted – a correspondence would have been established, the most laborious that can be imagined, because the most artificial.' Nor, as it happened, did Beckford much admire *Childe Harold*; and he gave an odd description of the poet: 'One seems to see the portentous Byron (a Fanfaron des Crimes as Louis XIV called the regent

(*Right*) William Beckford as a young man, by Romney

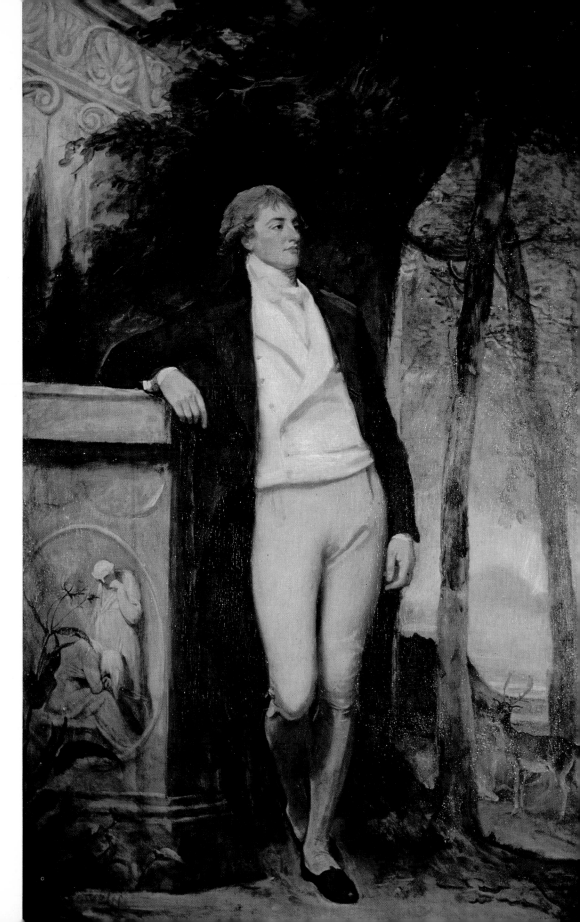

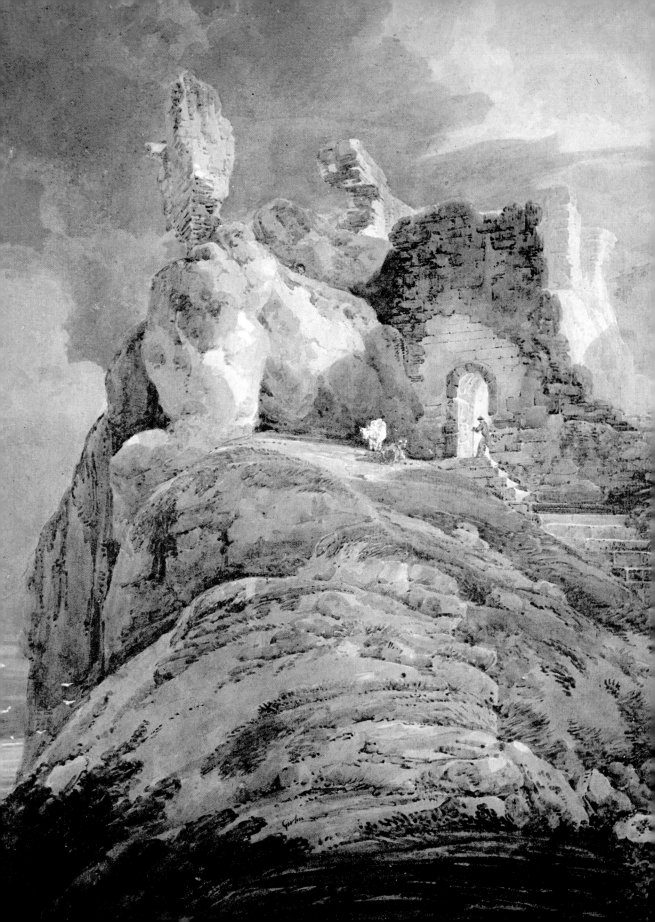

(*Left*) *The Rocking Stone*; a water-colour by John Girtin

Orléans) running furious muck with serpents (which turned out to be stuffed eels) and pretending to whip himself into madness.' A revolutionary can very seldom forecast the ultimate evolution of his own ideas; and, when he confronted Romanticism at its dizziest literary heights, Beckford felt that he himself belonged to a more sensible and better balanced age.

Yet a true Romantic he was – not only as the author of *Vathek* and the tutelary genius of Fonthill, but in his rôle as rebel spirit. He, too, had revolted against society, and knew that, because he had rebelled, society would at last exact its vengeance. He, too, saw himself as a 'lone being'. Not an animal understood him, he had once lamented to a woman friend. And elsewhere: 'How tired I am of keeping a Mask on my face. How tight it sticks – it makes me sore.' Byron declared that he had been 'cunning in his overthrow'; and Beckford might also have claimed that he had engineered his own tragedy. He had the taste for dark contrasts and violent extremes that reappears in all Romantic writing.

William Beckford on his deathbed. The author of *Vathek* died alone and unfriended. By Willes Maddox

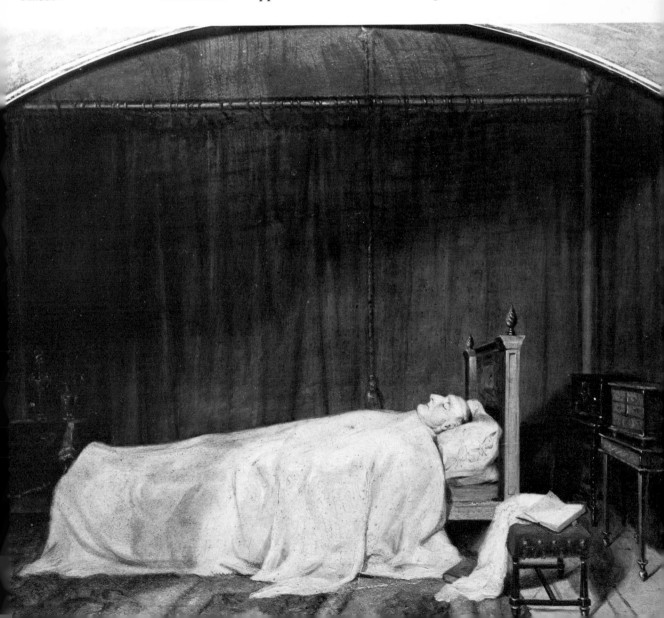

Eight years after the publication of *Vathek* appeared *The Mysteries of Udolpho*; and, although a modern critic might have no difficulty in finding a key either to Walpole's or to Beckford's narrative, he would be hard put to it to discover the secret tensions that engendered Mrs Radcliffe's story. The novelist was a blameless married woman, and, apart from occasional attacks of asthma, lived, so far as we can now judge, a happy, healthy, unadventurous life. But she was fond of foreign travel, and fond of firelit reveries; and in her books the places she had visited abroad assumed a wonderfully phantasmagoric colouring. The Castle of Udolpho embodies her recollections of a medieval stronghold perched above the Rhine:

> Towards the close of day the road wound into a deep valley . . . The sun had just sunk below the top of the mountains . . . whose long shadow stretched athwart the valley; but his sloping rays . . . streamed in full splendour upon the towers and battlements of a castle that spread its extensive ramparts along the brow of a precipice above . . . The whole edifice was invested with the solemn duskiness of evening. Silent, lonely, and sublime, it seemed to stand the sovereign of the scene . . .

The story itself is Mrs Radcliffe's account of what, she felt, might – or should – have occurred amid such a solitary and 'awful' setting. Her picture of the castle fascinated Sir Walter Scott, who went on to pronounce her narrative 'the most interesting novel in the English language'. What he particularly valued was her gift of creating suspense. Not until Mrs Radcliffe's reader had travelled almost half-way through her second volume, does her heroine, whose aunt had contracted an unfortunate marriage with a ruffianly Italian lover, sight the distant castle on its crag. But, once arrived there, she becomes absorbed in the circumambient air of mystery, and is exposed to a series of terrifying experiences that nearly undermine her reason. Montoni, Emily's gaoler and chief tormentor, is a dark Byronic hero-villain; none of his deadly plans succeed. Emily escapes from her long imprisonment in the castle after many strange vicissitudes; and, at the end of Volume IV, she is blissfully united to her chivalrous admirer Valancourt.

When *The Mysteries of Udolpho* appeared in 1794, it had a very favourable reception. It was the kind of novel that a popular journalist claims he cannot put down; and, despite its leisurely pace and remarkably involved plot, it is a book that still deserves re-reading. Again, its great charm is its strange somnambulistic atmosphere. 'To the warm imagination', wrote Mrs Radcliffe, 'the forms which float half-veiled in darkness afford a higher delight than the most distinct scenery the Sun can show.' And, at its best, her narrative recalls the wild pictorial fantasies of Piranesi and Salvator Rosa, where tiny human figures are seen painfully making their way through a perspective of tremendous rugged arches.

For Coleridge and his fellow critics, one of the book's attractions was its unexceptionable moral message. Virtue triumphs; every problem is solved; every occurrence that has inspired the heroine with feelings of supernatural dread receives a natural explanation. Much more disturbing was the effect of *The Monk*, which Coleridge denounced as heartily as he

had applauded Mrs Radcliffe. If not the most talented of the Gothic novelists, its author, Matthew Gregory Lewis, next to William Beckford, was certainly the oddest and the most arresting. Like Beckford, he was a romantic homosexual and derived his large inherited fortune from plantations in the West Indies. But, unlike the self-centred Beckford, he had a soft heart and an uneasy conscience. He was deeply perturbed about the miserable lot of his slaves, and paid two visits to Jamaica on purpose to investigate the system under which they lived and worked. Indeed, his early death – born in 1775, he died in May 1818 – was a direct result of this benevolent enterprise. He died on the journey home, and was buried at sea. But the coffin that enclosed his body refused to sink; and part of the hammock that had been wrapped around it struggled loose and formed a sail. The sail was immediately caught by the trade wind; and from the deck his shipmates watched poor Lewis go bobbing back towards Jamaica.

When Byron heard the news – they were London acquaintances – he was deeply shocked and saddened. Lewis, he wrote, though at times a 'damned bore', was also an excellent fellow, 'a jewel of a man'; and most of the novelist's contemporaries would appear to have held the same opinion. In his writings, on the other hand, he showed a very different character. His imagination was dark, perverse and sadistic – qualities that may perhaps have been due to the troubled circumstances of his youth and childhood. His father, a pompous, dignified personage, separated, while Lewis was still young, from his gay, volatile, attractive mother. Lewis was always his mother's darling; and he often attended her toilette to give expert advice about her clothes and jewels. Sometimes she took him to the theatre, where he learned to imitate, 'with thrilling accuracy', a celebrated actress's death-bed shriek. Lewis, moreover, had spent his formative years at an ancient, ghost-ridden house in Essex; and every night, on his way to bed, he was obliged to pass the haunted room.

Physically, perhaps emotionally, Lewis somehow never quite grew up. Small and neat, with pallid, projecting eyes, which reminded Sir Walter Scott of those of an insect, he always retained his fragile, boyish air. He was, moreover, so affectionate and highly strung that a single kind word – particularly if it fell from the lips of a Royal Duchess: Lewis was an inveterate snob – might produce a fit of nervous weeping. It was only once he had begun to write that he revealed his hidden nature; and then the wildest and most anarchic fancies would come tumbling out across the page. The three volumes of his novel *The Monk*, written on a visit to Holland during the space of ten weeks, were published in March 1796.

The success they achieved was overwhelming. As 'Monk' Lewis, he became the lion of every fashionable London party; and, to increase his fame, a horde of reviewers savagely attacked the novel, which they pronounced to be 'impious', 'libidinous', 'poisonous', 'corrupt', 'obscene'. If a parent saw *The Monk* 'in the hands of a son or daughter', declared *The Critical Review*, 'he might reasonably turn pale'. Nor, for many years to come, did the story lose its gift of shocking. Even Byron, when he re-read *The Monk* in 1813, was obliged to confess that he had been

slightly startled: 'These descriptions [he wrote] ought to have been written by Tiberius at Caprea – they are the *philtered* idea of a jaded voluptuary. It is to me inconceivable how they could have been composed by a man of only twenty . . . They have no nature – all the sour cream of cantharides.'

The austere Ambrosio is wooed by Matilda, disguised as Rosario, a young novice; frontispiece to a French edition of *The Monk*, 1807

The severity of Byron's criticism may nowadays strike us as a little far-fetched; but the surprise he felt is understandable. Although Lewis's private tendencies were believed to be unorthodox – Byron had heard reports of his successive male loves – he was otherwise a fairly innocuous product of the English upper-middle classes. Whence sprang the lurid imaginings that gave *The Monk* its special quality? There is no doubt that he was inspired by Mrs Radcliffe; but into the realms of Gothic romance he had brought a new disturbing element. Lust and cruelty, rape, matricide, incest were the subjects of which 'Monk' Lewis treated; and, not content with being improper himself, he dared to suggest that certain parts of the Bible were just as unbecoming as his own productions. In the second volume of *The Monk*, Elvira, 'that prudent mother', is said to have decided that Holy Writ, without careful censorship, was quite unsuited to a pure young girl: 'Many of the narratives can only tend to excite ideas the worst calculated for a female breast . . . and the annals of the brothel would scarcely furnish a greater choice of indecent expressions . . .'

This passage gave particular offence to the novelist's more high-minded readers, who, when they examined its immediate context, may well have thought that they heard the Devil preaching. For, although *The Monk* contains no 'indecent expressions', and loudly advocates the cause of Virtue, it was Vice that really fascinated Lewis and brought out all his youthful artistry. The scene of the opening chapter is laid in Madrid, at a Capuchin church and nearby monastery, where Ambrosio, the most famous preacher of the time, dispenses consolation to a host of penitents. Ambrosio is an extraordinarily handsome man, but so untouched by fleshly appetites that his admirers like to believe that he cannot distinguish between male and female.

In fact, his latent passions are as strong as his vanity; and, at the end of Chapter II, he succumbs to the advances of a personable novice named Rosario. Luckily, Rosario proves to be a lovesick girl, muffled up in monkish trappings; but Ambrosio's fall is none the less disastrous:

Drunk with desire, he pressed his lips to those which sought them; his kisses vied with Matilda's in warmth and passion: he clasped her rapturously in his arms; he forgot his vows, his sanctity, and his fame; he remembered nothing but the pleasure and [opportunity. 'Ambrosio! Oh, my Ambrosio!' sighed Matilda. 'Thine, ever thine', murmured the friar, and sunk upon her bosom.

There the curtain abruptly runs down, and Lewis, another master of suspense, plunges into the ramifications of an elaborate sub-plot. The curtain does not rise again to discover Ambrosio and the false Rosario until the start of Chapter VI, after we have been whirled around Middle Europe through a long series of wild and ghostly episodes, have escaped from a romantic robbers' den and encountered the Bleeding Nun, an

exceptionally appalling phantom. By that time 'the licentious monk' has begun to tire of his lascivious mistress. Now and then, he still 'rages with desire'; but Matilda's hold is slowly weakening. The bold young woman continues to tempt him to sin; 'but she soon was aware that she had satiated her lover by the unbounded freedom of her caresses . . . The delirium of passion being past, he had leisure to observe every trifling defect; where none were to be found, satiety made him fancy them.' Meanwhile, 'the overwhelming torrent of his desire', which Matilda had so unwisely unleashed, is surging out towards a new objective.

At this point, the wretched Matilda chooses to accept her congé. But if she cannot be Ambrosio's bedfellow, like another Louisa Beckford she can, at least, be his accomplice; and, having invoked the Powers of the Under-world and got the satanic hierarchy upon her side, she proceeds to abet him in his hideous schemes for debauching an unspotted virgin. She does more; she actually whets his lust by showing him, with the help of a magic mirror, the reflection of 'the enchanting girl' at a particularly unguarded moment:

She threw off her last garment, and, advancing to the bath . . . put her foot in the water. It struck cold, and she drew it back again. Though unconscious of being observed, an in-bred sense of modesty induced her to veil her charms; and she stood hesitating upon the brink, in the attitude of the Venus de Medicis. At this moment a tame linnet flew towards her, nestled its head between her breasts, and nibbled them in wanton play. The smiling Antonia . . . at length raised her hands to drive it from its delightful harbour. Ambrosio could bear no more . . . 'I yield', he cried, dashing the mirror upon the ground: 'Matilda, I follow you! Do with me what you will!'

Such is one of the descriptions that came very near to shocking Byron; and there are other equally voluptuous incidents in the author's third volume, where we read how Ambrosio, after various setbacks, manages to rape Antonia, only to learn that they are both the children of Elvira, whom meanwhile he has done to death. Thus incest is neatly coupled with matricide; and it remains for the Evil One to make a terrific appearance and preside over the grand finale.

'Monk' Lewis was an enthusiastic rather than a deeply gifted writer. As my quotations may already have shown, he had an extremely banal prose-style; but it is often redeemed by the tremendous verve and energy with which he hurls along his narrative. The pace is unflagging, like that of the runaway horses he describes, who 'dragged the carriage through hedges and ditches, dashed down the most dangerous precipices, and seemed to vie in swiftness with the rapidity of the winds'. His phantoms themselves are apt to be unconscionably loud and violent. And, when the Bleeding Nun appears at his victim's bedside, 'the most dreadful confusion' we are told, 'reigned through the castle. The vaulted chambers resounded with shrieks and groans; and the spectre, as she raged along the antique galleries, uttered an incoherent mixture of prayers and blasphemies. Otto was unable to withstand the shock . . .'

Lewis's romance, in short, is the climax of the eighteenth-century Gothic novel. From *The Castle of Otranto* it took its splendid architectural back-

ground; from *Vathek*, its spirit of wild impiety; from *The Mysteries of Udolpho*, its dungeons and chains and shadows and darkly sweeping mountain landscapes. But none of his predecessors had dared to go so far. Alongside his elaborate pictures of lust and licence, he places innumerable images of decay and death. Here he outdoes the Elizabethan poets. Shakespeare himself, in *Romeo and Juliet*, shows a greedy appetite for horrors; but Juliet, immured among the tombs of the Capulets, has an easy death compared with Lewis's heroine, who is eventually ravished by the infamous Monk near 'three putrid half-corrupted bodies'.

This was not, however, the end of the Gothic novel; and at the beginning of the next century the form was still so widely popular that, in *Northanger Abbey*, Jane Austen composed her famous dialogue between two impressionable young novel-addicts, Catherine Morland and Isabella

41

Thorpe. Isabella has just lent her friend a copy of Mrs Radcliffe's master-piece:

> ... 'And when you have finished "Udolpho", we will read the Italian together; and I have made out a list of ten or twelve more of the same kind for you.'
>
> 'Have you, indeed! How glad I am! – What are they all?'
>
> 'I will read you their names directly; here they are, in my pocket-book. "Castle of Wolfenbach", "Clermont", "Mysterious Warnings", "Necromancer of the Black Forest", "Midnight Bell", "Orphan of the Rhine", and "Horrid Mysteries". Those will last us some time.'
>
> 'Yes, pretty well; but are they all horrid, are you sure they are all horrid?'

Nor was the vogue confined to foolish young women who frequented the Bath circulating library. Before 1811, Shelley had dashed off two romances, *Zastrozzi* and *St Irvyne*, of the most extravagantly Gothic type; Mary Shelley, in 1818, wrote *Frankenstein*, a far more interesting and original story; in 1819 Dr John Polidori, Lord Byron's private travelling physician, endeavoured to take the literary world by storm with his necrophilic tale *The Vampyre*; and Thomas De Quincey published *The Avenger* as late as 1838. But the most remarkable product of the period was *Melmoth the Wanderer* by Charles Robert Maturin, which appeared in 1820.

Born in 1782, Maturin, though he claimed to be the descendant of a mysterious, but evidently high-born foundling, once picked up from the cobble-stones of the rue des Mathurines by an aristocratic French lady, was the ninth son of an Inspector of Roads for Ulster, and, after a brilliant career at Trinity College, Dublin, had taken 'the fatal step' of entering the Irish Church. Despite the fact that he was both zealous and eloquent, he made a very bad parson. Literature was always his real love. He had, moreover, a strongly developed taste for theatricals and dressing-up – a 'passion for the extravagant', writes his Victorian editor, not only un-suited to his rôle as a clergyman, but 'childish and even repellent to the ordinary British mind . . .' Maturin, indeed, was a born eccentric: ' . . . *Homme du monde et homme de coulisses*', recorded an anonymous con-tributor to the *Revue des deux Mondes*, '*fat, fier, amoureux du quadrille, de la table de jeu, et de la pêche: nous l'avons reconté en octobre sur les bords d'un lac, armé d'une ligne immense, vêtu comme un beau danseur de Londres ou de Dublin, en escarpins et en bas de soie . . .*'

Maturin's family-life was harmonious; and at home, too, he often exhibited himself in bizarre and unexpected guises. 'He liked people to be in the room when he was writing, especially if they were arguing, and his wife and one of his sisters . . . would often sit with him while he was com-posing. But, in order that he should not be drawn into the conversation, he adopted the Odysseus-like practice of covering his mouth with a paste composed of bread and water.'* Lockhart, however, describing Sir Walter Scott's visit to Dublin in 1823, when he entertained the novelist at break-fast, reports that Maturin used to compose with a wafer stuck upon his forehead, 'which was the signal that if any of his family entered the

* Introduction to the edition of *Melmoth* published in 1892.

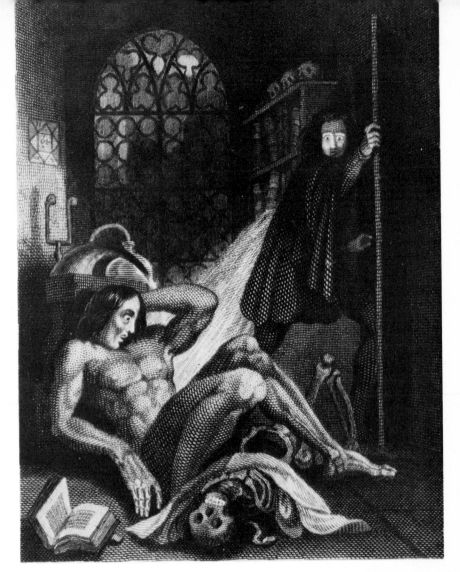

From the 1832 edition of *Frankenstein*, Mary Shelley's Gothic novel

sanctum, they must not speak to him'. Abroad, he adopted a distinctive style of dress – 'a well-made black coat and odd light-coloured stockinet pantaloons'; to which he added 'an overcoat of prodigious dimensions' if the day were cold and windy.

By the time he accomplished his masterpiece, Maturin had already written four tales, and a tragedy, *Bertram, or the Castle of St Aldobrand*, which had attracted the attention of Sir Walter Scott, who recommended the drama first to John Kemble, and then to Byron, an important member of the Drury Lane Committee. Byron found the dramatist 'a bit of a coxcomb', but, having heard that the poor fellow had had a 'long seasoning of adversity', sent him fifty guineas to relieve his needs; and *Bertram* was eventually produced with Edmund Kean as chief performer. It scored an immense success on the London boards; and, during the course of a single year, the printed text ran through seven editions.

His tragedy earned Maturin well over £1000. But he was both a wild

spender and a heavy gambler; and, until he died in 1824 – partly, it was thought, as the result of swallowing one night 'a bottle of embrocation by mistake . . . for his medicine' – he was seldom out of difficulties. Nonetheless, he had many consolations. His eloquent sermons at St Peter's, Dublin, always drew admiring crowds; and, since he claimed that he was the best dancer in the whole of the Established Church, he continued to arrange his popular quadrille parties. His wife was a beautifully dressed and exquisite rouged young woman. Maturin, we are told, could never bear naked cheeks, and, when they held a party, would often send Mrs Maturin back to her room 'if he did not think that art had been sufficiently employed'.

Apart from his eccentricity and his hopelessly spendthrift ways, there was nothing about the novelist's character that attracted hostile notice. But just as Lewis in *The Monk* had revealed a secret strain of dark imaginings, so Maturin, in his most celebrated novel, disclosed an unknown wealth of hideous fancies. Melmoth himself is a peregrinatory anarch, who has kept death and old age at bay by the sale of his immortal soul, on the understanding that he will be allowed to break the contract if he can find another human being prepared to link their destiny with his. Thus Melmoth wanders across the world and, though far more terribly and effectively, 'lies in wait for souls' like Beckford. Like Vathek, he has a basilisk glance; and, wherever he re-emerges, he spreads around him terror and confusion. His greatest triumph is to overcome the 'impregnable innocence' of the virgin Immalee, a girl brought up on a mysterious tropical island, whose cloistered charm symbolizes all that is bright and fresh and pure in nature.

Maturin enjoyed portraying bloodshed and rapine and 'scenes of horror indescribable'; but he was also genuinely concerned with the problem of Evil and with the origins of human guilt and pain. There seems no doubt that he had studied the Marquis de Sade:*

It is actually possible to become *amateurs in suffering*. I have heard of men who have travelled into countries where horrible executions were to be daily witnessed, for the sake of that excitement which the right of suffering never fails to give . . . It is a species of feeling of which we never can divest ourselves, – a triumph over those whose sufferings have placed them below us, and no wonder, – suffering is always an indication of weakness, – we glory in our impenetrability. *I* did, as we burst into the cell.

The cell into which the sadistic visionary bursts is the last refuge of an unhappy couple whom the Church has attempted to tear apart; and here Maturin enlarges on the strictly relative nature of moral and, indeed, aesthetic standards:

. . . I must do the Superior reluctant justice. He was a man . . . who had no more idea of the intercourse between the sexes, than between two beings of a different species. The scene that he beheld could not have revolted him more, than if he had seen the horrible loves of the baboons and the Hottentot women, at the Cape

* For a discussion of Maturin's indebtedness to Sade, see Mario Praz: *The Romantic Agony*.

of Good Hope; or those still more loathsome unions between the serpents of South America and their human victims, when they can catch them, and twine round them in folds of unnatural and ineffable union. He really stood as much astonished and appalled, to see two human beings of different sexes, who dared to love each other . . . as if he had witnessed the horrible conjunctions I have alluded to.

Maturin's aims, though not the methods he employed, immediately recall the work of Beckford; his object, he declared, was to 'depict life in its extremities, and to represent those struggles of passion when the soul trembles on the verge of the unlawful and the unhallowed'. As a literary artist, however, Maturin was far less gifted; and *Melmoth the Wanderer*, which runs to three substantial volumes, is an extraordinarily prolix narrative, rambling, often ill-composed, and clogged with over-written detail. Far more important than the book itself was the powerful spell it exercised. Few English novels of the period were so eagerly read and so much admired abroad; and among its devotees were Honoré de Balzac, Victor Hugo and Charles Baudelaire.

'*Quoi de plus grand, quoi de plus puissant relativement à la pauvre humanité*', demanded Baudelaire in *De l'Essence du Rire*, '*que ce pâle et ennuyé Melmoth?*' Balzac classed Maturin's hero, with Molière's Don Juan, Goethe's Faust and Byron's Manfred, among the '*grandes images tracées par les plus grands génies de l'Europe*'. And Hugo, who had also admired the French version of Maturin's best-known tragedy, used six passages taken from *Bertram* as chapter-headings for his early romance, *Han d'Islande*. Melmoth soon became one of the tutelary divinities of the French Romantic movement; and, when Alaric Watts visited Paris some time in the eighteen-thirties, he found that his link with the '*triste et terrible Maturin*' gained him an immediate entry into all the chief Romantic salons.*

Maturin had an equally important effect on the French view of the English character; for he confirmed the belief, which Byron had already inspired, that in the temperament of the Anglo-Saxon race there lurked a dark satanic strain. This view, with many variations, seems to have persisted throughout the nineteenth century. It reappears, for example, in the stories of Villiers de l'Isle-Adam, whose macabre tale, *Le Sadisme Anglais*, describes the relish of cruelty as a peculiarly English weakness, and includes a prose-translation of Swinburne's sadistic dithyramb *Anactoria*. It is even to be detected in the work of a grave historian, Jules Michelet's *Histoire de France*: 'This great English people [the historian announces] among so many good and solid qualities has one vice which spoils these very qualities . . . From Shakespeare to Milton, from Milton to Byron, their beautiful and sombre literature is sceptical, judaic, satanic, to sum up anti-Christian.' Michelet must certainly have read Maturin; and the wild fantasies of the improvident Irish clergyman, whose harmless life was haunted by such wicked dreams, may well have provided him with useful evidence.

* Among Maturin's later admirers were Dante Gabriel Rossetti and Oscar Wilde; and Wilde, who claimed a relationship with Maturin through his mother, the poetess 'Speranza', adopted the name Sebastian Melmoth when he emerged from Reading Gaol.

Maturin died at the age of forty-three; he had published *Melmoth the Wanderer* when he was thirty-eight. But it is a young man's book. Youth and childhood are seminal themes that run through most Romantic writing; and Walpole, Beckford, Lewis and Maturin seem all to have been distinguished by a curious touch of immaturity. In certain respects they had failed to grow up. Thus Walpole, a delicate mother's boy, never embarked on the trials of a completely adult love-affair; while Beckford retained many of

Another scene from Scott, drawn by Turner

the characteristics of an astonishingly gifted adolescent. Lewis, so long as he lived, had a strangely undeveloped aspect; and Maturin's wayward habits recall the diversions of his lively Irish schoolroom, where, with his numerous brothers and sisters, he used to organise charades and plays.

Childhood, however, is also a time of fear, of guilt and anxiety and dark appalling visions; and it was from his adventures in the haunted dream-world that the Gothic novelist derived his stories, which are impressive when they most closely resemble dreams, but apt to break down if he professes to deal with ordinary actions and emotions. Beckford alone had a genuine spark of genius. But the others, too, exercised a powerful effect upon the development of contemporary verse and prose. Coleridge, for example, was deeply influenced by the Gothic 'tale of horror'. Not only is *The Rime of the Ancient Mariner* a pre-eminently Gothic poem; but *Christabel*, besides its medieval background, contains in the person of Geraldine, the serpent-lady, a peculiarly 'horrid' character:

> Beneath the lamp the lady bowed,
> And slowly rolled her eyes around;
> Then drawing in her breath aloud,
> Like one that shuddered, she unbound
> The cincture from beneath her breast:
> Her silken robe, and inner vest
> Dropt to her feet, and full in view
> Behold! Her bosom and half her side –
> A sight to dream of, not to tell!

– lines that so disturbed Shelley, when Byron recited them at midnight on 18 June 1816, among his listeners being Mary Shelley, who was soon to write *Frankenstein*, and Dr John Polidori, the future author of *The Vampyre*, that he uttered a wild shriek, clutched his head in his hands and rushed desperately from the room.

2

The Cult of Youth

I n the present period, few sensitive, well-educated Englishmen would care to admit that they had had an altogether happy childhood, or had passed through adolescence without pain and struggle. So deep-rooted is the Romantic cult of youth, which regards youth as the proper time for rebellion, and the conflict between young and old as a necessary and important part of a young man's intellectual progress.

Such an attitude towards human relationships seems to have originated in the nineteenth century; the domestic records of the English Augustan Age reveal a very different point of view. Pope, Sterne, Gibbon and Boswell were all of them devoted sons. Boswell, it is true, once joined an Edinburgh mob that, under cover of darkness, was breaking Lord Auchinleck's windows; and this act of insubordination evidently caused him guilty pleasure. Yet he continued to cherish a profound respect for his solemn and sententious parent, whose approbation he was continually courting but could somehow never quite obtain; and when, during his memorable tour of the Hebrides, he was able to persuade his 'honoured father' to meet his venerated friend, Samuel Johnson, heard a vigorous argument almost immediately develop, and was then privileged to watch them wrestling in the pose of 'intellectual gladiators', his pride and satisfaction knew no bounds.

Edward Gibbon, too, not only admired his father's splendid appearance and 'the pleasing flexibility of his temper', but, as soon as he had surmounted the problems of youth, found he much enjoyed his company. Having himself a robust, eupeptic nature, the younger Gibbon did not bear grudges; and the sentence of the exile with which his father had seen

The apotheosis of childhood; from a commercial engraving by William Blake

49

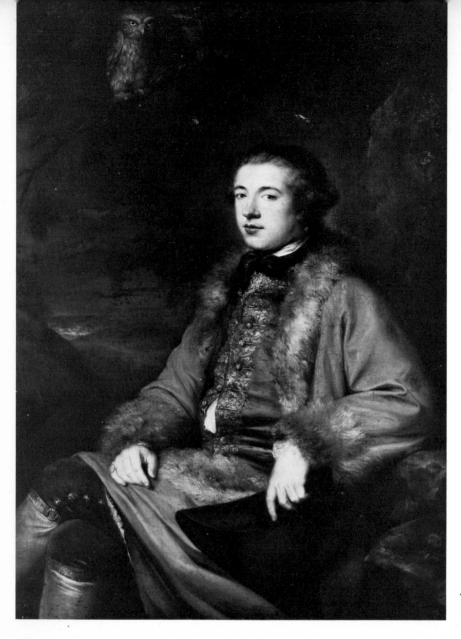

James Boswell as a young man; portrait by George Willison

fit to punish his religious backslidings, while he was still a callow boy at Oxford, had left him wholly unembittered. Nor did he revolt against his father's stern refusal to allow him to marry Suzanne Curchod, '*la seule femme* [he believed] *qui eût pu me rendre heureux*'. Two hours' sober reflection had sufficed to convince him that, although he might sigh as a lover, as a son he must obey; and a subsequent meeting with Mademoiselle Curchod assured him that he had made the right decision. It now struck him that the charming Swiss girl was naturally frivolous and insincere – '*fille dangereuse et artificielle*!'; and he was presently amused to learn that she had accepted the hand of a rich and respected, but uninspiring Swiss banker.

Thenceforward, the older and younger Gibbon lived together, wrote the historian, 'on the same terms of easy and equal politeness'. They were

(*Right*) John Keats in the library of his house at Hampstead, by Joseph Severn

50

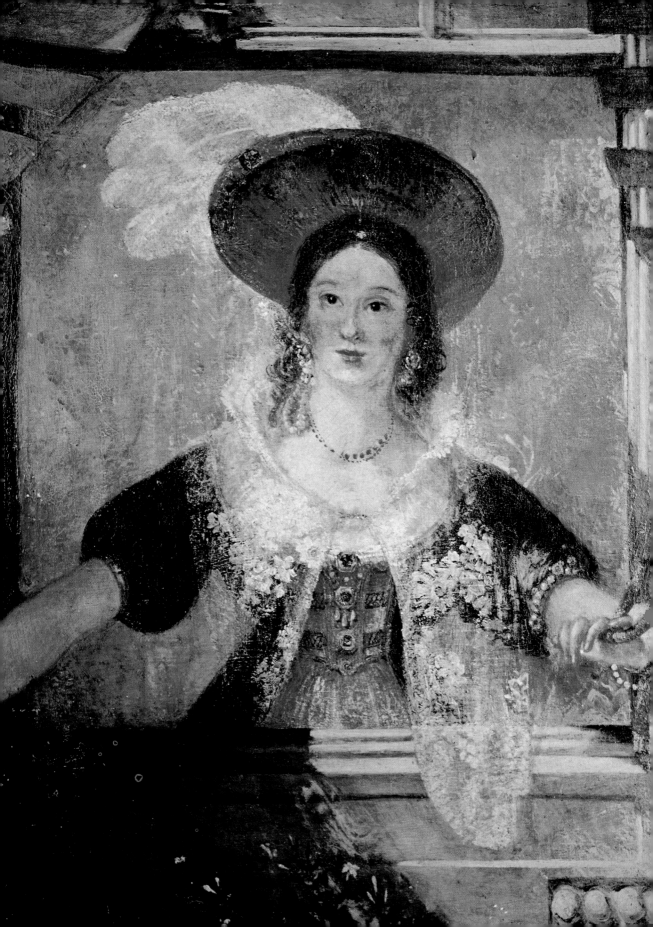

(Left) Jessica; painting
by Turner

fellow men of the world; as, in a somewhat more troubled fashion, were
Joseph Hickey and his son, William. At the age of seven, William was
already being encouraged to share the amusements of his father's circle;
and he remembered how, in 1756, he had seated himself upon the knee of
his godfather, the good-humoured Colonel Matthews: '... After dinner,
having just swallowed a bumper of claret that was given me, I, with a deep
sigh, said to him, "I wish I was a man." "Aye," observed the Colonel,
"and pray why so, William?" To which I quickly replied, "That I might
drink two bottles of wine every day." '

William Hickey's early training, as it turned out, failed to benefit his
adult character. He grew up an incorrigible rake and spendthrift; and, a
place having been found for him in his father's office, he took to plunder-

(Left) Edward Gibbon in
his early thirties;
portrait by H. Walton.
(Right) 'Ed. Gibbon the
Historian in Military
uniform'. Caricature of
Gibbon during his period
of 'military servitude'

ing the office till. His earliest misdeeds, William writes, cost his father
'near five hundred pounds'. But Joseph did not, as a Victorian parent
would almost certainly have done, hurl him into outer darkness, and
merely shook his head, declaring himself 'at a loss how to act or what to do
with me'. When William was convicted of yet another lapse, although
Joseph Hickey pulled out the pathetic stop and discoursed at some length
upon the subject of ungrateful children, he spoke less in tones of righteous
anger than in those of heartfelt private sorrow; and the only method of
correction he adopted was to ship the young man overseas.

An even more remarkably indulgent father was Henry Fox, the first
Lord Holland. Charles James Fox had been born in 1749, during the same
year as William Hickey; and, since his elder brother happened to be a

sickly child, afflicted with a 'distemper they call Sanvitoss dance', it was natural that Charles should become the focus of all his father's hopes and schemes. But Henry Fox watched over his son's development as if he had been cultivating a rare and precious plant, which, at the smallest touch of unkindness, might shrivel up and disappear. When his mother complained that Charles was 'dreadfully passionate' and wondered what she ought to do, 'Oh, never mind', her husband replied, 'he is a very sensible little boy, and will learn to curb himself.' Any form of contradiction, he felt, might inflict a serious mental injury: 'Let nothing be done', he ordered, 'to break his spirit. The world will do that business fast enough.'

Charles's spirit, however, proved quite indomitable; and, even as a baby, he seems to have taken full advantage of his devoted parent's good nature. Suppose that he wished to smash a precious timepiece, or plunge his sturdy arms into a bowl of cream, 'Well, if you must, you must', Henry Fox would murmur philosophically. On a later occasion, when he heard that little Charles was extremely cross and disappointed because a garden-wall, that he had looked forward to seeing pulled down, had been demolished in his absence, he promptly gave orders that the interesting stretch of brickwork should be put up again and once again destroyed.

(Left) Charles James Fox on leaving Eton; 'the tone of the school suffered a long-enduring change for the worse'. Leaving portrait by Reynolds. *(Right)* Fox in later life. Whether he worked or idled, he did so with consummate zest. Portrait by K.A.Hickel

Similarly, when he was ready to go to school, the choice of an establishment was left to the boy's discretion. Charles had 'determined', his father informed a friend, to join a fashionable boarding school at Wandsworth, just as he later determined for Eton and for Hertford College, Oxford. Eton, it is said, was never the same once Charles James Fox had made his mark there. When he was fourteen, his father decided he should visit Paris, provided him with a daily supply of guineas to lose in the Parisian gaming-rooms, and generally encouraged him to acquire a knowledge of all the most expensive modern vices. He returned home, we are told, 'so accomplished a gambler that the tone of the school suffered a long-enduring change for the worse'.

Unlike William Hickey's, Charles Fox's private character seems to have been improved by this permissive treatment. So long as he lived, he gambled wildly and, if his luck ran out, as it often did, borrowed recklessly and indiscriminately; but few happier and more amiable men have played a part in English public life. He had nothing of the grim self-absorption that disfigures the average statesman's portrait. Brought up to enjoy and understand the world, he remained an *homme du monde* of the finest and most civilised type: a lover of poetry who worshipped Homer and Shakespeare, and had made a close study of the works of Chaucer, a great traveller, an excellent boon companion, a student of life who, when he spoke to his fellow human beings – scholars, jockeys, peasants, fashionable ladies – always used their own language.

Whether he worked or idled, he did so with consummate zest; for he had learned the art of becoming entirely absorbed in any occupation that might take his fancy. He was an enthusiastic farmer and gardener; and he discovered unending 'sources of enjoyment' in a variety of much more trivial pastimes. Thus, after an arduous spell of politics, we hear that he drove off to Cheltenham and, on his holiday, spent much of the leisure he had earned trying patiently to tame a young rabbit.

The domestic history of eighteenth-century England is also illustrated, with incomparable vividness, by its numerous conversation-pieces. Hogarth's picture of *The Graham Children*, painted in 1742, and Zoffany's group-portrait of *The Duke of Atholl and his Family*, executed nearly a quarter of a century later, produce the same harmonious impression. No adults have been asked to attend the little Grahams' nursery-concert; but the Duke and Duchess appear in the midst of their seven cheerful sons and daughters, who are weaving crowns of flowers, helping their father with his rod and line, and chasing the family pet, a ring-tailed lemur, up into the branches of a small tree.

Each composition is distinguished by its gay, informal air; and the second emphasises the happy relationship of the placid parents and their lively children. The Duke seems a particularly benevolent father – a trait that he shares with many other parental figures portrayed by English eighteenth-century artists. Whereas in Victorian family-portraits, the Paterfamilias suggests a stern Jehovah among a choir of timid angels,

earlier canvases present him as Olympian Zeus, presiding easily and good-naturedly over a festive group of nymphs and heroes.

Both Hogarth and Zoffany, the reader will notice, depict children dressed in adult clothes. The boy was a miniature version of the man, whom his indulgent guardians encouraged to grow up as quickly as his strength allowed him, that he might enjoy the pleasures and privileges of the adult eighteenth-century world. It was a world that welcomed children, but attached no especial value either to the charms of babyhood or to the grace and innocence of childhood. Solid maturity counted for more than youth; and not until the closing decades of the century did parents begin to put their children into picturesquely childish garb.*

* The first fashion-plates illustrating children's clothes appeared in 1770. See Ann Buck, *A History of Children's Clothing*, 1965.

(*Left*) *The Graham Children*, by William Hogarth, 1742; a picture of carefree eighteenth-century childhood. (*Right, above*) *The Duke of Atholl and his Family*, by Zoffany, 1765; the cheerful parents share their children's fun. (*Below*) *The James Family*, by Arthur Devis, 1751; until the latter part of the century, a growing child wore adult clothes

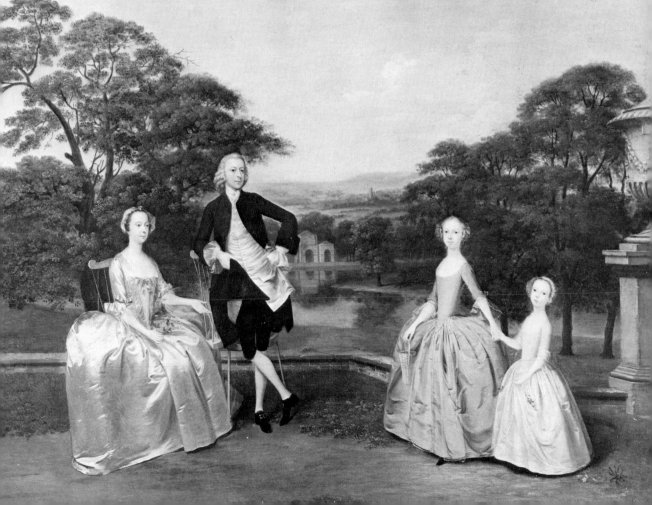

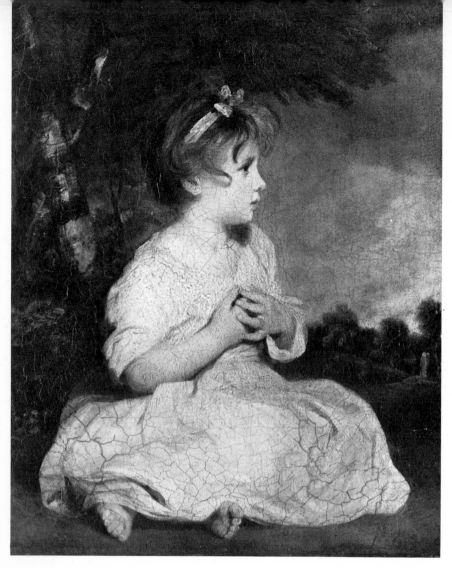

(*Left*) *The Age of Innocence*; Reynolds's sentimentalised portraits of children helped to set a new fashion.

Sir Joshua Reynolds's egregious *Age of Innocence* appeared in 1788; and the same subject was exploited by a long series of minor contemporary artists, including the Reverend Matthew William Peters, whose *Angel carrying the Spirit of a Child to Paradise* had been exhibited in 1783, but who often flavoured his sentimentalism with a touch of sly eroticism, and George Morland, who portrayed both attractive, well-bred children and good-looking hobnailed peasants – the virtuous peasant having now come into his own as the unspoiled Child of Nature.

William Blake produced his *Songs of Innocence* in 1789, his *Songs of Experience* in 1794. By 1806 Wordsworth had completed *The Prelude*; and in 1807 he published his *Intimations of Immortality*, which gave the Romantic attitude towards youth the form of a quasi-religious doctrine. But here it is important to remember that, though the idea of childhood as a peculiarly blessed state seems to have lapsed during the Augustan period, it can already be found in the work of certain seventeenth-century English

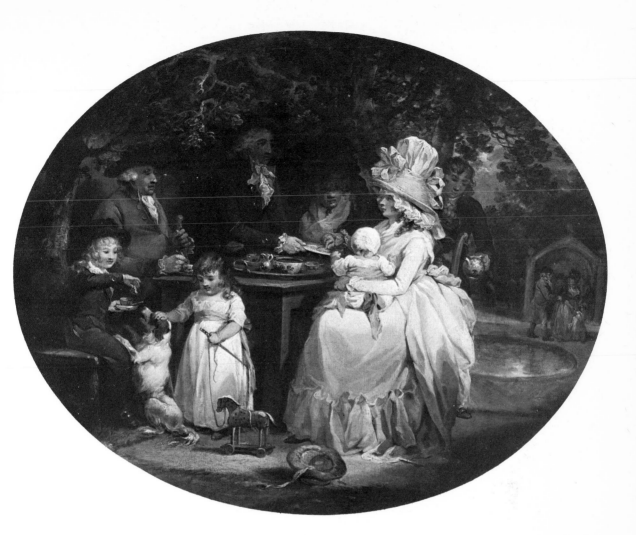

(*Right*) *The Tea Garden*,
by George Morland, 1790.
(*Overleaf, left*) Frontis-
piece to Blake's *Songs of
Innocence*, 1789. (*Overleaf,
right*) 'When the voices of
children are heard on
the green . . .' *Songs of
Innocence*

poets. Shakespeare himself, in *The Winter's Tale*, makes Polixenes speak of
the timeless joys he had once shared with his fellow sovereign Leontes:

> We were, fair queen,
> Two lads that thought there was no more behind,
> But such a day to-morrow, as to-day,
> And to be boy eternal . . .
> We were as twinned lambs, that did frisk i' th' sun,
> And bleat the one at th'other: what we changed,
> Was innocence for innocence; we knew not
> The doctrine of ill-doing, nor dreamed
> That any did. Had we pursued that life,
> And our weak spirits ne'er been higher rear'd
> With stronger blood, we should have answered heaven
> Boldly 'not guilty' . . .

Much later in the seventeenth century, two great religious poets, Henry
Vaughan and Thomas Traherne, so far disregarded the dogma of Original

59

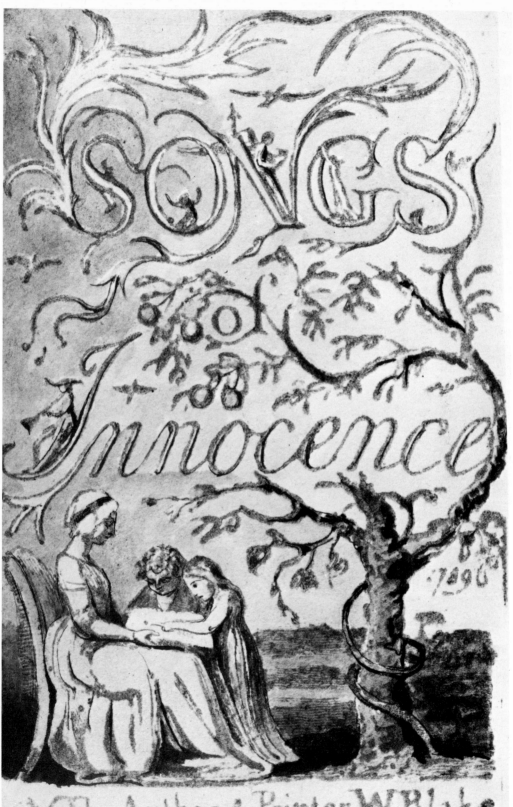

NURSES Song

When the voices of children are heard on the green
And whisprings are in the dale:
The days of my youth rise fresh in my mind,
My face turns green and pale.

Then come home my children, the sun is gone down
And the dews of night arise
Your spring & your day, are wasted in play
And your winter and night in disguise.

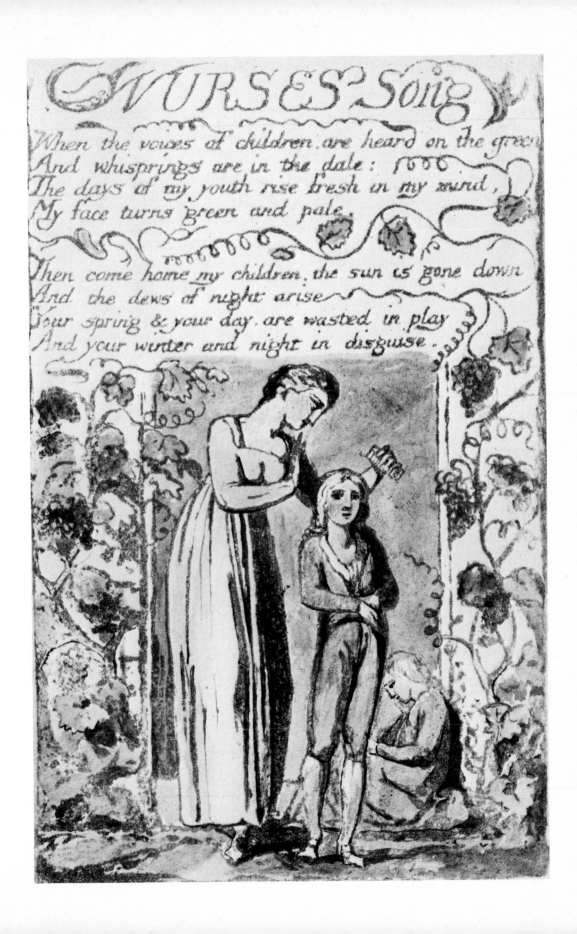

Sin as to suggest that every step we take towards manhood carries us farther and farther from the Earthly Paradise. Vaughan's poem *The Retreat* has an especially appealing music:

> Happy those early days! when I
> Shined in my angel infancy.
> Before I understood this place
> Appointed for my second race,
> Or taught my soul to fancy aught
> But a white, celestial thought,
> When yet I had not walked above
> A mile, or two, from my first Love,
> And looking back, at that short space,
> Could see a glimpse of His bright face . . .
> Before I taught my tongue to wound
> My conscience with a sinful sound,
> Or had the black art to dispense
> A several sin to every sense,
> But felt through all this fleshly dress
> Bright shoots of everlastingness.
>
> O how I long to travel back,
> And tread again that ancient track!
> That I might once more reach that plain,
> Where first I left my glorious train,
> From whence the enlightened spirit sees
> The shady city of palm trees . . .

If Vaughan clearly foreshadows Wordsworth, Traherne, both in his verse and prose, was obviously much akin to Blake. 'Suppose a river or a drop of water', he writes in his *Centuries of Meditations*,* 'an apple or a sand, an ear of corn, or an herb: God knoweth infinite excellencies in it more than we: He seeth how it relateth to angels and men . . . how it representeth all His attributes . . .' And elsewhere: 'Suppose a curious and fair woman. Some have seen the beauties of Heaven in such a person. It is a vain thing to say they loved too much. I dare say there are ten thousand beauties in that creature they have not seen.' Or again: 'The world is a pomegranate . . . which God hath put into man's heart . . . because it containeth the seeds of grace and the seeds of glory. All virtues lie in the World . . .'

His pantheistic sense of natural beauty Traherne then traces back to the secret experiences that had befallen him in early childhood. He had found the world a region of bewildering splendour, which he regarded as his private kingdom:

The corn was orient and immortal wheat, which never should be reaped, nor was ever sown. I thought it had stood from everlasting to everlasting. The dust and stones of the street were as precious as gold: the gates were at first the end of the world. The green trees when I saw them first through one of the gates transported and ravished me . . . The Men! O what venerable and reverend

* First printed from Traherne's manuscript by Bertram Dobell in 1908.

creatures did the aged seem! . . . And maids strange seraphic pieces of life and beauty! Boys and girls tumbling in the street, and playing, were moving jewels. I knew not that they were born or should die; but all things abided eternally as they were in their proper places . . . The city seemed to stand in Eden, or to be built in Heaven. The streets were mine, the temple was mine, the people were mine . . . The skies were mine, and so were the sun and moon and stars, and all the World was mine; and I the only spectator and enjoyer of it.

Later, he describes the sense of dread, amounting almost to supernatural terror, that swoops down, now and then, upon the childish spirit – an experience again and again described by Wordsworth in some of the most memorable passages of *The Prelude*:

Another time in a lowering and sad evening, being alone in the field, when all things were dead and quiet, a certain want and horror fell upon me, beyond imagination. The unprofitableness and silence of the place dissatisfied me; its wideness terrified me; from the utmost ends of the earth fears surrounded me . . . I was a weak and little child, and had forgotten there was a man alive in the earth.

Since the manuscript of Traherne's *Meditations* was not published until 1908, Wordsworth is unlikely to have read it or to have heard of its existence. Yet *The Prelude* translates many of the themes that had absorbed both Traherne and Vaughan into the imagery of Romantic verse. At the time he completed it, the poet was thirty-five; and the most crucial period of his life already lay some years behind him. Few stories have come down to us about the early stages of his childhood, except that his mother, who died when her son was eight, said that, of all her children, only William caused her real anxiety, and prophesied that he 'would be remarkable either for good or for evil' – a statement Wordsworth attributed to the fact 'that I was of a stiff, moody and violent temper', so violent that, 'some indignity having been put upon me', he had climbed to the attic of his grandfather's house, meaning to commit suicide with one of the old fencing foils that he knew were stored away there.

The happiest epoch of his existence had opened in 1778, when he entered the Grammar School at Hawkshead, a small Lancashire town between Coniston and Windermere, close to the shores of Esthwaite Water. He lodged at a friendly cottager's home and, with his schoolfellows, enjoyed all the rough amusements – swimming, riding, skating, bird's-nesting, flying kites and setting snares – of an athletic eighteenth-century boy. This was the 'seed-time' portrayed in *The Prelude*, the time when, under the spell of lakes and mountains, he had first begun to feel and think. He reached Cambridge a sober, self-confident youth; and in 1790 he and a fellow undergraduate set out upon a foreign holiday. The date was luckily chosen; they landed at Calais exactly a year after the Bastille's fall; and, as they trudged across France, past windows decked with bouquets and beneath garlanded triumphal arches, they admired the tremendous spectacle of a countryside in revolution –

France standing on the top of golden hours,
And human nature seeming born again.

Like a modern student in revolt, Wordsworth believed that Youth, which was so closely linked with Nature, had a direct access to the ultimate sources of wisdom:

> Youth maintains,
> In all conditions of society,
> Communion more direct and intimate
> With Nature, – hence, ofttimes, with reason too –
> Than age, or manhood . . .

– and that only a young man could enjoy the dazzling prospects opened by the Revolution as they deserved to be enjoyed:

> O pleasant exercise of hope and joy!
> For mighty were the auxiliars that then stood
> Upon our side, we who were strong in love!
> Bliss was it in that dawn to be alive,
> But to be young was very Heaven!

Yet, when he returned to France, towards the end of the year 1791, he had at first found the revolutionary prospect far less stirring and inspiring. Although he spent some instructive days in Paris, attended clamorous sessions of the Jacobins' Club and the National Assembly, examined the dusty site of the demolished Bastille, listened to the speeches of wild-eyed Patriots, and 'coasted round' the long array of taverns, gambling-houses, brothels and shops that lined the noisy courtyards of the Palais-Royal, what chiefly interested him was Le Brun's mournful picture of St Mary Magdalen, with its 'fair face' and 'ever-flowing tears'.

Soon afterwards he moved south to Orléans, where he hoped to settle down and learn the language, but was almost immediately swept off his feet by two very different, but equally disturbing passions. He fell in love, and he was once again deeply moved by the sights and sounds of

(Left) The demolition of the Bastille; from a contemporary etching. Soon afterwards Wordsworth arrived, to muse upon its dusty site. *(Right)* The young Wordsworth, by R. Hancock, 1798, during his *annus mirabilis*, the year of *Tintern Abbey*

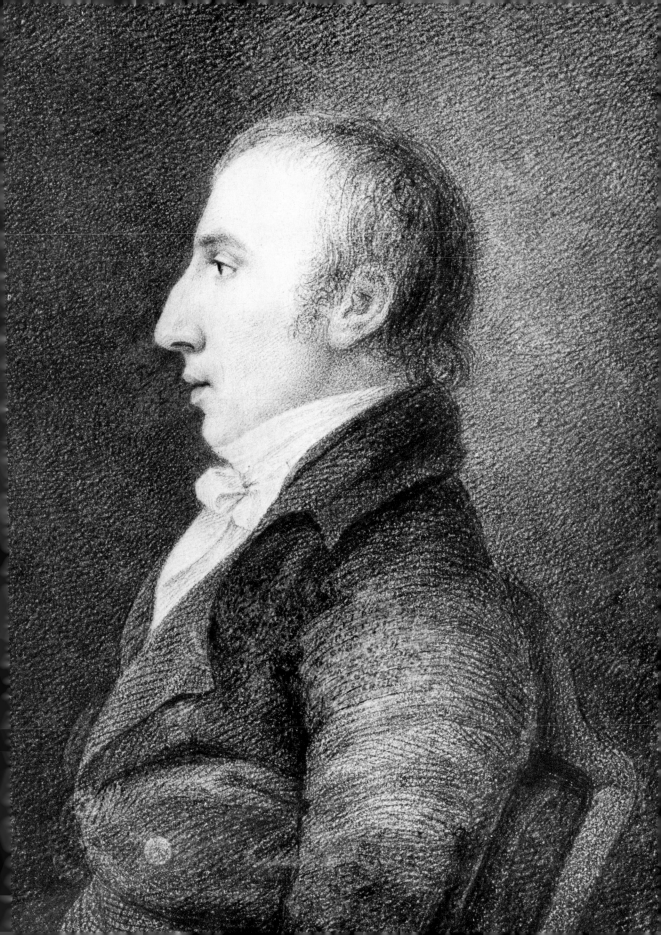

revolutionary France. At his cheap lodgings, he met a group of officers, members of the local garrison. With a single exception, they were fervent Royalists; and one, *The Prelude* informs us, left a particularly deep impression upon the poet's mind. For this officer, the arrival of the newspapers from Paris never failed to bring some new agony. His yellow, care-worn face would flush; the fingers of his unused hand would move restlessly towards his scabbard:

> . . . While he read,
> Or mused, his sword was haunted by his touch
> Continually, like an uneasy place
> In his own body. 'Twas in truth an hour
> Of universal ferment . . .

During that hour of ferment, the quiet young Englishman had learned some difficult and dangerous lessons.

They were lessons he later chose to forget. But, in 1791, Wordsworth was both an enthusiastic republican and an ardent follower of Jean-Jacques Rousseau. At Orléans, too, he enjoyed the companionship of a fellow revolutionary spirit, Michel Armand Beaupuy, the scion of a noble family, descended on his mother's side from Montaigne, whom the poet describes as 'an upright Man and tolerant' and who would take him around the neighbourhood, pointing out not only the derelict chateaux of the exiled landowners, but a 'hunger-bitten girl', a heifer roped to her arm, creeping along a solitary lane:

> . . . The girl with pallid hands
> Was busy knitting in a heartless mood
> Of solitude, and at the sight my friend
> In agitation said, ''Tis against *that*
> Which we are fighting.'

Simultaneously, the unsettling atmosphere of the time had had a strong effect upon his virgin heart and senses. At a house where he often passed the evening lived a young woman named Annette Vallon, herself a Royalist sympathiser, though evidently a product of the eighteenth-century Enlightenment. Annette herself remains a somewhat mysterious personage; but her letters, according to Professor Legouis,[5] show that she possessed 'an irrepressible exuberant sensibility', 'abounded in words', and was prone to wild effusions of romantic feeling. There can be no doubt that Wordsworth loved her passionately. This was an episode that, when he was writing *The Prelude*, he preferred to leave unmentioned, at least as having formed part of his own emotional development. He therefore inserted a long verse-story entitled *Vaudracour and Julia*, supposed to be the substance of a tragic tale once told him by his friend Beaupuy, which despite its lamentable conclusion – one of the most ridiculous pieces of versifying that its author ever perpetrated – includes some magnificent lines on the subject of a young man's first love:

> The house she dwelt in was a sainted shrine,
> Her chamber-window did surpass in glory

The portals of the East, all paradise
Could by the simple opening of a door
Let itself in upon him . . .

Like Annette, Julia presently learns that she is to bear her lover's child; and Vaudracour, like Wordsworth, aspires to 'honourable wedlock', but, as soon as his child is born, decides that he must temporarily desert his mistress, 'hie back' whence he had come and there seek to procure 'a sum of gold', which Vaudracour's father, who stands for Wordsworth's uncle, indignantly refuses him. The poet's illegitimate daughter, christened Anne Caroline, was born on 15 December 1792; and by the end of the year Wordsworth had regained England. Then, on 1 February war broke out between the two countries; and, although Wordsworth seems to have made a courageous but unsuccessful attempt to rejoin Annette during the autumn of 1793, their relationship was broken off.

This brief liaison, wrote Herbert Read, and its 'melancholy aftermath', was 'the deepest experience of Wordsworth's life', and provided the 'emotional complex from which . . . his subsequent career flows . . .' Read added a yet more sweeping assertion: that when he abandoned Annette – but can he be said to have abandoned her? – he lost not only 'his faith in youth and change' but his 'fundamental honesty'.* Wordsworth, however, continued to cherish his republican ideals long after he had been obliged to escape from France, and, ten years later, he framed an eloquent *Apology for the French Revolution*, advocating the use of violence against despotic governments, defending the confiscation of Church property, and pleading the cause of universal suffrage.

Meanwhile, the 'stings of viperous remorse' had begun at last to die away. He knew that he could never rejoin Annette; his love itself had slowly weakened; he had set up house with his devoted sister Dorothy, whose feelings for the man she called her 'Beloved' far exceeded the bounds of quiet family affection; and he had gained the friendship of a learned fellow poet, that extraordinary lost soul and man of genius, Samuel Taylor Coleridge. Both poets then inhabited the West Country, Coleridge at Nether Stowey, William and Dorothy at Alfoxden; and, as they walked over its wooded hills or down to its romantic coastline, they spoke of collaborating on a volume of poems that would embody a novel literary creed.

The subjects of Coleridge's contribution 'were to be, in part at least, supernatural'; but Wordsworth's themes 'were to be chosen from ordinary life; the characters and incidents were to be such as will be found in every village . . .' They would discard the pompous and periphrastic idiom cultivated by the eighteenth-century Augustan school, and employ the 'real language' of modern men – of men, however, 'in a state of vivid

* *Wordsworth*, 1930. On a later page, Read describes the period of 'disciplined calm', succeeding a state of 'remorse and solitary anguish', that enabled him to write *The Prelude*; and disciplined calm is seldom achieved by a fundamentally dishonest spirit.

sensation', when even an unlettered villager might express his thoughts with natural eloquence.

Each poet delighted in the other's gifts. Particularly wonderful, Wordsworth always remembered, was the power that Coleridge possessed of 'throwing out ... grand central truths from which might be evolved the most comprehensive systems'. Wordsworth, Coleridge informed Southey, was 'a very great man, the only man to whom *at all times* and *in all modes of excellence* I feel myself inferior'. Nor was Wordsworth inclined to dissent; without minimising his friend's splendid qualities, he was perfectly prepared to accept the position that Coleridge had allotted him; and Coleridge, who had long been wanting a hero, gladly sank back into a secondary rôle.

Yet, in character and personal appearance, they were a strangely ill-

The background of Wordsworth's poetic education; looking northwards over Grasmere

William Hazlitt in 1822;
drawing by William
Bewick

assorted pair – Wordsworth, angular, precise and dry; Coleridge, florid, round, expansive, voluble. During their *annus mirabilis*, 1798, when Wordsworth wrote *Tintern Abbey* and they published their joint volume of *Lyrical Ballads*, William Hazlitt, who was visiting Coleridge, studied them at close quarters. Coleridge's forehead, he wrote, was 'broad and high, light as if built of ivory, with large projecting eyebrows, and his eyes rolling beneath them, like a sea with darkened lustre'. But his mouth, which was 'gross, voluptuous, open, eloquent', belied the effect of his Socratic brow. His chin was 'good-humoured and round; but his nose . . . the index of the will, was small, feeble, nothing . . .'

As for Wordsworth, 'he answered in some degree to his friend's description of him, but was more gaunt and Quixote-like . . . quaintly dressed . . . in a brown fustian jacket and striped pantaloons. There was something

of a roll, a lounge in his gait'; and Hazlitt noticed 'a severe, worn pressure of thought about his temples, a fire in his eye (as if he saw something in objects more than the outward appearance), an intense, high, narrow forehead, a Roman nose, cheeks furrowed by strong purpose and feeling, and a convulsive inclination to laughter at the mouth, a good deal at variance with the solemn, stately expression of the rest of his face'.[6]

From their relation it was probably Wordsworth who received the greater benefit. While Dorothy – a strangely sibylline young woman, whose face was 'of Egyptian brown', and whose brilliant eyes were 'wild and startling'[7] – encouraged him to fix his attention on the exquisite minutiae of natural scenes, Coleridge helped him to organise his growing genius and look ahead into the poetic future. At the same time, he rebuilt his private existence. Though Dorothy satisfied his need for a spiritual consort, he presently decided he must acquire a wife; and the wife he chose was Mary Hutchinson, an amiable, self-effacing girl, who happened to be his sister's closest friend. They were married in October 1802. But Wordsworth's was an orderly character; and he did not enter marriage until he had met Annette and her daughter at Calais, and quietly ratified their separation. Now he was free to take up his life-work, and press forward with the huge autobiographical poem that, under a different title, *The Recluse*, he had begun to frame in 1798.

The poem was dedicated to Coleridge; and, perhaps because he valued it so much, and it therefore demanded endless changes, it remained in manuscript so long as its author lived. Few more ambitious poems have ever been composed; for its subject is nothing less than the education of a poet's mind, described in imaginative detail from early childhood down to manhood. At its best, an intensely poetic production – 'upon its greatness', writes Herbert Read, 'we base the claim of Wordsworth to be considered as one of our major poets' – at its worst it foreshadows some of the defects, among them a strain of moral complacency and intellectual self-sufficiency, by which, after ten years' brilliant flowering, his genius was slowly strangled.

The Prelude, moreover, despite the principles he had enunciated when he wrote his famous preface to *Lyrical Ballads*, is not couched in the idiom of the ordinary modern man. Some passages show the influence of Pope;* elsewhere Wordsworth is as decoratively periphrastic as any eighteenth-century rhymer. His reflective interpolations are frequently vague and diffuse; and, if the vagueness of the effect becomes too apparent, the poet himself inserts a bland apology. 'My drift I fear', he remarks, 'is scarcely obvious' – an admission he did not trouble to remove from the carefully revised text that he completed just before his death.

An artist who has bidden his youth farewell, and feels that he has lost the bloom of youthful innocence, Wordsworth sets out, like Marcel Proust, '*à la recherche du temps perdu*'. As a biographer has already reminded us,[8] there is something uncommonly Proustian about his description of a

* See, for example, the description of a card-game in Book I, which clearly originated from a passage in *The Rape of the Lock*.

Derwent and
Bassenthwaite lakes;
from an etching by
G. Pickering

poet's memory. The time-traveller he compares to a man who hangs from
the side of a 'slow-moving Boat', and gazes into the depths below him and
their glimmering, half-seen landscape –

> . . . Weeds, fishes, flowers,
> Grots, pebbles, roots of trees, and fancies more;
> Yet often is perplex'd, and cannot part
> The shadow from the substance, rocks and sky,
> Mountains and clouds, from that which is indeed
> The region, and the things which there abide
> In their true dwelling; now is crossed by gleam
> Of his own image, by a sunbeam now,
> And notions that are sent he know not whence,
> Impediments that make his task more sweet;
> – Such pleasant office have we long pursued
> Incumbent o'er the surface of past time.

Wordsworth had declared that a poet's work 'takes its origin from
emotion recollected in tranquillity'. The emotion, this famous pronounce-
ment implies, must be re-enjoyed and re-created; and when he wrote
The Prelude, his object was to relive the moments of visionary insight, now

71

pleasurable, now intensely fearful, that, as he listened to the solemn voices of Nature, 'the ghostly language of the ancient earth', had joined to make him what he was. Fear performs an important rôle in Wordsworth's story of his education. The spontaneous happiness he experienced at Hawkshead was not always blithe and unreflecting –

> . . . Even then I felt
> Gleams like the flashing of a shield; – the earth
> And common face of Nature spake to me
> Rememberable things . . .

And, again and again, 'the impressive influence of Fear' would check, or divert into a deeper channel, the overflowing tide of 'vulgar joy'.

Then the boy's spirits would suddenly fall; unaccountably his mood would change; the surrounding universe, in which he had seemed so much at home, would assume a dark, unfriendly aspect; and a sense of Nature's terrifying strangeness, accompanied no doubt by a sense of 'want and horror', would rush into his childish mind. As he looked back, he did not regret these crises; they, too, he believed, had helped to mould his spirit:

> Fair seed-time had my soul, and I grew up
> Fostered alike by beauty and by fear . . .

He had derived his education, not only from his moments of joy, but from his 'terrors, pains and early miseries'.

Panic terror, indeed, had formed the keynote of one of the earliest memories he could summon up. He was five years old; and, having gone out riding, he had become separated from his father's servant, and had ridden on and on over the moors until he reached an ancient gibbet, with the name of a long-dead murderer carved across the turf in 'monumental letters':

> A casual glance had shown them, and I fled,
> Faltering and faint, and ignorant of the road:
> Then, reascending the bare common, saw
> A naked pool that lay beneath the hills,
> The beacon on the summit, and, more near,
> A girl, who bore a pitcher on her head
> And seemed with difficult steps to force her way
> Against the blowing wind. It was, in truth,
> An ordinary sight; but I should need
> Colours and words that are unknown to man,
> To paint the visionary dreariness
> Which, while I looked all round for my lost guide,
> Invested moorland waste, and naked pool,
> The beacon crowning the lone eminence,
> The female and her garments vexed and tossed
> By the strong wind.

Three subsequent episodes, among the most celebrated in *The Prelude*, conclude on a melancholy or an apprehensive note. We read, for example,

Cockermouth, Wordsworth's birthplace.

'Fair seed-time had my soul, and I grew up, Fostered alike by beauty and by fear . . .'

how, one summer evening, he had taken possession of a skiff that he found moored beneath a lakeside tree, and had rowed out far across the water:

It was an act of stealth
And troubled pleasure, nor without the voice
Of mountain-echoes did my boat move on;
Leaving behind her still, on either side,
Small circles glittering idly in the moon,
Until they melted all into one track
Of sparkling light. But how, like one who rows,
Proud of his skill, to reach a chosen point
With an unswerving line, I fixed my view
Upon the summit of a craggy ridge,
The horizon's utmost boundary; far above
Was nothing but the stars and the grey sky.
She was an elfin pinnace; lustily
I dipped my oars into the silent lake,
And, as I rose upon the stroke, my boat
Went heaving through the water like a swan;
When, from behind that craggy steep till then
The horizon's bound, a huge peak, black and huge
As if with voluntary power instinct
Upreared its head. I struck and struck again,

And growing still in stature the grim shape
Towered up between me and the stars, and still,
For so it seemed, with purpose of its own
And measured motion like a living thing,
Strode after me.

Panic-stricken, he had turned his boat and, 'with trembling oars', regained the land:

 ... After I had seen
That spectacle, for many days, my brain
Worked with a dim and undetermined sense
Of unknown modes of being; o'er my thoughts
There hung a darkness, call it solitude
Or blank desertion. No familiar shapes
Remained, no pleasant images of trees,
Of sea or sky, no colours of green fields;
But huge and mighty forms, that do not live
Like living men, moved slowly through my mind
By day, and were a trouble to my dreams.

There is also his incomparable picture of the winter months at Hawkshead, when he had joined his friends in their skating-parties on the star-scattered surface of the frozen lake:

 All shod with steel,
We hissed along the polished ice in games
Confederate, imitative of the chase
And woodland pleasures, – the resounding horn,
The pack loud chiming, and the hunted hare.
So through the darkness and the cold we flew,
And not a voice was idle; with the din
Smitten, the precipices rang aloud;
The leafless trees and every icy crag
Tinkled like iron; while far distant hills
Into the tumult sent an alien sound
Of melancholy not unnoticed, while the stars
Eastward were sparkling clear, and in the west
The orange sky of evening died away.

Finally, there is his portrait of the lonely boy, who, although Wordsworth identifies him with a schoolfellow now buried in a nearby churchyard, may perhaps have been himself,* and whose pastime, as night descended, was to send out 'mimic hootings' to the silent owls, until they answered from the darkness:

 ... And they would shout
Across the watery vale, and shout again,
Responsive to his call, with quivering peals,
And long halloos and screams, and echoes loud,

* The boy whom Wordsworth introduces was possibly a friend, George Graham Gibson, who died in 1779; but the emotions he describes were certainly his own. 'The shock, I believe was a shock of more than mild surprise. It was of some obscure and nameless terror': Aldous Huxley, *Texts and Pretexts*, 1932.

Redoubled and redoubled, concourse wild
Of jocund din; and, when a lengthened pause
Of silence came and baffled his best skill,
Then sometimes, in that silence while he hung
Listening, a gentle shock of mild surprise
Has carried far into his heart the voice
Of mountain torrents; or the visible scene
Would enter unawares into his mind,
With all its solemn imagery, its rocks,
Its woods, and that uncertain heaven, received
Into the bosom of the steady lake.

Each of the visionary experiences that Wordsworth records seems to have had very much the same ending. Behind the beloved landscape where he was safe and at ease emerged a different aspect of the natural universe – a remote, terrifying world peopled by 'huge and mighty' shapes that over-shadowed his days and descended to haunt his dreams. Fear and wonder are among the strongest emotions of every child's imaginative life; and no other English poet has given such vivid expression to the childish conflict between delight and dread.

Wordsworth's description of the lonely boy who liked to tease the owls had once formed an independent poem; and, during a holiday abroad, he dispatched a preliminary draft to Coleridge, who acknowledged its welcome arrival on 10 December 1798. The last sentence, he wrote, 'I should have recognised anywhere; and had I met these lines running wild in the deserts of Arabia, I should instantly have screamed out "Words-worth!" ' Coleridge's appreciation, however, seems equally true of the entire fragment. Few passages are so completely Wordsworthian; and, like the other passages I have quoted from *The Prelude*, it may help to explain why Hazlitt, who did not always value Wordsworth's personal qualities, once characterised his genius as 'a pure emanation of the Spirit of the Age'.

Compared with *The Prelude*, the *Ode on Intimations of Immortality from Recollections of Early Childhood*, published in the year 1807, has a somewhat artificial framework. There Wordsworth, a staunchly self-confident man now that he had married and settled down and overcome his youthful troubles, endeavours to prove that the exquisite insights of childhood have since merged into a steadier kind of wisdom. True, he regrets his youth, and borrows Vaughan's theory that the growing child is gradually moving away from his celestial place of origin; but, although he has forfeited 'the visionary gleam', and Nature around him has lost its primitive radiance – 'of splendour in the grass, of glory in the flower' – he can afford to stand upon his adult dignity; and his nostalgic doubts are very soon dispelled:

. . . To me alone there came a thought of grief:
A timely utterance gave thought relief,
 And I again am strong:
The cataracts blow their trumpets from the steep;
No more shall grief of mine the season wrong;

(*Overleaf*) Wordsworth and Scott at Newark
Tower; from a contemporary lithograph

> I hear the Echoes through the mountains throng,
> The Winds come to me from the fields of sleep . . .

Nor has he lost the friends and teachers of his childhood:

> And, O ye Fountains, Meadows, Hills, and Groves,
> Forbode not any severing of our loves! . . .
> I only have relinquished one delight
> To live beneath your more habitual sway.

Meanwhile, as a poetic moralist, he can turn to the contemplation of 'the human heart', its 'tenderness, its joys, and fears', by which we have our mortal being.*

Wordsworth wrote the first four stanzas of his *Ode* on 27 March 1802; on 4 April Coleridge was composing a very different ode, to which he gave the name *Dejection*. The loss that Wordsworth did his best to rationalise, Coleridge regarded as totally irreparable. Nothing could restore the vision of his youth; even the colours of a landscape that had once delighted had inexplicably begun to fade:

> A grief without a pang, void, dark, and drear,
> A stifled, drowsy, unimpassioned grief,
> Which finds no natural outlet, no relief,
> In word, or sigh, or tear –
> O Lady!† in this wan and heartless mood,
> To other thoughts by yonder throstle woo'd,
> All this long eve, so balmy and serene,
> Have I been gazing on the western sky,
> And its peculiar tint of yellow green:
> And still I gaze – and with how blank an eye!
> And those thin clouds above, in flakes and bars,
> That give away their motion to the stars;
> Those stars, that glide behind them or between,
> Now sparkling, now bedimmed, but always seen:
> Yon crescent Moon, as fixed as if it grew
> In its own cloudless, starless lake of blue;
> I see them all so excellently fair,
> I see, not feel how beautiful they are!

Wordsworth and Coleridge, at that moment, were respectively thirty-one and twenty-nine; but, whereas Wordsworth, having fixed his memories in literature, rapidly grew middle-aged, Coleridge never managed to assume the sober mask of adult manhood, and remained throughout his life a lamentably undefended character, doomed to disappoint his

Coleridge in 1795, by P. Vandyke; the forehead, wrote Hazlitt, was 'broad and high'; the mouth, 'gross, voluptuous, open, eloquent . . .'

* Nine years earlier, ideas of the same kind occasionally emerge in Wordsworth's letters. 'I begin to wish much to be in town', he wrote to Matthews on 7 November 1793. 'Cataracts and mountains are good occasional society, but they will not do for constant companions.'

† Coleridge had originally written 'O Sara!', the lady he addressed being Sara Hutchinson, Wordsworth's sister-in-law, for whom about 1799, some four years after his marriage to Southey's sister-in-law, Sarah Fricker, he had conceived a hopeless passion. His daughter afterwards described her as 'a plump woman of little more than five feet', having beautiful light-brown hair, but otherwise 'devoid of grace and dignity'.

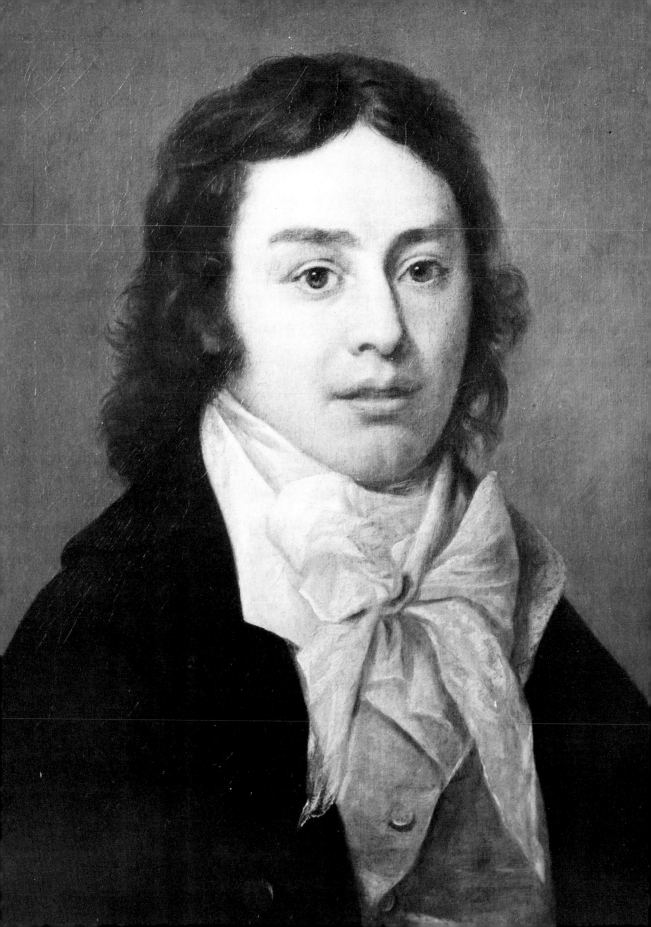

friends and, just as often, to be disappointed. There was, indeed, something almost infantile about certain aspects of his personality. He had a childish greed for affection and approval; and, though his great powers commanded immediate esteem, he would often seek to extort sympathy by a lachrymose display of weakness. In his correspondence he draws a pathetic self-portrait. With the abandon of a baby Gargantua, Coleridge heaves around through page after page, wailing, bleating and expostulating. Like many children, he took a fascinated interest in the lowlier functions of his own body; and his letters describe those functions at length, how they were impeded and obstructed, and the drastic methods he employed to set his organism running smoothly.

An opportunity of sharing his troubles – constipation, 'hysterical Wind' or excessive looseness of the bowels – very seldom came amiss; and, in August 1806, when he had recently returned from Malta, he wrote to inform Southey that the captain of the ship, 'as proud and Jealous an American as ever even America produced', had kindly consented to perform a nurse's office, and 'would come and . . . with tears . . . beg and pray me to have an enēma'. He detailed 'these shocking circumstances to you and my wife', he wrote, that they might participate in his undying gratitude.

By that time, Coleridge was a slave of opium; but the drug-habit seems to have been a symptom of his spiritual disturbances rather than their immediate cause.* At least, the habit and its terrible effects clearly formed a vicious circle. He absorbed opium, not only because his body had come to need it, but because he was now convinced that he had lost the gift of writing poetry:

The Poet is dead in me [he told William Godwin during the early months of 1801] – my imagination . . . lies, like Cold Snuff on the circular Rim of a Brass Candle-stick, without even a stink of Tallow to remind you that it was once cloathed and mitred with Flame. That is past by! – I was once a Volume of Gold Leaf rising and riding on every breath of Fancy . . .

The miseries that opium bred, which could only be relieved by a yet more massive dosage, provided him with the excuse he needed for postponing any further effort. His friends despaired; in the autumn of 1810 he received a particularly painful blow. Wordsworth was reported to have said that he had been 'a rotten drunkard', and had proved 'an absolute nuisance' while he lived among the Wordsworth family. Such was the end, Coleridge lamented, of '15 years' most enthusiastic self-despising and alas! self-injuring friendship . . .'

Coleridge was never to regain either his belief in his own genius or his faith in human nature; and he began to penetrate more and more deeply into a terrifying world of dreams. For him, he had already told Tom Wedgwood on 16 September 1803, dreams were 'no Shadows, but the

* See Alethea Hayter, *Opium and the Romantic Imagination*, 1968. Coleridge's addiction would appear first to have had a serious effect on his health between 1800 and 1804.

Nether Stowey,
Coleridge's home during
the happiest period of
his poetic life

very Substances and foot-thick Calamities of my Life . . .' While he was
awake, 'by patience, employment, effort of mind' he could 'keep the fiend
at Arm's length; but the Night is my Hell, sleep my tormenting Angel.
Three nights out of four I fall asleep, struggling to lie awake'; and the
'Night-screams', with which he returned to consciousness, again and again
disturbed his family.

The Rime of the Ancient Mariner, written in 1797 at Nether Stowey, during
the happiest period of his attachment to Wordsworth, was a symbolic
representation of his sense of guilt; which had been complicated, long
before he had reached middle age, by a self-destructive sense of weakness.
He felt, he informed Robert Southey, six weeks before he wrote to Wedg-
wood, that he was 'an herbaceous Plant, as large as a large Tree, with a
Trunk of the same Girth, and Branches as large and shadowing – but
with *pith within* the Trunk . . . that I had *power* not *strength*, an involuntary
Imposter . . .'

This, he added, was 'as fair a statement of my habitual haunting, as I
could give before the tribunal of Heaven. How it arose in me, I have but
lately discovered; still it works within me, but only as a disease, the cause

and meaning of which I know'. Coleridge himself never passed on that knowledge; clearly, he did not attribute his disease entirely to the malevolent effects of opium; and he may well have traced it home to the peculiar circumstances of his childhood. Like Wordsworth, he had been shaped by his early life; but Coleridge's childhood had been as disturbed and unhappy as Wordsworth's had been blithe and purposeful.

'From infancy to boyhood, and from boyhood to youth', he would declare in moments of depression, although his father and mother had cherished him, he was treated 'most, MOST cruelly'. A jealous nurse had made his existence wretched; and he was sorely plagued by an elder brother, Frank, who developed 'a violent love of beating me'. The fact that he was a sluggish, yet obstinate and conceited child also helped to warp his temper. 'Fretful and timorous, and a tell-tale', he took refuge in the enchanted realm of books, which soon acquired so strong a hold on his mind that his father presently decided to destroy some of the more attractive and alarming volumes:

So I became a *dreamer* – and acquired an indisposition to all bodily activity – and I was fretful, and inordinately passionate, and as I could not play at any thing, and was slothful, I was despised and hated by the boys; and because I could read and spell, and had, I may truly say, a memory and understanding forced into almost an unnatural ripeness, I was flattered and wondered at by all the old women ... Before I was eight years old I was a *character* – sensibility, imagination, vanity, sloth, and feelings of deep and bitter contempt for all who traversed the orbit of my understanding, were even then prominent and manifest.[9]

Coleridge's father, schoolmaster and parish priest, a man 'without guile, simple and generous ... conscientiously indifferent to the good and the evil of this world', had died in 1781 when his son was only nine; and in 1782 the child was sent to London, to continue his education as a Bluecoat boy at Christ's Hospital, where he lived solitary and self-absorbed, a 'playless day-dreamer', who gazed hour after hour through an iron-barred window of the ancient school buildings, or lay listlessly upon their leaded roof.

Then, in 1791, Coleridge sauntered up to Cambridge; but at Jesus College, we are told, he was 'a proverb to the University for Idleness' and incurred debts that he had no means of paying. The result was a sudden moral crisis, during which he 'fled to Debauchery', embarked on a six-weeks' drinking-bout, and eventually, as he looked back over the last two years – 'What a gloomy *Huddle* of eccentric actions, and dim-discovered motives!' – determined he would join the army. At the beginning of December 1793, he enlisted as a trooper in the 15th Light Dragoons under the curious, but characteristic pseudonym of Silas Titus Comberbacke.

In the army Coleridge displayed both his talent for collecting misfortunes and his gift of winning sympathetic friends. The awkward trooper, who could not groom his horse or even learn to clean his carbine,* and,

* 'Whose is this rusty carbine?' an officer is said to have demanded. 'Is it very rusty?' Coleridge inquired. 'Very rusty!' 'Then, Sir, it must be mine.'

Christ's Hospital, as Coleridge knew it. A lonely 'playless day-dreamer', he spent many hours upon its leaded roof

like Alice's White Knight, often tumbled headlong from the saddle, but who chalked up Latin tags, quoted Euripides and carried a Greek text stuffed into his saddle-holsters, soon attracted general interest. His officers, representatives of a stern military tradition, seem to have agreed to treat him gently; and, his brothers having bought his discharge and, at the same time, paid his Cambridge debts, he quietly returned to Jesus College, where his tutor, James Plampin, received him with 'exceeding and most delicate kindness'.

Coleridge's next plunge was into Pantisocracy – as he named the scheme of founding a small egalitarian community, meant to combine 'the innocence of the patriarchal age' and 'the knowledge and genuine refinements of European culture', that Southey and his friends had hatched. Under the influence of Southey, then a republican and Rousseauite, Coleridge considered emigrating to America, in a party that was to consist of twelve adventurous male enthusiasts and twelve like-minded young women. But, when he learned that Southey proposed to take a servant with them, he experienced some serious doubts; and little by little the Pantisocratic idea receded into the limbo of abandoned causes.

Meanwhile, Southey had become his moral counsellor; and to him Coleridge divulged the passion he had long entertained for a charming Welsh girl, Mary Evans. But Southey had decided that his friend should

marry his future sister-in-law, Sara Fricker; and relentlessly he urged on the plan until Coleridge's over-sensitive reluctance had at last been broken down. His first addresses to Sara, he admitted just after his marriage in November 1795, were 'paid from principle, not feeling, and from feeling and from principle I renewed ... I met a reward more than proportionate to the greatness of the effort. I love, and I am happy!' His happiness, however, was short-lived; although he soon outgrew his fellow Pantisocrat's influence, Southey's domestic legacy proved sadly lasting.

Coleridge found that he had taken on a woman whom even the warm-hearted Dorothy Wordsworth described as an inveterate 'fiddle faddler', and who was self-centred, demanding, unimaginative and ill-tempered.* Before long Coleridge complained that he and Sara were 'not suited to each other', and admitted that he thought of leaving home. Only moral considerations held him back: 'Carefully have I *thought thro*' the subject of marriage, and deeply am I convinced of its indissolubleness.' He loved his 'dear children' – Hartley, born in 1796, and named after the eighteenth-century philosopher, David Hartley, founder of the system of associational psychology to which he and Wordsworth were both indebted; and Derwent, born in 1800. But his family-life, he declared, was 'gangrened' to 'its very vitals'.

A different course had been taken by Wordsworth's marriage. About 1816, when he was a man of forty-six, some six years after his estrangement from Coleridge, a year after the publication of his last considerable narrative poem, *The White Doe of Rylstone*, he entered upon what a modern biographer calls his 'long, patient, and dignified old age'.[10] He had a devoted, sensitive, intelligent, sometimes quietly humorous wife, who would love and protect him for nearly half a century, conducting his correspondence, copying his poems and generally acting, he wrote, as an 'inestimable fellow-labourer'; and Dorothy remained his poetic second self, till – undermined by the passionate conflicts she had hidden since girlhood – her precarious sanity at last broke down. Among his children, Wordsworth was particularly attached to his enchanting daughter Dora. She incorporated all the qualities he had once recognised, and, as the years went by, had perhaps begun to miss, first in Dorothy and then in Mary.

Yet Wordsworth ossified – a process that did not involve merely his political and his religious views. He preferred to forget and, wherever he could, to conceal, the republican and pantheistic theories that had so strongly influenced his early manhood; and he knew that many contemporary poets now reviled him as an arch apostate. 'What a beastly and pitiful wretch that Wordsworth!' Shelley exclaimed in 1818. 'That such a man should be such a poet! I can compare him with no one but Simonides, that flatterer of the Sycilian tyrants ...' Worse was the effect of his growing conservatism upon his imagination and his creative

* It is fair to add that Richard Reynell, an early visitor, described Mrs Coleridge as 'sensible, affable, good-natured, thrifty and industrious, and always neat and prettily dressed'. Coleridge, of course, was a remarkably difficult husband; and he himself admits that, in the 'little Hovel' they shared, poor Sara was sometimes 'tired off her legs with servantry'.

Wordsworth at thirty;
portrait by R. Carruthers

faculties. A critic has pointed out how often the words 'type' and 'emblem'
occur in Wordsworth's later poems;[11] and, while in *The Prelude* a visionary
experience is recollected for its own mysterious sake, he now presented his
impressions of the world for their moral and symbolic value. Romantic
literature was fast becoming respectable; and he himself began to assume
the solemn, unbending attitude of a literary Grand Old Man.

No such change had overtaken Coleridge. His poetic genius might have
long ago died; but in middle age his character was as helplessly volatile as
it had ever been in youth. Wordsworth's early poems were the product of
insight, courage and determination; Coleridge's, of strength and weakness
curiously interlocked. I have suggested elsewhere that the images he
employed reflect his yearning 'to escape from a physical and mental
prison. Everything flickering, flame-like, evanescent, swiftly moving and

as swiftly vanishing, had for Coleridge an especial charm'.[12] On a voyage across the Mediterranean, he wrote in 1809, he had particularly admired the spectacle of its phosphorescent surges – the 'beautiful white cloud of Foam' that 'at momentary intervals coursed by the side of the Vessel'; while 'little stars of flame danced and sparkled and went out with it; and every now and then light detachments of this white cloud-like foam dashed off . . . each with its small constellation over the Sea, and scoured out of sight like a Tartar Troop over a wilderness'.

It is his contemplation of the fire-clad water-snakes that finally enables the Ancient Mariner to discard his tragic burden:

> Beyond the shadow of the ship,
> I watched the water-snakes:
> They moved in tracks of shining white,
> And when they reared, the elfish light
> Fell off in hoary flakes.
>
> Within the shadow of the ship
> I watched their rich attire:
> Blue, glossy green, and velvet black,
> They coiled and swam; and every track
> Was a flash of golden fire.
>
> O happy living things! no tongue
> Their beauty might declare:
> A spring of love gushed from my heart,
> And I blessed them unaware:
> Sure my kind saint took pity on me,
> And I blessed them unaware.

Coleridge had little of Wordsworth's continuous energy. Except in *The Ancient Mariner* and perhaps half a dozen short poems, the immense promise with which he had entered the world was very seldom fully realised; and traces of his genius lie confusedly scattered over a wide and often arid surface, though his notebooks, his essays, his correspondence and his labyrinthine magnum opus, *Biographia Literaria*. Nor had he Wordsworth's gift of seizing the visionary moment. Only in *Frost at Midnight*, which he wrote during the winter months of 1798, did he produce such an exquisite quintessence of feeling as Wordsworth was soon to achieve in the finest pages of *The Prelude*.

Coleridge's poem has a triple theme; he writes of his present solitude, scarcely disturbed by the fluttering movement of his fire and the soft breathing of the two-year-old Hartley, now lying sound asleep beside him; of his lonely, meditative boyhood behind the bars of Christ's Hospital; and of the radiant future he predicts for Hartley, who will enjoy the spiritual equipoise and close communion with Nature that he himself has always lacked:

> Great universal Teacher! he shall mould
> Thy spirit, and by giving make it ask.
> Therefore all seasons shall be sweet to thee,

Whether the summer clothe the general earth
With greenness, or the redbreast sit and sing
Betwixt the tufts of snow on the bare branch
Of mossy apple-tree, while the nigh thatch
Smokes in the sun-thaw; whether the eve-drops fall
Heard only in the trances of the blast,
Or if the secret ministry of frost
Shall hang them up in silent icicles,
Quietly shining to the quiet Moon.

Coleridge in 1814, by
W. Allston. Four years
earlier, Wordsworth was
reported to have said
that he was an 'absolute
nuisance' and a 'rotten
drunkard'

Coleridge's prophesies, alas, were unfulfilled. Hartley Coleridge, gayest and lightest of children, 'a spirit dancing on an aspen leaf', was to become a chronic drunkard, and lose his Oriel fellowship, before he reached the age of thirty.

Just as Hazlitt had studied Wordsworth and Coleridge during the springtime of their poetic lives, so Thomas Carlyle cast a sharply observant

glance on their subdued and sunless autumn. His memories of Coleridge dated from 1824, when the elderly poet was living at Highgate under the devoted care of Dr James Gillman, who had agreed to break him of the drug-habit. Carlyle's first impressions were decidedly brutal:

I have seen many curiosities [he wrote to brother John, on June 24th]; not the least of them I reckon Coleridge . . . Figure a fat, flabby, incurvated personage, at once short, rotund, and relaxed, with a watery mouth, a snuffy nose, a pair of strange brown, timid, yet earnest-looking eyes . . . He is a kind, good soul, full of religion and affection and poetry and animal magnetism. His cardinal sin is that he lacks *will*. He has no resolution. His very attitude bespeaks this. He never straightens his knee-joints . . . In walking he does not tread, but shovel and slide . . . His eyes have a look of anxious impotence. He *would do* with all his heart, but he knows he dares not.

It is interesting to compare this preliminary sketch with the more literary, and somewhat kindlier portrait that Carlyle slipped into his *Life of John Sterling*:

The good man, he was now getting old . . . and gave you the idea of a life that had been full of sufferings . . . Brow and head were round, and of massive weight, but the face was flabby and irresolute. The deep eyes, of a light hazel, were as full of sorrow as of inspiration; confused pain looked mildly from them, as in a kind of mild astonishment . . . He hung loosely on his limbs . . . and a lady once remarked, he never could fix which side of the garden walk would suit him best, but continually shifted in corkscrew fashion, and kept trying both . . . His voice, naturally soft and good, had contracted itself into a plaintive snuffle and singsong; he spoke as if preaching . . . I still recollect his 'object' and 'subject', terms of continual recurrence in the Kantean province; and how he sang and snuffled them into 'om-m-mject' and 'sum-m-mject', with a kind of solemn shake and quaver, as he rolled along.

Carlyle did not encounter Wordsworth until the latter period of the poet's life, when he 'felt himself to be a recognised lion . . . and was in the habit of coming up to Town with his Wife for a month or two every season to enjoy his quiet triumph and collect his bits of tribute . . .' But Wordsworth had read *The French Revolution* on its appearance in 1837 and, thinking perhaps of his own youth and of the Royalist officers he had met at Orléans, had been offended by Carlyle's scornful references to the vices of the *ancient régime* – 'the sneer born of Conceit', he suggested – so much so that he had written a dignified sonnet in which he took some 'recent histories' to task.[13] At a breakfast-party, Carlyle remembered, the old lion talked of the epistolary homages he received, and of etymology and literature, laying special emphasis on the practical side of the art, 'literary laws, practices, observances'.*

For the rest [records Carlyle] he talked well in his way; with veracity, easy

* *Reminiscences*, 1887. At a later and more fruitful meeting, Wordsworth related how 'he had been in France during the earlier or secondary stage of the Revolution; had witnessed the struggle of *Girondins* and *Mountain*, in particular the execution of Gorsas, "the first *Deputy* sent to the Scaffold"; and testified strongly to the ominous feeling which that event produced in everybody . . .'

brevity and force; as a wise tradesman would of his tools and workshop . . . His voice was good, frank and sonorous . . . rather than melodious; the tone of him business-like, sedately confident . . . His face bore marks of much, not always peaceful, meditation; the look of it not bland or benevolent, so much as close, impregnable and hard . . . There was enough of brow . . . rather too much of cheek . . . He was large-boned, lean, but still firm-knit, tall and strong-looking when he stood: a right good old steel-gray figure, with a fine rustic simplicity about him . . .

Such was the impression that Carlyle committed to his *Reminiscences.* To his brother, Dr John Carlyle, he told a slightly different tale. Words-worth might be dignified, shrewd and natural; 'one finds also a kind of *sincerity* in his speech: but for prolixity, thinness, endless dilution it excels all other speeches I have heard from mortal. A genuine man (which is much), but also essentially a *small* genuine man . . . The shake of hand he gives you is feckless, egotistical; I rather fancy he *loves* nothing in the world so much as one could wish.'

Towards the end of his life, though Wordsworth's domestic affections were still strong, he evidently wanted passion. As for Coleridge, the habit of preaching that Carlyle noted had characterised him throughout his whole career – Hazlitt, too, had observed it; and we often catch an echo of a parsonic snuffle or whine, not only in his private letters, but in his note-books and his essays. Coleridge's prose works bear an odd resemblance to Ruskin's; they are no less diffuse and irregular; and he shared Ruskin's strain of self-pity. But, like Ruskin, again and again he produces either some incisive critical judgement or some luminous poetic image.

His definition of 'essential poetry', for example, could scarcely be improved on. As the result of all his reading and meditation, he announces in *Biographia Literaria*:

I abstracted two critical aphorisms . . .; first, that not the poem we have *read,* but that to which we *return* with the greatest pleasure, possesses the genuine power and claims the name of *essential poetry.* Second, that whatever lines can be translated into other words of the same language without diminution of their significance . . . are so far vicious in their diction . . . Our genuine admiration of a great poet is a continuous *under-current* of feeling . . . I was wont boldly to affirm that it would be scarcely more difficult to push a stone out from the pyramids with the bare hand than to alter a word, or the position of a word, in Milton or Shakespeare (in their most important works at least), without making the author say something else, or something worse, than he does say.

Just as valuable are those observations of Nature and of the human heart which reveal his own poetic sensibility; as when he describes the sound of a breeze rushing through the 'stiff and brittle-becoming foliage' of an autumn wood; the setting of a huge half-moon behind the moun-tains opposite his cottage-window, and the various shapes that it presented before it disappeared beneath a ridge; 'two perfect moon-rainbows, the one foot in the field below my garden, the other in the field nearest but two to the church . . . grey-moonlight-mist-colour'; and 'the giant shadows sleeping amid the wan yellow light of the December morning',

Pages from Blake's *Songs of Innocence*

which 'looked like wrecks and scattered ruins of the long, long night'. Nor could the tragedy of his personal life have been better summed up than in the brief paragraph he composed during the course of the year 1817: 'If a man could pass through Paradise in a dream, and have a flower presented to him as a pledge that his soul had really been there, and if he found that flower in his hand when he awoke – Aye! and what then?' Coleridge himself had passed through Paradise; and, once he had awoken from his early poetic reveries, nothing could alleviate his sense of exile.

Concerning the subject of youth, and the relationship that both he and Wordsworth had sought to establish between youth and the creative spirit, he puts forward in *Biographia Literaria* a particularly original and important theory:

To carry on the feelings of childhood into the powers of manhood; to combine the child's sense of wonder and novelty with the appearances which every day for perhaps forty years had rendered familiar ... this is the character and privilege of genius, and one of the marks which distinguish genius from talents. And therefore is it the prime merit of genius, and the most unequivocal mode of

manifestation, so to represent familiar objects as to awaken in the minds of others a kindred feeling . . . and that freshness of sensation which is the constant accompaniment of mental no less than of bodily convalescence.

He concludes with a generous tribute to the poetic ally who had long ago abandoned him: 'in all Mr. Wordsworth's writing' such a faculty, he suggests, was 'more or less predominant', and constituted the essential 'character of his mind'.*

Coleridge's theory also applies to the whole of the Romantic Revolution, which, at the outset, was a revolt of Youth against Age, and of the visionary imagination against the rule of adult intellect. No literary movement is completely clear-cut; and Pope himself, though Romantic critics agreed in deploring his oppressive effect on modern English literature, possessed some strong Romantic leanings. It seems true, however, that, whereas the Augustan poet attempted to preserve the recognised frontiers of human knowledge, and rarely wished to go beyond them, the Romantics hóped to enlarge those frontiers, by exploring tracts of experience outside the limits of the conscious mind.

Hence the Romantics' preoccupation with dreams, and with the fantasies that surround us between sleep and waking; with the terrors as well as the joys of childhood, and with the secrets of the dark subconscious. For the sober pleasure of recognition – which we feel when an Augustan poet confers new grace upon some long-familiar truth – they substituted the wild excitement of discovery. Among their other triumphs, the Romantics could justly assert that they had rediscovered England. In Blake's phrase, they 'cleansed the doors of perception', and to the world that the Augustans had tamed and harmonised they gave back its primitive wildness and strangeness, and something of its ancient innocence.

* Coleridge was quoting from an essay he had already published in *The Friend*. His ideas were later adopted by one of the greatest of French nineteenth-century poets. There is no evidence that Charles Baudelaire had studied Coleridge's prose works; but, in his wonderful essay, *Un Peintre de la Vie Moderne*, he describes genius as '*l'enfance retrouvée à volonté, l'enfance douée maintenant, pour s'exprimer, d'organes virils et de l'esprit analytique . . .*' Baudelaire, too, compares the artist to an 'eternal convalescent'.

3

'Easeful Death'

Coleridge died in his sixty-second, Wordsworth in his eighty-first year. But Keats, Shelley and Byron all led short and crowded lives; and today it is hard to dissociate the idea of early death from our vision of a great Romantic poet. John Keats compressed his poetic existence into a particularly brief period – just how brief we are sometimes inclined to forget – between the opening months of 1815, when he began to dash off imitative verses, and September 1820, when, his genius realised but his health and spirits broken, he set sail to meet his death abroad.

His moment of most intense productivity had been reached in 1819. Late in April, he wrote his *Ode to Psyche*; and it was followed in May by the *Ode to a Grecian Urn*, the *Ode on Melancholy* and the *Ode to a Nightingale*. Of these, the latter, though it has obvious defects, is a peculiarly characteristic and revealing work. Poems are evolved through a process of crystallisation; and the experience that helped to precipitate Keats's ode cannot be exactly fixed. But that spring he was living at Wentworth Place, a pleasant little new-built house, close to the verges of Hampstead Heath, which he shared with his rabelaisian friend, Charles Brown. Nightingales haunted the trees – for the purposes of his poem, they became a 'forest dim' – that overlooked the flower-beds of the small garden; and one morning, as soon as he had finished breakfast, he carried a chair out on to the grass, and spent two or three hours reflecting and writing beneath the shadow of a plum tree.

When he returned, Brown watched him put away some closely written

John Keats; life-mask by B.R.Haydon; 'a genius more purely poetical never existed . . .'

93

sheets among the books that filled his room. They contained the original draft of his ode, which appeared, with its sister odes, and *Lamia, Isabella, The Eve of St Agnes* and the splendid unfinished *Hyperion*, in his third and last volume. As Keats had expected, the book was ill-received. Charles Lamb and an unknown young enthusiast, Percy Bysshe Shelley, recognised its startling merits. But the newspaper critics announced that it was a typical production of the Cockney school, and a pretentious 'nosegay of enigmas'.

Thereupon the poet abandoned hope. In the spring of 1819, however, he had been tolerably sanguine and almost at peace with the surrounding world. The attraction he felt for his neighbour, Fanny Brawne, the slender, fair-haired, nineteen-year-old girl, whom, when he first met her, he had described as probably a 'minx' – 'beautiful and elegant, graceful, silly, fashionable and strange' – was not yet an all-absorbing passion. And, although poor Tom, his hapless younger brother, had died of tuberculosis towards the end of 1818, he himself, thanks to his natural vitality, kept an energetic hold on life. His mind was deeply reflective and imaginative; but many of his ordinary tastes and pursuits were strongly, sometimes crudely masculine. He enjoyed walking, sightseeing, drinking, punning, talking bawdy, and was not averse from the random amatory adventures that Brown and other friends encouraged.

Physically, John Keats was a prepossessing young man, short in stature, only five feet high – but compact and well proportioned, with large hazel eyes, curling red-gold hair and a 'brisk and winning face', made up of sensuous, finely moulded features. Among his friends he seems to have aroused an instinctive admiration; and his own devoted affection for his friends appears again and again throughout his correspondence. Such was the social being. A study of his poetic and visionary self reveals a very different personage; and the *Ode to a Nightingale* – even more perhaps than the *Ode on Melancholy* or his most painfully impassioned sonnets – suggests how profound were the conflicts that had ridden him since early childhood. Keats, like Shelley and Byron, possessed what the Freudian psychologist would call a deeply rooted 'death-wish'. Whence had it originated? To questions of this kind there can be no wholly satisfactory answer, since nine-tenths of a man's emotional experience lie hidden deep beneath the surface. Nevertheless, some interesting discoveries have been made about the poet's youth, and about the curious set of family circumstances that may have helped to shape his feelings.

His father, Thomas Keats, had originally come up from the West Country to work as a groom and ostler at the Swan and Hoop livery stables, which carried on a profitable trade in Moorfields, near the precincts of St Paul's. There he had married his employer's daughter, and, soon after his marriage, in October 1794, had become the master of the business. Thomas Keats was a handsome, vigorous, pleasure-living tradesman, said to have been 'much above his station in life'. His wife Frances was equally pleasure-loving – 'passionately fond of amusement' indeed; and, while one report describes how he would display her pretty

(*Right*) Keats, 1819, by A. Brown. His friends admired his 'brisk and winning face'

(*Below*) Fanny Brawne; silhouette portrait by Auguste Edouard; 'beautiful and elegant, graceful, silly, fashionable and strange'

legs when he raised her petticoats to cross the greasy London cobbles, a more prejudiced witness declared that 'her passions were so ardent that it was dangerous to be alone with her'. At all events, she was highly attractive and volatile; and her son George spoke both of her domestic extravagance and of the 'doting fondness' that she showed her children. John, her eldest son, was born on or about 31 October 1795.* But this secure and cheerful family-life was suddenly cut short on 15 April 1804, when Thomas Keats was thrown from his horse and received terrible injuries to his skull, of which, the following day, he died.

Almost immediately his widow married again. Keats's mother was no less precipitate than Hamlet's in making her way into a second bed; only some two months later, at the same church, St George's, Hanover Square, that she had attended for her first marriage, she gave her hand to William Rawlings, a poor and undistinguished bank clerk. Their relationship, however, broke down just as abruptly as it had begun. Mrs Rawlings not only left her husband but vanished temporarily from her children's life; she was rumoured to have come to no good, and to be living in sin with 'a Jew at Enfield named Abraham'. The Keats children were brought up by their maternal grandmother, Alice Jennings, a sensible, warm-hearted woman; until Frances, having evidently tired of her new adventures, drifted back into the family, among whom she died, a victim of tuberculosis – the disease that was to destroy two of her sons – early in the year 1810.

Keats was fourteen; and his mother's death, we learn, caused him 'impassioned and prolonged grief'. During childhood, his attitude towards Frances had been jealous and protective; and we hear that once, when she fell ill and the physicians had prescribed a period of complete rest, John borrowed an old sword and stood sentinel outside her door. He also responded to his mother's feminine charm, and admired her dashing, wayward personality. She was 'a singular Character'; and from her (thought a contemporary) he might be supposed to have derived 'whatever was peculiar in his Mind and Disposition'. Her remarriage, her mysterious flight and her pathetic reappearance were all impressed upon his memory; and he used to say, reported Joseph Severn, that his 'great misfortune' had been that, since he was an infant, 'he had had no mother'. The desertion of this beloved, delusive parent inspired him with a deep distrust for the whole human race, but particularly for women who were young and beautiful. 'I can scarcely remember', he wrote, 'counting upon any happiness. I have suspected every Body.'

To distrust Life is to cherish the idea of Death; and that morning at Wentworth Place, as he sat beneath the plum tree's branches, and relived his recollections of a nightingale he may have heard the night before, the idea returned to haunt his mind:

> Darkling I listen; and for many a time
> I have been half in love with easeful Death,

* This was the date that Keats accepted as his birthday. But he had been born less than nine months after his parents' marriage.

The Enchanted Castle, by
Claude Lorrain;
remembered by Keats
when he wrote his *Ode to
a Nightingale*

Call'd him soft names in many a musèd rhyme,
To take into the air my quiet breath;
Now more than ever seems it rich to die,
To cease upon the midnight with no pain,
While thou art pouring forth thy soul abroad
 In such an ecstasy!
Still wouldst thou sing, and I have ears in vain . . .

The completed poem gives us an especially vivid insight into the
method by which Keats built up his verse. One image is allowed to suggest
another; and the poet does not move ahead along a single predetermined
line, so much as permit himself to be wafted away through a series of
dissolving visions; until his imaginative journey comes to an end with
Ruth 'amid the alien corn', and with the 'magic casements' and 'perilous
seas' that he may have owed to his recollections of a seventeenth-century
French picture.*

No less evocative of Keats at this period is the *Ode on Melancholy*, written
during the same month and year. It is a strange, feverish, intricate pro-
duction; and Keats had originally meant it to enclose a stanza, describing
a Coleridgean Ship-of-Death, framed in the wildest neo-Gothic style. As
the poem stands, the effect that it produces is sufficiently extravagant.

* This picture is thought to have been *The Enchanted Castle* by Claude Lorrain, which Keats
knew only through engravings, but described at length in his *Epistle to John Hamilton Reynolds*.
See Aileen Ward, *John Keats: The Making of a Poet*, 1963. Like Pope and Wordsworth, Keats
evidently possessed a keen pictorial imagination.

Keats had always a greedy love of sensation; and here the sensations he pursues are those of pleasure and pain, joy and melancholy intermingled. Each feeling derives an added keenness from its close connection with its opposite; and the reader is advised, when melancholy overcomes him, to heighten the exquisite anguish of his mood by feeding on the spectacle of youth and beauty:

> Then glut thy sorrow on a morning rose,
> Or on the rainbow of the salt sand-wave,
> Or on the wealth of globèd peonies;
> Or if thy mistress some rich anger shows,
> Emprison her soft hand, and let her rave,
> And feed deep, deep upon her peerless eyes.
>
> She dwells with Beauty – Beauty that must die;
> And Joy, whose hand is ever at his lips
> Bidding adieu; and aching Pleasure nigh,
> Turning to poison while the bee-mouth sips . . .

The scene conjured up by the fourth, fifth and sixth lines has, it must be admitted, a touch of genial absurdity. More significant, however, is the poet's choice of images. Like Shakespeare in *Troilus and Cressida*, Keats frequently employs expressions associated with the sense of taste. He was a greedy young man. We know that he loved drinking claret; and Haydon tells us that, before he began to drink, he would sharpen his sensitive taste-cells with a dash of cayenne. Thus, throughout his ode, he describes the cult of sorrow in terms of drinking or of eating, and reserves a particularly gluttonous image for the poem's last stanza:

> Ay, in the very temple of Delight
> Veil'd Melancholy has her sovran shrine,
> Though seen of none save him whose strenuous tongue
> Can burst Joy's grape against his palate fine;
> His soul shall taste the sadness of her might,
> And be among her cloudy trophies hung.

It was exuberance of this kind that offended Byron and so many other early-nineteenth-century critics, who saw in Keats only an untutored adolescent, running riot among wild, voluptuous fancies.

Byron's criticism, of course, was especially savage. Keats's poetry, he told John Murray in October 1820, was 'a sort of verbal masturbation'; the poet himself, a 'miserable Self-polluter'; and not until 30 July 1821, did he seek to make amends. During the interval, he had read and admired *Hyperion*, and had heard the tale of Keats's death: 'You know very well', he wrote to Murray, 'that I did not approve of Keats's poetry, or principles of poetry . . . but, as he is dead, omit *all* that is said *about him* in any MSS. of mine, or publication. His *Hyperion* is a fine monument and will keep his name.'

As often happened, after indulging some initial prejudices Byron produced a sound and generous judgement. Much of the classical lore with which Keats decked out his earlier verses seems to have been taken

straight from Lemprière's *Classical Dictionary* – a book that English school-boys then found dangerously entertaining – and to have little real place in the poet's own imagination. When he embarked on the poem that Byron praised, he handled his classical subject with far greater confidence; the fallen Titan is no mere legendary shape, but one of the 'huge and mighty forms' that had overshadowed Wordsworth's boyhood. While *Endymion* is a bright, fantastic labyrinth, as full of decorative details as an Augustan grotto, the world of *Hyperion* is spacious, hushed and cold, dominated by the figure of the ancient earth-spirit, whom Keats has reclothed in Miltonic majesty:

> Deep in the shady sadness of a vale
> Far sunken from the healthy breath of morn,
> Far from the fiery noon, and eve's one star,
> Sat gray-hair'd Saturn, quiet as a stone,
> Still as the silence round about his lair;
> Forest on forest hung about his head
> Like cloud on cloud. No stir of air was there,
> Not so much life as on a summer's day
> Robs not one light seed from the feather'd grass,
> But where the dead leaf fell, there did it rest.
> A stream went voiceless by, still deadened more
> By reason of his fallen divinity
> Spreading a shade: the Naiad 'mid her reeds
> Press'd her cold finger closer to her lips.

No single circumstance, or set of circumstances, can explain the evolution of an artist's genius. It may, however, help us to understand some of the characteristics of his individual style – the poet's obsession, for instance, with a certain group of images – and the nature of deep-rooted conflict that he was endeavouring to resolve through art. In Keats's history, the disasters of his early life had evidently had a profound effect upon his emotional development. He had adored his attractive mother; and his mother had betrayed him. Her death itself may have appeared a kind of betrayal. Thenceforward he had regarded happiness as an illusion, and had 'suspected every Body' – those whom he most deeply suspected being the women he found most delightful. Fanny Brawne herself, an affectionate and well-behaved girl, he was perpetually accusing of some minor misdeed; and there were times when he refused to see her – 'I am a Coward', he admitted, 'I cannot bear the pain of being happy' – so violent were the passions she aroused, and so fatally did the resultant crisis break into his working days.

His mother, too, had infected his imagination with the idea that the beautiful were always doomed. She had vanished at the height of her charm and youth; she had returned home to die of a slowly wasting disease, lustreless, 'pale, and spectre-thin', just as her son had entered adolescence. It has been suggested by a modern poet-critic that *La Belle Dame Sans Merci* represents both Death and Fanny Brawne. Undoubtedly, the 'fairy's child', who has victimised the unhappy knight, stands for the

delusive Female Principle; but, although, by that time, Keats's Fata Morgana may perhaps have resembled Fanny Brawne – his beloved, at least, in her more maddening and disturbing aspects – she must originally have sprung from his recollections of a very different Fanny, his tempestuous, ill-fated mother.

It is easy to overstress the poet's self-destructive traits. With the death-wish that colours so much of his imagery, and gave to the rhythm of his verse its peculiar lazily voluptuous flow, he combined an intellect that was always sternly vigilant and a sense of poetic vocation that, at least until his strength had begun to break down, supported him throughout his whole career. During his lifetime, his 'consciousness of Genius' made a strong impression on Benjamin Robert Haydon; and, towards the end of March 1821, when he heard of the poet's death, he committed a farewell tribute to his journal:

Poor Keats, – a genius more purely poetical never existed! In conversation he was nothing, or if anything weak and inconsistent. Keats was in his glory in the fields! The humming of the bee, the sight of a flower, the glitter of the sun, seemed to make his nature tremble! his eyes glistened! his cheek flushed! his mouth positively quivered and clentched! He was the most unselfish of human creatures . . . he cared not for himself, and would put himself to any inconvenience to oblige his Friends, and expected his Friends to do the same for him . . . He was proud, haughty, and had a fierce hatred of rank; but had a kind heart, and would have shared his fortune with any man who wanted it . . . The

(*Left*) Fanny Brawne; a miniature portrait. (*Right*) Sketches of Keats's head, made by B.R.Haydon in November 1816

last time I saw him was at Hampstead, lying in a white bed with a book, hectic, weak, and on his back, irritated at his feebleness, and wounded at the way he had been used . . . I told him to be calm, but he muttered if he did not soon recover he would cut his throat. I tried to reason on such violence, but it was no use; he grew angry, and I went away very deeply affected.

Haydon noted that 'I have enjoyed Shakespeare more with Keats than with any other Human creature!' He also tells us that, while they were contemplating his enormous painting of *Christ's Entry into Jerusalem*, which, among the bystanders, incorporated portraits of Keats and Wordsworth, the young man, 'getting suddenly up, and approaching it . . . placed his hand on his heart, and bowing his head "there is the being I will bow to", said he – he stood before Voltaire!' Though he pretended to despise Pope, thereby enraging Byron, Keats had a much more catholic point of view than most of his fellow Romantic poets and perhaps, despite the defects of his education, a more genuinely receptive mind. He was completely innocent both of Shelley's doctrinaire prejudice, and of the harsh didactism that often disfigured Wordsworth. He had decided, he wrote, that 'the only means of strengthening one's intellect is to make up one's mind about nothing – to let the mind be a thoroughfare for all thoughts, not a select party' – and mistrusted the poet who preached like Coleridge, promulgated moral systems like Wordsworth, or, like Shelley laid down social laws. He was an aesthete in the noblest meaning of the word, an entirely free and uncommitted artist.

What Keats might have done, had he been able to cling to life, is always an absorbing problem. Is it not possible that he might have formed a creative link between Augustan and Romantic literature? *Endymion*, he knew, was full of adolescent failings. Six months after its publication, he agreed that it was a 'slipshod' work. But 'that it is so is no fault of mine . . . It is as good as I had power to make it – by myself. Had I been nervous about its being a perfect piece . . . and trembled over every page, it would not have been written; for it is not in my nature to fumble – I will write independently – I have written independently *without Judgement*. I may write independently, and *with Judgement* . . . The Genius of Poetry must work out its own salvation in a man: it cannot be matured by law and precept, but by sensation and watchfulness . . . That which is creative must create itself.'

Whereas Shelley had the stuff of a martyr, Keats had the makings of a modern hero. His heroism, however, depended on a sense of vocation; and, once he had lost hope and felt his strength declining, Death, which he had so often courted in verse, became an horrific and repulsive spectre. On his twenty-fifth birthday, 31 October 1820, accompanied by his devoted attendant, Joseph Severn, Keats landed at Naples under a wet and gloomy sky. For a while his spirits revived; he enjoyed the boisterous animation of a southern seaport. A few days earlier, while the English travellers were still detained in quarantine, he had written to Mrs Brawne – to Fanny he could not bear to write – about the noise and bustle round the brig: 'Give my love to Fanny, and tell her, if I were well there is

enough in this Port of Naples to fill a quire of Paper', adding pathetically, '– but it looks like a dream – every man who can row his boat and walk and talk seems a different being from myself.'

Even so, during their stay at Naples, he experienced some momentary gleams of pleasure. Climbing 'the beautiful open road which leads up to Capo di Monte and the Ponte Rossi . . . he was struck and moved by the sight of some rose-trees in full bearing'; though he threw the flowers away when he discovered that they had no fragrance. And, on their way home, he derived 'intense enjoyment', when they halted near the Capuan Gate, from 'watching a group of *lazzaroni* or labouring men, as, at a stall with fire and cauldron . . . they were disposing of an incredible quantity of macaroni, introducing it in long unbroken strings into their capacious mouths . . . "I like this", said he . . . "Give them some *carlini* that they may eat more! Glorious sight! How they take it in!" '

Later, while he and Joseph Severn – 'a very good fellow', Keats commented bitterly, 'but his nerves are too strong to be hurt by other people's illnesses' – were journeying northwards on the way to Rome, he admired the desolate sweep of the Campagna, and remarked that its 'vast billowy wastes' recalled a silent inland sea. As they neared Rome, a strange crimson-cloaked figure, which might have sprung straight from a canvas by Magnasco or Salvator Rosa, appeared at the wayside in the tawny

Naples, by Turner. 'There is enough in this port of Naples to fill a quire of paper – but it looks like a dream . . .'

Rome, the Piazza del
Popolo, by Samuel
Palmer

distance – a robed cardinal out shooting song-birds, flanked by a pair of
liveried footmen and assisted by a tame owl.

They reached Rome, and passed through the Lateran Gate, on 15
November, driving straight to the Piazza di Spagna, where Dr Clark, a
resident English physician, had taken for them a small apartment which
looked out across the Spanish Steps. After their first glimpse of the forest-
grown Colosseum, the city soon began to lose its charm. Their landlady
harried them; tradesmen cheated them; and Keats, with an explosion of
his former energy, was once seen to hurl a whole basketful of ill-cooked
food, purchased from a nearby *trattoria*, through the window of their
lodgings. He had still sufficient energy to ride on the Pincian – until a
flirtation that appeared to be developing between an English acquaintance
and the celebrated beauty Princess Pauline Borghese, whom they occasion-
ally met under the shade of the umbrella-pines, tried his love-racked
nerves beyond endurance. But, during December, a sudden and un-
expected relapse drove the poet back to bed.

The narrow slip of room that became his last refuge – less than seven
metres broad by some five and a half metres long – has an incongruously
cheerful ceiling, strewn with a pattern of white-and-gold rosettes upon an
azure-blue ground, now faded to much the same colour as a pale Italian
spring-time sky. Even in February 1821 it must have been a noisy room;

for the square below contained Bernini's boat-shaped fountain, *The Barque*, perpetually spouting water from the mouths of stone cannon; while a tide of talkative pedestrians flowed up and down beneath his windows. There Keats lay and fingered the oval white cornelian that had been a farewell gift from Fanny Brawne. Otherwise, everything that reminded him of his lost happiness he had desperately put behind him. The silk lining that Fanny had sewn into his travelling-cap felt, he once complained, as though it scorched his head. He died, with a few consoling words for his exhausted attendant: 'Don't be frightened – I shall die easy – be firm, and thank God it has come!' – on 23 February. Fanny's un-opened letters were to be buried beside him; and he had instructed Severn that the short epitaph he had already composed – *Here Lies One Whose Name was Writ in Water* – should be surmounted by the representation of a broken-stringed lyre.*

Keats had gone to his death unwillingly; Byron embarked on his last adventure voluntarily, almost cheerfully, knowing he would not return. He, too, had had a cruel childhood; and a complex group of relationships had determined his attitude towards the world at large. His mother, whom he disliked and despised, had remained to exasperate her only son until he reached the age of twenty-three; but his father, whose memory he defended, had died when he was very young; while behind his father loomed his grandfather and grand-uncle – strange personages he had never seen, who had founded the 'heritage of storms' to which he traced his own misfortunes.

* There may possibly have been some symbolic significance in the fact that only four of its eight strings are broken.

Newstead Abbey; from a nineteenth-century print

Stories of 'the wicked Lord', the eccentric recluse at Newstead, and of Admiral Byron, 'Foulweather Jack', so called because a series of hurricanes seemed to follow his ship around the globe, played an important part in the ancestral legend; but Byron's father, though he scarcely remembered him, made no doubt an even deeper mark upon his adolescent life. Captain John Byron, 'Handsome Jack', one of the best-looking men of his day, had been a charmer, a rake, a spend-thrift and, ultimately, a tragic wastrel. The Admiral's eldest son, John Byron was born on 7 February 1756, educated at Westminster and a French military school, and had served in America with the Brigade of Guards, but soon sold his commission and returned to London, where he immediately gained renown both as a gambler and as a man of love. Among his early conquests was the beautiful Lady Carmarthen, who became his mistress during the summer of the year 1788 and, after a scandalous divorce case, married him in 1789. Young, rich and a peeress in her own right, she bore her husband three children. Only one survived, the future Augusta Leigh. She herself died – according to some stories, of a broken heart; so unkind had been John Byron's conduct – in January 1794.

With his wife the Captain lost her income; and, being a cheerfully unscrupulous man, accustomed in earlier life to insist that the women he loved should help him pay his gambling debts, he began to look around him for a second heiress. At Bath, then the happy hunting-ground of matrimonial adventurers, he found a twenty-year-old Scottish girl, Miss Catherine Gordon of Gight, said to have a patrimony of more than £23,000, and promptly set about her subjugation. Miss Gordon claimed to have royal blood; she was 'haughty as Lucifer', declared her son, but,

according to a contemporary, 'provincial in her accent and manner', and in her person coarse and awkward. She spoke with a Northern brogue, and walked with an ungainly roll. Captain Byron was the most graceful of men. For the moment, however, he needed money; and he married Miss Gordon at Bath on 13 May 1785. Their son, christened George Gordon, entered the world, at 16 Holles Street, near Oxford Street, London, on 22 January 1788. By that time, Captain Byron had run through a large part of his wife's fortune, the estates of Gight had been sold, and he was already fleeing from his creditors.

Such was the atmosphere of Byron's early childhood – one of near-poverty, constant insecurity and hideous domestic turmoil, as his passionate, foolish mother endlessly bickered and struggled with her selfish, un-scrupulous, delightful husband. They led a vagrant life, usually in different lodgings; but for a while the good-humoured Captain Byron continued to enjoy his previous pursuits, took a seaside house, where he entertained his friends, and chartered 'a very fine Lugger', in which he gaily ran across the Channel. He loved France; and, during the autumn of 1790, plagued beyond endurance by his English creditors, he decided to escape abroad. His sister, Mrs Leigh, had a house at Valenciennes. Thither he removed, and there he established himself with his usual grace and self-assurance.

When he first arrived, despite his diminished income, he could still afford to cut a dash, and wrote a lively report to his sister, Frances Leigh, of his successful housekeeping and various local love-affairs:

As for me, here I am, and in love with whom? A new actress who is come from Paris; she is beautiful and played last night in L'Epreuve Villageoise . . . As for Madame Schoner – she fairly told me, when drunk, that she liked me, and I really do not know what to do . . . We are all well here, and Josephine in the best order – as she gets no money and plenty of abuse; it is the only way to treat her . . .

At the same time, he had found some other amusements. He believed, he told his sister, that he had already had 'one third of Valenciennes, particularly a girl at L'Aigle Rouge . . . I happened to be there one day when it rained so hard . . . She is very handsome and very tall, and I am not yet tired.'

Next spring, the prospect began to darken. Perhaps his health was failing; and the little money he had contrived to beg or borrow seems finally to have disappeared. The appeals that reached his sister in England grew more and more desperate and unashamed. 'I am really without a shirt', he wrote, '. . . I have not a sou . . . I have but one coat to my back, and that in rags . . . I would rather be a galley slave . . .' There is something both squalid and pathetic – with an occasional hint of ferocious abandon – about the Captain's last letters. Meanwhile his deserted wife was herself demanding help: 'Though I have not the pleasure of being personally known to you', she wrote to Mrs Leigh in January, 'I hope you will forgive this trouble. Some time ago I wrote to Mr Byron, telling him I had not a farthing in the world . . . and begging him to ask you to lend him thirty or forty pounds to send to me, to which he returned for answer

that he could not think of asking you as you had been so good to him but that he had wrote to a person that would send it to me. This was only to put me off . . .' She begged, therefore, that Mrs Leigh would supply those thirty or forty pounds, to avoid 'arrestments on my income', concluding with the forlorn assurance: 'I will pay you honestly in May.'

We do not know whether her unknown sister-in-law was prepared to come to Mrs Byron's rescue; but John Byron certainly remained aloof. He was glad, he remarked to Mrs Leigh on 16 February, that she had heard from Mrs Byron; 'she is very amiable at a distance; but I defy you and all the Apostles to live with her two months . . . For my son, I am happy to hear he is well; but for his walking, 'tis impossible, as he is club-footed.' The bankrupt exile was now closely confined within the shrinking circle of his own miseries; and on 2 August 1791, after he had made a will, in which he bequeathed to Mrs Leigh a sum of money he did not possess, and appointed his son 'heir of my real and personal estate', he died suddenly at Valenciennes. He was thirty-five; and a biographer has suggested that he may have killed himself.

Mrs Byron mourned him bitterly. She did not think, she declared, that she would recover from her husband's loss; 'necessity, not inclination, parted us, at least on my part . . . and notwithstanding all his foibles, for

Byron at the age of seven, his first portrait; engraved by Edward Friden from a painting by John Kaye of Edinburgh

they deserve no worse name, I ever sincerely loved him . . .' Like many imaginative writers, Byron claimed to have a long memory; and, in conversation with his garrulous friend, Tom Medwin, he would later assert that, although he had seen John Byron for the last time when he was not yet three years old, 'I perfectly remember him', adding that he had very early felt 'a horror of matrimony, from the sight of domestic broils . . . He seemed born for his own ruin, and that of the other sex.'

This was the severest verdict the poet consented to pass on his disastrous, unhappy father. Elsewhere he defended him warmly. It had been alleged, he wrote, that his father's conduct was brutal, particularly towards his first wife. But, 'so far from being "brutal", he was, according to the testimony of all who knew him, of an extremely amiable and (*enjoué*) joyous character, but careless (*insouciant*) and dissipated . . . It is not by "brutality" that a young Officer in the Guards seduces and carries off a Marchioness, and marries two heiresses. It is true that he was a very handsome man, which goes a great way.'

Here the student of Byron's life confronts an extraordinarily interesting, but as yet unanswered question. Had the poet read his father's last letters? Surely he must have done so; for those letters, still unpublished in their entirety, were found among his personal archives. But, if he had read them, and considered the sidelights they cast on John Byron's progressive degradation, how did he reconcile their contents with his agreeable image of the joyous, carefree man of pleasure? The correspondence has another aspect that, if he ever looked into it, would undoubtedly have struck Byron. It is said to show that the relationship between John Byron and his sister had not been altogether blameless. Byron, we know, was fascinated by the idea of incest. May not the correspondence, when he eventually turned its pages, have tended to confirm his secret leanings?

On a different plane, Byron championed his father because, at an early age, he had learned to hate his mother. 'Ah, you little dog', Mrs Byron would exclaim, 'you are a Byron all over; you are as bad as your father!' And, even in childhood, Byron gladly accepted the implied responsibility, and resigned himself to the 'heritage of storms' that went with his Byronic blood. He became a pessimist and a determined fatalist nearly as soon as he began to think.

'Like Sylla, I have always believed that all things depend upon Fortune, and nothing upon ourselves', he wrote in the notebook of memories and reflections that he kept between October 1821 and May 1822. 'I am not aware of any one thought or action worthy of being called good to myself or others, which is not to be attributed to the Good Goddess, Fortune!' He might have added that this was equally true of everything that could be called evil. Captain Byron had told his sister that his son was clubfooted; and, although the exact nature of his deformity remains obscure,*

* Byron's latest biographer, Professor Leslie Marchand, has decided, nevertheless, that the evidence 'points clearly to some form of clubfoot'. See *Byron: A Biography*, 1957. The laced boots that Byron wore, to improve the appearance of his leg, can still be examined in his publisher's famous collection of Byroniana at No. 50 Albemarle Street.

Aberdeen, by N. Purser.
Here Byron walked as a
child with Agnes Gray

his right foot was seriously misshapen, which caused him to walk with a shuffling, sliding gait; and attempts to remedy the condition during his early youth had cost him endless pain and misery. Here Byron was even unluckier than Pope; for the curvature of Pope's spine had developed by slow stages after a happy and harmonious childhood, and had had a purely accidental origin. Byron, however, knew that he had been marked from the womb, and felt that his humiliating defect was a part of his tormented heritage.

Any reference to his lame foot immediately aroused his anger. When he was a child, walking through the streets of Aberdeen beside his nursemaid, Agnes Gray, they met another nurse who, in good-natured, gossiping fashion, exclaimed that he was certainly a handsome boy; but 'what a pity he has such a leg!' '*Dinna speak of it*', he cried, in the Scottish brogue he never quite lost, and lashed out furiously at the stupid woman with the little whip he carried. Nor did his mother, aggrieved, excitable and ill-tempered, provide a reassuring influence. They were poor; she continually harped on their poverty; the first school that he attended in Aberdeen was a cheap and shabby place. Equally comfortless were the lodgings they occupied; and, in his red jacket and nankeen trousers, he often wandered off into an adjacent courtyard – from which he was sometimes chased away – to entertain himself as best he could. It was a lonely childhood; and during those formative years, Byron first acquired the

109

ineradicable sense of solitude that haunted him until he died. His adult life was a dramatic and varied scene, where the same conflicts – the conflicts of his youth – were perpetually enacted and re-enacted against a long series of rapidly changing backgrounds.

In childhood, too, he was first initiated into the mysteries of sexual pleasure. 'My passions', he wrote in *Detached Thoughts*, 'were developed very early – so early, that few would believe me, if I were to state the period, and the facts which accompanied it.' His nurse, Agnes Gray, had been followed by her younger sister, May, who, like Agnes, was a pious Calvinist and helped to infect the little boy's mind with the ideas of sin and predestination, but a far less warm and gentle character. In 1799 John Hanson, the family lawyer, discovered that May had been systematically ill-treating him, and that, during Mrs Byron's absence, she had 'brought all sorts of Company of the lowest Description into his apartments . . .' Hanson learned, at the same time – though he kept the knowledge to himself, and only imparted the story many years later to the poet's devoted friend, Hobhouse – that it had also amused her to arouse his senses. When Byron was nine, Hobhouse recorded, 'a free Scotch girl used to come to bed to him and play tricks with his person – Hanson found it out and asked Lord B – who owned the fact – the girl was sent off'. His sexual precocity, Byron believed, had had a lasting effect on his imagination. 'Perhaps', he suggested, 'this was one of the reasons which caused the anticipated melancholy of my thoughts – having anticipated life.'

Simultaneously, he had tasted romantic love. For Mary Duff, a child of his own age, for his cousin Margaret Parker, 'one of the most beautiful of evanescent beings', whom he adored when he was about twelve years old, and who had inspired his 'first dash into poetry', and, some years later, for Mary Chaworth, descendant of the William Chaworth killed by his grandfather, 'the Wicked Lord', he conceived passions all the more lasting because they were entirely innocent. He was always fond of remembering those early loves, and referred with especial tenderness to Margaret Parker.

Her dark eyes! her long eye-lashes [he wrote], . . . I do not recollect scarcely anything equal to the *transparent* beauty of my cousin . . . She looked as if she had been made out of a rainbow . . . My passion had its usual effects upon me: I could not sleep, could not eat; I could not rest; and although I had reason to know that she loved me, it was the torture of my life to think of the time which must elapse before we could meet again – being usually about *twelve hours* of separation!

In Byron's amatory life, the guilty appetite that had been aroused by May Gray existed side by side with a cult of 'ideally beautiful unpossessed love',[14] which assumed, when he entered adult life, now a heterosexual and now a homosexual guise.

At Harrow, it had adopted the second form; and he soon collected around him a circle of beloved friends, all attractive young patricians – Clare, Dorset, Delawarr, Gordon, Tattersall, Wingfield and others whom he spoiled and patronised. There seems no doubt that some of these attachments had a strongly homosexual colouring. 'My School friend-

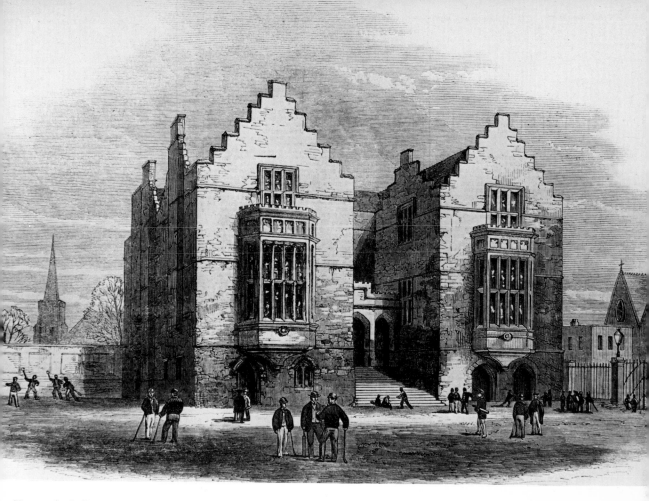

Harrow in the later
nineteenth century; 'my
school friendships were
with me *passions* . . .'

ships', he declared, 'were with me *passions* (for I was always violent) . . .
That with Lord Clare began one of the earliest and lasted longest . . . I
never hear the word "Clare" without a beating of the heart even *now* . . .'
Their affection was 'only interrupted by distance'; and, some years after
he had left England and put the English scene behind him, the two old
friends happened to meet 'on the road between Imola and Bologna'. Both
were intensely moved: 'This meeting annihilated for a moment all the
years between . . . Clare, too, was much agitated . . . for I could feel his
heart beat to his fingers' ends, unless, indeed, it was the pulse of my own
which made me think so . . . We were but five minutes together; but I
hardly recollect an hour of my existence which could be weighed against
them.'

He left Harrow with passionate regret; his reluctant recognition that he
was 'no longer a boy' had been, he said, 'one of the deadliest and heaviest
feelings' in his whole career. Thus, like Wordsworth and Coleridge, he
became obsessed by the idea of youth, and attributed to his youthful
emotions an unexampled strength and freshness. Thenceforward he was
perpetually looking back – to the 'green paradise' he had shared with
Margaret Parker; to his life at Harrow; and, once he had achieved fame
and taken London by storm, to the adventurous period that he had spent

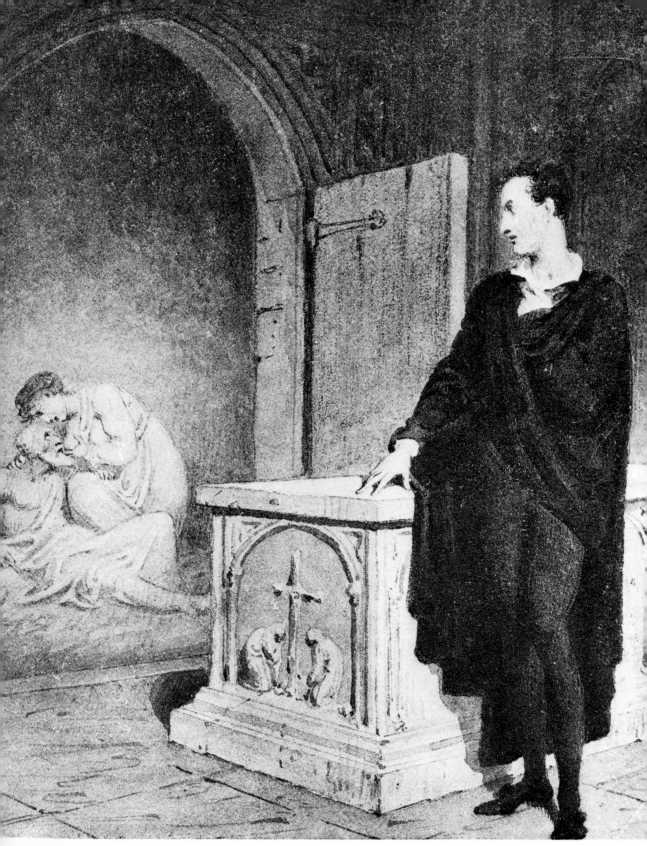

Byron at the zenith of his
fame; portrait by
Thomas Phillips, R.A.

in Greece, to the rocky, sunny islands among which he had travelled, and
the 'interesting white squalls and short seas of Archipelago memory'.

His past fascinated him; and, even a boy, he confronted the future in a
strangely unhopeful, though often aggressive and vainglorious mood.
Such was the mood in which he addressed his detestable mother at the age
of sixteen: 'The way to *riches*, to *greatness* lies before me. I can, I will cut
myself a path thro' the world or perish in the attempt ... I will carve
myself the passage to Grandeur, but never with Dishonour. These,
Madam, are my intentions.' True, Cambridge, where he was at first 'so
completely alone' that it 'half broke' his spirits, had somewhat lowered his
rebellious energies; and he had returned from Greece, he told Mrs Byron,
'without a hope, and almost without a desire'. But in the luggage that he
was bringing home to England lay the manuscript of *Childe Harold*. On
the morning of 10 March 1812, he awoke to find himself a famous poet.

To calculate the literary merits of *Childe Harold* has never been an easy
task; the opening cantos, which first presented the public with its sable-
suited hero, may be described, if not as a good poem, at least as one of the
most memorable bad poems ever published in the English language.
Byron's protagonist gives a strangely distorted impression of his own
adolescent personality:

> For he through Sin's long labyrinth had run,
> Nor made atonement when he did amiss,
> Had sighed to many though he loved but one,
> And that loved one, alas! could ne'er be his.

The Byronic Hero; water-
colour sketch by Westall

Meanwhile Childe Harold's secret thoughts, we are told, have con-
demned him to a state of moral solitude:

> . . . Oft-times in his maddest, mirthful mood
> Strange pangs would flash along Childe Harold's brow,
> As if the Memory of some deadly feud
> Or disappointed passion lurked below . . .
> For his was not that open, artless soul
> That feels relief by bidding sorrow flow,
> Nor sought he friend to counsel or condole,
> Whate'er his grief mote be, which he could not control . . .
>
> His house, his home, his heritage, his lands,
> The laughing dames in whom he did delight,
> Whose large blue eyes, fair locks, and snowy hands,
> Might shake the Saintship of an Anchorite,
> And long had fed his youthful appetite . . .
> Without a sigh he left, to cross the brine,
> And traverse Paynim shores, and pass Earth's central line.

Although this self-portrait delighted the public at large, it puzzled his sardonic friend Hobhouse, who afterwards remarked that, at the time when the poem was written, the dear fellow had had no conspicuous vices, and that his early sins had amounted to nothing worse than 'a little . . . or a good deal of drinking'. He might have added that the guilt-ridden Childe was largely based on a fictitious character. John Moore's novel *Zelucco*, which had appeared in 1789, also depicts the vicissitudes of a dark and wayward spirit, whose father is dead, and whose 'mistaken mother' helps to encourage his destructive whims, so that he bursts 'into flashes of rage at the slightest touch of provocation'. Byron admitted the resemblance and, in his original preface, declared that to draw 'the sketch of a modern Timon, perhaps a poetical Zeluco', had been the intention with which he set forth. Thus the Childe had started life as a figment of Gothic romance; only at a later stage did he begin to absorb some of the vivid colouring of the poet's own divided nature. Byron then discovered that he had created a Frankenstein, whose companionship he often found distasteful, until he cut the link by producing Don Juan, a much more sympathetic *alter ego*.

Meanwhile Childe Harold had come to embody the mood, and reflect the sufferings, real or imaginary, of an entire generation. During his lifetime Byron received, and carefully stored away, an enormous mass of unsolicited letters, from enthusiasts who passionately admired his work, and believed that he alone, as the creator of *Childe Harold*, could understand their deepest problems.[15] What they shared was a pervasive sense of malaise, a feeling that the society to which they belonged had deceived and disappointed them. Byron's relationship with his readers was highly personal. They revered the poet; it was to the man – or their idealised version of the man – that they addressed their frenzied pleas; imploring that he would send them a lock of his hair; begging for an assignation; or paying tribute to his poetic genius, but commenting severely on his moral views, and regretting that 'one, who speaks "so sweetly and so well" should not be *all* he might be'.

To each he had brought some private message; many claimed that a

The Byronic Heroine;
water-colour sketch by
Westall

study of his poems had completely revolutionised their life and outlook. 'Upon perusing *Childe Harold . . .*', wrote a young woman, 'I became as it were animated by a new soul, alive to wholly new sensations.' The legend of Byron's wickedness evidently increased his charm; and a typical effusion, composed by 'a young lady of *deservedly unsullied fame*', reached him in September 1814. Her motives were pure; she was obeying, she wrote,

an irresistible inclination to address a man whose character as far as she has learned from public report . . . she *dares not* admire and whom she *never saw;* but

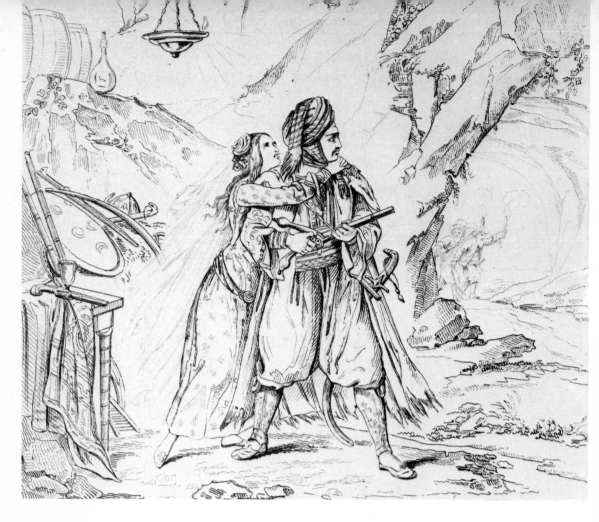

she cannot read his works with the attention she has done, without believing his mind would sympathise with her own, and feeling herself strongly interested in his sorrows . . . To Ld Byron she must ever remain concealed; yet that some notice was taken of this address . . . may cast a gleam of sunshine over the almost broken heart of

<div style="text-align: right">ROSALIE</div>

The Bride of Abydos, one of the Romantic verse-tales with which Byron delighted his readers before 1816; illustration by A. Colin

Before he left England for the second and last time, Byron gave the world six further lengthy verse-tales, *The Giaour, The Bride of Abydos, The Corsair, Lara, The Siege of Corinth* and *Parisina*. Of these, *The Corsair*, written at break-neck speed,* '*con amore*, and much from *existence*', and published early in February 1814, had an extraordinary wide success; for ten thousand copies – 'a thing perfectly unprecedented' – were sold by John Murray upon the day of publication. Thomas Moore said that it was 'fearfully interesting . . . wild, touching, and "negligently grand" '; and it was warmly praised by the editor of the *Quarterly Review*, that ferocious Tory, William Gifford. Again the protagonist is a romantic anarch:

> Unlike the heroes of each ancient race,
> Demons in act, but Gods at least in face,

* According to Moore, he produced, while he was writing it, nearly two hundred lines a day.

In Conrad's form seems little to admire,
Though his dark eyebrow shades a glance of fire . . .
Sun-burnt his cheek, his forehead high and pale
The sable curls in wild profusion veil;
And oft, perforce, his rising lip reveals
The haughtier thought it curbs, but scarce conceals . . .
His features' deepening lines and varying hue
At times attracted, yet perplexed the view,
As if within that murkiness of mind
Worked feelings fearful, and yet undefined . . .

Like Childe Harold, the lonely and mysterious Corsair bears a striking resemblance to the hero of a Gothic novel; and Byron was amused, though not altogether astonished, when Hobhouse told him of 'an odd report that *I* am the actual Conrad . . . and that part of my travels are supposed to have passed in privacy'. This, he hinted, was somewhere 'near the truth', but not, of course, 'the whole truth'. If Byron, towards the end of his Grand Tour, had preferred to be alone in Greece, his reasons would appear to have been amatory rather than aggressive and piratical – he was enjoying the company of his young friend Nicolo Giraud, and of another Greek boy, 'my dearly beloved Eustathius', an 'amiable *paidé*', who 'pranced' at his side across the Peloponnesian mountains under the shadow of a small umbrella,* and from whom he parted with 'as many kisses as would have sufficed for a boarding school, and embraces enough to have ruined the character of a county in England . . .'

Yet, although neither hero was a deliberate self-portrait – a point that Byron often emphasised – each corresponded to a certain aspect of his creator's personality. When he wrote *Childe Harold*, he was by no means a hardened offender; still less was he a romantic exile. The sketch he had drawn was very largely false; but, between the publication of the poem's opening cantos and his final goodbye to England, he had *made* it come true, realising in his private life the state of isolation and moral desperation that he had previously portrayed in literature. For just as the man with a deep sense of anxiety – what modern psychologists call an 'anxiety complex' – needs a constant supply of problems that entitle him to feel anxious, so the man who is carrying a burden of guilt must be perpetually committing misdemeanours to justify his sense of sin.

How else can we explain the bewildering imprudence that had characterised his social conduct? No man could have courted disaster more ingeniously or repeatedly; as he himself acknowledged in his *Epistle to Augusta*, he had hastened the progress of his own ruin:

I have been cunning in mine overthrow,
The careful pilot of my proper woe.

Byron, like his predecessor, William Beckford, had a naturally self-

* 'The next morning I found the dear soul upon horseback, with those ambrosial curls hanging down his amiable back, and to my utter astonishment, and the great abomination of Fletcher, a *parasol* in his hand to save his complexion from the heat. However . . . we travelled on very much enamoured . . . till we got to Patras . . .' Byron to Hobhouse, 29 July 1810.

destructive spirit, and (to quote the words of their joint successor, Maturin) was profoundly attracted by those secret 'struggles of passion' where 'the soul trembles on the verge of the unlawful and the unhallowed', and the human capacity for feeling and suffering is pushed to its extreme limits.

At the same time, Byron was a born gambler, who had inherited his father's love of desperate odds. He had a notion, he wrote in 1821, 'that Gamblers are as happy as most people, being always *excited*'. And, in 1813 before he had completed his tragedy, but was already beginning to prepare the climax: 'The great object of life is sensation – to feel that we exist, even though in pain. It is this "craving void" which drives us to gaming – to battle – to travel – to intemperate, but keenly felt pursuits of any description, whose principal attraction is the agitation inseparable from their accomplishment.'

The knowledge that he was committing a sin, for which, as his wise old friend Lady Melbourne had warned him, there was 'no forgiveness in this world, whatever there might be in the next', encouraged Byron in 1813 to embark upon a new adventure – the 'strange summer adventure', his liaison with Augusta Leigh, that eventually brought about his downfall.

(*Left*) Augusta Leigh; from a drawing by George Hayter. 'Her faults were mine – her virtues were her own . . .' (*Right*) Lady Byron; 'Princess of Parallelograms' and an 'unforgiving' wife

Fashionables of 1816; a contemporary caricature of Byron in Hyde Park

This, he informed Tom Moore, was 'a far more serious ... scrape than any of the last twelve months ...' There was 'a mixture of the terrible', he told Lady Melbourne, about his recent thoughts and feelings that made all other emotions – 'even passion (pour les autres)' – seem uninteresting and insipid.

Byron's fatalism always rose to the surface during periods of acute emotional strain. 'There was a helplessness about Byron', noted his last admirer, Lady Blessington, 'a sort of abandonment of himself to his destiny as he called it, that commonplace people can as little pity as understand.' Because Augusta shared his blood – through a father who is said himself to have cherished an incestuous affection for his sister – he may have concluded that she was bound to share his fate; and the drama of their relationship grew still more explosive after Byron's ill-starred marriage. Then the storm broke; and, on 25 April 1816, having parted from Augusta with bitter tears, and apostrophised his 'unforgiving' wife in a rather feeble set of verses, Byron bade farewell to England. The 'wandering outcast of his own dark mind' was now the exile in fact that he had long been in imagination.

4

Romantic Exiles

Early next morning, 26 April 1816, Byron and his suite, which included Fletcher, his devoted but querulous valet, and Dr Polidori, the handsome, conceited young man whom he had recently appointed his personal physician, disembarked at Ostend. All of them needed rest; Byron himself, though an admirable sailor, had been sea-sick 'by contagion'; and they moved to a local inn, where, wrote Polidori, 'as soon as he reached his room, Lord Byron fell like a thunder-bolt upon the chambermaid'.

That afternoon, Byron again took the road in his enormous travelling carriage. Having passed through Ghent, Antwerp and Brussels – whence the poet made a brief expedition to the field of Waterloo – they visited Cologne, admired the 'massy swells' of the Rhine and the romantic prospect of orchards, vineyards and battlemented crags clambering up above the stream, then crossed into Swiss territory, which Byron saluted as the ancestral home of freedom, and sighted Geneva and its lake towards the end of May. At the Hôtel d'Angleterre in Sécheron, Byron, asked to sign the register, declared that he was a hundred years old.

Another English party had preceded them; and immediately Byron received the kind of pleading and teasing feminine note to which he was already well accustomed. 'I am sorry', remarked his correspondent, 'you are grown so old; indeed I suspected you were 200 from the slowness of your journey. I suppose your venerable age could not bear quicker travelling. Well, heaven send you sweet sleep – I am so happy.' A post-script suggested that he should 'direct under cover to Shelley, for I do not

Venice in the early nineteenth century; *The Column of St Mark*, by Bonnington

Byron at Genoa on
the eve of his
departure for Greece.
Pencil sketch by
Count d'Orsay

wish to appear either in love or curious'. Byron's first impulse was to dis-
regard the message. His correspondent, he knew, must be the 'odd-headed
girl', named Mary Jane, or Claire, Clairmont, who, that same winter,
while he was still living at Piccadilly Terrace in a state of half-demented
gloom, had written to him soliciting his advice and help, and, after a good
deal of preliminary skirmishing, which he himself had done nothing to
encourage, had boldly insisted that she should become his mistress.

Byron had agreed. Though he did not welcome such unwomanly
advances, if he were sufficiently hard-pressed he very often gave way; and,
once his sensuality had at length been aroused, he played his part with
due abandon. But he had never pretended that he loved Claire, had
frequently told her that she was a 'little fiend', and begged her not to
haunt his doors. All in vain; the infatuated young woman constantly
reappeared upon his threshold; and one day she had brought her step-
sister, daughter of the renowned 'philosopher' William Godwin and of the
heroic feminist Mary Wollstonecraft, who had died while giving birth to
Mary.

Claire was eighteen, Mary nineteen; but two years earlier, Byron soon
learned, Mary had eloped with the scapegrace son of a respectable Sussex
landowner, Percy Bysshe Shelley, whom each of his adoring companions
believed to be a great poet. Claire hoped that she might also admire
Byron, and later assured him that, were an attachment to develop, she
would certainly not oppose their union, but would 'redouble my attentions

Claire Clairmont, by Amelia Curran; 'as to all these "mistresses", Lord help me, I have had but one'

to please her' and 'do everything she tells me, whether it be good or bad ...' Mary proved to be somewhat more cautious than her intrepid step-sister; but Claire was glad to be able to report that he had made a good impression. 'Mary is delighted with you', she wrote, 'as I knew she would be ... She perpetually exclaims: "How mild he is! How gentle! How different from what I expected." '

These were the acquaintances whom Byron found awaiting him at the Hôtel d'Angleterre. He was in no hurry to answer Claire's messages, and allowed a night and the following day to pass before he gave her any sign of life. Nor does he seem to have been anxious to meet Shelley, against whose subversive moral principles he had already warned Claire. Then, returning from a journey across the lake, in search of a house where he could settle down, he encountered Shelley and the two girls; and no doubt it was Claire who hurried forward to effect a proper introduction. What was said at the time we cannot tell; but the friendship that began beside the lake would last so long as Shelley lived.

Perhaps it was founded on a joint recognition of their extreme dis-

similarity. When Shelley was presented to the author of *Childe Harold* he saw, not the typical Byronic hero, swart, commanding, fiercely taciturn, but a rather small man, just over five feet eight inches high, with thick dark-reddish curls, a delicately pallid skin and, though his gait apt to be hesitant and awkward – he was always struggling to conceal his lame foot – a general air of restless energy. Byron had a compact and muscular frame, and was devoted to such masculine sports as swimming, boxing, pistol-practice. Taciturnity, it very soon appeared, was not the poet's most conspicuous trait. Indeed, he loved to joke, delighted in social gossip and, if his mood were calm, could be remarkably, even embarrassingly, talkative.

Shelley, on the other hand, was a slender, stooping, hollow-chested young man, a little above the average height, whose large hands and feet, and curiously loose and shambling movements, very often gave him the look of a clumsy undeveloped boy. He had a slightly receding chin, a small roundish, fair-complexioned face, a nose that was perceptibly tip-tilted, and a dishevelled shock of red-brown hair. But his mouth was expressive, and his eyes were intensely blue. Shelley's worst feature seems to have been his voice, which, as often he became excited, rose to a discordant bird-like scream. Otherwise his manner was grave and courteous; and Byron noted with relief that, despite the revolutionary views he professed and the strange bohemian life he led, he was unmistakably an English gentleman – 'as perfect a gentleman as ever crossed a drawing-room . . .' In questions of social rank, Byron was peculiarly sensitive – he could not forget his shabby-genteel childhood, or the momentous occasion when his schoolmaster had called him into his study, offered him some cake and wine, and told him that he was 'now a lord'; and the discovery that his fellow poet belonged to the same social class, or at least to a lowlier division of the same class, he found extremely reassuring.

Thus their introduction went off smoothly and pleasantly; and, when Byron composed his *Vision of Judgment*, and described how the Archangel Michael confronts his noble adversary, the Prince of Darkness, it may have been Shelley and himself he saw. The two spirits know they are separated by a gulf that they can never hope to span:

> Yet still between his Darkness and his Brightness
> There passed a mutual glance of great politeness.

Similarly, Byron appreciated Shelley's innocence and charm, though, according to Claire Clairmont, he would sometimes hint that his verses might be more accomplished; while Shelley, notwithstanding his friend's worldly views and the selfish and cynical life he led, admitted that the author of *Childe Harold* possessed a true poetic genius.

At their first meeting, Byron was twenty-eight, Shelley not yet twenty-four. But Byron felt that he was now an old man; and Shelley had experienced as many dramatic crises as might have occupied an average lifetime. He, too, believed that he was a victim of society; but, whereas

Byron admitted that his downfall had been very largely of his own making, Shelley, being the less cynical or, possibly, the more disingenuous, felt that the blows society dealt him were almost always unprovoked. On one side stood the devoted enthusiast, Shelley; on the other, the threatening cohorts of Prejudice, Tyranny and Superstition. He envisaged his opponents with terrifying vividness, but not in any great detail; nor did he pause to inquire why they should have turned their fury against a single inoffensive writer. Today the bulk of his enemies appear to have had very much the same origin. They were the direct descendants of his father, Timothy Shelley, Member of Parliament and prosperous landowner, who lived peaceably at Field Place, Sussex.

Born on 4 August 1792, Shelley had had all the advantages of a placid early childhood. So long as he remained at home he certainly enjoyed himself; and his sister Hellen recollected in her old age that he was then invariably good-tempered. Shelley's first letter, addressed to 'Dear Kate' just before his eleventh birthday, is concerned with preparations for a picnic:

We are to have a cold dinner over at the pond, and come home to eat a bit of cold chicken and peas at about nine o'clock. Mama depends upon your bringing Tom over tomorrow, and, if you don't, we shall be very much disappointed. Tell the bearer not to forget to bring me a fairing, – which is some ginger-bread, sweet-meat, hunting-nuts, and a pocket-book. Now I end.

> I am not
> Your obedient servant,
> P. B. Shelley.

Timothy Shelley was no domestic tyrant. An enterprising agriculturist and a kindly landlord, he is said to have been tall, with extremely sharp blue eyes, and to have walked his fields in 'yeoman-like garb', wearing stout tanned leather gaiters. As for his wife, she was a sensible, commonplace woman, and, Shelley himself agreed, 'mild and tolerant, yet narrow-minded'. It was at his private school, Syon House Academy, near Brentford, that the idea of Tyranny, and of the eternal struggle, 'the harsh and grating strife', between oppressors and oppressed, seems to have entered their son's imagination. He was a girlish child; and a schoolfellow remembered him 'fighting with open hands and rolling on the floor when flogged, not from the pain, but from a sense of the indignity'.

Though Shelley had been wretched at Syon House, which at length became 'a perfect Hell', it was there, says his cousin Tom Medwin, that a series of absorbing lectures on astronomy, chemistry and biology, 'opened to Shelley a new universe of speculations'. Thenceforward, writes another schoolfellow, his mind was 'alway roving upon something romantic and extraordinary, such as spirits, fairies, fighting, volcanoes etc., and he not unfrequently astonished his schoolfellows by blowing up the boundary palings of the playground with gunpowder, also the lid of his desk in the middle of schooltime . . . At times he was considered to be almost on the borders of insanity.'

When he reached Eton, the same existence continued. Again he was

Shelley as a boy; his sister, Hellen, remembered that he was extraordinarily sweet-tempered

oppressed; again he was lonely, and, nicknamed 'Mad Shelley' or 'Shelley the atheist', strode through the crowd in a wild-eyed waking dream. But, if his school life had taught him the meaning of tyranny, at home he fought his first real battles. His sisters, Elizabeth, Mary and Hellen,* had long been his devoted allies; they loved and admired their impulsive, adventurous brother; and, while they grew up, he did his best to enclose them within the magic circle of his own imaginings. Already he had begun to need proselytes; but proselytism became increasingly difficult under Mr Shelley's humdrum rule. Thus, Shelley's attitude towards his father, for whom, during his childhood, he had clearly felt a warm affection, was coloured, as he emerged from adolescence, by a deep instinctive jealousy.

* Elizabeth had been born in 1794; Mary, in 1797; Hellen in 1799. They were followed by another sister, Margaret, born in 1801.

Eton College; a
contemporary engraving

In Timothy Shelley he saw the type of parental tyrant – 'Old Killjoy', personification of all those noxious principles against which he had declared war.

Hellen and Elizabeth were their brother's favourites; and of Hellen he had had especially high hopes. She 'would be a divine little scion of infidelity,' he remarked, 'if I could get hold of her'. Hellen had been the chief cause, she afterwards asserted, of the breach between her father and her brother; for Mr Shelley 'one day made the discovery that Bysshe was endeavouring to inculcate me with his peculiar tenets and opinions, and he then and there ejected my brother from the house . . .' But Shelley had also tried his hand at proselytising his oldest sister; and, since the gospel of free love was among the 'peculiar tenets' that he harboured, when an Oxford friend announced that he had fallen in love with Elizabeth, Shelley helpfully suggested that they should form a free union. Elizabeth was outraged; she rejected his strange proposal; and Shelley was surprised and pained to hear her talk of ordinary marriage, an institution for which he had conceived 'ineffable, sickening disgust'.

Whatever its genesis, the pattern of rebellion had been fixed some time before he reached Oxford, where the Master and Fellows of University College soon took over the rôle of his oppressive father. As an undergraduate, he had made few friends; and his only close companion was the clever young son of a successful Yorkshire barrister, Thomas Jefferson

Hogg, with whom he took day-long walks through the prosaic country round Oxford, or discoursed far into the night on an immense variety of exciting and disturbing subjects. Shelley had gone up to Oxford in October 1810, and early in 1811 he published *St Irvyne*, his second venture into modern fiction, a Gothic romance of the most extravagant type, which, although it contains an elaborate self-portrait, even his fondest admirers agree to be entirely worthless.

His next literary undertaking, however, was of a much more original and dangerous kind. In February 1811, he issued a pamphlet entitled *The Necessity of Atheism.* Assisted by Hogg, he did all that he could to distribute it about the city; and a copy was soon snapped up by a Fellow of New College, who insisted that the bookseller in whose shop he had discovered it should immediately destroy his stock. Meanwhile, another copy of the anonymous pamphlet had been dispatched by Shelley, under an assumed name, to the Professor of Poetry at Oxford; and the Professor had carried it off to University College, and there demanded prompt action. On 25 March 1811, both Shelley and Hogg were sent down, for 'contumaciously refusing to answer questions', and repeatedly declining to disavow the pamphlet. Shelley was astonished. 'Expelled, expelled!' he cried when he returned to his rooms, 'his head shaking with emotion, his whole frame quivering.' Such was his surprise, indeed, that he hastened to write to his father, describing the 'late tyrannical violent proceedings' of which he had been made the victim.

Although Timothy Shelley was proud of his bookish son, and six months earlier had expressed a good-humoured willingness to encourage and assist him in his 'printing freaks', he now ordered that he should retire to Field Place, 'abstain from all communication with Mr Hogg', and 'place yourself under the care and society of such gentlemen as I shall appoint ...' Not ungenerously, however, he also suggested that the 'young Lunatic' might do well to go abroad, and possibly pay a visit to the Isles of Greece; for he believed that 'travelling would ... dispel the gloomy ideas which he has too long fix'd on objects tending to produce Temporary Insanity'. This plan the young rebel brushed aside – he said, Timothy Shelley complained, that 'he would not leave Hogg'. In the long, exhausting quarrel that ensured, neither father nor son appeared to the best advantage; Timothy Shelley was pompous and sanctimonious, the poet profusely argumentative and solemnly provocative. But, at length, Mr Shelley agreed to grant him his freedom,* adding a modest allowance of £200 a year.

Shelley's expulsion from Oxford is a subject that demands especial notice; for not only does it illustrate the conflict between father and son that became the prototype of so many later conflicts; but the fierce hatred of the Christian faith that had inspired him to produce his pamphlet shows the intensely personal bias – personal to the point of irrational frenzy – that often underlay his adult views. 'O! I burn with impatience

* Timothy Shelley, however, was not an entirely free agent. There was no escaping the fact that the family estates had been entailed upon his heir.

for the dissolution of Christianity', he had written to Hogg towards the end of 1810, 'it has injured me. I swear on the altar of perjured love to revenge myself on the hated cause of the effect . . . I think it to the benefit of society to destroy opinions which can annihilate the dearest of its ties. Oh! how I wish I were the Antichrist! that it were mine to crush the demon; to hurl him to his native hell . . .'

Edward Gibbon's attack upon the Christian ethos was derived from a studious, though perhaps a misguided, reading of all the historical evidence he could assemble; the explanation of Shelley's passionate outpouring lies in the circumstances of his own immediate past. That winter Elizabeth Shelley had definitely rejected Hogg, and Shelley himself had lost Harriet Grove, the pretty cousin whom he had once been persuaded that he adored, and who eventually accepted the hand of a neighbouring country gentleman. 'She is no longer mine!' he told Hogg. 'She abhors me as a sceptic, as what *she* was before! Oh Christianity! When I pardon this last, this severest of thy persecutions, may God (if there be a God) blast me!'

Simultaneously, he exalted the idea of Love – 'love, love, infinite in extent, eternal in duration . . .' But did he, Shelley demanded – again Hogg was his privileged confidant – 'love the person, the embodied entity? . . . No! I love what is superior, what is excellent, or what I conceive to be so; and I wish, ardently wish, to be profoundly convinced of the existence of a Deity, that so superior a spirit might derive some degree of happiness from my exertions: for love is heaven, and heaven is love.' In Shelley's later life, the desire to love, coupled with the difficulty of deciding just where he ought to place his love – he was quickly aroused, and as easily disappointed – would cause him endless misery and trouble. But one consolation never failed him. He believed that he was suffering in the cause of virtue; and behind every persecution he encountered he thought that he could recognise the same enemy.

Very often the enemy's lurking presence was visible to Shelley's eye alone. Two of his sisters, Mary and Hellen, were now at school on Clapham Common; and, when he visited them, he noticed among their friends an attractive girl named Harriet Westbrook, the daughter of a retired businessman, who had once kept a London coffee-house. During his days of disgrace, after his expulsion from Oxford, she proved a sympathetic listener; and he soon learned that the kindness she had shown him had exposed her to invidious comments; that her schoolfellows ignored her, would 'not even reply to her questions' and called her 'an *abandoned* wretch'. Shelley had immediately guessed that she would make a hopeful proselyte. But, as yet, she had not moved his heart; 'if I know anything about love, I am *not* in love', he assured Hogg, who had been alarmed by this hasty new attachment. Then, within the space of a week, the situation underwent a sudden change. At the beginning of August, he again reported to Hogg. Harriet's father, he wrote, had 'persecuted her in a most horrible way, by endeavouring to compel her to go to school. She asked my advice: resistance was the answer . . . And in consequence of my advice *she* has thrown herself upon *my* protection! I set off for London on

A portrait by
E.E.Williams, believed
to represent Shelley

Monday. How flattering a distinction! – I am thinking of ten million things at once.'

As he had promised, Shelley left Wales, where he had been staying with his cousin, Thomas Grove, and rushed to Harriet Westbrook's side. He found her sadly altered; and, after some hesitation, she confessed that she had become 'violently attached' to him. Shelley's mood was 'embarrassed and melancholy'; he was still by no means sure that he loved Harriet – it was Hogg's devoted friendship that he really valued; and marriage would involve the abandonment of his dearest principles.* Nevertheless, on 25 August 1811, the two desperate young people fled to Edinburgh and, almost as soon as they arrived, having given false ages and a false certificate of residence, were duly married under Scottish law.

Shelley was just nineteen, Harriet not yet seventeen. Both were innocent;

* Shelley's most authoritative biographer, Newman Ivey White, believes that a novel that Harriet had sent him, *Adelina Mowbray*, which describes how a high-minded young man, like Shelley a stalwart opponent of marriage, decides to marry the woman he loves to protect her against a hostile world, may have helped him change his mind.

both were enthusiastic; but, whereas Shelley's protean temperament included a dangerous self-destructive strain, his wife's was placid and straightforward, a blend of animal vitality and unassuming good nature. Everyone who observed Harriet Shelley agreed that she was a remarkably attractive girl, with fair hair, a pink-and-white skin and a supple, well-shaped body. Her appearance, Hogg tells us, was invariably neat and elegant – 'always pretty, always bright, always blooming; smart, usually plain in her neatness; without a spot, without a wrinkle, not a hair out of its place. The ladies said of her that she always looked as if she had just that moment stepped out of a glass-case; and so indeed she did.'

Yet, despite her obvious attractions and a passionate interest in new bonnets, Harriet was no seductive ignoramus. She had received an excellent education; and Hogg declared that he had rarely met a girl 'who had read so much as she had, or who had so strong an inclination for reading'. She loved to read aloud – but only serious books, 'of a calm, soothing, tranquillizing, sedative tendency' – in 'the most distinct utterance' that he had ever heard. There were times, as her voice flowed on and on, when, Hogg tells us, he had to struggle against a tendency to fall asleep, and 'the more drowsy Bysshe' would quietly drop off; at which Harriet, otherwise so good-humoured, began to grow a little peevish.

Harriet's chief drawback was that she had an elder sister whom she regarded with the deepest reverence. Unmarried, over thirty years old, a handsome, commanding, sharp-eyed personage, Eliza Westbrook was entirely devoted to her 'dearest Harriet's best interests', and would reflect on them endlessly while she sat alone in her bedroom, brushing her heavy mane of coarse black hair. Such, at least, was Hogg's account of the Westbrooks. But then, Hogg was a somewhat biased witness; for it was he, rather than the aggressive Eliza, who had first introduced a harshly discordant note into the existence of the Shelley household.

From Edinburgh the Shelleys had moved to York, where Hogg was now established in the rôle of law student; and, having decided that he must briefly revisit Sussex – at Field Place, when he heard that Elizabeth Shelley might very soon be married off, he created a violent domestic scene and, according to Mr Shelley, terrorised his mother and his sisters – he had entrusted Harriet to Hogg's friendly care. On his return, he discovered that, during his absence, the false friend had attempted to seduce his wife. Shelley was intensely hurt; though the feelings that Hogg's behaviour aroused were of a characteristically unexpected sort. He did not believe, as he reminded Hogg, that marriage entitled one to the exclusive possession of another human being. But, in these matters, he pointed out, poor Harriet's views were sadly prejudiced; and Hogg should have respected her prejudice, and certainly never allowed himself to become the dupe of an insensate physical passion.* .

The vehement interchange of letters that immediately followed throws

* In his *Life*, Hogg naturally omitted any reference to this discreditable episode, but published extracts from Shelley's dramatic letter of remonstrance, describing them as fragments of an unsuccessful novel.

a curious and disconcerting light upon the relations of the two young men. Shelley would appear to have been fiercely indignant, not so much because Hogg had attempted Harriet's virtue, as because, by giving way to his unworthy desire, he had brutally betrayed their former friendship. He felt 'half-mad', he wrote. Was their friendship totally ruined? Was 'all past, like a dream of a sick man which leaves but bitterness?' Yet he still loved Hogg, whom he had once regarded as the 'best, the noblest of men', and whom, even now, he could hardly bear to thrust behind him: 'Oh how I have loved you. I was even ashamed to tell you! and now to leave you *for ever* . . . no not for ever. Night comes . . . Death comes . . . Assuredly dearest dearest friend reason with me . . . I am a child in weakness.'

It seems clear that Hogg's nature, and perhaps Shelley's, included a definitely homosexual strain; for Hogg, that cool, caustic, self-satisfied young man, had fallen so deeply under Shelley's spell that he always desired, and felt obliged to pursue, the women whom his friend loved. Later, with Shelley's blessing, he formed a passionate attachment to Mary Godwin – Mary, taking her cue from her lover, apparently did not reject his pleas; and, after Shelley's death, he became the common-law husband of Shelley's last love, Jane Williams.

In Shelley's vocabulary, the word 'love' had a multitude of different meanings. He had loved his sisters; he had loved and worshipped Hogg; and Harriet herself, who bore him two children, on a lowlier and less romantic plane must have had a considerable share of his affection. It did not occur to him that he often bestowed his love with little regard for the beloved's welfare; that loving, as he practised the art, might become an insidious form of self-indulgence; or that, if he ceased to love, the idol he dethroned and discarded still deserved some human sympathy. Like all charmers, male or female, he was apt to be dazzled by his own gifts; and, while he was exerting his charm, he frequently lost sight of the beloved object's real existence. Then he awoke from his vision, disturbed and angry. '*The Epipsychidion* I cannot look at', he would write in 1822; 'the person whom it celebrates was a cloud instead of a Juno'; and 'poor Ixion' now recoiled from 'the centaur' – the literary result of his attachment to Emilia Viviani – that had been begotten by his wild embrace.

Of all the clouds with which Shelley grappled, few were quite so pathetic as Elizabeth Hitchiner, the plain, gaunt, high-minded schoolmistress, who had begun to correspond with him early in the summer of 1811, and whom he soon recognised as 'one of those beings who carry happiness, reform, liberty, wherever they go'. Again his faculty of loving was called into play; and Shelley's professions of friendship grew increasingly extravagant. 'I love you', he informed her, 'more than any relation. I profess you are the sister of my soul, its dearest sister, and I think the component parts of that soul must undergo complete dissolution before its sympathies can perish . . .' By the close of 1812, however, he was deeply disillusioned; he confessed that he had been 'entirely deceived' as to Miss Hitchiner's republicanism, and nicknamed her 'the Brown

Demon ... an artful, superficial, ugly, hermaphroditical beast of a woman
...' Later, he wrote that she was 'a woman of desperate views and dreadful
passions but of cool and undeviating revenge'. Then his resentment sub-
sided, and he found her merely ridiculous, and would quote from an
unfortunate poem she had composed, emitting eldritch shrieks of laughter.

No less variable was Shelley's attitude towards the hapless girl he
married. Harriet had loyally accompanied him on all his altruistic
expeditions – to the Lake District where he interviewed Robert Southey,
who recognised the young revolutionist as 'just what I was in 1794', but
who, Shelley felt, had now been 'corrupted by the world, contaminated
by Custom'; to Dublin, where he preached the cause of Liberty, and,
with the assistance of his wife and sister-in-law, scattered leaflets from his
window; to Devon, where they left some bills unpaid; and to Wales,
where he endeavoured to finance the building of an embankment, but
was arrested for a debt of £70. It was in Wales that Shelley seems first to
have experienced one of those traumatic nervous crises, during which he
believed that an unknown assailant had made a savage attack upon his
person. No one else had seen the mysterious enemy; but a pistol-shot,
which he may himself have discharged, had pierced the poet's flannel
nightgown; and these midnight alarums and excursions drove the
Shelleys from their comfortable house at Tanyrallt.

Meanwhile, the poet was making new friends. He had long reverenced
the author of *Political Justice*, now a hard-working publisher of children's
books; and, on 4 October 1812, accompanied by Harriet and Eliza, he
had dined with William Godwin and his family. Mary Godwin, a girl of
fifteen, happened to be away in Scotland; and not until 1814, after 'the
Tanyrallt assault' and the publication of his poem, *Queen Mab*, did Shelley
begin to notice the slim, eager schoolgirl, who bore her famous mother's
Christian name. Harriet afterwards declared that it was Mary's link with
Mary Wollstonecraft that had first captured his imagination. She may
well have been right. Shelley's physical desires were not inactive; but
almost always they appear to have been aroused by some kind of intel-
lectual stimulus. In Mary Godwin he adored her mother's image; and on
26 June 1814, there came, at last, a 'sublime and rapturous moment',
when Mary, from whom (Shelley assured Hogg) he had being doing his
best to conceal 'the true nature of my affection', took the initiative and
boldly 'confessed herself mine, who had so long been hers in secret ...'

The scene of this declaration was a London churchyard, beside the
tomb of Mary Wollstonecraft. On 6 July, Shelley had a painful interview
with William Godwin and, wrote the indignant philosopher, 'had the
madness to disclose his plans to me, and to ask my consent. I expostulated
... with so much effect that ... he promised to give up his licentious
love ...' Godwin also appealed to his daughter; and she, in her turn,
promised she would give up Shelley. Godwin now assumed that he had
gained his point; but, alas, 'they both deceived me'. On 28 July, the lovers
eloped to France, taking Mary's step-sister, Mary Jane Clairmont, as
their interpreter and sole companion.

Shelley's drawing of his
Tanyrallt Assailant,
copied by Miss Fanny
Holland

Towards the end of June, both Harriet and her infant child had been living in the country; but, five or six days after he had spoken to Godwin, Shelley begged she would return, and then poured out the tale, 'accompanied', she said, 'with the most violent gestures and vehement expostulations', of his impassioned love for Mary, adding that, unless she were prepared to release them, they might both commit suicide. Shelley's gift of self-deception was a conspicuous trait at every stage of his career; but seldom had it assumed a more fantastic shape than in his treatment of the unlucky Harriet. Why, he now demanded, 'could we not all live together, I as his sister', Mary Godwin, as his wife? Harriet, though she found it difficult to overcome her 'prejudices', seems to have been affectionate and understanding; and, that same day, Shelley dashed off a particularly ill-considered letter. His attachment to her, he wrote, was unimpaired:

Our connection was not one of passion and impulse. Friendship was its basis, and on this basis it has enlarged and strengthened. It is no reproach to me that you have never filled my heart with an all-sufficing passion; perhaps you are even yourself a stranger to those impulses, which one day may be awakened by some nobler and worthier than me . . . Can your feelings for me differ in their nature from those which I cherish towards you? Are you my lover whilst I am

only your friend, the brother of your heart? If they do not, the purest and most perfect happiness is ours. I wish you could see Mary; to the most indifferent eyes she would be interesting only for her sufferings, and the tyranny which is exercised upon her.

Harriet, at the time, was three months pregnant – her second child, Charles, would make a premature appearance on 30 November 1814; and Shelley's attempt to organise a *ménage-à-trois*, in which Harriet was

Mary Shelley during her widowhood, by Eastlake. 'Poor Mary! hers is a sad fate...'

relegated to the part of sister, while Mary took her place as his wife, shows his remarkable disregard of human feelings. Naturally, Harriet soon grew less magnanimous; and that autumn, when Shelley returned to England after his romantic flight through France and Germany, and he learned that, lonely and distraught, she had seen fit to consult his family

solicitor, he accused her of the 'basest and blackest treachery'. He had been an idiot, he declared, 'to expect greatness or generosity from you, that when an occasion of the sublimest virtue occurred, you would fail to play a part of mean and despicable selfishness . . . You are plainly lost to me for ever. I forsee no probability of change.'

Because Harriet's behaviour had disappointed him, it followed she must be deeply wicked; and, even before his elopement, Shelley had persuaded himself and, during their early conferences, managed to persuade Mary, that Harriet had betrayed him with a certain Major Ryan, and that the unborn child could not be his. No evidence has been produced to support this charge. Similarly, in January 1817, when Shelley learned that Harriet had taken her own life, and that her corpse, the body of 'a respectable female far advanced in pregnancy', had been recovered from the Serpentine, he produced an elaborate description of her last days, which, according to his modern biographers, he must have largely manufactured.

'It seems', he told Mary, 'that this poor woman . . . was driven from her father's house, and descended the steps of prostitution until she lived with a groom of the name of Smith, who deserting her, she killed herself . . . Everything tends to prove . . . that beyond the mere shock of so hideous a catastrophe having fallen on a human being once so nearly connected with me, there would, in any case have been little to regret.' Everyone 'does *me* full justice'. The true culprit was 'that beastly viper her sister', who, 'unable to gain profit from her connexion with me', had 'secured to herself the fortune of the old man . . . by the murder of this poor creature'. Yet, only a few days later, Shelley wrote to the detestable Eliza Westbrook, assuring her that he gave no credence to 'any of the imputations generally cast on your conduct . . . I cannot help thinking that you might have acted more judiciously, but I do not doubt you intended well'.

The most realistic picture of Shelley's relations with Harriet, and the most reasonable account of why, at length, they broke down, is preserved in a conversation reported by Peacock, said to have taken place during the summer of his passion for Mary. All who knew him, Shelley announced, 'must know that the partner of my life should be one who can feel poetry and understand philosophy. Harriet is noble animal, but she can do neither.' It had always appeared to him, Peacock replied, that his friend had been very fond of Harriet. 'Without affirming or denying this, he answered: "But you did not know how I hated her sister." ' That Harriet's limitations – or the limitations of any other woman he had once loved – entitled her to some tenderness was obviously not a thought that had ever crossed the poet's mind. The failure of inferior beings to live up to his own standards merely filled him with intense repugnance. Shelley's angelic egotism made just as many victims as Byron's demonic sensuality.

When the two exiles met beside the Lake of Geneva, each was carrying a heavy burden – a load, which often threatened to overwhelm him, of fears and grievances and dark suspicions, aggravated, where Byron was concerned, by a strain of passionate remorse. 'One is simply compelled to perceive', writes his American biographer, 'that, at least between the ages

of twenty and twenty-three, Shelley was on the verge of insanity as it is ordinarily recognised.' Not only did he suffer 'delusions of persecution' and terrifying hallucinations; but his 'wild impulsiveness and the extreme sensibility by which he could assimilate to himself the experience of others had a definitely recognisable pathological tinge . . .'[16]

Some of his fantasies recall the effects of opium; and we know that, during his visit to the Lake District, on the eve of a strange adventure that preceded and foreshadowed the dramatic 'Tanyrallt assault', he had undergone a succession of nervous attacks which obliged him to seek relief in laudanum, and that he often carried around with him, and sometimes produced, a large bottle of the insidious fluid. Throughout his life, he was haunted by dreams, both the dreams of sleep and waking visions; and at Lerici, where he saw the ghost of Byron's love-child, Allegra, rising naked from the moonlit waves, he was also one day to meet his *doppelgänger* as he walked upon the terrace, and hear his mirror-image pronounce the enigmatic words: 'How long do you mean to be content?' Insanity, observed Tom Medwin, 'hung as by a hair suspended' over Shelley's head; and, in 1811, he had told Hogg that he did not find it difficult to excuse madness, 'because I myself am often mad'.

Byron, too, in 1816, now and then felt that he was drawing very close to the borders of insanity. During his visit to Switzerland, he afterwards declared, what with 'metaphysics, mountains, lakes, love inextinguishable, thoughts unutterable, and the nightmare of my own delinquencies', he had at times been 'half-mad', and would 'many a good day, have blown my brains out, but for the recollection that it would have given pleasure to my mother-in-law . . .' Shelley, however, seems to have exerted a calming and restraining influence; and even the importunate devotion of Claire Clairmont, who once again became an unloved mistress, may temporarily have helped to raise his spirits. Together Byron and Shelley had purchased a boat; and they spent many evenings on the water – the delightful evenings of which Byron wrote in an apostrophe to the lake itself, when he launched his new *Childe Harold*:

> It is the hush of night, and all between
> Thy margin and the mountains, dusk, yet clear,
> Mellowed and mingling, yet distinctly seen,
> Save darkened Jura, whose capt heights appear
> Precipitously steep; and drawing near,
> There breathes a living fragrance from the shore,
> Of flowers yet fresh with childhood; on the ear
> Drops the light drip of the suspended oar,
> Or chirps the grasshopper one good-night carol more.
>
> He is an evening reveller, who makes
> His life an infancy, and sings his fill;
> At intervals, some bird from out the brakes
> Starts into voice a moment, then is still.
> There seems a floating whisper on the hill,
> But that is fancy . . .

Yet 'clear, placid Leman' was often vexed by storms; and in such explosions of natural wrath and ferocity Byron took a deep, instinctive pleasure:

> From peak to peak, the rattling crags among
> Leaps the live thunder! Not from one lone cloud,
> But every mountain now hath found a tongue,
> And Jura answers, through her misty shroud . . .
>
> And this is in the Night: – Most glorious Night!
> Thou wert not sent for slumber! let me be
> A sharer in thy fierce and far delight, –
> A portion of the tempest and of thee!
> How the lit lake shines a phosphoric sea,
> And the big rain comes dancing to the earth! . . .

It was during one of these sudden Alpine storms, after sailing to Meillerie, where they had revisited the romantic background of *La Nouvelle Héloïse*, that both poets nearly lost their lives. Their vessel was almost swamped. Shelley could not swim; but, though, on Byron's advice, he stripped his coat off, he then sat down, grasped a pair of iron rings and announced 'with the greatest coolness (his friend remembered), that "he had no notion of being saved, and that I would have enough to do to save myself, and begged not to trouble me" '. Shelley's obstinate courage – perhaps the tenacity of his death-wish – seems to have impressed Byron. There was, indeed, something extraordinarily lovable about the younger poet at his best; and his charm and candour and bold enthusiasm were much in evidence upon their Alpine holiday. As for Shelley, he responded to Byron's genius, by which he felt himself so completely overshadowed that he began to lose faith in his own poetic gifts.

An observant spectator of their growing friendship was Byron's physician, Polidori; and to him Shelley – 'bashful, shy, consumptive', Dr Polidori noted – gave yet another highly inaccurate account of his quarrel with his father and his separation from his wife. His father, Shelley declared, had attempted to confine him in a madhouse.* Being convinced that he had not long to live, he had 'married a girl for the mere sake of letting her have the jointure that would accrue to her', but, when he had discovered that his fears were groundless, had 'found he could not agree', and that his marriage had then become intolerable.

On 18 June, Shelley's imaginative propensities were revealed in a somewhat different light. The whole party was greatly addicted to ghost-stories and Gothic novels; Shelley was deeply interested in *The Monk*; and that evening (as I have related elsewhere) some lines that Byron read aloud from *Christabel* had a catastrophic effect upon his fellow poet's nerves. Later, once he had been caught and pacified, he supplied an appropriate explanation. He had been looking at Mary, he said, when he recollected a story he had heard of a woman who 'had eyes instead of

* Shelley had also informed Peacock 'of a plot laid by my father and uncle, to entrap me and lock me up'. Peacock dismissed this story as one of his friend's 'semi-delusions'.

nipples, which taking hold of his mind horrified him', caused him to utter an unearthly shriek and sent him hurtling through the door.

Matthew Lewis himself, it so happened, had been invited to join Byron as his guest at the Villa Diodati. There Shelley soon encountered him; and, although after dinner the author of *The Monk* told some admirable ghost-stories, Shelley was dismayed to learn that, except as a subject for exciting narrative, Lewis gave little credit to the supernatural, and assumed – a particularly annoying assumption – that a man who, like Shelley, believed in ghosts must necessarily believe in God. But he was glad to hear that Lewis was genuinely concerned about the welfare of his negro slaves; and at Diodati, together with Byron and Polidori, he witnessed a codicil to his last will and testament that Lewis had just then drawn up, in which he enjoined his heirs to continue the system of reform that he had introduced upon his vast plantations. We do not know what Lewis made of Shelley; but John Cam Hobhouse, who followed Lewis, found Byron's new friend an odd, exasperating character – a 'lean and feeble' young man, with an offensively shrill and squeaky voice.

By that time, Shelley and his companions had decided to return to England, and Claire had informed Mary and Shelley that she expected to

(*Right*) *Hilly Scene*, by Samuel Palmer. (*Overleaf*) *Childe Harold's Pilgrimage in Italy*, by Turner

bear her lover's child. Byron's attitude was coolly philosophical. Unlike Shelley, he was seldom deceived about the importance of his own passions; and he felt that he need not blame himself, since 'I never loved nor pretended to love her', and had merely done what any other man would have done in the same inflammatory circumstances. When Mrs Leigh, who had heard garbled reports of his behaviour at the Villa Diodati, wrote him a reproachful letter, he was gently reassuring:

. . . As to all these 'mistresses', Lord help me – I have had but one. Now don't scold; but what could I do? – a foolish girl . . . would come after me, or rather, went before – for I found her here – and I have had all the plague possible to persuade her to go back again . . . Now, dearest, I do most truly tell thee, that I could not help this . . . I was not in love, nor have any love left for any; but I could not exactly play the Stoic with a woman, who had scrambled eight hundred miles to unphilosophize me.

A little later, he added a footnote: 'I forgot to tell you that the demoiselle who returned to England from Geneva went there to produce a new baby B . . .'

On 29 August, Shelley departed for England, carrying the manuscript of *Childe Harold, Canto III*; on 17 September, Byron and Hobhouse set out to explore the Bernese Alps. Byron kept a journal of his tour, which he sent home to his sister, a piece of romantic travel-writing that deserves to stand beside Gray's description of his journey with Horace Walpole through the terrors of the Mont Cenis. Again he enjoyed a resounding Alpine storm, 'thunder, lightning, hail; all in perfection, and beautiful'; and, at their first halt, he admired a splendid torrent, 'in shape curving over the rock, like the *tail* of a white horse streaming in the wind, such as it might be conceived would be that of the "*pale* horse" on which Death is mounted in the Apocalypse. It is neither mist nor water, but a something between both; its immense height . . . gives it a wave, a curve, a spreading here, a condensation there, wonderful and indescribable.'

Next day, they ascended the Wengen Mountain, whence they surveyed 'the *Yung frau*, with all her glaciers; the *Dent d'Argent*, shining like truth', the Kleiner Eigher, the Grosser Eigher and the majestic Wetterhorn. 'From where we stood . . . we had all these in view on one side; on the other, the clouds rose from the opposite valley, curling up perpendicular precipices like the foam of the Ocean of Hell, during a Springtide – it was white, and sulphury, and immeasurably deep . . .'* Elsewhere they passed a glacier that recalled 'a frozen hurricane', and 'whole woods of withered pines, all withered; trunks stripped and barkless, branches lifeless . . . their appearance reminded me of me and my family'.

For the most part, Byron was content to ride, his mount being a young mare, 'as quiet as any thing of her sex can be . . . a very tame pretty childish quadruped'. But, now and then, he climbed on foot – which

* The mists boil up around the glaciers; clouds
 Rise curling fast beneath me, white and sulphury,
 Like foam from the roused ocean of deep Hell . . .
 Manfred, Act 1, Scene II.

shows that his deformity was far less crippling than some of his biographers have assumed – and limped gallantly ahead up the more difficult slopes, till beads of sweat rained from his forehead. But even here he was haunted and obsessed by his memories of the last few years; and it was to them he returned as he finished his journal and consigned it to Augusta:

> . . . In all this – the recollections of bitterness . . . which must accompany me through life, have preyed upon me here; and neither the music of the Shepherd, the crashing of the Avalanche, nor the torrent, the mountain, the Glacier, the Forest, nor the Cloud, have for one moment lightened the weight upon my heart nor enabled me to lose my own wretched identity in the majesty, and the power, and the Glory, around, above, and beneath me.

He was 'past reproaches', he wrote, and 'past the wish of vengeance'. But an hour would come – and there he broke off: '*To* you, dearest Augusta, I send, and *for* you I have kept this record . . . Love me as you are beloved by me.'

An Avalanche in the Alps, by P.de Loutherbourg, 1803

To Byron's Alpine adventures we owe his symbolical drama, *Manfred,* an extravagant piece of Gothic fantasy, which he had begun to compose before he left Switzerland.* His immediate inspiration was Goethe's *Faust,* which Lewis had read to him at the Villa Diodati, translating as he went along. But Manfred, the haunted, heart-broken wizard, poised on the dizzy brink of suicide, is yet another self-portrait; while Astarte,

* 'I wrote a sort of mad Drama, for the sake of introducing the Alpine scenery in description . . . Almost all the *dram. pers.* are Spirits, ghosts, or magicians . . . so you may suppose that a Bedlam tragedy it must be . . .' Byron to Moore, 25 March 1817.

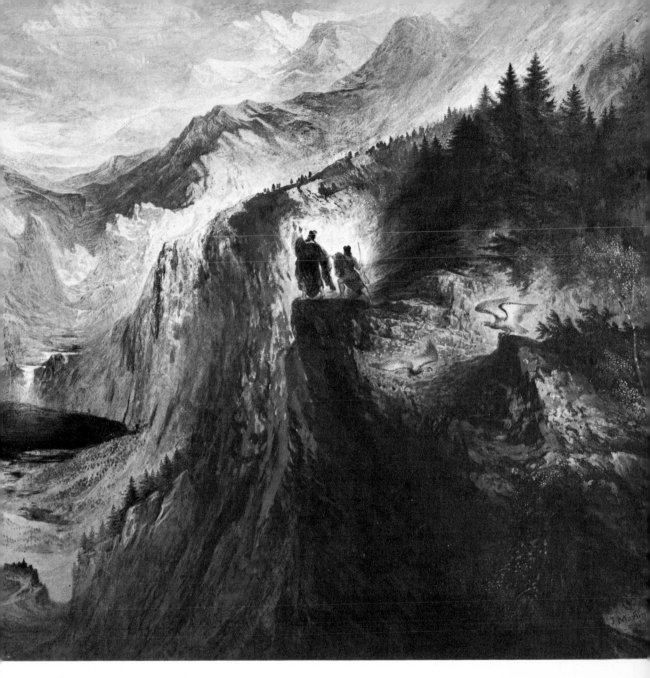

*Manfred on the Jungfrau,
by John Martin; 'I
wrote a sort of mad
drama, for the sake of
introducing the Alpine
scenery in description...'*

whose phantom he conjures up from the void, can only represent Augusta
Leigh:

> She was like me in lineaments – her eyes –
> Her hair – her features – all to the very tone
> Even of her voice, they said were like to mine;
> But softened all, and tempered into beauty:
> She had the same lone thoughts and wanderings ...
> Pity, and smiles, and tears – which I had not;
> And tenderness – but that I had for her;
> Humility – and that I never had.

> Her faults were mine – her virtues were her own –
> I loved her, and destroy'd her!

The Third Canto of *Childe Harold* was published, amid almost universal acclaim, on 18 November 1816; and Lady Byron herself, a stern critic of modern literature, could not refrain from measured praise. Her husband, she remarked, was 'the absolute monarch of words, and uses them, as Bonaparte did lives, without more regard to their intrinsic value . . .' Its successor, with its grandiose historical set-pieces, appeared in April 1818. But Byron himself preferred the Third, 'the *best*', he said, 'which I have ever written'; and it remains the fullest and noblest expression of a certain aspect of his genius:

> 'Tis to create, and in creating live
> A being more intense, that we endow
> With form our fancy, gaining as we give
> The life we image, even as I do now . . .
>
> Yet must I think less wildly: – I *have* thought
> Too long and darkly, till my brain became,
> In its own eddy boiling and o'erwrought,
> A whirling gulf of phantasy and flame:
> And thus, untaught in youth my heart to tame,
> My springs of life were poisoned. 'Tis too late!
> Yet am I changed; though still enough the same
> In strength to bear what Time cannot abate,
> And feed on bitter fruits without accusing Fate.

It is in the Fourth Canto, however, that with a last outpouring of rebellious pride – the pride of Milton's Fallen Angel – Byron finally completes his character. Childe Harold has ceased to be the literary reflection of his author's adolescent malaise, and steps forward as the imaginative product of a far deeper strain of adult feeling:

> But I have lived, and have not lived in vain:
> My mind may lose its force, my blood its fire,
> And my frame perish even in conquering pain;
> But there is that within me which shall tire
> Torture and Time, and breathe when I expire . . .

His invention of a new hero, the scapegrace Don Juan, marks the concluding stage in the history of Byron's genius. The later Childe Harold had sprung into life amid Alpine peaks and streams and meadows. Don Juan was begotten and born beneath the sultry skies of Venice, where from November 1816 to May 1819 Byron enjoyed a long, luxurious *villegiatura*. He was now resigned, he said, to 'making life an amusement'; and he proceeded to amuse himself with his usual passionate energy. He knew not how it was, he informed Tom Moore; but, 'my health growing better, and my spirits not worse, the "*besoin d'aimer*" came back upon my heart . . . after all, there is nothing like it'. His first Venetian favourite, Marianna Segati, a 'very pretty', but possessive and highly excitable woman, was the wife of his good-natured landlord, a draper in the

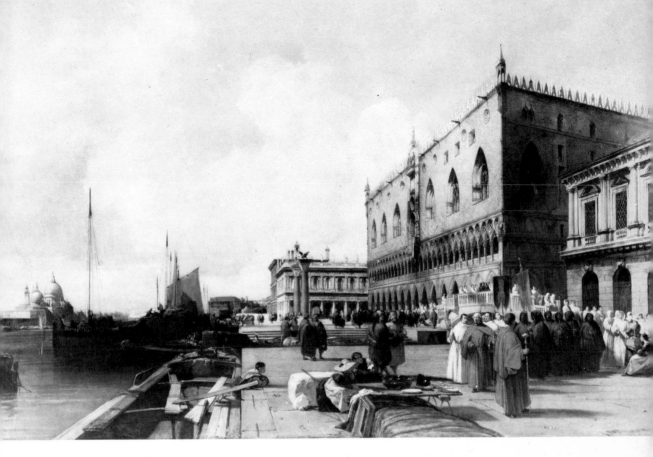

Venice, the Ducal Palace with a Religious Procession, by Bonnington, 1828

Frezzeria; and she was soon succeeded by Margarita Cogni, a far more difficult and dangerous mistress, who added 'the strength of an Amazon' and the disposition of modern Medea to her other splendid attributes.

His new life apparently suited him well. Shelley had left England, with Mary and Claire and their children, during the early spring of 1818; and, when he visited Byron towards the end of August, he found him carefree and delightful 'the liveliest and happiest looking man I ever met'. The object of Shelley's visit was to enable Claire Clairmont to see her daughter, Clara Allegra, who was now nineteen months old, and living under her father's benevolent, but always rather desultory charge. Byron raised no difficulties – he would do everything he could for Allegra, provided that he need not meet Claire. Meanwhile Shelley was charmed and stimulated by his exhilarating conversation; and not until he returned to Venice in October did he glimpse the darker side of Byron's existence at the Palazzo Mocenigo.

The women among whom Lord Byron spent his time, he then reported to Peacock, were creatures of the lowest sort, 'the people his gondolieri pick up in the streets. He allows fathers and mothers to bargain with him for their daughters.' He had also resumed his old Levantine habits. Among his dissolute associates, Shelley observed, were 'wretches who

149

seem almost to have lost the gait and physiognomy of man, and who do not scruple to avow practices, which are not only not named, but I believe even conceived in England'. Byron made no attempt to defend his moral conduct; 'he says he disapproves, but he endures. He is heartily and deeply discontented with himself; and contemplating in the distorted mirror of his own thoughts the nature and the habits of man, what can he behold but objects of contempt and despair?'

This was the spirit that Shelley also detected in the final canto of *Childe Harold*, which, 'if insane', he said, was 'the most wicked and mischievous insanity that ever was given forth'. But about Byron's extraordinary mixture of virtues and vices Shelley could seldom quite make up his mind; and in his preface to *Julian and Maddalo*, one of the most successful poems he had yet composed, he described Count Maddalo, the character that stands for Byron, as a person of 'consummate genius . . . capable, if he would direct his energies to such an end, of becoming the redeemer of his degraded country . . .' Yet, although 'in social life no human being can be more gentle, patient, and unassuming than Maddalo', and 'his serious conversation is a kind of intoxication', which holds his listeners as by a spell, 'his weakness is to be proud . . . His passions and his powers are incomparably greater than those of other men; and instead of the latter having been employed in curbing them, they have mutually lent each other strength . . . I say Maddalo is proud, because I can find no other word to express the concentered and impatient feelings which consume him; but it is on his own hopes and affections only that he seems to trample . . .'

During the next four years, Shelley's attitude towards Byron passed through many different phases, oscillating between intense attraction, puzzled exasperation and, occasionally, acute repulsion. He was glad to see Byron escape from Venice, and achieve a state of comparative calm at Ravenna as the accredited consort of the well-meaning Countess Guiccioli; but Byron's treatment of his discarded mistress, Claire, whom he had now come to detest and despise, he considered coldly selfish; and there were other incidents – for instance Byron's ready reception of the story spread by a couple of dismissed servants about Shelley's alleged relationship with Claire, who, they alleged, had borne him a secret child*
– that exhibited Don Juan in a somewhat unattractive light.

Meanwhile Byron was apt to grow impatient. Although he esteemed Shelley and had a friendly feeling for Mary, he found it hard to tolerate the unending complications of the distracted Shelley household; and he deeply resented their covert suggestions that he was not a good and loving father. They themselves had already lost two children; and he believed that a diet of tea and green fruit was as ill-suited to childish stomachs as were large draughts of undiluted atheism to the nourishment of youthful minds. Thus, when he heard the damaging stories that had gone abroad,

* It is true that, at Naples, on 27 February 1819, Shelley registered the birth of a mysterious female child, Elena Adelaide Shelley, who then vanishes completely from the record; and that the problem of her parentage has never been cleared up.

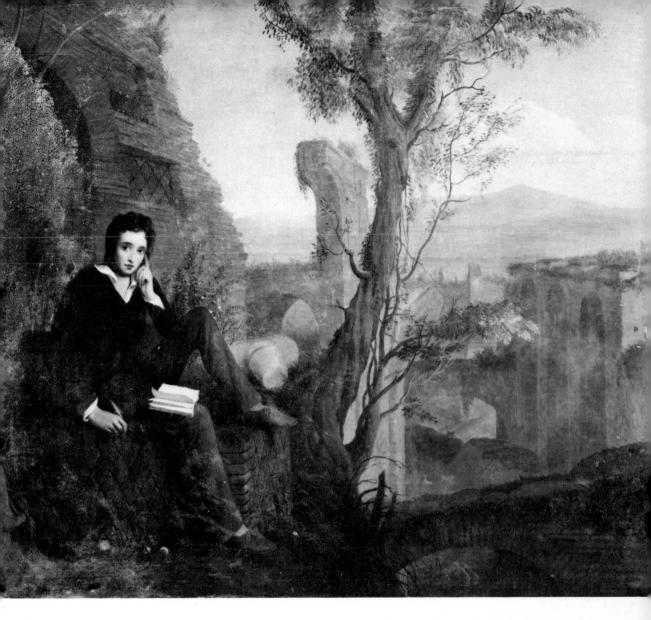

Shelley in the Baths of Caracalla, by Joseph Severn. 'A phantom among men, companionless . . .'

he quietly accepted them and shrugged his shoulders. 'Shiloh' – his latest nickname for Shelley, whom, in reference to his sinuous method of walking, he had also dubbed 'the Serpent' – was without question a man of 'talent and honour', albeit wildly prejudiced against the ordinary principles of religion and morality; 'of the facts, however, there can be little doubt; it is just like them'. And, on a tiresome letter he had lately received from Claire, he scrawled that 'the moral part' did not come very well 'from the writer now living with a *man* and his *wife* – and having planted a child in the Fl— Foundling, etc.'

At the time, he said nothing to Shelley himself; and nearly a year passed before he ventured to broach this annoying and distasteful subject. He finally did so when Shelley visited Ravenna in August 1821, explaining, of course, that he had never believed the story, and promising that he would

151

do all that he could do to scotch so vile a piece of gossip . . . Otherwise Shelley's reunion with Byron proved particularly inspiring and enjoyable. Again he succumbed to the charm of his friend's society, and every evening accompanied him on his usual leisurely ride through the pine-forest that divided the city from the sea. He was much amused by Byron's present entourage. Besides his customary retinue of servants, it included 'ten horses, eight enormous dogs, three monkeys, five cats, an eagle, a crow, and a falcon', as well as the Egyptian crane, the peacocks and the guinea fowl, which wandered up and down the grand staircase.

Byron, he remarked, had greatly improved, both in his moral attitude and in his general health and spirits, since he had left Venice, given up the bohemian pleasures of that demoralising 'Sea-Sodom', and become the more or less contented inhabitant of the staid Palazzo Guiccioli. 'He lives with one woman . . . and is in every respect an altered man. He has written three more cantos of "Don Juan". I have yet only heard the fifth, and I think that every word of it is pregnant with immortality.' The Fifth Canto of Byron's narrative poem (which describes how Juan is sold into slavery, and chronicles his bizarre adventures in a Turkish seraglio) realised, he felt, 'in a certain degree, what I have long preached of producing – something wholly new and relative to the age, and yet surpassingly beautiful'. Such were the merits of the poem that Shelley despaired. He thought that he might probably abandon verse: 'It offends me to see my name classed among those who have no name . . . The cup is justly given to one only of an age; indeed, participation would make it worthless: and unfortunate they who seek it and find it not.'

Had Shelley criticised the work in detail, it would have been interesting to see which of the Fifth Canto's 159 stanzas he singled out for special praise. Perhaps his eye would have alighted on Byron's picture of the slave-market:

Silhouette of Byron, 'as he appeared after his daily ride at Pisa', cut by Mrs Leigh Hunt, 1822

> Like a backgammon board the place was dotted
> With whites and blacks, in groups on show for sale,
> Though rather more irregularly spotted:
> Some bought the jet, while others chose the pale.
> It chanced amongst the other people lotted,
> A man of thirty, rather stout and hale,
> With resolution in his dark grey eye,
> Next Juan stood, till some might choose to buy.
>
> He had an English look; that is, was square
> In make, of a complexion white and ruddy,
> Good teeth, with curling rather dark brown hair,
> And, it might be from thought, or toil, or study,
> An open brow a little marked with care:
> One arm had on a bandage rather bloody;
> And there he stood with such *sang froid*, that greater
> Could scarce be shown, even by a mere spectator . . .
>
> 'You take things coolly, Sir', said Juan. 'Why',
> Replied the other, 'what can a man do?

Don Juan and Haidée;
illustration by A.Colin

There still are many rainbows in your sky,
But mine have vanished. All, when Life is new,
Commence with feelings warm, and prospects high;
But Time strips our illusions of their hue,
And one by one in turn, some grand mistake
Casts off its bright skin yearly like the snake.'

The charm of *Don Juan* lies in its masterful blend of diverse yet complementary qualities. A poem that had set out, its author informed Tom Moore, 'to be a little quietly facetious upon everything', it has the vernacular ease that Byron had borrowed from Pope, combined with the elusive lyricism of his own poetic period. In no other poem is the writer so much himself. Here is Byron's latter-day feeling that life must be made an amusement, tempered by his inborn melancholy and his natural sense of doom. Thus in the Third Canto, where he depicts the idyllic love-affair between Juan and the enchanting Greek girl, Haidée, he reiterates his hardly gained belief that any conquest of pleasure – even innocent pleasure – has at some time to be paid for; and that the price is almost always dreadful:

They were alone, but not alone as they
Who shut in chambers think it loneliness;

The silent Ocean, and the starlight bay,
The twilight glow, which momently grew less,
The voiceless sands, and dropping caves, that lay
Around them, made them to each other press,
As if there were no life beneath the sky
Save theirs, and that their life could never die . . .

Alas! they were so young, so beautiful,
So lonely, loving, helpless, and the hour
Was that in which the Heart is always full,
And, having o'er itself no further power,
Prompts deeds Eternity cannot annul,
But pays off moments in an endless shower
Of hell-fire – all prepared for people giving
Pleasure or pain to one another living.

When Shelley bade goodbye to Byron at Ravenna in August 1821, he
had less than another year of life before him; and the last period of his
existence, though it included moments of wild delight, was crossed by many
threatening shadows. Whereas Byron had now settled down, calmly and
comfortably enough, into a quasi-domestic relationship with Teresa
Guiccioli, the slow estrangement between Shelley and Mary was growing
more and more perceptible. Mary fretted against the comparative isolation
in which she was obliged to live as Shelley's wife. 'Poor Mary!', remarked
her husband, 'hers is a sad fate . . . She can't bear solitude, nor I society
– the quick coupled with the dead.' The loss of her children, Clara and
William, had brought on moods of black depression; and she had ceased to
give him the sympathy that he expected and, indeed, demanded. Once
more he suffered from 'the want of those who can feel, and understand me';
and, 'whether from proximity' or 'the continuity of domestic intercourse,
Mary does not'. Meanwhile his affections remained as volatile as ever;
and, having given up hope of Sophia Stacey and Emilia Viviani, he had
presently transferred his love to Jane Williams, the attractive young
woman, 'pretty and amicable', though vain and selfish, who with her
titular husband, Edward Williams, a half-pay lieutenant in the 8th
Dragoons, had joined the Shelleys at the Casa Magni.

At Ravenna, Byron had played an enthusiastic, and not inactive part in
Italian revolutionary politics, and he was soon to lend his practical support
to the cause of Greek freedom. But Shelley's perfervid liberalism lacked
any kind of solid focus. He now saw himself as a nympholeptic waif, a
forever lost and wandering soul; and into *Adonais*, the elegy on the death
of Keats that he composed in 1821, he threw a curious self-portrait:

Midst others of less note, came one frail Form,
A phantom among men; companionless
As the last cloud of an expiring storm
Whose thunder is its knell; he, as I guess,
Had gazed on Nature's naked loveliness,
Actaeon-like, and now he fled astray
With feeble steps o'er the world's wilderness,

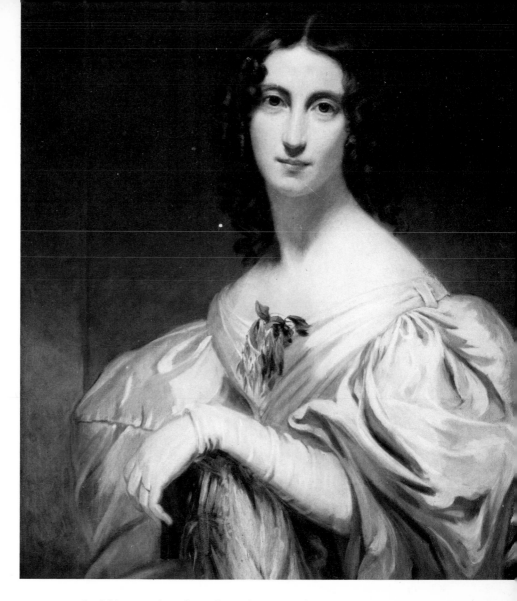

Jane Williams; portrait
by George Clint

And his own thoughts, along that rugged way,
Pursued, like raging hounds, their father and their prey.

It is in *Adonais* and some of his shorter poems, rather than in the confused sublimities of *Prometheus Unbound* – 'too deep for the brief fathom-line of thought or sense' – in his lamentations rather than in his proclamations, that we find the clearest proof of Shelley's genius. Like Byron, an imperfect artist, he had a somewhat faulty ear; and 'the gentle seriousness, the delicate sensibility, the sustained energy without which true greatness cannot be', and which he had failed to distinguish, he said, in Ariosto, is not always apparent in his more ambitious works. Only when he voices his dazzled appreciation of the natural universe beneath his eyes – 'the inconstant summer of delight and beauty which invests this visible world' – and compares his ecstatic visions with his own bereaved existence, does he achieve his full poetic stature; as, for example, in the moving short

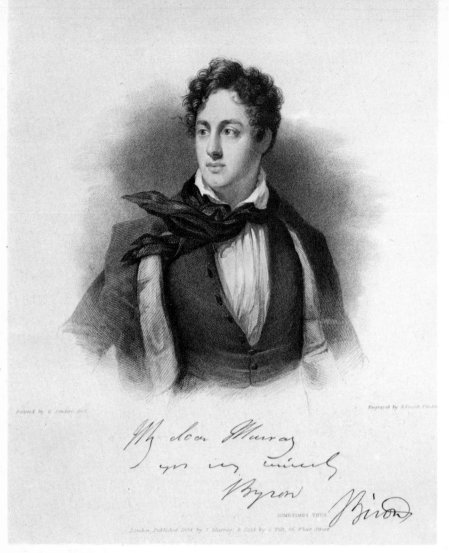

Byron the sailor; after
G. Sanders, 1807

poem that, during the autumn of 1818, he wrote upon the beach near
Naples:

> Yet now despair itself is mild,
> Even as the winds and waters are;
> I could lie down like a tired child,
> And weep away this life of care
> Which I have borne, and yet must bear,
> Till death like sleep might steal on me,
> And I might feel in the warm air
> My cheek grow cold, and hear the sea
> Breathe o'er my dying brain its last monotony.

For Shelley, as for Byron, the sea had an unending fascination. He was
no less devoted to rivers and streams and the smallest English country
brooks; and one of his most attractive oddities was his habit of launching
fleets of paper vessels, constructed from any letters he happened to have in

his pocket, and carefully ballasted with small change. At Lerici, though Trelawny's earlier attempts to teach him to swim had nearly ended in his death, he pursued his courtship of the sea; and he had now acquired a boat, the *Don Juan*, on which he and the companionable Edward Williams sailed out across the Gulf of Spezia.

The sea, however, is a symbol, not only of life, perpetually changing and renewed, but of destruction and annihilation. At Lerici he had many fearful nightmares; and, beside dreaming that he had strangled Mary, on the same night he saw the apparitions of Jane and Edward Williams, both dead and broken by the waves, and heard them warn him that the sea had invaded the house and would soon begin to tear it down. Shelley's love of the sea was evidently connected with his hidden death-wish; and Trelawny, who elsewhere asserts that, at Naples, he had already attempted to commit suicide, tells a story of his life at the Casa Magni, that, despite Trelawny's habit of myth-making, certainly deserves some credence. Shelley, he relates, while he and Jane Williams, accompanied by her two children, were floating upon the surface of the bay, suddenly proposed that they should 'solve the great riddle' by allowing the skiff they occupied to sink beneath them.

It was early in July 1822, that Shelley and Williams set from Livorno for the last time, aboard their beloved *Don Juan*. The 8th was a still, oppressive day; and, between two and three o'clock that afternoon, Trelawny bade them goodbye, and, through a glass, watched the *Don Juan* disappear into a heavy bank of fog. By Trelawny and other observers on the shore the boat was never seen again; and meanwhile a squall, that had suddenly obscured the gulf, sent other vessels scudding back to safety.

The captain of a Livornese craft afterwards reported that he had caught sight of the *Don Juan*, and had shouted to the crew that, if they valued their lives, they should immediately reef the canvas. 'One gentleman', presumably Williams, then struggled to haul down the sails; but his companion, who had seized his arm, appeared to be restraining him. Some days later, their almost fleshless bodies, unrecognisable except by the clothes they wore and the books – volumes of Sophocles and Keats – that Shelley had stuffed into his coat-pockets, were washed ashore near Viareggio. Byron's final summing-up of the friend he had lost was contained in the letters he dispatched to England. 'There is thus another man gone,' he wrote to Tom Moore, 'about whom the world was ill-naturedly, and ignorantly, and brutally mistaken.' And to John Murray: 'You were all brutally mistaken about Shelley, who was, without exception, the *best* and least selfish man I ever knew. I never knew one who was not a beast in comparison.'

5

The Visionary Landscape

As Wordsworth advanced into middle life, he became more and more concerned with the past of English literature, and liked to bestow gently patronising praise on its lesser-known poets. One of his acquaintances was Alexander Dyce, editor of Shakespeare and learned anthologist, who had recently produced a volume of *Selections from the Poetry of English Ladies*. In 1829 and 1830, Wordsworth wrote to him at some length, discussing the merits of various women writers, and especially recommending Lady Winchelsea, for whom he had always felt a high regard. '. . . Her style in rhyme', he observed, 'is often admirable, chaste, tender, and vigorous; and entirely free from sparkle, antithesis, and that over-culture which reminds one by its broad glare, its stiffness, and heaviness of the double daisies of the garden, compared with their modest and sensitive kindred of the fields.'

Anne Finch, better known as the Countess of Winchelsea, had been born in 1660 and, having lived on to enjoy the friendship of Swift and Gay and Pope, died in the year 1720. Pope paid her the highest tribute he could – he occasionally borrowed and improved her lines. What attracted him was her feminine sensibility; whereas Wordsworth appreciated her curious descriptive gifts and her unexpectedly Romantic outlook. Both appear in a poem that she entitled *A Nocturnal Reverie*. Lady Winchelsea was not an unhappy woman; she steered clear of the worst Romantic perils, and, thanks to the support of her devoted and erudite husband, soldier, courtier and member of the Royal Society of Antiquaries, seems to have led a very pleasant life. But she suffered from occasional attacks of

The Romantic dreamer, as portrayed by a Victorian artist, William Edward Milner

159

'The Spleen' (about which she wrote a lively poem) and cultivated the 'not unpleasing melancholy' that was also dear to Pope.

Thus she welcomed solitude; and one solitary night she found herself gazing across a dimly moonlit landscape, where her eye gradually picked out a series of delightful details – the 'freshened grass' that had risen with the decline of day; 'the sleepy cowslip'; the woodbine and bramble-rose; the dark-red bells of the foxglove, which in the moonshine looked so strangely pale; 'scattered glow-worms', patches of dusky woodland and 'the swelling haycocks' down the valley. So far her *Reverie* is a charming but commonplace poem. Then suddenly the effect becomes mysterious – not, however, because she aimed at an air of mystery, but because the realistic image that she introduces, like many Wordsworthian images of the same kind, had been 'felt in the blood, and felt along the heart', keenly observed and sensitively apprehended.

Yet it amounts to little enough; a horse, turned loose for the night, is moving silently towards her window:

> When the loosed horse now, as his pasture leads,
> Comes slowly grazing through the adjoining meads,
> Whose stealing pace, and lengthened shade we fear,
> Till torn-up forage in his teeth we hear ...

The last line, from an Augustan point of view, must have appeared strikingly inelegant; for the Augustans divided the raw materials of nature into subjects that deserved poetic expression and others that were 'low' and tedious. And what could be lower than a solid English horse – no Pegasus or Bucephalus; perhaps it was an aged cart-horse – cropping the dew-wet grass of an ordinary English field? But Lady Winchelsea possessed the Wordsworthian gift of seeing the objects that stirred her imagination with the fresh, unclouded eye of childhood. The horse's distorted shadow and drifting, stealthy movement awoke in her a childish dread, which only vanished when the sound of its grinding jaws, strangely distinct in that midnight hush, brought back an adult sense of place and time.

Almost equally romantic is the poem's closing passage. Here Night, during the absence of 'tyrant man', is presented as a separate universe, which allows the restless human mind an unexampled scope and freedom:

> When a sedate content the spirit feels,
> And no fierce light disturbs, whilst it reveals;
> But silent musings urge the mind to seek
> Something, too high for syllables to speak;
> Till the free soul to a composedness charmed,
> Finding the elements of rage disarmed,
> O'er all below a solemn quiet grown,
> Joys in the inferior world, and thinks it like her own:
> In such a night let me abroad remain,
> Till morning breaks, and all's confused again;
> Our cares, our toils, our clamours are renewed,
> Or pleasures, seldom reached, again pursued.

This is an idea that the average Augustan poet would have seized on as

White Horse Frightened by a Lion, by George Stubbs, 1770

an opportunity for sententious moralising; but Lady Winchelsea, although in her last couplet she strikes a lightly moral note, is more concerned to express the inexplicable emotion – 'something, too high for syllables to speak' – that she draws from her relationship with unresponsive Nature.

When the poem was written we cannot tell. Lady Winchelsea's one

collection of verses, *Miscellany Verses*, was published anonymously in 1713; but *A Nocturnal Reverie* seems to reflect the mood of a comparatively young, rather than an elderly or middle-aged woman, who would have been less anxious to 'remain abroad', leaning from her bedroom window, throughout the small hours of a summer morning. It may have been composed, therefore, soon after her marriage to Colonel Finch (who had not yet succeeded to his earldom) in the year 1684, possibly in 1685 during an unaccompanied visit to Tunbridge Wells, whither she had gone to cure her spleen. At all events, we may assume that she wrote it before the opening of the eighteenth century.

Hers was a small talent; we cannot pretend that Lady Winchelsea had any of the qualifications of a major poet. But her *Nocturnal Reverie*, which preceded Pope's *Eloisa to Abelard* by some two, or even three decades, certainly reveals the earliest glimmerings of a romantic and intuitive approach to Nature. It was a false dawn. Although many Augustan poets tried their hands at writing landscape poems, the model they usually adopted was Sir John Denham's *Cooper's Hill*, published in 1642, and reprinted in 1655 with the addition of a famous quatrain. Denham dovetailed brief descriptive passages into an elaborate framework of historical and political allusions. The result delighted Pope, who spoke of 'majestic Denham', and constructed his own *Windsor Forest* on very much the same principles. True, Pope pays his private homage to Nature, and rehearses the beauties of the ancient forest where he had been brought up and passed his carefree youth; but his most eloquent tributes are always reserved for the ambitious works of 'tyrant man'.

No Augustan poet questioned Man's supremacy, or doubted that Nature was a kind of pattern-book, through which God (who had now drawn off to a convenient distance) taught his human subjects how to live and write. Meanwhile everything about him conspired to enhance the poet's self-esteem. England was fast becoming a superbly beautiful country, as the great landlords and their favourite architects and gardeners set to work on the seventeenth-century landscape, not only felling and replanting woods, but scooping out valleys and remoulding hills, the whole terrain being designed to provide a background for an impressive architectural feature, sometimes an old house diligently brought up to date, sometimes a splendid new Palladian edifice, the work of William Kent or Colen Campbell, or another gifted member of the modern Burlingtonian school.

The England that was thus created, and to which a multitude of later designers contributed their own improvements, lasted far into the nineteenth century; and foreign tourists, driving from Dover to London, often commented on the beauty, orderliness, yet picturesque variety, of the scenes through which they travelled – a gentleman's seat, glimpsed at a distance, among the trees of its romantic park; the prosperous farms and the clusters of pretty cottages, each with its well-tended garden. These scenes also delighted the contemporary English poet, who loved to describe a landscape that was half-natural and half-artificial, where Nature

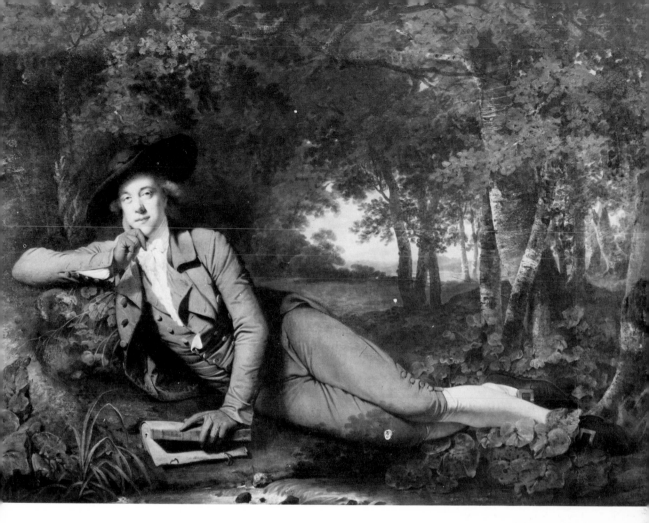

An eighteenth-century contemplative, Sir Brooke Boothby, by Joseph Wright of Derby, 1781

flourished under the control of Man, but Man exerted his supremacy in a spirit of admiring friendship.

The early-eighteenth-century nature poets were seldom very active characters. Whereas the Romantics would stride over rocks and fells, arguing at length about poetry, philosophy and the future of the human race, they were apt to recline in some not-too-uncomfortable position which commanded an imposing prospect, and encourage their thoughts to drift out, quietly and lazily, across the variegated scene below. Such was the attitude adopted by John Dyer, whose celebrated poem, *Grongar Hill*, appeared in 1726. A native of South Wales, he had an especial affection for the landscape of the Vale of Towy:

> . . . So oft I have, the evening still,
> At the fountain of a rill,
> Sat upon a flow'ry bed,
> With my hand beneath my head;
> While stray'd my eyes o'er Towy's flood,
> Over mead, and over wood,
> From house to house, from hill to hill,
> 'Till Contemplation had her fill.

Wordsworth was fond of John Dyer, whom he entitled 'the Bard of the Fleece' – a reference to the fact Dyer had also published an extremely long blank-verse poem upon the subject of the wool trade – and applauded his 'skilful genius' in a somewhat lumbering sonnet. Dyer's *Ruins of Rome*, composed after his visit to Italy, is an equally ambitious effort; but the 158 lines he dedicated to Grongar remain his most attractive piece of writing. Here the Gothic mode that Pope had already popularised is combined with faint suggestions of the new Romantic sensibility. High upon the slopes that the poet loved stood the shattered remnants of an ancient castle:

> 'Tis now the raven's bleak abode;
> 'Tis now th'apartment of the toad;
> And there the fox securely feeds;
> And there the pois'nous adder breeds
> Conceal'd in ruins, moss and weeds;
> While, ever and anon, there falls
> Huge heaps of hoary moulder'd walls.

Dyer's concentric meanderings do not take him very far afield. But he completed his poem with a triplet that rings exquisitely clear and true:

> Grass and flowers Quiet treads,
> On the meads, and mountain-heads . . .
> And often, by the murm'ring rill,
> Hears the thrush, while all is still,
> Within the groves of Grongar Hill.

Dyer, a country clergyman, who, before he took Holy Orders, had

John Dyer; poet, itinerant artist and country clergyman

earned his living as an itinerant artist, died in 1758. A far more original and interesting poet was his contemporary William Collins. But poor Collins, though Johnson assures us that 'his morals were pure and his opinions pious', had a peculiarly irresolute, unbalanced temper. His grey

eyes, we are told by Gilbert White, were 'so very weak at times as hardly to bear a candle in the room'; and such was his constitutional idleness that, once he had left Oxford, his relations decided that he was 'too indolent even for the army' and had, therefore, better join the Church. Collins rejected this cynical advice, and managed to exist on a couple of diminutive legacies until he died in 1759. During the last five years of his life, he became a hopeless melancholic. He was living at the time in Chichester; and the ancient cloisters of the Cathedral, we learn, often echoed to his groans and sighs.

Both Collins's verse and his unhappy private life secured him the interest of nineteenth-century critics. Coleridge, for example, discussing his ambitious *Ode on the Poetical Character*, wrote that the second section of the poem, the 'Epode', had 'inspired and whirled *me* along with greater agitations of enthusiasm than . . . the most *impassioned* scene in Schiller or Shakespeare'. Here it is as a nature poet that he chiefly concerns us. Collins's *Ode to Evening* suggests an idyllic landscape by Gainsborough, all delicate leaf-browns and dissolving blues and greens:

> Then lead, calm Vot'ress, where some sheety lake
> Cheers the lone heath, or some time-hallow'd pile,
>> Or upland fallows grey
>> Reflect its last cool gleam.
>
> But when chill blust'ring winds, or driving rain,
> Forbid my willing feet, be mine the hut
>> That from the mountain side
>> Views wilds, and swelling floods,
>
> And hamlets brown, and dim discovered spires,
> And hears their simple bell, and marks o'er all
>> Thy dewy fingers draw
>> The gradual dusky veil.

Only in the third of his pellucid unrhymed quatrains does he seem to reflect some deeply felt experience, not unlike one of those visionary experiences that form the subject of *The Prelude*:

> Now air is hush'd, save where the weak-ey'd bat,
> With short shrill shriek flits by on leathern wing,
>> Or where the beetle winds
>> His small but sullen horn.

Collins himself was a creature of the twilight, solitary, elusive, purblind; and in the bat and the beetle, as they flitted across his path, he found poignant images of his own bemused condition.

Another idle poet, though a far more placid personage, was the stout, eupeptic James Thomson, who entered the world in 1700 and, having caught cold on a riverside lawn, left it in August 1748. The son of a Scottish clergyman, he was originally intended for the Church; but, during the ten agreeable years he spent at Edinburgh University, he appears little by little to have changed his mind. Then, like many

James Thomson; stout,
eupeptic author of
The Seasons

eighteenth-century Scots, Thomson set out to conquer England; and in
1726 he published his poem *Winter*, and launched the highly successful
series of *Seasons* that soon established his fame among the *cognoscenti*.

Thomson is one of those poets of whom it is written that they were
'universally beloved'. He was also laughed at, and, being a solid, good-
natured man, clearly did not discourage ridicule. He is said to have been so
lazy that he was once observed to devour a ripe peach on a garden-wall
without removing his hands from the pockets of his breeches; and, in later
life, even by eighteenth-century standards, the poet grew immensely fat.
His character, nevertheless, included elements of darker feeling. He was
profoundly superstitious – perhaps because his father, having attempted

to lay a well-known ghost, had died 'under the oppression of diabolical malignity'. At Edinburgh, if he were left alone in his college room, he would sometimes take fright, his contemporaries remembered, and emerge bellowing for help and comfort.

He could be industrious too, when a poetic fit descended, usually began to compose well after midnight, and then walked in his library 'till near morning, humming over . . . what he was to correct and write out next day'. The Augustan Age had few more popular poets; and, after his death, William Cowper, in his last 'glimmerings of cheerfulness' just before his final breakdown, walked by moonshine in St Neot's churchyard and 'spoke earnestly of Thomson's *Seasons*'.

Now his colours have faded beyond recognition, though a certain decorative charm persists. *The Castle of Indolence* – for Thomson, a highly appropriate title – which he wrote at the very end of his life, is a nicely turned Spenserian pastiche; but *The Seasons*, if never displeasing, are often very dull indeed.* Thus Thomson pays his courteous tribute to the spring:

> Come, gentle Spring, ethereal mildness, come;
> And from the bosom of yon dropping cloud,
> While music wakes around, veiled in a shower
> Of shadowing roses, on our plains descend.
>
> O Hertford, fitted or to shine in courts
> With unaffected grace, or walk the plain
> With Innocence and Meditation joined
> In soft assemblage, listen to my song,
> Which thy own season paints – when nature all
> Is blooming and benevolent, like thee.

* Today his best-known work is *Rule Britannia*; though he is seldom credited with its authorship.

> And see where surly Winter passes off
> Far to the north, and calls his ruffian blasts:
> His blasts obey, and quit the howling hill,
> The shattered forest, and the ravaged vale;
> While softer gales succeed, at whose kind touch . . .
> The mountains lift their green heads to the sky.

One of the plates executed by Bentley and commissioned by Horace Walpole for the Strawberry Hill edition of Gray's *Elegy*

The 'Hertford', apostrophised in the fifth line, was, of course, an aristocratic patroness. Lady Hertford, Johnson explains, had herself poetic aspirations, and, every summer, would invite 'some poet into the country to hear her verses and assist her studies. This honour was one summer conferred on Thomson, who took more delight in carousing with Lord Hertford and his friends than assisting her ladyship's poetic operations, and therefore never received another summons'. It was Lady Hertford who saw the fruit-loving poet idly at work among her ripe peaches.

For Thomson, as for Dyer and Collins, there was nothing either fearful or mysterious in the splendours of the natural world. Thomson, indeed, recommended his fellow poets to fix their attention on natural prospects rather than on 'dry, barren themes', because it was a form of poetic exercise that he himself found particularly enjoyable.

I know no subject [he wrote in his preface to *The Seasons*], more elevating, more amusing; more ready to awake the poetical enthusiasm, the philosophical reflection, and the moral sentiment, than the works of nature. Where can we meet with such variety, such beauty, such magnificence? . . . What more inspiring than a calm, wide survey of them? In every dress nature is greatly charming – whether she puts on the crimson robes of the morning, the strong effulgence of noon, the sober suit of the evening, or the deep sables of blackness and tempest! . . . There is no thinking of these things without breaking out into poetry; which is, by-the-by, a plain and undeniable argument of their superior excellence.

For the second generation of eighteenth-century poets, Gray, Goldsmith and Cowper, the natural universe was still 'greatly charming'; and even Gray, who had responded with delight and alarm to the 'horrid' grandeur of the Alps, presents in his noble *Elegy*, written twelve years after he had threaded the Mont Cenis, an essentially anthropomorphic view of Nature. The twilit landscape very soon dissolves – while, as in Collins's poem, a beetle drones across the summer dusk; and Gray reverts to an imaginative contemplation of human hopes and fears and miseries. His genius is seen at its best when he is both nostalgic and sententious:

> For who, to dumb forgetfulness a prey,
> This pleasing anxious being e'er resigned,
> Left the warm precincts of the cheerful day,
> Nor cast one longing lingering look behind?

But Gray's anxiety arises from his keen attachment to life, not, like the fears that haunted Pascal and Wordsworth, from deeper, more mysterious causes.

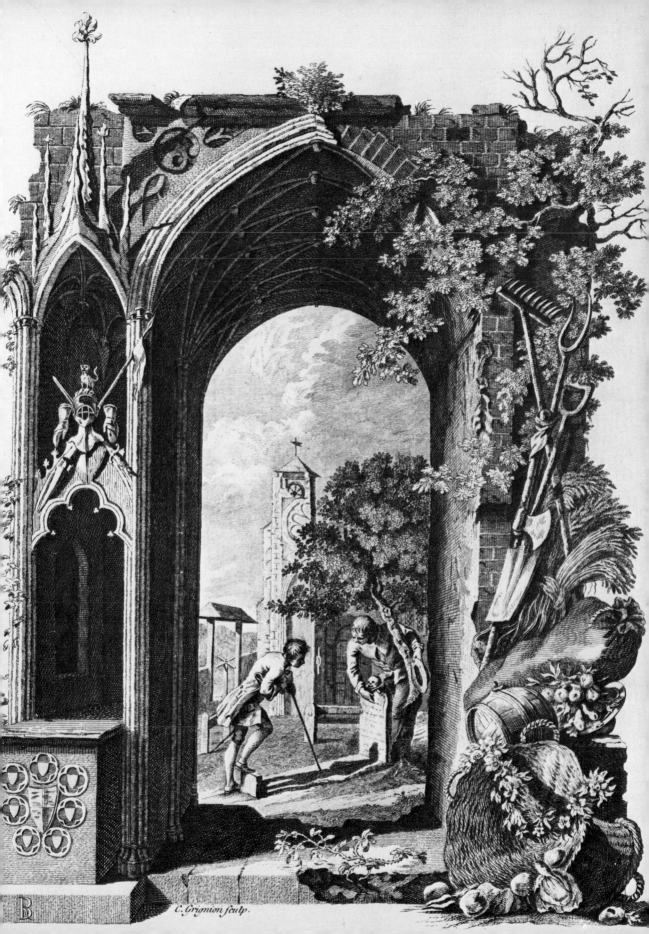

C. Grignion sculp.

Cowper, too, wrote pleasantly of Nature, but only with profound emotion when he thought of himself, and, as in *The Castaway*, composed about 1790, recalled the tragic shipwreck of his plans and dreams:

> No voice divine the storm allayed,
> No light propitious shone;
> When, snatched from all effectual aid,
> We perished, each alone:
> But I beneath a rougher sea,
> And whelmed in deeper gulfs than he.

All these poets affected a taste for solitude – even Thomson, who can rarely have experienced it, as he talked and drank in the London coffee-houses or wandered through Lord Hertford's orchard – and sometimes spoke of deserting 'the busy world' and retiring to a romantic hut or cavern.

> Oh for a lodge in some vast wilderness,
> Some boundless contiguity of shade . . .

sighed Cowper from his comfortable home at Olney. Meanwhile, the influence of Jean-Jacques Rousseau, the greatest Solitary of his age, a man who feared and distrusted his fellow human beings as much he would have liked to love them, had made its way across the English Channel.* Wherever he went, both his heterodox views and his strangely unsettled and unsettling character aroused a storm of public hatred; and the emotional security that he was always denied by Man he sought among the lakes and mountains.

Yet Rousseau was to remain a humanist; though he applauded the romantic scenery of the Alps and recorded their beneficent effect upon his mind, he adds that he 'could have spent the whole time in contemplating these magnificent landscapes, if I had not found still greater pleasure in the conversation of the inhabitants'. He had moods, however, when Nature alone sufficed him, and he developed an exquisitely close relationship with the world of trees and rocks and waters. Thus, in *Les Confessions* and a later work, *Les Rêveries du Promeneur Solitaire*, he describes how, having been 'lapidated' and chased out of his house by the hostile citizens of Motiers, he had sought refuge on the island of St Pierre, near Neuchâtel, in the middle of the Lake of Bienne.

There, he says, he 'bade goodbye to my century and my contemporaries', and spent two supremely happy months, which he hoped would last a lifetime. Not only did he botanise, along the shores of the island – 'nothing could have been more remarkable than the delight, the rapture I felt at each new discovery I made about the organisation . . . of the vegetable kingdom'; but being, like Shelley, a passionate lover of water,

* By 1791 it had penetrated English royal circles; and the Duke of Kent, one day to beget the future Queen Victoria, when he was setting out to take up a post abroad, asked that Rousseau's novels should be included in his travelling library.

he would recline endlessly beside the lake, while the sight of its incessant flux and reflux, and the rhythmic cadence of the sounds that filled his ears, plunged him in a delicious waking dream.

All his life, the Solitary Walker continues, he has noticed that the experiences he remembers with most satisfaction are not his wildest pleasures and his keenest joys. Everything mundane decays and changes; and both our passions and our affections are harnessed to the same cycle. Yet there are moments of release, fugitive states of mind, in which the soul discovers a really solid resting-place – '*une assiette assez solide pour s'y reposer tout entière et rassembler là tout son être* – when the individual is completely himself, and has no need of past or future; when time means nothing to him; the present becomes eternal; and every emotion vanishes except the ecstatic awareness of his own existence. So long as that state endures, he who enjoys it may well decide that he is truly happy, *non d'un bonheur imparfait, pauvre et relatif . . . mais d'un bonheur, parfait et plein, qui ne laisse dans l'âme aucun vide qu'elle sente le besoin de remplir*'. Such was the happiness that, in 1765, Jean-Jacques Rousseau, unhappiest of human vagrants, often experienced on the island of St Pierre. By abandoning himself to the gentle flow of sensations, and merging his own identity with the life of the surrounding universe, he invented a new approach to Nature that would revolutionise Romantic poetry.

Rousseau had died when Wordsworth was four years old; but, at the end of the eighteenth and the beginning of the nineteenth century, few foreign writers were so much alive in England. His novels, *Julie, ou la Nouvelle Héloïse* and *Émile, ou Traité de l'Éducation*, had a profound effect on social conduct; and a great many educated men and women – for example, Georgiana, Duchess of Devonshire, and her beloved friend, Lady Elizabeth Foster – regarded *la Nouvelle Héloïse* as a precious guide-book to the realms of thought and sentiment. During their early manhood, Wordsworth and Southey had been enthusiastic Rousseauites; and Wordsworth, though he discarded his social doctrines once the French Revolution had realised some of those doctrines in a peculiarly violent form, never quite outgrew the influence of Rousseau's poetic sensibility. It haunts the pages of *The Prelude* and all his finest youthful poems. He, too, had known the mysterious state of being experienced by Rousseau on the Isle de St Pierre.

From such experiences sprang the Visionary Landscape, built up by the great Romantic poets, where the poet's faculty of observing Nature, and grandly generalising what he saw, counted for less than his gift of rediscovering it in moments of intensely heightened vision. During his poetic youth, Wordsworth repeatedly enjoyed these sudden brilliant gleams of insight; and, although he would later assert that they had had a heavenly origin, and were part of the celestial heritage that God bestows on every new-born child, at the time when he planned and launched *The Prelude* he was still content to record without explaining, and merely describes them as mysterious visitations that had shaped his character and formed his genius.

Moonlight, with a Light-house, by Joseph Wright of Derby

Similar experiences have occasionally come the way of most imaginative human beings; and in an admirable essay, published fifteen years ago, Kenneth Clark discusses these 'Moments of Vision',[17] and seeks to determine the rôle they have played in the history of modern art. The moment of vision, he suggests, might perhaps be more accurately called a 'moment of intensified physical perception', during which, often as the result of allowing the mind and eye to dwell at length upon some natural object, 'unconsciously thought and perception are merged', and we achieve a sudden dazzling awareness both of our separate selves and of the world around us. The use to which writers put these moments is one of the distinguishing features of Romantic poetry. Augustan poets had attempted a 'calm, wide survey' of a world that they admired and loved; Wordsworth and his friends sought a relationship with Nature that was both passionate and directly personal; and they achieved it through ecstatic glimpses. They were literally 'possessed' by the scenes they contemplated; and only when the sense of possession failed did they decline from poetry into humdrum verse.

Each poet had an image, or images, that particularly excited his imagination. Coleridge, for example, whose love of anything that was radiant, elusive and transitory has been noted on an earlier page, was always fascinated by the moon; and Kenneth Clark quotes a significant passage that occurs among his miscellaneous jottings:*

In looking at objects of nature ... as at yonder moon, dim-glimmering through the dewy window pane, I seem rather to be seeking ... a symbolical

William Wordsworth in later life, by B.R.Haydon, 1842

* This passage attracted the notice of Walter Pater, who quotes it in *Appreciations*. Coleridge rounds it off with a characteristic sentence: 'While I was preparing the pen to make this remark, I lost the train of thought which had led me to it.'

language for something within me that forever and already exists, than observing anything new. Even when that latter is the case, yet still I have always an obscure feeling, as if that new phenomenon were a dim awakening of a forgotten or hidden truth of my inner nature.

Thus the Romantic poet, while he rediscovered the natural world, was also rediscovering himself, and accepted the images he loved as 'master-symbols' of his own experience. At the same time, he was travelling back into youth; 'it is questionable', writes Kenneth Clark, 'if there is any central image in an artist's work which did not come to him as a moment of vision in childhood . . .' No doubt Coleridge's passion for the moon was conceived on the leaded roof of Christ's Hospital; and every sight or sound that moved the adult Wordsworth had already entered his imaginative life long before he left Gateshead.

Few poets have owed more than Wordsworth to the mystic powers of memory, or received greater benefit from the dazzling moments of vision in which Rousseau had discovered his only happiness. Whenever we think of Wordsworth, we are bound eventually to think of Coleridge; and whereas the author of *The Prelude*, writes Walter Pater,[18] was 'distinguished by a joyful and penetrative conviction of the existence of certain latent affinities between nature and the human mind' – a conviction that 'took the form of an unbroken dreaming' – Coleridge 'could never have abandoned himself to the dream . . . because the first condition of such abandonment must be an unvexed quietness of heart'; and even during Coleridge's happiest period, while he and his friend were producing the *Lyrical Ballads*, we feel 'that faintness and obscure dejection which clung like some contagious damp to all his work'.

At its most enchanting, the visionary landscape of *The Prelude* has the distinction, without the delusive character, of some extraordinarily vivid dream. It bore no resemblance to any other landscape yet created by the human spirit; and, once it had appeared – since Nature follows Art – the world itself began to assume a subtly different and more mysterious aspect. Wordsworth's physical senses stood him in good stead; they were peculiarly well developed. To an exquisite sharpness of eye he added a wonderfully receptive ear; and very often it is his poetic notation of a sound that lends a passage its especial quality. For example, the noise of a falling acorn, recorded in his *Introduction*:

> . . . Now here, now there, an acorn from its cup
> Dislodged, through sere leaves rustled, or at once
> To the bare earth dropped with a startling sound

Later, in Book II, we read of the single wren that haunted the ruins of an ancient abbey:

> Our steeds remounted and the summons given,
> With whip and spur we through the chauntry flew
> In uncouth race, and left the cross-legged knight,
> And the stone-abbot, and that single wren
> Which one day sang so sweetly in the nave
> Of the old church, that – though from recent showers

The earth was comfortless, and touched by faint
Internal breezes, sobbings of the place
And respirations, from the roofless walls
The shuddering ivy dripped large drops – yet still
So sweetly 'mid the gloom the invisible bird
Sang to herself, that there I could have made
My dwelling-place, and lived for ever there . . .

And again in Book V, where he is describing one of the strange occurrences that brought with them a wave of terror:

> . . . That very week,
While I was roving up and down alone,
Seeking I knew not what, I chanced to cross
One of those open fields, which, shaped like ears,
Make green peninsulas on Esthwaite's Lake:
Twilight was coming on, yet through the gloom
Appeared distinctly on the opposite shore
A heap of garments . . .
> Long I watched,
But no one owned them; meanwhile the calm lake
Grew dark with all the shadows on its breast,
And, now and then, a fish up-leaping snapped
The breathless stillness.

Like Pope, Wordsworth had both a painter's eye and a keen pictorial imagination; and almost every prospect he conjures up in *The Prelude* is invested with a radiant air of light and space. Thus he describes how, during a summer vacation from Cambridge, he had attended a rustic ball, and returned home as the dawn broke:

> Two miles I had to walk along the fields
Before I reached my home. Magnificent
The morning was, in memorable pomp,
More glorious than I ever had beheld.
The Sea was laughing at a distance; all
The solid Mountains were as bright as clouds,
Grain-tinctured, drench'd in empyrean light;
And, in the mountains and the lower grounds,
Was all the sweetness of a common dawn,
Dews, vapours, and the melody of birds,
And Labourers going forth into the fields.*

Wordsworth's poetic existence (which I have glanced at, in a previous chapter, from a somewhat narrower point of view) falls clearly into two main periods. First, he enjoyed his heavenly flashes of insight; then, as middle age approached, he did his best to rationalise them. Although the original version of *The Prelude* was not completed before 1806, as early as 1798, when he produced his famous *Lines Composed a Few Miles above Tintern*

* Elsewhere I have quoted from the 1850 text; but, for this passage, I have used the earlier version, which seems the more impressive of the two.

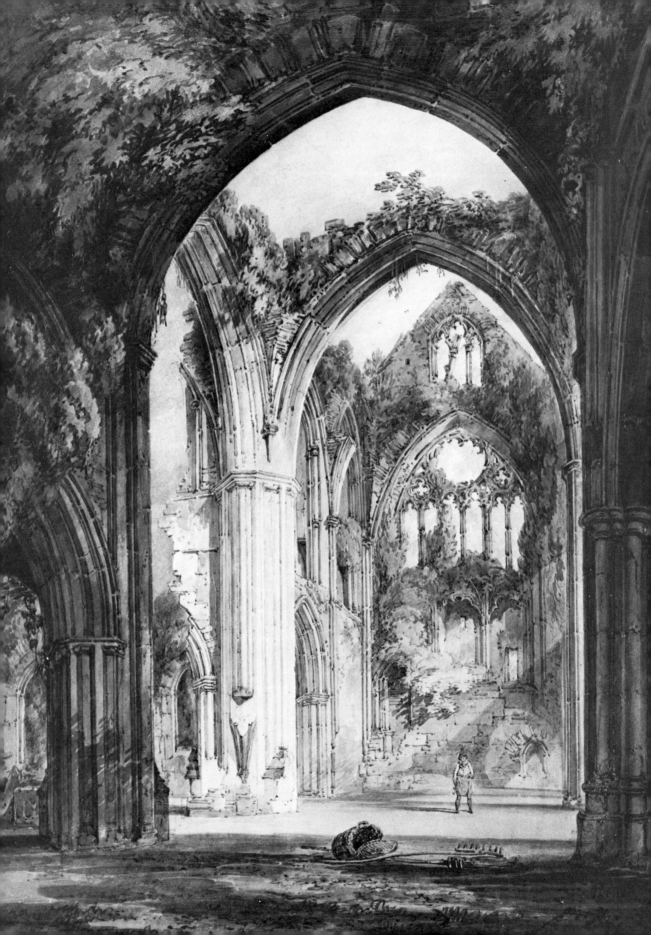

Tintern Abbey, by Turner

Abbey, he already felt the need to incorporate his discoveries in some moral or religious system. 'No poem of mine', he wrote, 'was composed under circumstances more pleasant for me to remember than this. I began it upon leaving Tintern, after crossing the Wye, and concluded it just as I was entering Bristol, in the evening, after a ramble of four or five days, with my sister.' Not until he had reached Bristol, he says, was any part of the poem written down.

Did Wordsworth really carry in his head a fully formed poem of almost 160 lines? It seems more probable that he composed the exordium while he was sitting with Dorothy – 'my dear, dear Friend . . . my dear, dear Sister!' – looking down upon the placid Wye; and that the whole poetic edifice was enlarged and thoroughly reorganised once he had returned home. The opening lines are a simple record of happiness, raised for the moment to the pitch of visionary exaltation:

> Five years have past; five summers, with the length
> Of five long winters! and again I hear
> These waters, rolling from their mountain-springs
> With a soft inland murmur. – Once again
> Do I behold these steep and lofty cliffs,
> That on a wild secluded scene impress
> Thoughts of more deep seclusion; and connect
> The landscape with the quiet of the sky.
> The day is come when I again repose

Mountainous Landscape with a Bridge, by Thomas Gainsborough

Here, under this dark sycamore, and view
These plots of cottage-ground, these orchard-tufts,
Which at this season, with their unripe fruits,
Are clad in one green hue, and lose themselves
'Mid groves and copses. Once again I see
These hedge-rows, hardly hedge-rows, little lines
Of sportive wood run wild: these pastoral farms,
Green to the very door; and wreaths of smoke
Sent up, in silence from among the trees! . . .

Lake Albano and Castel Gandolfo, by J. R. Cozens, son of Beckford's friend and drawing-master

Next came an effort – and the effort was strenuous – to justify an emotion he could not quite explain. As in the *Intimations*, he distinguishes his earlier self –

The sounding cataract
Haunted me like a passion: the tall rock,
The mountain, and the deep and gloomy wood,
Their colours and their forms, were then to me
An appetite; a feeling and a love,
That had no need of a remoter charm,
By thought supplied . . .

– from the adult poet who, although he is 'still a lover', now likes to think that he has founded his affections upon a much more solid basis –

> . . . well pleased to recognise
> In nature and the language of the sense
> The anchor of my purest thoughts, the nurse,
> The guide, the guardian of my heart, and soul
> Of all my moral being.

Wordsworth, of course, was then a fervent Pantheist; and, although we may not accept a modern critic's assertion that the poet's attempt to set forth his creed is 'shuffling' and muddle-headed,* we must agree that, despite its moving eloquence, it is poetry at second hand. Moments of vision, observes Kenneth Clark, 'if transplanted from the field of purposeless contemplation to that of virtuous action, lose their independent life';[19] and, as Wordsworth became less prepared to enjoy them, and more and more concerned to give them a moral value, the brilliant Visionary Landscape he had created in his youth began gradually to lose its radiance.

Among contemporary poets for whom Wordsworth expressed a keen and almost unqualified admiration was the Reverend George Crabbe. Sixteen years older than himself, Crabbe had died in 1832; and in 1834, when the poet's son published an excellent biography, Wordsworth wrote him a warmly appreciative letter. 'Any testimony to the merit of your revered father's Works' would, he suggested, be superfluous; 'they will last from their combined merits as poetry and truth, full as long as anything that has been expressed in verse since they first made their appearance' – that is to say, since 1781, over ten years before the future author of *The Prelude* had issued his juvenile *Descriptive Sketches*.

Crabbe was also admired by Scott, Tennyson, Edward Fitzgerald, Cardinal Newman and, more surprisingly perhaps, by Byron. 'Crabbe's the man', Byron wrote to Murray in September 1817, despite the fact that 'he has got a coarse and impracticable subject'. In *English Bards and Scotch Reviewers*, he had already dubbed him 'Nature's sternest painter, yet the best'; and he now excepted Crabbe from the condemnatory verdict he had passed on younger poets of the modern school, remarking elsewhere that he considered 'Crabbe and Coleridge the first of these times in point of power and genius'. As for Scott, we are told that, during his final period of tragic decline, the only books that he wished to hear read aloud were the Bible and Crabbe's collected poems.

'Crabbe has a world of his own', the aged Tennyson remarked to Edward Fitzgerald; and, indeed, few landscapes created by an English poet have a more sharply individual character. Not that it is a gay or appealing world; Crabbe's sober, sad-toned universe reflects the dominant mood of its creator's lonely and self-doubting spirit. Yet, apart from grave domestic misfortune, Crabbe led a tolerably happy life, enjoyed

* William Empson, *Seven Types of Ambiguity*: 'There is something rather shuffling about this attempt to be uplifting yet non-denominational, to put across as much pantheism as would not shock his readers.' But he must 'protest again', Empson adds, 'that I enjoy these lines very much . . .'

many successes, married his first love, and reared a number of devoted children. Evidently, the main source of his private unhappiness lay very far below the surface.

Born at Aldborough, on the Suffolk coast, in December 1754, the son of the Aldborough 'Salt-Master', or collector of the local salt-duties, he began to earn a livelihood as surgeon's apprentice, farm-labourer and warehouse clerk, but, in 1779, escaped to London, carrying a bundle of unpublished verses. There, when he had spent his last few shillings, Crabbe had been lucky enough to attract the attention of the famous Edmund Burke, under whose auspices *The Library* appeared in 1781, and *The Village* in 1783. The sale of *The Library* was particularly 'rapid and extensive'; and 'my father's reputation (records his biographer) was . . . greatly raised, and permanently established by this poem'. Dr Johnson himself consented to correct *The Village* and, according to Boswell, 'took the trouble not only to suggest slight corrections . . . but to furnish some lines . . .' Meanwhile Burke had persuaded him to enter the Church, and procured him a post as domestic chaplain to the Duke of Rutland, a civilised and benevolent nobleman, wedded to 'the most celebrated beauty in England', who treated Crabbe and his young wife with unfailing

The Reverend George Crabbe; a restless, uneasy man, with his noble white head and his courteous but rueful smile

Crabbe's birthplace at
Aldborough

sympathy and kindness. Crabbe would afterwards declare that the four
quiet years he spent in the Duke's service were the happiest period of his
whole existence; and, having left Belvoir, he was promptly appointed to a
comfortable and well-found living.

A single cloud darkened this pleasant prospect – Sarah Crabbe was
a 'frank, cordial, charming', but hopelessly unbalanced woman. Nowa-
days she would be called a manic-depressive; 'during the hotter months
of every year', wrote her son, 'she was oppressed by the deepest dejection
of spirits I ever witnessed'; and her fits of depression were followed by
'long intervals, in which, if her spirits were a little too high, the relief to
herself and others was great indeed'. Crabbe loved her; 'never was there
a better husband', his sister claimed, 'except that he was too indulgent'.
And, after her death in 1813, he made a pathetic note upon a letter of
hers that he had lately re-read: 'Nothing can be more sincere than this,
nothing more reasonable and affectionate; and yet happiness was denied.'

In his other personal relations, though he enjoyed his fame and liked
visiting his aristocratic patrons, Crabbe seems to have lacked both gaiety
and spontaneity. With his noble white head and his courteous but rueful
smile, he remained a dignified but distant figure. Even at home, he was a

restless, uneasy man. Either he would plunge into a meticulous study of the natural world around his doors, botanising, mineralising, entomologising, or suddenly set off on some unpremeditated expedition. Thus, one fine summer day, we are told, he 'was seized with . . . so intense a longing to see the sea, from which he had never before been so long absent, that he mounted his horse, rode alone to the coast of Lincolnshire, sixty miles from his house, dipped in the waves', and immediately rode back again.

At the same time, he had become an opium-addict. When he was thirty-six, he had begun to use the drug as a remedy for occasional attacks of vertigo; and, throughout the rest of his life, he continued to absorb it in small, but regular and gradually increasing doses. Unlike Coleridge and De Quincey, Crabbe avoided all its worst results. Nevertheless, it certainly distorted his dreams, which grew more and more numerous and strangely lurid; and his dreams had evidently a strong effect upon his literary imagination, not only in the three long poems that he devoted to dreamers and dreaming, but in his homeliest domestic chronicles.

Crabbe's literary career was broken by an interval of silence that lasted more than two decades; and much of the work that holds our attention today, *The Parish Register*, *The Borough*, *Tales in Verse* and *Tales of the Hall*, was published after he had reached the age of fifty. But then, Crabbe seems to have been born old. Whereas Wordsworth had written his greatest poems under the vernal signs of Youth and Hope, Crabbe dedicated his genius to autumn, the season he found most attractive, with its sombre half-tones, its sweeping cloud-shadows and occasional bursts of pallid sunshine. He, too, was fascinated by the movement of water; but the streams that flow through Crabbe's verse have usually diminished to a sullen trickle.

Every poem arises from a slow accumulation of feeling and experience – a lengthy process, which can often be traced back far into the poet's earliest memories. Crabbe, we know, had had a rough youth. The Salt-Master, his grandson tells us, was 'a man of imperious temper and violent passions'; and mid-eighteenth-century Aldborough was 'a poor and wretched place', consisting of two parallel and unpaved streets that ran 'between mean and scrambling houses . . . The range of houses nearest to the sea had suffered so much from repeated invasions of the waves, that only a few scattered tenements appeared erect among the desolation . . . The beach consists of successive ridges – large rolled stones, then loose shingle and, at the fall of the tide, a strip of fine hard sand. Vessels of all sorts, from the large heavy trollboat to the yawl and prame, drawn up along the shore – fishermen preparing their tackle, or sorting their spoil – and nearer the gloomy old town-hall . . . a few groups of mariners . . . taking their quick short walk backwards and forwards, every eye watchful of a signal from the offing – such was the squalid scene', writes his biographer, that first impressed itself upon the youthful Crabbe.

'Nor [he continues] was the landscape in the vicinity of a more engaging aspect – open commons and sterile farms, the soil poor and sandy, the herbage bare and rushy, the trees . . . withered and stunted by the bleak

Estuary with Boats; an
East Anglian landscape
by J. S. Cotman, *c.* 1808

breezes of the sea.' From these materials Crabbe produced *The Village*,
the most considerable of his early works:

> Lo! where the heath, with withering brake grown o'er,
> Lends the light turf that warms the neighbouring poor;
> From thence a length of burning sand appears,
> Where the thin harvest waves its wither'd ears;
> Rank weeds, that every art and care defy,
> Reign o'er the land, and rob the blighted rye:
> There thistles stretch their prickly arms afar,
> And to the ragged infant threaten war;
> There poppies nodding, mock the hope of toil;
> There the blue bugloss paints the sterile soil;
> Hardy and high, above the slender sheaf,
> The slimy mallow waves her silky leaf;
> O'er the young shoot the charlock throws a shade,
> And clasping tares cling round the sickly blade;
> With mingled tints the rocky coasts abound,
> And a sad splendour vainly shines around.

Although his poem was written as a counterblast to Goldsmith's melli-
fluous *Deserted Village*, which had appeared in 1770, Crabbe is not merely

concerned to set the social record straight, by exploding the legend of the happy, innocent peasant, and providing an authentic glimpse of the 'guilt and famine' that weighed upon East Anglian labourers.* During his lifetime, Crabbe's unsparing realism always made a strong appeal. This was the side of his work that contemporary critics preferred. For them, he was a brilliant story-teller and a shrewd delineator of human types. Nor were they entirely wrong. Even at its most pedestrian, Crabbe's sober jog-trot verse has some of the merits of descriptive prose:

> He was a man of riches, bluff and big
> With clean brown broadcloth, and with white cut wig:
> He bore a cane of price, with riband tied,
> And a fat spaniel waddled at his side . . .

What moves us today in his long description of the sad East Anglian flatlands is a very different, far more enigmatic quality. The weeds he has listed with such exactitude possess a savage independent life. The thistle, stretching its fierce arms, springs like a marauder from that barren soil: 'the slimy mallow' is a Circean enchantress; and the shade that the charlock casts evidently betokens doom and sorrow. Just as Coleridge gazed at the cloudy moon or the surges of a phosphorescent ocean, seeking a 'symbolical language for something . . . that forever and already' existed in the recesses of his own mind, Crabbe, when he stared at a patch of weeds, a sterile field, a lonely beach, experienced one of those moments of heightened perception which, if they are to be preserved and understood, must be translated into poetry.

The period of silence that divided his working life did not much affect his outlook; new experiences merely confirmed the impressions that he had gained in childhood. Nevertheless, his visionary landscape acquired an even darker colouring. He had watched, day after day, the gradual breakdown of his wife's intelligence; and every night he had explored a labyrinth of dreams, from which he would emerge gloomily remarking: 'The leather-lads have been at me again.' These apparitions, according to Edward Fitzgerald, were the subject of one of Crabbe's recurrent nightmares. Surrounded by a troop of ruffianly boys, he would try to beat them off, only to find, when he struck out with the stick he carried, that they were made of solid leather.

Often he noted a hideous contrast between the worlds of sleep and waking. He would return home from a fashionable party and go to bed with pleasant thoughts; but, 'asleep, all was misery and degradation, not my own only, but of those who had been. That horrible image of servility and baseness . . . It is the work of imagination, I suppose; but it is very strange.' Crabbe's attachment to opium had begun in 1790; and the habit was well established by 1807, when he produced *The Parish Register*. But, unlike Coleridge, he was at no time a slave of the drug; for opium, which heightened Coleridge's perceptions, slowly undermined his gifts of

* 'The sentiments of Mr Crabbe's admirable poem', writes Boswell, 'as to the false notions of rustic happiness and rustic virtue, were quite congenial with Dr Johnson's own . . .'

Mousehold Heath, by
John Crome, 1818–20

self-expression; whereas Crabbe continued to record his feelings with
unimpeded strength and fluency.

Yet the opium-habit may well have accentuated his phantasmagoric
view both of Nature and of Man. Crabbe's human personages are almost
always a close-knit part of the natural background against which they
move. They share its sadness and darkness and its air of circumambient
melancholy:

> But now dejected, languid, listless, low,
> He saw the wind upon the water blow,
> And the cold stream curl'd onward as the gale
> From the pine-hill blew harshly down the dale;
> On the right side the youth a wood survey'd,
> In all its dark intensity of shade;
> Where the rough wind alone was heard to move,
> In this, the pause of nature and of love . . .
> Far to the left he saw the huts of men,
> Half hid in mist that hung upon the fen;
> Before him swallows, gathering for the sea,
> Took their short flights, and twitter'd on the lea;
> And near the bean-sheaf stood, the harvest done,
> And slowly blacken'd in the sickly sun;
> All these were sad in nature, or they took
> Sadness from him, the likeness of his look . . .

Such were the lines, taken from *Delay has Danger*, that Tennyson, him-self brought up in the East Anglian fens, told Fitzgerald that he found so moving; and they may be compared with a passage from *Peter Grimes*, which describes how Grimes, the master of an Aldborough 'slave-shop', who has beaten his innocent apprentice to death, is gradually overwhelmed by guilt and madness:

> When tides were neap, and, in the sultry day,
> Through the tall bounding mud-banks made their way,
> Which on each side rose swelling, and below
> The dark warm flood ran silently and slow;
> There anchoring, Peter chose from man to hide,
> There hang his head, and view the lazy tide
> In its hot slimy channel slowly glide;
> Where the small eels that left the deeper way
> For the warm shore, within the shallows play;
> Where gaping mussels, left upon the mud,
> Slope their slow passage to the fallen flood; –
> Here dull and hopeless he'd lie down and trace
> How sidelong crabs had scrawl'd their crooked race,
> Or sadly listen to the tuneless cry
> Of fishing gull or clanging golden-eye . . .
> He nursed the feelings these dull scenes produce,

And loved to stop beside the opening sluice;
Where the small stream, confined in narrow bound,
Ran with a dull, unvaried, sadd'ning sound . . .

It is true that, in his copious verse-tales, Crabbe also drew some pretty pictures – for example, a sketch in *The Borough*, of the early nineteenth-century Suffolk coast:

Then through the broomy bound with ease they pass,
And press the sandy sheep-walk's slender grass,
Where dwarfish flowers among the gorse are spread,
And the lamb browses by the linnet's bed;
Then 'cross the bounding brook they make their way
O'er its rough bridge – and there behold the bay! –
The ocean smiling to the fervid sun –
The waves that faintly fall and slowly run . . .

But in these agreeable vignettes he never quite achieves the tense imaginative concentration that we distinguish in his gloomier landscapes, where the effect he produces is all the more impressive because it is firmly founded upon naturalistic observation. When Crabbe makes a deliberate attempt to produce a Romantic poem, as in *The World of Dreams* and *Sir Eustace Grey*, the result is slightly artificial. We are aware that he is manufacturing verse. It is when he returns to the obsessive memories of his boyhood that the diligent versifier becomes a poet.

6

Painting as Feeling

S ir Humphry Davy, chemist and physicist, was born in 1778 and
died in 1829. During his professional life, encyclopedias tell us,
besides inventing his famous Safety Lamp and discovering 'the
exhilarating effect of nitrous oxide', he isolated potassium and sodium,
calcium, barium, boron, magnesium and strontium, 'established the
elementary nature of chlorine, advanced the theory that hydrogen is
characteristically present in acids, and classed chemical affinity as an
electric phenomenon'.[20] But he had another aspect – one equally attuned
to the inquiring spirit of his age; he was the intimate friend of Coleridge
and Southey, and an ambitious, if ungifted poet; and as a young man,
walking across the hills, he had enjoyed an unexpected revelation:

> Today, for the first time [he wrote in his diary] . . . I have had a distinct
> sympathy with nature. I was lying on the top of a rock . . . the wind was high,
> and everything in motion; the branches of an oak tree were waving and mur-
> muring; yellow clouds, deepened by grey at the base, were rapidly floating over
> the western hills . . . the yellow stream below was agitated by the breeze;
> everything was alive, and myself part of the series of visible impressions; I
> should have felt pain in tearing a leaf from one of the trees.

Here the young scientist seems to be speaking for the whole Romantic
movement – not only for his familiar friends, the poets, but for some of the
greatest nineteenth-century painters. At the time, there was an unusually
close connection between the different branches of creative art; and,
while certain writers had a keen pictorial sense, many painters, both good
and bad, acquired an extraordinary gift of self-expression, and were

Study of ash trees, by
John Constable

189

Barges on the Stour; sketch by Constable; 'willows, old rotten planks, slimy posts and brickwork, I love such things . . .'

strongly influenced by poetic ideas and images. John Constable has been described as 'the most Wordsworthian' of English artists;[21] and the fact that he liked to quote Wordsworth, both in his correspondence and in the text of his catalogues, suggests that he recognised a real affinity. Constable's attitude towards his art was often that of the Romantic poet. 'Painting is with me', he declared, 'but another word for feeling'; and he shared Crabbe's passionate devotion to the background of his youth. 'The sound of water escaping from mill-dams . . .', he wrote in the same letter, 'willows, old rotten planks, slimy posts and brickwork, I love such things . . . I associate my "careless boyhood" with all that lies on the banks of the Stour; those scenes made me a painter, and I am grateful.' Wherever his travels might lead him, he would still 'paint my own places best'.

Like Crabbe, Constable was a native of Suffolk. Born at East Bergholt in October 1776, the son of a substantial miller, he never lost his deep

affection for that placid, yet extremely various county, which had taught him all he knew and all, he felt, he wished to know. The artist, he believed, should make it his chief business to produce 'a pure and unaffected representation' of the scene beneath his eye. He was a perfervid naturalist, so concerned with the imaginative truth of his works that he refused obstinately to paint in a bird unless an actual bird had crossed his field of vision. He was prepared to wait, he explained, no matter how long, 'till I see some living thing; because if any such appears, it is sure to be appropriate to the place. If no living thing shows itself, I put none in my picture.'

Nature's marvellous variety impressed him as much as its transcendent beauty. 'The world is wide,' he noted, 'no two days are alike, nor even two hours; neither were there ever two leaves of a tree alike since the creation of the world . . .' From the painter's point of view, he had decided, nothing could be called ugly; '*I never saw an ugly thing in my life*: for let the form of an object be what it may, light, shade, and perspective will always make it beautiful.' But he did not undervalue the importance of sheer technique; and the delicate luminosity of his most enchanting landscapes – such as the view of Salisbury Cathedral across the meadows, painted seven years before his death – had been imposed on the surface of his canvas by a highly expert method. When he visited Constable one day, wrote Solomon Hart in his *Reminiscences*, 'I found him with a palette-knife, on which was some white, mixed with a viscous vehicle . . . Upon expressing my surprise, he said "Oh! My dear Hart, I'm giving my picture the dewy freshness." He maintained that the process imparted the dewy freshness of nature, and he contended that the apparent crudeness would readily subside', thanks to a chemical change that must soon occur in the substance of the paint itself.

Similarly, he seems to have had little patience with the idea of the 'inspired' artist; and Charles Leslie relates how, 'on hearing somebody say of the celebrated collection of Raphael's drawings that belonged to Sir Thomas Lawrence, "They inspire", he replied: "They do more, they inform."' Again, we learn that, when 'the amiable but eccentric Blake, said of a beautiful drawing of an avenue of fir trees . . . "Why, this is not drawing, but *inspiration*"', Constable retorted rather sharply: 'I never knew it before; I meant it for drawing.'

Yet, despite the importance he attached to pure technique, he was, above all else, a visionary artist. Like Rousseau beside the Lake of Bienne, he did his best to submerge his identity in the existence of the natural world, and to free his mind from preconceptions. When he sat down to make a sketch, he said, 'the first thing I try to do is, *to forget that I have ever seen a picture*'. Faced with a subject that absorbed him, he became entirely still and silent; and Leslie remarks that 'a curious proof of the stillness with which he had sat one day while painting in the open air, was the discovery of a field mouse in his coat pocket'.

His aims were modest. Constable despised the false heroics – 'the taste for the *prodigious* and the *astounding*, a taste very contrary to his own' – of much nineteenth-century art and literature, and frequently quoted Dr Johnson's aphorism: 'That which is *greatest* is not always *best*.' 'My art',

he declared, 'can be found under every hedge'; his visions were invariably based upon 'laborious' observation; we can feel sure that, if he painted a willow or an elm, he had made a careful study both of the genus itself and of the individual tree. He had also a countryman's knowledge of wind and weather. 'It would be difficult to name a class of landscape', he said, 'in which the sky is not the keynote.' During his East Anglian youth, he had learned to love clouds; and his sketches of clouds are as strangely moving as his rapid impressions of streams and trees and hills.

Spring was the painter's favourite season; and, at least until his wife died in 1828, he avoided any suspicion of Romantic melancholy. For him, the word was a term of dispraise; he would remark that a prospect was 'grand but melancholy', and write that, although they were melancholy, he admired the blossoms of the elder. Thus he detested Byron; and, when

Clouds by Constable; 'it would be difficult to name a class of landscape in which the sky is not the keynote'

192

he heard of the poet's end, commented that the world was rid of him; 'but the deadly slime of his touch still remains'.

Despite the professional quarrels in which he often engaged, Constable was generous and warm-hearted, cherished his wife whom he addressed in his letters sometimes as 'my dearest love', sometimes as 'my darling Fish', and proved an equally devoted father. 'His fondness for children', his biographer informs us, 'exceeded ... that of any man I ever knew'; '*children*', he said, '*should be respected*'; and Leslie describes the elderly painter, who was to die within the next two days, walking down Oxford Street, on his way home from a meeting of the Royal Academy, and hearing a child cry out upon the pavement opposite: 'The griefs of childhood never failed to arrest his attention, and he crossed over to a little beggar-girl who had hurt her knee; he gave her a shilling and some kind words, which, by stopping her tears, showed that the hurt was not very serious . . .'

Maria Constable, by her husband; sometimes 'my dearest love', sometimes 'my darling Fish'

No less strong was Constable's liking for animals; and his correspondence is full of references to a particularly engaging cat named Billy, and to Billy's consort, Lady Hampstead.

Yet his cheerfulness, it seems, was hard-won. His passage through the world had not been smooth; and the loss of Maria Constable, whom he had married after a long and anxious courtship, was a blow from which he never quite recovered. Then the shadows began at last to descend; 'every gleam of sunshine is blighted for me', he groaned. 'Tempest on tempest rolls – still', he continued with his customary resolution, 'the darkness is majestic.' His later works, suggests Kenneth Clark,[22] often reveals a certain 'loss of confidence' – not in his 'sketches from nature . . . in which he achieves the rapturous self-identification of his harmonious years', but in his finished large-scale pictures.

At every period of his artistic life, it is his brilliant working-sketches, rather than the large compositions into which they afterwards grew, that have the freshest and the liveliest beauty. There he seems not only to observe the facts of Nature, but, by concentrating on them in a mood of trance-like absorption, to reach a poetic truth behind the facts – the truth

that, we are told, the ancient Chinese masters sought when, with a few flying strokes of a heavily ink-charged brush, they drew a flower, a twig, a bird. The apparent simplicity of Constable's approach, indeed, has encouraged many third and fourth-rate artists to believe they could become his followers; that all an artist needs is a lifelong love of Nature, a clear eye and a steady hand. For Constable, at a first glance, merely puts down what he sees – a deserted sand-pit and two or three poppies just beneath its crumbling edge; an old gate leading to a harvested field; a stretch of ploughland under stormy clouds; ancient trees shadowing an angle of the Stour; or the thorns and furze-bushes of Hampstead Heath. But everything that catches Constable's eye is intensely felt as well as seen; and, in his own way, he realises Coleridge's definition of the true creative artist. Combined with the intellectual powers of manhood, he retains a childish capacity for awe and wonder.

If Constable was the most Wordsworthian of English artists, Turner was the most Byronic. It was a relationship that would have astonished Byron himself; and, had they met, the proud and touchy poet might have found very little to say to the rough, short-spoken painter. In 1809, when Byron

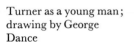

Turner as a young man; drawing by George Dance

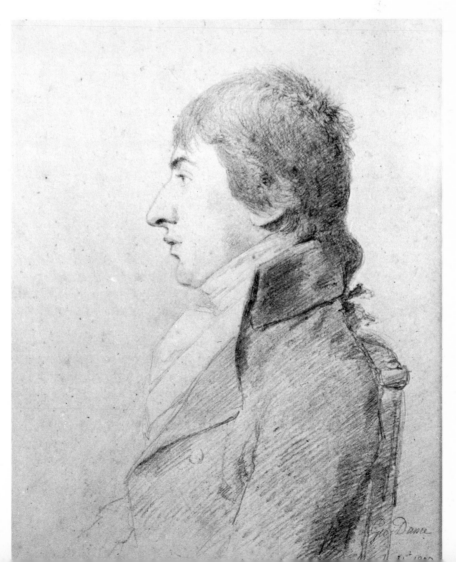

was twenty-one years old and just about to leave England, Turner, a man of thirty-four, happened to be visiting Lord Egremont, his patron and personal friend, at Petworth; and one of his fellow guests has left us a thumbnail sketch of the impression that he made. He bore a strong resemblance, we learn, to a prosperous master-carpenter, with his 'lobster-red face, twinkling, staring grey eyes, white tie, blue coat with brass buttons . . . turned-up boots, large fluffy hat and enormous umbrella'.

A second account, written in 1810, provides some further vivid details. The famous artist was a diminutive 'Jewish-nosed man in an ill-cut brown coat, striped waistcoat, and . . . frilled shirt, sketching on a small piece of paper, held almost level with his waist'. Turner's odd clothes often surprised contemporaries; unlike the elegant Sir Thomas Lawrence, he made no attempt to cut a gentlemanly dash or conceal his modest origins. From his father, 'a chatty old fellow', who kept a hairdresser's shop in Covent Garden, he had inherited not only his ruddy complexion and large hooked nose, but his sternly parsimonious habits. His mother provided a more extravagant strain. The daughter of a successful London butcher, she was a handsome and arresting personage. But it is said that he had an ungovernable temper, and that, towards the end of Mary Turner's life, 'she was insane and in confinement'.

Throughout his career, any suggestion that his works showed signs of madness, that, as Hazlitt said, they were 'a waste of morbid strength', particularly enraged the artist. Perhaps he sometimes feared for his own sanity; and his mother's collapse may have had a decisive effect upon the growth of his imagination. During his youth, Claude and Poussin were the stars he had set out to follow; and the great canvases, topographical, historical, mythological, that secured him fame and riches, certainly aim at, though they do not always achieve, an air of classic grace and harmony. But even in those works there are many hints of tension; he had an instinctive penchant for wild, excessive subjects; and in 1805 he painted his *Shipwreck*, the first of the grandiose stormscapes with which he paid a Romantic tribute to violently destructive nature.

From that point, Turner's vision of life grew increasingly apocalyptic; until his pictures came to suggest a series of prodigious battlefields, where the Creative Spirit wages an endless war against elemental Night and Chaos. Meanwhile the framework of his compositions had begun to lose its regularity; theories of colour now absorbed him; and he filled his grey-paper notebooks with a host of rapid, brilliant sketches in which pure colour took the place of form. In the pictures of his last period, Colour is itself the hero; and his subjects dissolve into a vertiginous maelstrom of darting lights and swirling shadows.

Among these later works, none is more extraordinary than *The Snow-storm*, the picture of a steam-boat signalling through a blizzard, which he exhibited at the age of sixty-seven. Turner's description of how and why he had produced it illustrate both the methods he adopted and his attitude towards his art. When Charles Kingsley informed him that his old mother had greatly liked *The Snowstorm*, Turner replied that he had painted his

Crossing the Brook; one of the early pictures with reflections of Claude and Poussin, on which Turner had built up his popularity

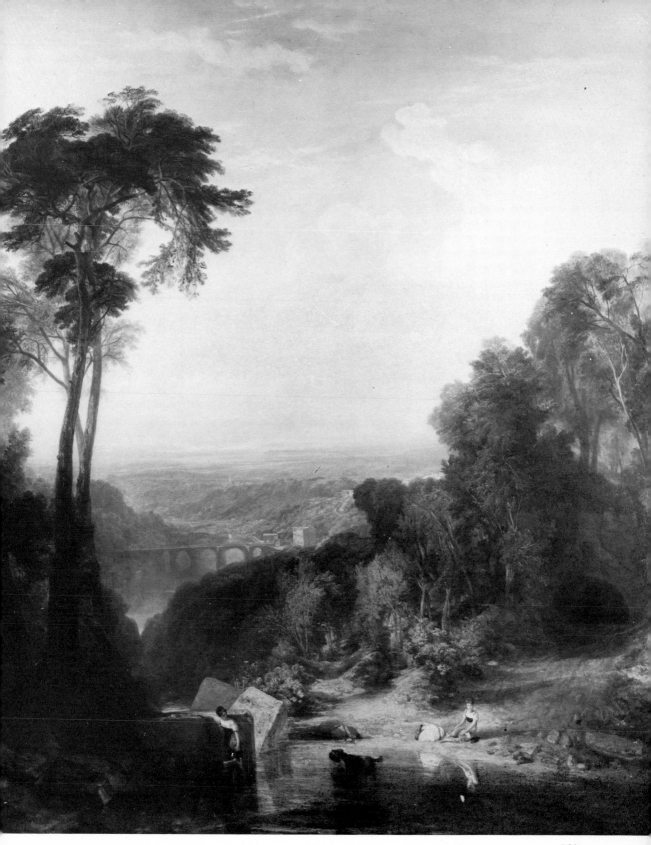

197

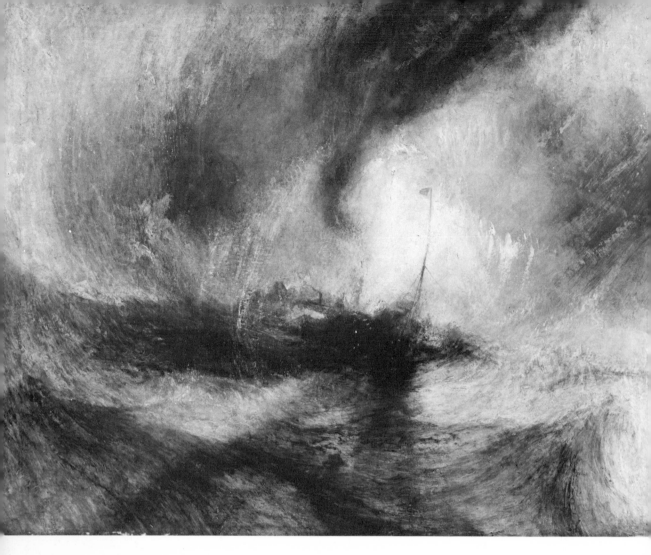

picture merely because he wished to represent the scene: 'I got the sailors to lash me to the mast to observe it. I was lashed for four hours, and I did not expect to escape, but I felt bound to record it if I did. But no one had any business to like it.'

Much earlier, in the company of Hawksworth Fawkes, son of a country gentleman who often bought his drawings, he had watched the progress of a thunderstorm as it swept across a northern landscape. Turner commanded his friend to remark its beauty; and, while he spoke, 'he was making notes of its form and colour on the back of a letter. I proposed some better drawing-block, but he said it did very well. He was absorbed – he was entranced. There was the storm rolling and sweeping and shafting out its lightning over the Yorkshire hills. Presently the storm passed, and he finished. "There", said he, "Hawkey; in two years you will see this again, and call it Hannibal crossing the Alps." ' Nor was the young man disappointed. Exhibited in the year 1812, *Snowstorm: Hannibal and his army crossing the Alps* commanded general admiration, and was described by the diarist Crabb Robinson as the most marvellous landscape he had ever seen.

198

Young or old, Turner continued to regard himself as an impassioned student in the school of Nature, and to look on his art as a faithful rapportage of Nature's more prodigious aspects. But he was no ordinary unreflecting reporter; and his tremendous efforts to record his observations formed part of a far deeper struggle. Though he worshipped his art, and was certainly not inclined to underestimate his splendid gifts, painting alone did not wholly satisfy him, and he sought relief in writing poetry. His ambitious poem, *The Fallacies of Hope*, of which the first extract was attached to *Hannibal Crossing the Alps*, eventually became a life-work. The complete manuscript he never attempted to publish; but, year by year, he would dredge up long quotations, through which he endeavoured, rarely with much success, to explain and intensify a picture's meaning.

As a versifier, oddly enough, he did not follow the Romantic poets. He respected Byron; but the master he chose was James Thomson; and, under Thomson's influence, he poured out a turbid mixture of sententious moralising and pseudo-philosophic gloom. *The Fallacies of Hope*, even in extracts, is not a very readable production; but it shows the versifier trying to add some element that, for all his resolute self-assurance, he must have felt his pictures lacked. Thus, with his lurid and dramatic canvas, *Slavers Throwing Overboard the Dead and Dying – Typhon Coming on*, he associated a curious poetic footnote:

> Aloft all hands, strike the top-masts and belay;
> Yon angry setting sun and fierce-edged clouds
> Declare the Typhon's coming.
> Before it sweeps your decks, throw overboard
> The dead and dying – ne'er heed their chains.
> Hope, Hope, fallacious Hope!
> Where is thy market now?

These verses were composed in 1840; and in 1843 he was moved to comment on a representation of *The Morning after the Deluge*:

> The ark stood firm on Ararat; th' returning sun
> Exhaled earth's humid bubbles, and emulous of light,
> Reflected her lost forms, each in prismatic guise
> Hope's harbinger, ephemeral as the summer fly
> Which rises, flits, expands, and dies.

Here, at least, Turner's poetic commentary increases our knowledge of his man himself. His 'deepest impulse', writes Kenneth Clark, had always been 'towards catastrophe; and Ruskin was right in recognising as one of his chief characteristics a profound pessimism.'[23] The images that excited his genius were seldom of a cheerful kind; he preferred scenes of ruin, destruction, death, and loved the interplay of violent contrasts. Yet he also loved the sun; and, though the story that, on his death-bed, he abruptly announced that 'The Sun is God', may perhaps be a pleasing literary legend, there is no doubt he painted light in a profoundly reverential spirit. Hence the interest of the verses quoted above, which describe the sun returning to the earth, and reclothing it with forms of prismatic beauty. Like the Manichaeans, he seems to have envisaged a

world-system delicately balanced between tremendous Opposites, between the Destroyers, who manifest themselves in fire and flood and plague and famine, and the Sun-God, who guards and reconciles and constantly refreshes Nature.

Such beliefs, and the accompanying fears and anxieties, have sometimes led to mental breakdown. The artist, however, had a strongly disciplined mind; and few more industrious painters or draughtsmen have ever worked in modern Europe. From a tour that had lasted two months he would return with some four hundred sketches; and he had soon become an accomplished businessman, asking good prices and using the money he earned to make extremely sound investments. Otherwise his personal life was chaotic. Awkward and ugly as well as fiercely proud, he never took the decisive step of marrying; while his love-affairs, for the most part drab and sordid, were always conducted in the deepest secrecy. It was rumoured that he would occasionally retire to Wapping, where he 'wallowed' among base companions; and a tale was circulated, after the artist's death, that John Ruskin in the rôle of executor, had been obliged to commit to the flames a large number of improper drawings. But, although one or two erotic sketches survive, their impropriety is not obtrusive; and Turner's odd habits seemed merely to have reflected his natural loneliness and taste for solitude.

Perhaps he was not averse, as he advanced through middle age, from developing into a kind of sacred monster. With his queer hat and awkward brass-buttoned coat, he dominated exhibitions. When he sent in his promised canvas, it was apt still to be 'a mere dab'. Then, on Varnishing Day, Turner would arrive and set about completing it.

Such a magician, performing his incantations in public, [wrote a fellow artist, E. V. Rippingille[24]] was an object of interest and attraction . . . For the three hours I was there . . . he never ceased to work, or even once looked or turned from the wall on which his picture hung. All lookers-on were amused by the figure Turner exhibited in himself, and the process he was pursuing with his picture. A small box of colours, a few very small brushes, and a vial or two, were at his feet, very inconveniently placed . . . Leaning forward and sideways over to the right, the left-hand button of his blue coat rose six inches higher than the right, and his head buried in his shoulders and held down, presented an aspect curious to all beholders . . . In one part of the mysterious proceedings Turner, who worked almost entirely with his palette knife, was observed to be rolling and spreading a lump of half-transparent stuff over his picture, the size of a finger in length and thickness. As Callcott was looking on I ventured to say to him, 'What is that he is plastering his picture with?' to which enquiry it was replied, 'I should be sorry to be the man to ask him' . . .

Although newspaper critics often attacked his pictures – they were particularly dismayed by his surging stormscapes, where the waves, they said, resembled nothing so much as 'a mass of soapsuds and whitewash' – he never wanted an influential following; but his most celebrated and most eloquent champion did not emerge until 1843. Early that summer, John Ruskin, writing under the pseudonym 'A Graduate of Oxford',

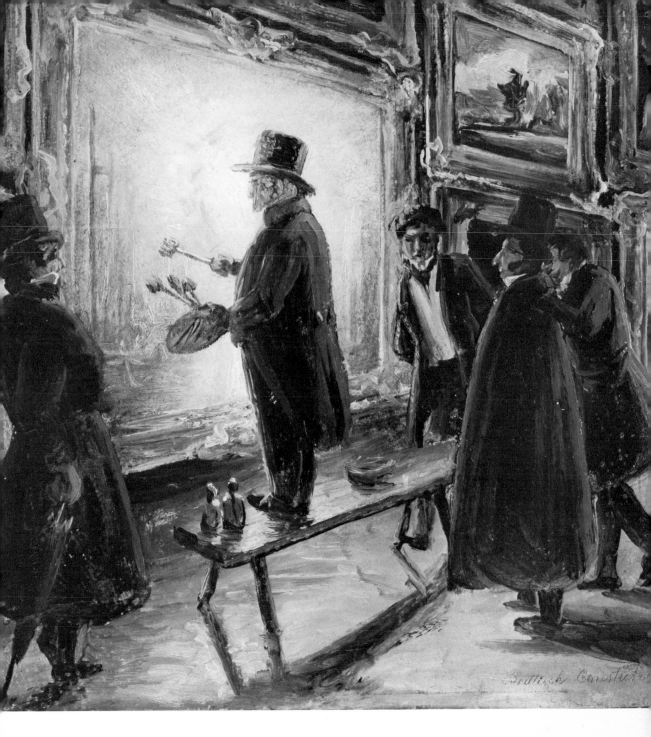

Turner on Varnishing Day,
by T. Fearnley, 1836; a
'magician performing his
incantations in public'

issued the preliminary volume of his *Modern Painters*, which he sub-titled
*Their superiority in the art of landscape painting to all The Ancient Masters proved
by examples of The True, the Beautiful, and the Intellectual, from the works of
modern artists, especially from those of J. M. W. Turner, Esq., R.A.*

Ruskin was then twenty-four, the only child of adoring elderly parents,
a remarkably precocious and gifted, but strangely inexperienced young

man. He needed a hero; and Turner supplied his need. Turner's early style, he admitted, was far too suggestive of the work of Claude and Poussin; but the present-day artist he boldly compared to the great Angel of the Apocalypse, 'glorious in conception – unfathomable in knowledge – solitary in power ... sent as a prophet of God to reveal to men the mysteries of His universe ...' Ruskin had already met his idol, three years before the publication of his book. 'Everybody had described him to me', Ruskin wrote in his diary, 'as coarse, boorish, unintellectual, vulgar ... I found ... him a somewhat eccentric, keen-mannered, matter-of-fact, English-minded gentleman: good-natured evidently ... shrewd, perhaps a little selfish, highly intellectual, the powers of his mind not brought out with any delight in their manifestation ... but flashing out occasionally in a word or a look.'

Since he detested humbug, the artist refused to pretend that he really valued *Modern Painters*; and he was afterwards to announce that Ruskin's eulogies had not afforded him the smallest ray of comfort. At last, however, after fifteen months' silence, when they happened to meet at a dinner-party, Turner spoke some grateful words, consented to drive home in Ruskin's carriage and, as they reached his own door, 'vowed he'd be damned if we shouldn't come in and have some sherry. We were compelled to obey, writes Ruskin, 'and so drank healths again ... by the light of a single tallow candle in the under room ...'

That Turner grew fond of his votary, and may have acquired a certain insight into the problems of the young man's temperament, is shown by a letter he wrote him, at a time when Ruskin's ill-judged marriage was clearly drifting to disaster. The message is neither long nor effusive, yet somehow produces the impression of being deeply heartfelt:

> My dear Ruskin
> ! ! ! Do let *us* be happy
> Yours most truly and sincerely
> J.M.W.Turner.

Nothing could save the Ruskins' marriage; and Ruskin slipped deeper and deeper into a mood of busy, self-righteous isolation. He did not admire the painter's last works; and, when he heard that Turner had died on 19 December 1851, he told his father than 'though saddened', he was 'perhaps more relieved than distressed ... It will not affect my health, nor alter my arrangements.' But his huge collection of Turner's drawings accompanied him throughout his life. They decorated the walls of his lonely room at Brantwood; and he continued to enjoy them as he worked or brooded; till one day, sitting with a pair of young disciples, he remarked that they, too, like everything else in the world, had begun to lose their early radiance.

Turner was less unfortunate. Although his strength declined – partly because he could not accustom his jaws to a set of false teeth – as late as the summer of 1851 his conversation impressed an acquaintance, Francis Turner Palgrave, future editor of *The Golden Treasury*, 'with its eminent sense and shrewdness'. He talked 'neither wittily nor picturesquely ...

Visitors to Turner's Gallery, by George Jones

but as a man of sense before all things', and 'appeared as secure in health, as firm in tone of mind, as keen in interest, as when I had seen him years before; as ready in his dry short laugh, as shrewd in retort, as unsoftened in that straightforward bearing which seems to make drawing-room walls start and frightens diners-out from their propriety'.

True, he was aggrieved by the general stupidity of critics, who, when they applauded his latest pictures, usually did so for the wrong reasons; but, if they had failed to understand him, they continued obstinately to proclaim that he was a man of mighty genius. 'This wonderful colourist', remarked the *Literary Gazette* in 1846, 'is out of the pale of our criticism, and belongs to a world of his own . . . Every year brings the same outcry of extravagance and folly, and of supreme admiration. Grant the style, and there are certainly amazing things in these paintings to call forth encomium . . .'

Hazlitt had set the tone of contemporary journalistic criticism as long ago as 1816. Turner, he said, 'the ablest landscape painter now living',

was an artist who delighted 'to go back to the first chaos, or to that state of things when the waters were separated from the dry land, and light from darkness . . . All without form and void. Some one said of his landscapes that they were *pictures of nothing, and very like*'. But, during the years that followed, although newspaper critics still admitted that they were often baffled by his works, they learned to enjoy the sensation of bafflement, and willingly enthroned him as a Grand Enigma.

Meanwhile Turner's personal habits were growing more and more secretive. Much of his later period was spent in the small, low-roofed, ramshackle house, 119 Cheyne Walk, that he had bought beside the Thames at Chelsea, and equipped with a flimsy aerial catwalk, whence he could observe sunrise and sunset and the river's majestic ebb and flow. There his companion was a middle-aged housekeeper, popularly assumed to be his mistress. Mrs Booth's unpretentious solidity – 'exactly like a fat cook and not a well-educated woman'; she had once kept a Margate lodging-house – sometimes shocked his clever friends. But she appears to have satisfied the artist's simple requirements; and, locally, he used her name. Among his Chelsea acquaintances he passed as 'Admiral Booth' – a naval officer in reduced circumstances. But the neighbouring children called him 'Puggy'. He shared Constable's affection for children; and, when he was a young painter, on a visit to a family he knew, he would allow them to wind and unwind 'his ridiculously large cravat'.

Turner died after a short illness. A doctor, whom he had summoned from Margate, warned him that he had not long to live; and the old man responded to the warning in his usual forthright manner. 'Go downstairs', he commanded, 'take a glass of sherry and then look at me again.' The physician obeyed, but merely repeated his verdict. 'Then,' said Turner, 'I am soon to be a nonentity.' He died at ten o'clock in the morning. It had been a dull and gloomy day; but just before nine, his London doctor remembered, 'the sun burst forth and shone directly on him with that brillancy he loved to gaze on and transfer the likeness to his pictures'. Later, his body was moved from Chelsea to the desolate house in Queen Anne Street, at which he had been accustomed to hold his exhibitions. Most of the furniture had already vanished; and the hangings of the gallery, 'once a gay moreen, showed a dirty yellow here and there, where the stains from the drippings of the cracked skylight had not washed out all the colour'. He left behind him an enormous hoard of canvases, some so spoiled by neglect and exposure that they were scarcely recognisable.

Five years earlier, one of the old man's bitterest adversaries, Benjamin Robert Haydon, had reached a much more tragic end. Haydon had been keeping a diary since 1808, and into its pages he had poured a brilliantly candid narrative of his impassioned love-affair with Art and Life. It was a story of wild hopes, immense, ambitious plans and, latterly, of repeated failures and unending disappointments. 'O God bless us all', he wrote on 20 June 1846, 'through the evils of this day. Amen.' And on 21 June:

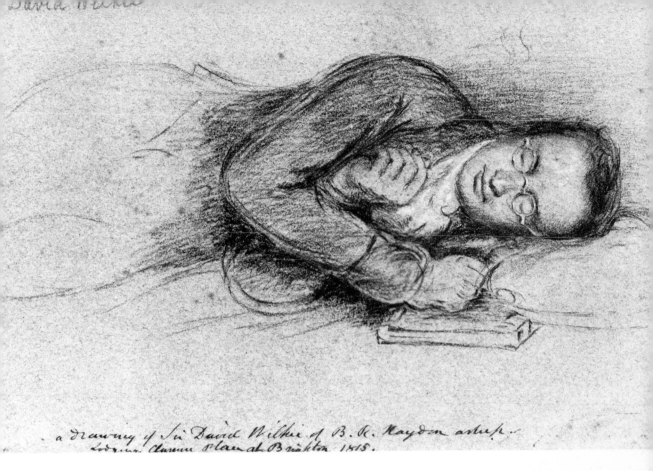

*a drawing of Sir David Wilkie of B. R. Haydon asleep.
during dinner time at Brighton 1815.*

Haydon asleep; sketch
by Sir David Wilkie,
1815

'Sunday. Slept horribly. Prayed in sorrow and got up in agitation.'
Finally, on 22 June:

<div align="center">

God forgive – me – Amen

Finis

of

B.R.Haydon

</div>

– followed by a garbled line from *Lear*, a play that, no doubt, he had once
enjoyed in the company of his young admirer, John Keats.

He left his journal open at this last entry, beside a New Testament,
turned back at a chapter in Matthew that describes the Second Coming.
Then, having shot, but failed to kill himself, he grasped a razor and
fiercely slashed his throat – the wound he inflicted nearly seven inches
long – and fell dead before a huge unfinished canvas which he had placed
upon a nearby easel. An inquest established that, when he took his life, 'the
said Benjamin Robert Haydon was in an unsound state of mind'; while
an autopsy showed that he had suffered from a 'long-standing cerebral
disease'.

Yet a host of contemporaries had shared his own belief that Haydon
was a man of genius; and both Keats and Wordsworth had dedicated
effusive sonnets to their richly gifted friend. Born in 1786, the offspring of
a Plymouth bookseller and printer, he had come to London in the year

1804, and had at once made his name at the Royal Academy Schools, where he studied under Henry Fuseli, as a particularly energetic and ambitious pupil. Soon afterwards he obtained some valuable commissions; and in January 1808 he first set eyes on the splendid reliefs and statues that Lord Elgin, an enlightened Scottish dilettante, had recently brought back from Greece. Their 'breathing nature', unaffected majesty' and 'naked simplicity' at once electrified the young man's mind. The Elgin Marbles set him a standard that dominated his whole career. For Haydon, alas, an entirely impossible standard. He possessed a full share of integrity and intelligence, of spiritual zeal and nervous energy. But the greatest gift had been denied him. And not only did Haydon lack genius; he had very little real talent.

That is to say, he had little artistic talent; for he was always an accomplished writer; and what he failed conspicuously to do in paint, he could very often do in words. The five solid volumes of his diaries, which an ingenious Victorian editor compressed into a single book, draw a marvellously vivid self-portrait. They are the record of a Romantic Artist par excellence; and the effect they produce is doubly strange and poignant because they show us the Creative Spirit operating in a partial void. We observe its operations; we follow its struggles and ecstasies. Yet nothing important or decisive happens; out of the turmoil emerges a long procession of enormous white elephants.

Yet how moving the spectacle is, whether Haydon writes of himself and his stormy private dramas, or of some gigantic new canvas that, once he has completed it – already he has begun to flex his muscles – will bring him nation-wide renown! He had 'torn up' his strength, he wrote in 1815, by his 'paroxysms of application'; and, while he was at work on *The Judgement of Solomon*, he claimed that he had laboured at his easel no less than 'sixteen hours a day . . . I hardly slept, and such was the rage of passion for work that it resembled the lecherous fury of a Lion rushing about the woods unable to find its mate . . . Could my strength have lasted, I should have gone mad.' In 1834, he was still working 'till my optick nerve aked'; and, at certain moments, these excesses of application seemed positively to blunt his appetites: 'I have not time to suffer the petty interruption of love, to be harassed by the caprice of my mistress, or the jealousy of my own disposition – all this is delightful, no man on earth could enjoy it more, but all this distracts attention and disturbs thought.'

Haydon managed, however, to make time; nor did he regret the precious hours he lost in the pursuit of any woman whom he found attractive. 'Tho my vices', he wrote, 'have cost me many a pang, yet they have also given me many a new idea.' He welcomed the extremes of sensation, and, at one period, almost relished his servitude to an 'infernal woman', a 'beautiful devil', for whom 'everything in Nature, light and darkness, solitude or society, beauty or deformity, every object that seeing, smelling, touching, or tasting could reach, were . . . sources [of] licentious gratification. "The perfume of flowers has an amorous smell", she would say, trembling . . .' His diaries are full of references to 'sleepy and lustrous'

eyes, 'bending and voluptuous' hips; and to his infatuation for the cele-
brated Mrs Norton, who (he rightly suspected) was Lord Melbourne's
mistress, and whom he declared he would develop into 'as dreadful a
whore as ever cursed the World since Messalina!'* But he was also deeply
and passionately attached to his patient wife, Mary.

Like his fellow Romantics, he often described his dreams; and, once at
least, a particularly stirring dream (which Freudians may construe as they
please) inspired him to begin a picture:

August 30 [1836]. Awoke at four with a terrific conception of Quintus Curtius,
after a sublime dream. I dreamt I was with the Duke of Wellington near the sea.
I stripped. It was a grand storm. I plunged in, and swam as I used in my youth
... I saw an enormous wave, rising, curling and black. Suddenly I found my
beautiful Mary close to me with her heavenly face! We were both looking at the
sublime wave as it rolled towards us; at last it came quite close. I told her to
hold tight. She smiled, rosy red. At the instant it was overwhelming us, a
terrific flash of lightning broke from its top, and it roared in by us to the left ...
We saw it stretch in its gurgling sweeping glory on the beach, and break harm-
less. I awoke and found the Duke and the moment consciousness came over me,
Quintus Curtius darted into my head.

Not long afterwards, the artist relates, he was 'sitting at breakfast with
the dear Children', when 'a timid tingle of the bell made us all look
anxiously. A whisper in the hall, and then the Servant entered with,
"*Mr Smith*, Sir, wishes to see you." I went out & was taken in Execution.'
Haydon was already acquainted with the life of debtors' prisons; and from
the King's Bench he soon escaped thanks to a not unkindly landlord, who,
nevertheless, impounded the contents of his studio and sold his grinding
stone and brushes. Such was the tenor of Haydon's creative existence –
sublime visions and moments of rapturous happiness, constantly inter-
rupted by some terrifying knock on the door and the stern reminder of an
unpaid bill. But Haydon continued to trust in God and, with even more
courage and confidence, trusted in his own genius. Towards the end of
May 1846, less than a month before his suicide, he can still record that,
although he is just now suffering from influenza, he has managed to enjoy
a day of 'glorious' work.

Meanwhile the pictures accumulated – huge and dull and blank and
empty: *Alexander Taming Bucephalus*; *Uriel Revealing himself to Satan*; *Napoleon
in Egypt, Musing on the Pyramids at Sunrise*; *Napoleon Musing at St Helena*;
Wellington Musing on the Field of Waterloo. Haydon had an exalted view of
history, which he conveyed through a style that he believed to be the classic
grand manner, but was, in fact, a laborious accumulation of the heaviest
academic clichés. Only when he begins to write, does he rise above the
commonplace, and rapidly throws off an image that catches the essence of
some memorable scene or character. Thus, having attended the Coronation

* This was in 1836. Afterwards they quarrelled violently; but Haydon saw her again, at a
distance, in 1841: 'She was much altered – her cheeks sunken and painted ... There was a
languid grace in the position of the head. Her jet hair in antique dress and the dark glitter of her
Eye was still powerful.'

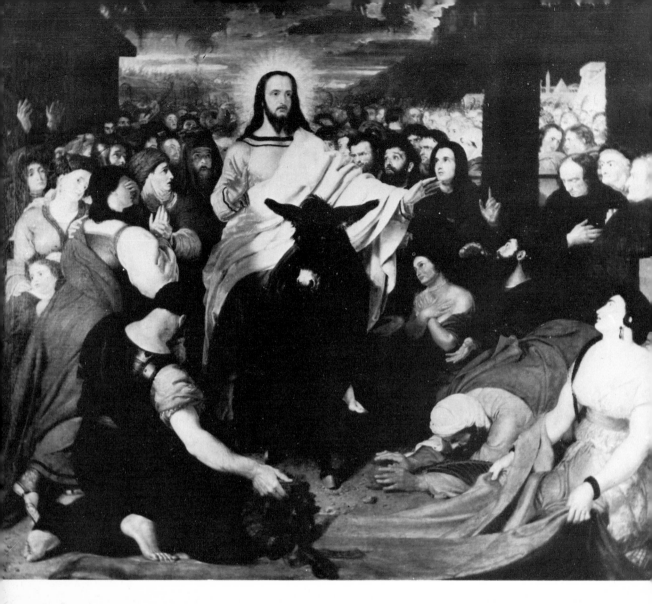

ceremonies of King George IV in July 1821, he compares the arrival of
the sovereign to the emergence of the rising sun:

> ... There are indications which announce his approach; a streak of light – the
> tipping of a cloud – the singing of the lark – the brilliance of the sky, till the cloud
> edges get brighter and brighter ... So with a king's advance. A whisper of
> mystery turns all eyes to the throne. Suddenly two or three rise; others fall back;
> some talk, direct, hurry, stand still, or disappear ... Something rustles, and a
> being buried in satin, feathers, and diamonds rolls gracefully into his seat. The
> room rises with a sort of feathered, silken thunder.

One of Haydon's dearest ambitions was to commemorate the deeds of
modern heroes. He developed a personal cult for the Duke of Wellington,
and was sorely disappointed when the quick-tempered veteran, whose
fashion in trousers he had copied, and whom he liked to call 'Dukey', made
it clear that he found his professional attentions an exasperating waste

*Entry of Christ into
Jerusalem*; in the back-
ground (extreme right,
divided from the central
figure by a column),
Haydon has portrayed
Wordsworth and Keats

(*Right*) *Medea and Jason
with the Golden Fleece*, by
Henry Fuseli. (*Overleaf*)
The Plains of Heaven, by
John Martin

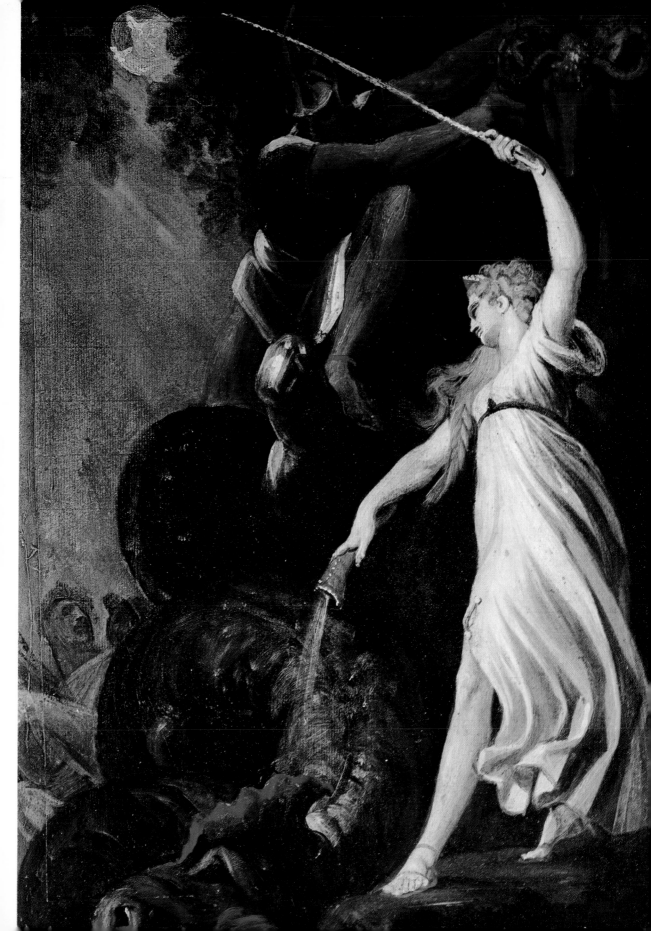

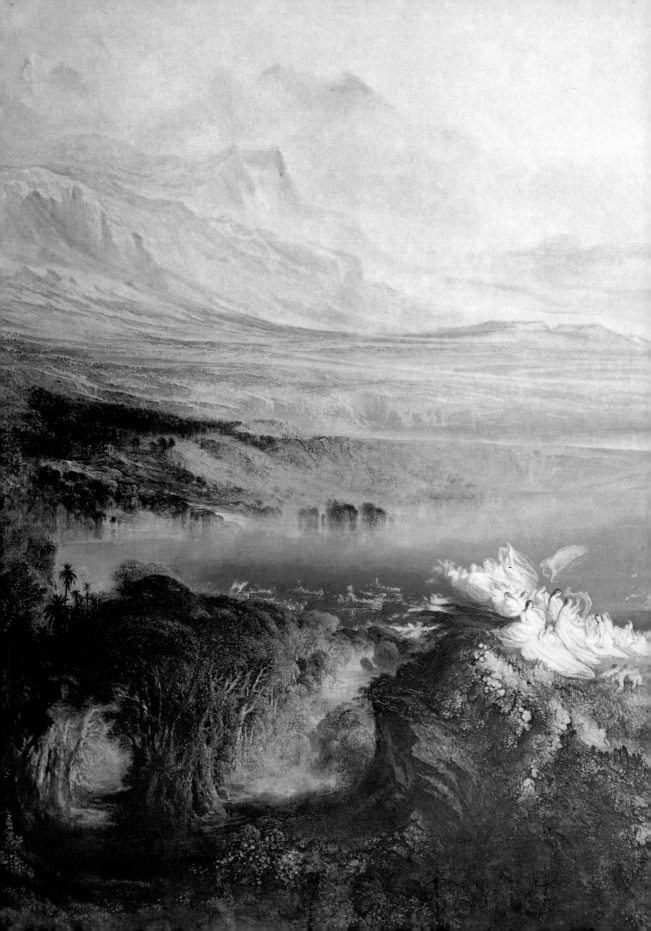

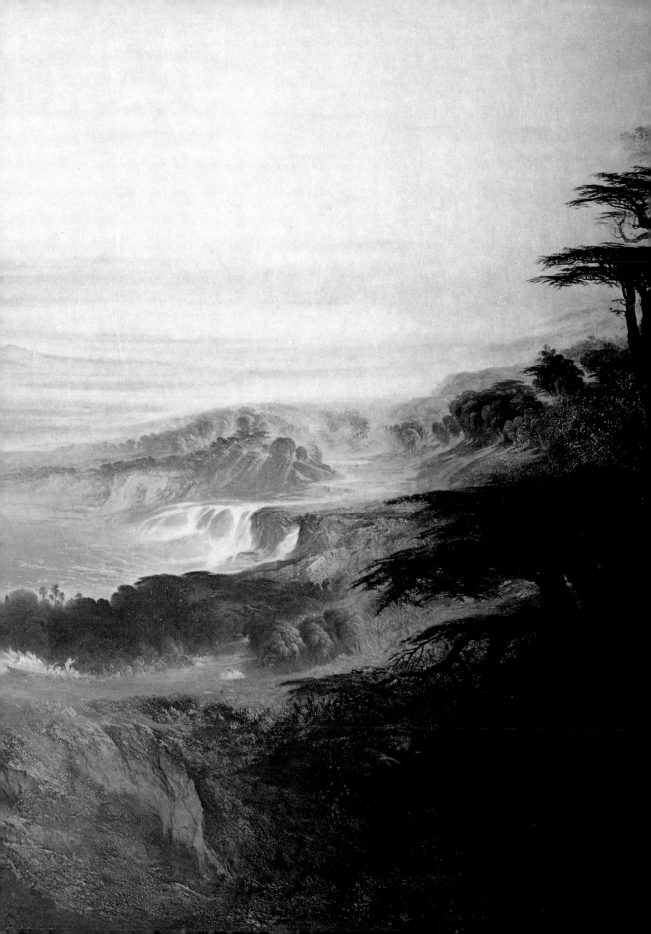

of time. The canvases that Haydon devoted to Wellington and Napoleon are particularly lifeless works. Yet his verbal sketch of the aged Talleyrand, seated amid his English acquaintances, is a fascinating piece of portraiture: 'If you saw Talleyrand's impenetrable face at a game of Whist, it was impossible not to feel your heart convulsed with unaccountable apprehensions. The Satin face of Lord Holland, the Dandy amiability of Palmerston, the dozing apathy of Lord Melbourne, the vapid restless, boyish, waspish expression of Edward Stanley, the pompous, tall, aristocratic elevation of Lord Grey, made one's nature sink', as one contrasted them 'with that imperturbable watching self-possession'. In the English gentlemen, 'there was more *assumption* than *meaning*'; in Talleyrand's appearance, 'all was meaning'. Although Haydon failed as an historical painter, again and again his journals show that he possessed a vivid sense of history.

Why Haydon's failure should have been so complete must remain an unsolved problem. But then, the causes of failure are almost as difficult to analyse as the origins of great achievement. Was it merely the lack of executive skill that made his enormous canvases so dull and vapid? He was a highly intelligent, acutely sensitive man; yet something always intervened between his soaring vision and the picture. Perhaps the impediment was a form of egotism. Poets like Wordsworth and Coleridge had equally self-centred minds; yet their intense absorption in themselves and their own concerns became ultimately a source of strength. Haydon's egotism was petty and constricting; he had a naturally solipsistic character, for which nothing existed that did not directly relate to B.R.Haydon, his virtues and his struggles, his ambitions and private dreams. Certainly he was a true Romantic – if only as a *reductio ad absurdum* of the Romantic personality. But Romanticism was a force beyond his control; the spirits that he had conjured up refused obstinately to do his bidding.

English civilisation has always been much indebted to perigrinatory foreign artists – to Holbein in the sixteenth century, to Van Dyck in the seventeenth and, during the Augustan Age, to that incomparable pair of statuaries Rysbrack and Roubiliac. Strangest of all, though not the most talented, was Henry Fuseli, otherwise Johann Heinrich Fuessli, a German-Swiss, the descendent of a long line of artists and scientists, who was born at Zurich in 1741 and reached London in 1763, where he soon attracted the notice of Sir Joshua Reynolds, Joseph Johnson, the well-known Radical publisher, and, a yet more important patron, the famous banker, Thomas Coutts. In 1769 he left England and began an eight years' tour of Italy, during which he developed a passionate admiration for the genius of Michelangelo; but by 1779 he was back again among his English friends, and presently secured election to the Royal Academy. In 1799 he became its Professor of Painting, and, in 1801, succeeded Richard Wilson as its Keeper.

(Left, above) The Primitive City, by Edward Calvert. *(Below) Disappointed Love*, by Francis Danby

Shortish, prematurely white-haired, with a beaked nose, enormous wiry eyebrows and 'eyes of a bright and penetrating blue', Fuseli, like many

other small men, had a large, aggressive personality. At the Royal Academy Schools, his pupils are said to have admired him and enjoyed his odd, erratic ways; while his fellow artists respected his knowledge, though they sometimes found him puzzling. By women, we are told, he was much loved. In his compatriot, Angelica Kauffmann, he inspired a deep attachment, and in Mary Wollstonecraft, a violent passion that threatened to overturn his marriage.*

Evidently, his character delighted and bewildered his one-time pupil, Benjamin Robert Haydon, who, in the pages of his diary, now denounces him as 'a Traitor – mean, malicious, cowardly & debauched'; now records the energy and point of his after-dinner conversation: 'Fuzeli [*sic*] . . . said that a subject for a Picture should astonish, surprize, or move; if it did neither it was not fit . . .' On a a later occasion, the diarist tells us that they had spent five hours together 'spouting Homer, Virgil, Dante, & Milton'; and that he would not soon forget Fuseli's recitation of some famous verses from the *Odyssey*. As Fuseli 'rattled away' these lines, 'I thought I saw the stone suddenly leap & roll & crash down the Hill again, while Sisyphus in despair again began his labours . . . I never leave Fuzeli without a greater delight for my art, without being more full of grand Ideas, without being instructed by some observation, or delighted by a flash of wit . . .'

Yet the artist's personality had also a somewhat sinister, even a slightly diabolic side. He had not met Fuseli for eighteen months, Haydon writes on 7 January 1814; and, having meanwhile passed his days in the company of Raphael and similarly elevated spirits 'without the shattering horror of his contaminating conceptions', he could now appraise his character and views afresh: 'He really shocked me. All his feelings & subjects were violent & horrid & disgusting. I returned home with an inward gratitude to God that I escaped in time, that I had purified my soul from the influence of his dark & dreary fancy.'

What Fuseli had said we do not know; but Haydon had firm religious beliefs and, although troubled by 'burning appetites' and an ineradicably 'lascivious' turn of mind, always worshipped the domestic virtues; while Fuseli was a cynical hedonist and possibly a modern Satanist, versed in the kind of occult studies that had once fascinated William Beckford. During his lifetime, he was popularly nicknamed 'Principal Hobgoblin Painter to the Devil'; and his paintings and drawings show a preoccupation with sin that appears both in his choice of subjects and in the smallest details of his pictures – details often deliberately distorted to give the image added meaning. He had Aubrey Beardsley's gift of conferring an expression of latent evil on every face and every attitude.

Fuseli had acquired, however, one extremely loyal champion; nothing could persuade William Blake that he was not a wise and good man. 'Blake was more fond of Fuseli', we learn from his disciple and biographer,

* Fuseli had married an English girl; Mary Wollstonecraft proposed to join Fuseli's household as his 'spiritual concubine'. When she was refused, she made a journey to France, where she met the American, Gilbert Imlay, who became the father of her first child.

Self-portrait by Henry
Fuseli

Frederick Tatham, 'than of any other man on earth'; and the poet voiced
his affection in an explosive piece of doggerel:

> The only Man that e'er I knew
> Who did not make me almost spew
> Was Fuseli: he was both Turk & Jew –
> And so, dear Christian Friends, how do you do?

But, although Blake considered him a 'super-eminent artist', and warmly
defended his work against 'Sir Joshua and his gang of Cunning Hired
Knaves', Fuseli's appreciation of Blake was a good deal less extravagant.
He had employed Blake as a journeyman engraver, and willingly admitted
that he was 'damn'd good to steal from'; but 'fancy', he informed Faring-
ton, 'is the end and not a means in his designs . . . The whole of his aim is
to produce single shapes and odd combinations'. When they met, he would
occasionally tease Blake about his supernatural privileges. The Virgin
Mary had appeared to him, Blake had explained, and told him that one of
Fuseli's pictures was 'very fine'. What, he demanded, could the painter say
to that? 'Say?' Fuseli replied, 'Why nothing, only her ladyship has not an

immaculate taste.' But, when Blake arrived at the Academy, anxious to copy a plaster cast of the *Lacoon*, Fuseli welcomed him in his most courteous manner: 'You here, *Meesther Blake*? We ought to come and learn of you, not you of us!' Blake then took his place among the students, and received his old friend's congratulations with a 'cheerful, simple joy'.

Fuseli's surprise, on hearing that the Virgin Mary had admired one of his pictures, is not difficult to understand. Brought up as a disciple of the early German masters, he had afterwards diverged into the 'terrible path of Michelangelo', had followed the lead of the Italian Mannerists, and had learned lessons in the portrayal of the human face from his early companion, Johann Kaspar Lavater, who believed that the study of physiognomy could be reduced to an exact science. Out of these borrowings he had evolved an eclectic, yet highly individual style, that reflected some of the most peculiar traits of his own rebellious personality. He was a successful illustrator; and, although his plan for illustrating Byron's *Corsair* – a commission offered him by the Princess of Wales – seems never to have taken shape,* he produced a lengthy series of pictures on Shakespearian and Miltonic themes, bringing out in every subject he chose either a startlingly macabre or an unexpectedly lubricious tone. Other English poets he treated with the same licence; even in Cowper's anodyne verses he discovered depths of troubled feeling.

As an artist, Fuseli belongs to the shadowy dream-world of the Gothic novel. His painting, *Young Woman Imprisoned with a Skeleton, Watched by an Old Man in Armour*, and his pencil-and-wash sketch, *Girl Combing her Hair, Watched by a Young Man*, are perfect specimens of Gothic fantasy. The girl who combs her hair is naked; and both the watching men appear to be *voyeurs*, rigidly fixed in their enjoyment of that particularly sterile vice. Each composition suggests an erotic dream. During his lifetime, a story was circulated that, before he retired to bed, Fuseli would devour a plateful of raw beef, because he hoped that it might improve his dreams; and the tale may well incorporate some grains of fact. Certainly, the nightmare was a subject he found appealing. While, in one picture, the dreaded beast, with its pale glaring eyes and floating mane, thrusts its neck between the curtains of a bed, in another, bestridden by a devil, it plunges through an open window, leaving behind it a pair of naked women who, further to complicate the effect, are evidently sapphic lovers.

Among Fuseli's works were a quantity of drawings that have never been exhibited, and were intended only for his private circle. Some were destroyed, presumably by the artist's widow, when he died in 1825. But many of them escaped the bonfire; and, from the psychological, if not from the pornographic point of view, these strange erotica deserve notice. Fuseli employed a number of odd conventions in his treatment of the female figure. His women are apt to be fantastically elongated; and their faces, apart from a look of frigid contempt, remain disturbingly

* On March 22nd, 1814, Byron records in his journal that 'the Princess of Wales has requested Fuseli to paint from the *Corsair* – leaving to him the choice of any passage for the subject'.

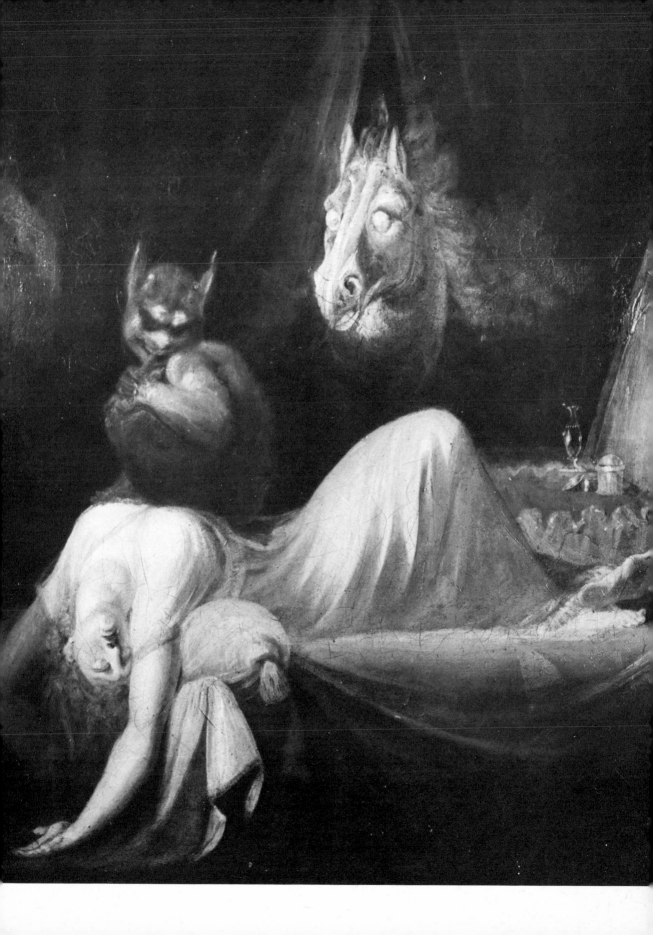

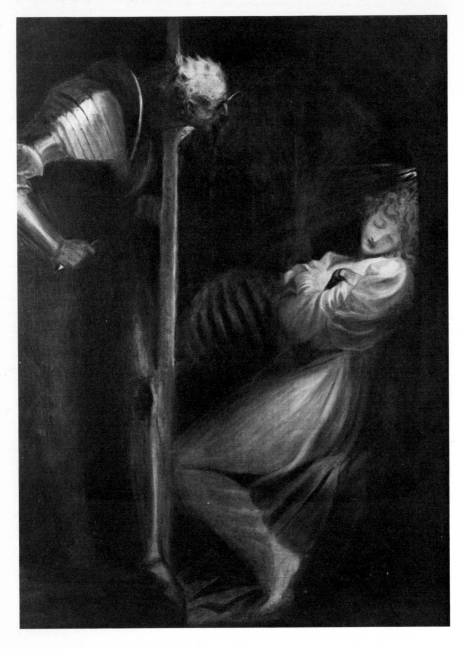

expressionless. They have small heads, like the head of an insect; and the size of the cranium is emphasised by some kind of towering headgear, which parodies the modes of the day without precisely reproducing them.

Sacheverell Sitwell has compared one of these figures to a ferocious praying mantis;[25] and we know that Fuseli, since his boyhood, had been a passionate student of entomology. His women are insect-women; and, as the praying mantis is accustomed to do, we may assume that they devour their mates. The artist, suggests Frederick Antal, shared the vices of his master, Rousseau, and must have been 'haunted from his early youth by

his conception of lascivious, haughty, almost bestial women . . .'[26] Yet,
whereas some of his more innocent works have an unexpectedly erotic
tinge, his erotic drawings, the art-historian writes, are often 'rather cold
and cerebral'. His protagonists seem not to be making love, or engaging in
any activity that might warm the heart, so much as planning and executing
an elaborate calligraphic pattern. The niceties are preserved, though the
decencies disappear. Fuseli's heroines perform their wild gyrations without
disturbing a braid or ruffling a single feather.

Haydon, who had remarked of Turner, that his pictures seemed to be

(*Above*) *The Nightmare*;
water-colour drawing by
Fuseli, 1810. (*Below*)
Pencil drawing by Fuseli
of a woman seen from
behind, 1817

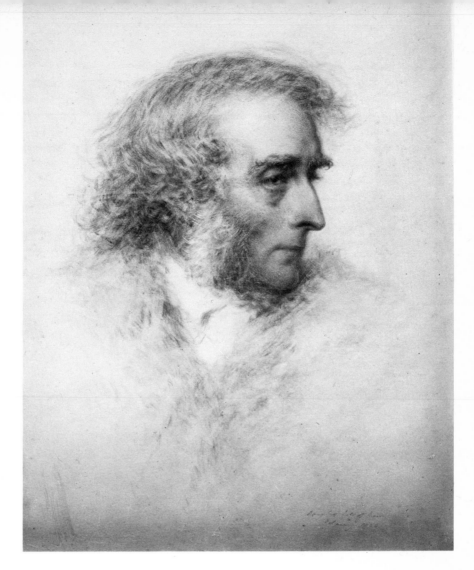

John Martin in old age,
sketched by his son,
Charles

'the works of a savage, suddenly excited to do his best to convey to his fellows his intense impression of the scenery of Nature', found much that he respected and admired in the enormous canvases of John Martin. 'That fellow should have wings!' he said, 'He is an extraordinary fellow in his way.' Martin's taste for grandeur exceeded even his own. Had he not gazed appreciatively at one of Haydon's largest pictures, but then objected that 'it wanted more space . . . a town 10,000 feet high, & a hall or two which a man might take a bed in halfway before he got to the end of it'? Martin, of course, compared with himself, might be an inexperienced painter; but of *The Destruction of Nineveh*, he wrote that there was 'really nothing like Martin's Picture in the World'; and their friendship did not decline until July 1832, when they suddenly fell out over a debt of £25, which Haydon had omitted to pay back – 'on a principle of honor & affection', he protested – and which Martin attempted to regain by firing off a lawyer's letter. Such conduct, Haydon felt, could only be attributed to 'sheer spite. My late glory has biliousized all the Painters! Poor Martin!'

221

Perhaps it was hardly his fault. He was 'beginning to feel wealthy & to love accumulation'.

Martin, indeed, had had more than his fair share both of fame and of prosperity, and had first achieved success with his picture of *Joshua*, which he exhibited in 1816, at the age of twenty-seven. Thenceforward triumph had followed triumph. In 1817, he had been appointed Historical Painter to the newly married Princess Charlotte and her consort, Prince Leopold; in 1819, he had produced *The Fall of Babylon* and, in 1821, *Balshazzar's Feast* – works, declared a contemporary journalist, that revealed a 'greatness and grandeur . . . never even dreamed of by men until they first flashed with electric splendour upon the unexpecting public'. Painters and writers combined to sing his praises.* *Balshazzar's Feast* was a truly phenomenal work, announced his fellow artist, David Wilkie. Martin, decided Bulwer Lytton, could only be compared to Raphael and Michelangelo; and the modern master, 'a great soul lapped in majestic and unearthly dreams', was he felt, 'more original, more self-dependent . . .' Meanwhile the artist's fame had travelled abroad. His early patron awarded him the Order of Leopold; and Louis-Philippe, the 'Citizen King' of the French, struck a golden medal in his honour.

John Martin had arrived at an opportune moment; *Balshazzar's Feast* made its appearance during the same year as *Parisina* and *The Siege of Corinth*, and not long before Byron published *Manfred* and launched the second *Childe Harold*. Though he was an unworldly character, Martin had an excellent sense of timing; his gifts were perfectly adapted to the spiritual climate of his generation, and to that 'taste for the *prodigious* and the *astounding*', which John Constable so much deplored. He was, moreover, an accomplished craftsman. Born in 1789 of a poor Northumbrian family, when he came to London in 1806 he had been apprenticed to a glass-painter; and 'the contrasted enamelled colours' of the glass-painter's technique he continued to employ throughout his whole career.[27] They gave his vast pictures their curious hardness and brightness and look of vivid unreality.

The artist himself was a good-natured man, 'of lively enthusiastic disposition'. At thirty-three, he is described as 'fair, extremely good-looking, well-dressed and gentlemanly, and . . . out of doors he seemed to delight in a light primrose-coloured vest with bright metal buttons, a blue coat set off with the same, his hair carefully curled and shining with macassar oil'. Superficially, except for a curious habit of emitting sudden snorts or sneezes, there was nothing bizarre about his conversation. But, like Fuseli, he believed that the aim of a picture was to astonish and surprise; like Turner's, his imagination always veered toward catastrophe; and the subjects that he favoured were scenes of universal ruin, against a background of gigantic architecture, storm-swept clouds and beetling ridges. Size fascinated him; and he was at pains to establish the exact

Joshua Commanding the Sun to Stand Still, by John Martin, 1816; the artist's copy of a much larger original

* During the eighteen-forties, however, Ruskin was to crucify his picture in many pages of eloquent abuse.

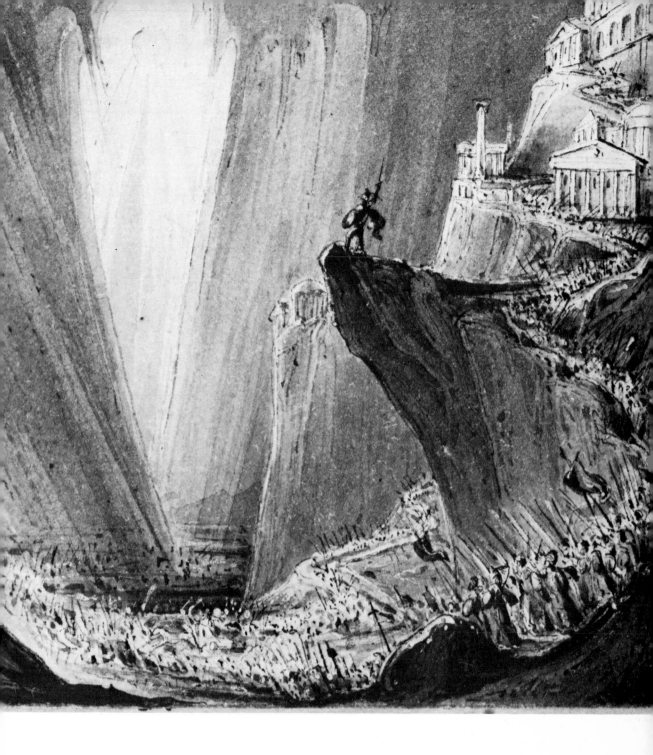

proportions of his landscapes. Thus, of *The Deluge*, he wrote that 'the highest mountain in the Picture will be found to be 15,000 Ft., the next in height 10,000 Ft. and the middle-ground perpendicular rock 4,000 feet'. Many of his compositions seem to have been derived from nightmares; and, if we can still appreciate them, it is because they evoke the

atmosphere of some particularly appalling childish dream. Unfathomable gulfs are waiting to swallow us up; the heavens gape and the earth yawns; while his great glassy perspectives stretch on and on, between ranks of huge forbidding buildings.*

John Martin died in 1854, having been seized with paralysis as he sat before his latest picture, *The Meeting of Jacob and Esau*; but Francis Danby, his disappointed rival, survived him until 1861.† There had been some, including the eccentric poet, Thomas Lovell Beddoes, who considered that Danby was the finer artist. Was not Martin's *Deluge* a mere 'rascally plagiarism upon Danby?', Beddoes demanded in 1826. Three years later, as the result of an unhappy marriage and some imputations of 'moral perversity, not to say obliquity', the painter was rejected by the Academy and driven into foreign exile. But, during his heyday, he produced such canvases as *The Upas Tree*, a vision of Nature at its most atrocious, *The Delivery of Israel out of Egypt* and *The Opening of the Sixth Seal*. From the point of view of the present study, Danby's apocalyptic picture is an especially interesting work. It caught the eye of William Beckford, then a sexagenarian recluse, who hastened to acquire it for his rich collection.

In the eighteen-thirties, at the Royal Academy Schools, a particularly gifted and well-liked student was a young Londoner named Richard Dadd. While his diligence and sparkling amiability pleased the masters under whom he worked, some of his fellow pupils, among whom was W. P. Frith, future author of such triumphs of popular Victorian art as *Derby Day* and *Ramsgate Sands*, were convinced that he possessed a share of genius; which, wrote Frith, 'would assuredly have placed him high in the first rank of painters, had not a terrible affliction darkened one of the noblest natures and brightest minds that ever existed . . .'

There was nothing about Dadd's youthful character to suggest that it concealed a violent strain. But in 1842, when he was twenty-five, he accompanied his friend, Lord Foley, on a journey round the Middle East and, having visited Cairo and climbed the Pyramids, began, perhaps as the result of sunstroke, to suffer from disturbing visions. At night, he complained, he sometimes lay down 'with my imagination so full of wild vagaries that I have doubted my own sanity'. These vagaries grew more and more alarming; on the return journey, in Rome, he experienced a sudden impulse to attack the Pope; and, back in England, he spoke of 'the great Fiend', which always followed close behind him.

Dadd's father, who was devoted to the brilliant young man, now decided he must leave London, and together they travelled to Cobham, and took rooms at the local inn. The old man's solicitude appeared to irritate Dadd; and that same evening, as they walked through Cobham

The Deluge, by John Martin

The Opening of the Sixth Seal, by Francis Danby; bought for his collection by the sexagenarian William Beckford

* Martin's family had a history of mental disorders, his brother Jonathan, nicknamed 'Mad Martin' being the pious pyromaniac who, in February 1829, did his best to burn down York Minster, and successfully destroyed the choir and its noble fourteenth-century roof.

† For a valuable appreciation of this artist's work, see Geoffrey Grigson's essay, 'Some Notes on Francis Danby, R.A.', *The Cornhill*, Autumn 1946.

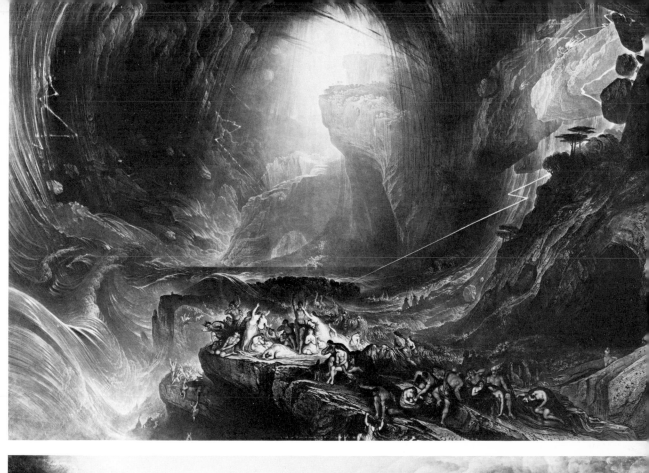
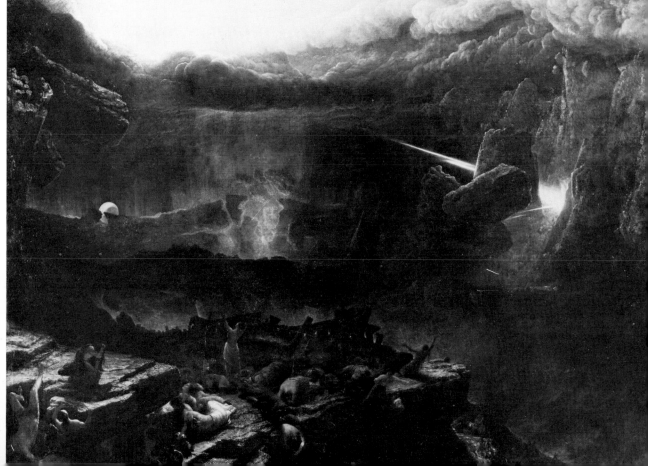

Wood, he stabbed his father to the heart and, leaving the body where it had fallen, on the brink of a deep chalk pit, gained the coast and crossed the English Channel. When he was arrested near Fontainebleau, after bungling a second murder, the police are said to have discovered amid his effects a lengthy list of his intended victims. Brought home, he was pronounced a criminal lunatic, and relegated first to London's ancient Bedlam, then to the recently founded asylum at Broadmoor. A prisoner he remained for over four decades, from 1844 until 1886.

Meanwhile an intelligent physician had studied his case, and encouraged him to paint and draw. The result was a considerable output of work, some of it decorative and quaintly conventional, but here and there revealing the touch of the true Romantic spirit. His immediate successors, the young Pre-Raphaelite artists, were apt to temper their Romantic imaginings with a sense of moral purpose. But Dadd was an uncommitted visionary; and, since his personal existence was now a death-in-life, nothing distracted him from endlessly exploring the dream-world of his own fancies. It was a labyrinthine world, in which beauty and horror united to form a series of obsessive patterns.

One of his most beautiful productions was the miniature landscape that

Richard Dadd: (*Left*) *The Child's Problem*, 1857. (*Right*) *Port Straggling*; the sky behind the castle on the crag is delicately stippled with the colours of a rosy-golden dawn

he entitled *Port Straggling*, a delicately diaphanous water-colour, worked and re-worked with the tip of an exquisitely patient brush, which shows a busy Mediterranean harbour, crowded into the shadow of a huge, fantastic rocky pinnacle. But Dadd's greatest achievement was surely the small oil-painting that, in his usual mysterious way, he called *The Fairy Feller's Masterstroke*. As a youth, before his captivity began, he had very often painted fairies; and the fairies he then depicted were no more alarming than those of his whimsical contemporary, Richard Doyle.

In the picture that he painted at Broadmoor, the littleness of the Little People assumes a completely different guise. Dadd takes refuge from the misery of his present life in the diminutive universe they may be supposed to inhabit deep among the grass and flowers. But, as he peers between the feathered grass-stalks that slant left and right across his view, what confronts him is a world as strange and forbidding as the life of any mad-house. Most of his personages have a weirdly irrational air – for example, the hideous pair of lovers dressed in the bygone fashions of his prime; or the little old man, clearly a prey to some desperate form of melancholia, who crouches at their feet and squints into vacancy, fists tightly clenched upon his knees. Others are strangely calm and beautiful, yet wear a look of lurking malice.

Such are the two young women, who rise to the left of the picture, with winged head-dresses and short pleated skirts. The girl nearest the edge of the design has sharply pointed breasts which strain against her pale-blue bodice; and her curiously bulging calves emphasise the smallness of her feet in their tiny unheeled dancer's shoes. Are they Good and Bad Fairies? Pleasure and Suffering? But then, what is the rôle of the white-bearded apparition which, with one hand raised like that of Jehovah, appears to be emerging from beneath some kind of flowery shelf; and why are a couple of cloaked and befeathered travellers gazing down upon the scene? So numerous are the figures depicted, and so perplexingly do some of them merge into the complex background of leaves and flowers and stones, that every attempt to count them produces a slightly different total.

Yet more than forty living shapes have been crammed into the composition. Among them there are no doubt several portraits of the artist's gaolers and his fellow captives; and elsewhere they must incorporate memories of his past, or symbolise his secret fears and longings. But no commentator can explain the scene as a whole. Clad in the homespun coat of an honest English woodsman, the Fairy Feller is swinging above his head a primitive stone-bladed axe. He is about to try his strength on one of the polished hazel-nuts that lie thickly scattered in the foreground; and some writers have assured us that he hopes to break a magic spell that is gripping the assembled company. But the axe will never descend; the spell will never be broken. Perhaps Richard Dadd's central personage stands for the Creative Artist. He himself died, still a prisoner, at the age of sixty-seven.

Detail from *The Fairy-Feller's Masterstroke*, 1855–64

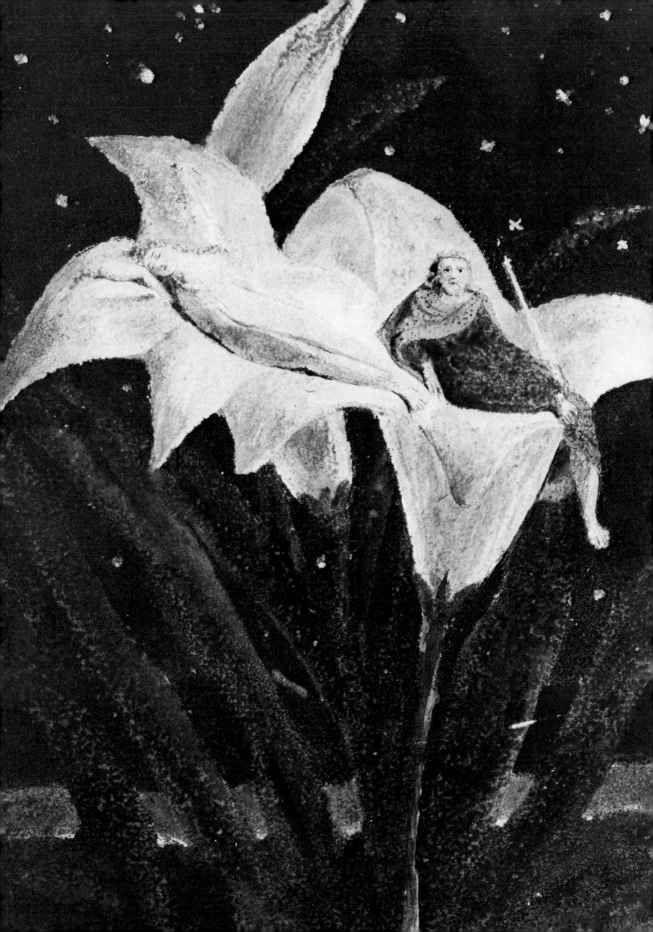

7

The Earthly Paradise

During the years of disgrace and decline that followed her tragi-comic escapade with Byron, Lady Caroline Lamb had adopted a familiar remedy; announcing that she despised the fashionable world, she had set up as an intellectual hostess. At her parties, one or two old friends – those who would still accept her invitations – were paraded, more or less unwillingly, before the representatives of art and literature; and such an occasion was attended by a contemporary diarist on 20 January 1820.

I dined at Lady Caroline Lamb's [writes Lady Charlotte Bury]. She had collected a strange party of artists and literati and one or two fine folks, who were very ill assorted with the rest of the company, and appeared neither to give nor receive pleasure from the society among whom they mixed. Sir T. Lawrence, next whom I sat at Dinner, is as courtly as ever . . . but I never feel as if he was saying what he really thought . . .

Lawrence's fellow artists were considerably less distinguished – for example:

Mrs M., the miniature painter, a modest, pleasing person; like the pictures she executes, soft and sweet. Then there was another eccentric little artist, by name Blake; not a regular professional painter, but one of those persons who follow the art for its own sweet sake . . . He appeared to me to be full of beautiful imaginations and genius; but how far the execution of his designs is equal to the conceptions of his mental vision, I know not, never having seen them.

Oberon and Titania resting on lilies; from *The Song of Los* by William Blake

Meanwhile, the stately Sir Thomas was growing somewhat cross and restive, and 'looked at me several times', Lady Charlotte noted, '. . . as

Blake on Hampstead
Heath, 1821; pencil
drawing by John Linnell

if he despised me for conversing with so insignificant a person. It was
evident Sir Thomas did not like the company he found himself in, though
he was too well-bred and too prudent to hazard a remark upon the
subject.' Despite the portrait-painter's reproving glances, Lady Charlotte
had been deeply charmed by Blake:

He looks care-worn and subdued; but his countenance radiated as he spoke of
his favourite pursuit . . . I could not help contrasting this humble artist with the
great and powerful Sir Thomas Lawrence, and thinking that the one was fully
if not more worthy of the distinction and fame to which the other has attained
. . . Mr Blake, however, . . . evidently lacks that worldly wisdom and that grace
of manner which make a man gain an eminence in his profession . . . Every word
he uttered spoke the perfect simplicty of his mind, and his total ignorance of all
worldly matters. He told me that Lady C. L. had been very kind to him. 'Ah!'
said he, 'there is a deal of kindness in that lady.'

William Blake, when Lady Charlotte encountered him, was a man of
sixty-two, and his *Songs of Innocence* and *Songs of Experience* were already far
behind him. But, next year, he was to produce a major work, the exquisite

232

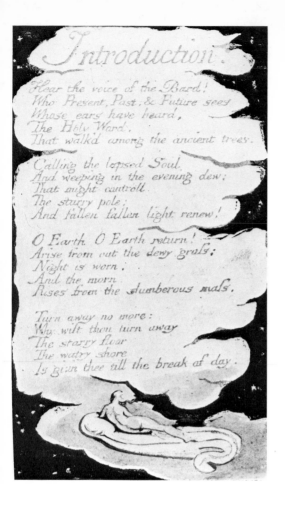

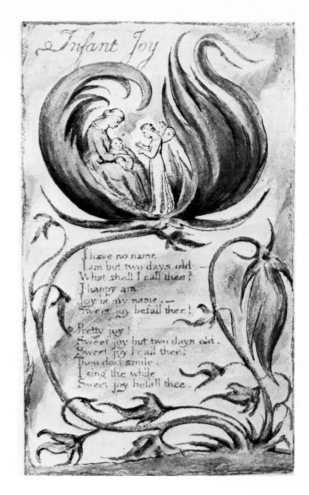

(*Left*) *Songs of Experience,*
1794. (*Right*) *Songs of*
Innocence, 1789

wood-cut illustration that he devised for Virgil's *Pastorals*: and he would
continue to work until he died without that smallest loss of zeal and
energy. Blake had struck him, remarked a young admirer, Francis Oliver
Finch, '*as a new kind of man*, wholly original . . . in all things'. 'He was a
man without a mask', said Samuel Palmer, 'his aim single, his path
straightforward, and his wants few . . .' Once Palmer and Blake had
happened to be visiting an exhibition at the Royal Academy; and he
remembered 'Blake in his plain black suit and *rather* broad-brimmed but
not Quakerish hat, standing so quietly among all the dressed-up, rustling,
swelling people, and myself thinking "How little do you know *who* is
among you."' Blake, moreover, was a singularly happy man. 'His dis-
position was cheerful and lively', wrote Frederick Tatham, 'and was never
depressed by any cares but those springing out of his art . . . Secrecy was
unknown to him. He would relate there things of himself that others make
it their utmost endeavour to conceal.' 'If asked', concluded Samuel
Palmer, 'whether I ever knew, among the intellectual, a happy man,
Blake would be the only one who would immediately occur to me.'

Since the poet-artist died on 12 August 1827, having been born on

Blake seldom paid much attention to 'the delusive Goddess Nature'. One of his few life-drawings

28 November 1757, his life covers a particularly crucial period in the history of the English Romantic Movement. Horace Walpole had published *The Castle of Otranto* when William Blake was six years old; *Childe Harold* appeared when he was fifty-six; and he survived to read the tremendous news of Byron's death at Missolonghi. Yet how justly can Blake himself be described as a Romantic poet and artist? Many of his beliefs were the exact antithesis of Romantic ideology; and, far from respecting and adoring Nature, he frequently expressed his deep abhorrence for what he called 'the world of Vegetation'. 'The delusive Goddess Nature', indeed, was among the adversaries he had set out to vanquish. 'This World of Imagination', he protested, 'is the World of Eternity . . . whereas the world of Generation, or Vegetation, is Finite and Temporal. There exist in that Eternal World the Permanent Realities of Every Thing which we see reflected in this Vegetable Glass . . .' Palmer, who had carefully studied his views on art, afterwards summed them up more simply: 'Nature is not at all the standard of art, but art is the standard of nature. The visions of the soul, being perfect, are the only true standard by which nature must be tried. The corporeal executive is no good thing to the painter, but a bane.'

Thus Blake was reluctant to improve his draughtmanship, which often

234

(*Left*) Plate from *Milton*. (*Right*) Personages in Blake's complex mythology, Los, Enitharmon and Orc; from *Urizen*

needed some improvement, by drawing from a human model. He admitted 'drawing from life always to have been hateful to him', and spoke of it 'as looking more like death, or smelling of mortality'. He preferred to rely on his own visionary insight into the World of the Imagination – a Platonic paradise that contained the 'Permanent Reality' of every object in the natural universe. He himself, he believed, was a privileged agent between the eternal and the temporal; and his pictures were merely an accurate transcript of his heavenly visions, which had first been granted him when he was a four-year-old child, and had seen the face of God, terribly close and real, just outside his father's window.

So he believed. In fact, most of his pictorial visions sprang straight from his unconscious memory. They were derived from his recollections of art – of the Gothic effigies in Westminster Abbey which he had drawn and engraved while he was an apprentice, learning his business under James Basire; of modern prints after Michelangelo; and of ancient statues and reliefs that he had examined at the British Museum. Blake was as clever as a caddis-fly in the use to which he put his borrowings; but nothing could shake his conviction that each of his angels and devils was the portrait of a supernatural sitter, who had appeared to him on one of his walks round London, or had crossed the threshold of his studio. Catherine Blake, a

235

warm-hearted, uneducated woman, daughter of a Battersea market-gardener, did not pretend that she shared his visionary gifts; but, such was her devotion to the genius she had married, that she never questioned their reality. Once his young friend, George Richmond, complained that he was feeling sluggish and dispirited; and Blake immediately appealed to Catherine: 'It is just so with us, is it not, for weeks together, when the visions forsake us? What we do then, Kate?' 'We kneel down and pray, Mr Blake.'

During his lifetime, though Blake had many admirers – they included George Romney (who considered that his imaginative drawings were as fine as those of Michelangelo), Flaxman, Fuseli, even the proud Sir Thomas Lawrence, and, among writers, Wordsworth, Coleridge, Southey, Charles Lamb and Walter Savage Landor – it was generally thought that, despite his brilliant accomplishments, the eccentric engraver must be a little mad; and a story went around that, for a period of his existence, he had actually been shut up in Bedlam. But then, madness is a strictly relative term; apart from his visions, or hallucinations, Blake gave no signs of clinical insanity, and was a man who conducted his affairs with unfailing skill and prudence. He remembered Blake, wrote Samuel Palmer, 'in the quiet consistency of his daily life, as one of the sanest, if not the most thoroughly sane man I have ever known. The flights of his genius were scarcely more marvellous than the ceaseless industry and skilful management . . . which enabled him on a very small income to find time for very great work.' His third Prophetic Book, *The Marriage of Heaven and Hell*, includes the unexpected statement that 'All deities reside in the human breast'; which would seem to imply that he believed that his own visions had a primarily subjective source. But, whatever their origin, they assumed a concrete form; to Blake his imaginative adventures were no symbolic projection of his moods and dreams. Only once did he profess to have met a ghost – a 'scaly, speckled' figure standing at his garden-door; other unearthly presences he had met and conversed with since the days of early childhood.

It was then that God had 'put his head to the window'; and, not long afterwards, he had watched angels moving to and fro among some country haymakers, and had seen the boughs of a tree on Peckham Rye spangled with a flock of seraphs. His visions followed him from childhood to old age. As an elderly man, assisted by his disciple, John Linnell, and the artist-astrologer, John Varley, he drew his famous succession of Visionary Portraits. These 'angel-visits', Varley tells us, generally took place between nightfall and five o'clock in the morning; 'and so docile were his spiritual sitters, that they appeared at the wish of his friends'. But sometimes 'the shape which he desired to draw was long in appearing, and he sat with his pencil and paper ready and his eyes idly roaming in vacancy'. Then, 'all at once the vision came upon him, and he began to work like one posest'.

Blake's visitants ranged from Pindar, Corinna and Lais to the horrible 'Ghost of a Flea' and, a curiously doltish personage, the Egyptian architect

(*Right*) *Death on a Pale Horse*, by William Blake

The Ghost of a Flea; 'here he comes! his eager tongue whisking out of his mouth . . .'

who had built the Pyramids. He was 'more than usually excited' by the spectral Flea. 'He looked earnestly into the corner of the room, and then said, "here he is – reach me my things – I shall keep my eye on him. There he comes! his eager tongue whisking out of his mouth, a cup in his hand to hold blood and covered with a scaly skin of gold and green . . ." ' Blake was much interested in the Flea's mouth, and made a delicate marginal sketch, showing its pointed tongue and cruel jaws.

This is not the place to attempt to find a way through the labyrinth of Blake's Prophetic Books. Just as Shakespeare's Sonnets resemble a haunted cavern, where unnumbered footsteps lead away into the darkness but very few are seen emerging, the Prophetic Books remain a focus of mystery, that, year after year, continues to attract explorers, who penetrate the depths of the cavern only to be swallowed up. Blake's prophetic writings cannot be appraised from a literary point of view alone; if we are to absorb their full value, we must first accept the theory, current among Blakeian zealots, that Blake was expounding an important secret doctrine – the 'Perennial Philosophy', said to have been evolved by mystics and magicians from the revelations of the 'thrice-great Hermes'. Without the support of some such theory, our efforts are bound to end in failure; for often the imagery that Blake employs is both confused and repetitious; while his catalogues of proper names are calculated to wear down even the most enthusiastic student:

Hampstead, Highgate, Finchley, Hendon, Muswell hill rage loud
Before Bromion's iron Tongs and glowing Poker reddening fierce;
Hertfordshire glows with fierce Vegetation; in the Forests
The Oak frowns terrible . . .

(Left) Sadak in Search of the Waters of Oblivion, by John Martin

239

> Humber and Trent roll dreadful before the Seventh Furnace,
> And Tweed and Tyne anxious give up their Souls for Albion's sake.
> Lincolnshire, Derbyshire, Nottinghamshire, Leicestershire,
> From Oxfordshire to Norfolk on the Lake of Udan Adan,
> Labour within the Furnaces, walking among the Fires
> With Ladles huge and iron Pokers over the Island white.

Considered from a literary standpoint, Blake's prophetic language often reveals the influence of James Macpherson, whose *Fragments of Ancient Poetry* and two epic poems, *Fingal* and *Temora*, alleged to have been written by an Irish bard named Ossian, had made a triumphant appearance early in the seventeen-sixties. Only now and then does his exhausted admirer stumble on passages of splendid eloquence. For Blake, the world of reality, or World of Vegetation, resembled a thin semi-transparent sheet, laid across a luminous panorama of the World of the Imagination, which he also called 'Jerusalem'. So much more intense was the picture below that it frequently shone through into the sheet above, producing a pattern that evokes the splendid complexity of the poet's double life. Thus, on the twenty-sixth and twenty-seventh plates of *Jerusalem: The Emanation of the Giant Albion*, the gigantic work that Blake began to write and etch in 1804, but did not finish until 1820, he printed, after a solemn address 'To The Jews', an uneven but strangely moving lyric:

> The fields from Islington to Marybone,
> To Primrose Hill and Saint John's Wood,
> Were builded over with pillars of gold,
> And there Jerusalem's pillars stood . . .
>
> Pancrass and Kentish-town repose
> Among the golden pillars high,
> Among the golden arches which
> Shine upon the starry sky.
>
> The Jew's-harp-house and the Green Man,
> The Ponds where Boys to bathe delight,
> The fields of Cows by Willan's farm,
> Shine in Jerusalem's pleasant sight . . .

More widely known is the lyric, 'And did those feet in ancient time', written as an introduction to *Milton*, and nowadays sung with resounding effect by innumerable massed choirs. Blake's task was to rebuild Jerusalem upon the soil of modern England; but the City he envisaged was a very different place from the average nineteenth-century Utopia. His spiritual theories, for instance, had a strongly sexual colouring; Blake seems to have established a link between desire and inspiration;* and among the barriers that he longed to overcome were the restrictions that

* See an illustration to *Milton*, in which a pair of lovers are stretched out on a rock, while an eagle floats above their heads.

(*Below*) Urizen, the obscurantist demiurge, whose earthly agents are Newton and Locke. (*Right*) Sleeping lovers with the eagle of inspiration; from *Milton*

(*Right*) A page of *Jerusalem*

Jerusalem.
Chap: 2.

Every ornament of perfection. and every labour of love.
In all the Garden of Eden. & in all the golden mountains
Was become an envied horror. and a remembrance of jealousy:
And every Act a Crime. and Albion the punisher & judge.

And Albion spoke from his secret seat and said

All these ornaments are crimes. they are made by the labours
Of loves: of unnatural consanguinities and friendships
Horrid to think of, when enquired deeply into: and all
These hills & valleys are accursed witnesses of Sin
I therefore. condense them into solid rocks. stedfast:
A foundation and certainty and demonstrative truth:
That Man be separate from Man, & here I plant my seat.

Cold snows drifted around him: ice coverd his loins around
He sat by Tyburns brook. and underneath his heel. shot up
A deadly Tree. he namd it Moral Virtue. and the Law
Of God who dwells in Chaos hidden from the human sight.

The Tree spread over him its cold shadows. (Albion groand)
They bent down. they felt the earth and again enrooting
Shot into many a Tree: an endless labyrinth of woe!

From willing sacrifice of Self. to sacrifice of (miscall'd) Enemies
For Atonement: Albion began to erect twelve Altars.
Of rough unhewn rocks. before the Potters Furnace
He namd them Justice. and Truth. And Albions Sons
Must have become the first Victims. being the first transgressors
But they fled to the mountains to seek ransom: building A Strong
Fortification against the Divine Humanity and M

orthodox Christianity had placed on the free exchange of sexual pleasure. In *Jerusalem* he often reverts to this theme:

> For the Sanctuary of Eden is in the Camp, in the Outline,
> In the Circumference, and every Minute Particular is Holy:
> Embraces are Cominglings from the Head even to the Feet,
> And not a pompous High Priest entering by a Secret Place.

Like Shelley, Blake is said to have contemplated putting his theories of free love into matrimonial practice, and to have suggested that, in the Biblical fashion, he should be allowed to keep a concubine. When Catherine Blake expressed her dismay, he quietly gave up the project; but the Prophetic Books are full of references to jealousy, and to 'the Infernal Veil' that darkens jealous female hearts. Thus he looked back to a world of perfect freedom

> Where every Female delights to give her maiden to her husband:
> The Female searches sea & land for gratifications to the
> Male Genius . . .
> She Creates at her will a little moony night & silence
> With Spaces of sweet gardens & a tent of elegant beauty,
> Closed in by a sandy desert & a night of stars shining
> And a little tender moon & hovering angels on the wing . . .

At an earlier period, the visionary poet might well have been denounced as a pernicious heretic; and, if his inquisitors had studied *The Marriage of Heaven and Hell*, which he composed after *The Book of Thel* and *The French Revolution*, between 1790 and 1793, they would have shown him no mercy. Though Blake described himself as a 'Worshipper of Christ', whom he

From *The Book of Thel*

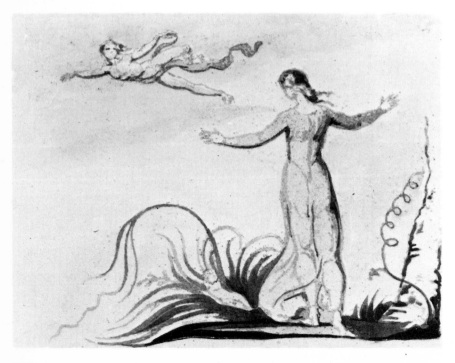

regarded as a prototype of the Imaginative Artist, his Christianity was always suspect; and it is clear that a number of Gnostic beliefs had crept into his religious system. Like the Gnostics, he asserted that the Jehovah of the Old Testament – in Blake's mythology, Urizen, or 'Your Reason' – was an obscurantist demiurge. 'The Creator of this World', he declared, 'is a very Cruel Being', who, through the malevolent use that he made of Reason, had promulgated 'his iron laws' and condemned humanity, over whom he now ruled, to a state of 'separation and division'. Urizen's earthly agents are Newton and Locke, with their 'Philosophy of Five Senses'. Only by returning to the World of the Imagination, where 'Man has no Body distinct from his Soul', can the human race recapture its innocent primeval unity.

It is *The Marriage of Heaven and Hell* that contains the clearest expression of the prophet's revolutionary doctrines. None of the other Prophetic Books is so succinct and so dramatic. It is, moreover, a work of literary art, almost unencumbered by the mythological personages – Thel, Los, Enitharmon, Lurah, Har, Tiriel, Heva, Mnetha, Tharmas, Urthona, Vala, Orc, and the rest of Blake's home-made pantheon – who elsewhere puzzle and distract the reader. Swinburne ranked it, he said, as 'about the greatest work' that the eighteenth century had produced

in the line of high poetry and spiritual speculation . . . The book teems with heresies and eccentricities; every sentence bristles with some paradox . . . The humour is of that fierce grave sort whose cool insanity of manner is more horrible . . . to the Philistine than any sharp edge of burlesque or glitter of irony; it is huge, swift, inexplicable. The rarity and audacity of thoughts and words are incomparable; not less their fervour and beauty.

The text of *The Marriage of Heaven and Hell* Blake had cast mainly in the form of aphorisms; and most of the prophet's arrows are aimed, either at the arbitrary division that Christian moralists have sought to establish between Good and Evil, or at the distinction that the benighted followers of Urizen draw between the Body and the Soul. His third chapter, entitled 'The Voice of the Devil', opens with a list of disconcerting propositions:

All Bibles, or sacred codes, have been the causes of the following Errors:
1. That Man has two real existing principles, Viz: a Body & a Soul.
2. That Energy, call'd Evil, is alone from the Body, & that Reason, call'd Good, is alone from the Soul.
3. That God will torment Man in Eternity for following his Energies.

But the following Contraries to these are True:
1. Man has no Body distinct from his Soul . . .
2. Energy is the only life, and is from the Body, and Reason is the round or outward circumference of Energy.
3. Energy is Eternal Delight.

John Milton, adds Blake, had fully grasped the truths outlined above; and the reason he wrote 'in fetters when he wrote of Angels & God, and at liberty when of Devils & Hell, is because he was a true Poet and of the Devil's party without knowing it'. Next, he proceeds to unfold 'A memorable Fancy':

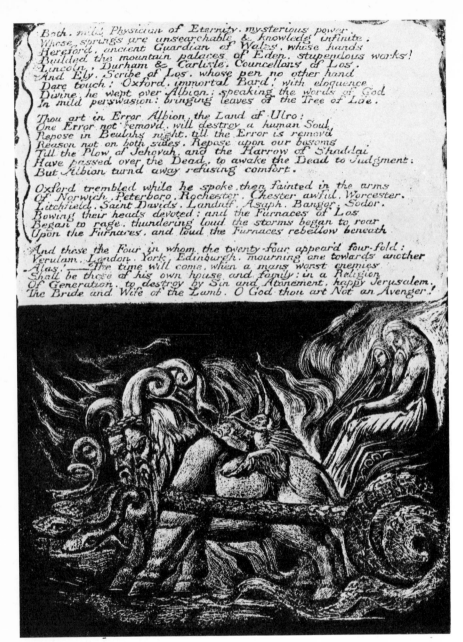

Both. mild Physician of Eternity. mysterious power.
Whose springs are unsearchable & knowledg infinite.
Hereford. ancient Guardian of Wales. whose hands
Builded the mountain palaces of Eden. stupendous works!
Lincoln. Durham & Carlisle. Councellors of Los.
And Ely. Scribe of Los. whose pen no other hand
Dare touch: Oxford. immortal Bard! with eloquence
Divine. he wept over Albion: speaking the words of God
In mild perswasion: bringing leaves of the Tree of Life.

Thou art in Error Albion, the Land of Ulro:
One Error not removd. will destroy a human Soul
Repose in Beulahs night. till the Error is removd
Reason not on both sides. Repose upon our bosoms
Till the Plow of Jehovah. and the Harrow of Shaddai
Have passed over the Dead, to awake the Dead to Judgment:
But Albion turnd away refusing comfort.

Oxford trembled while he spoke, then fainted in the arms
Of Norwich. Peterboro. Rochester. Chester awful. Worcester.
Litchfield. Saint Davids. Landaff. Asaph. Bangor. Sodor.
Bowing their heads devoted: and the Furnaces of Los
Began to rage. thundering loud the storms began to roar
Upon the Furnaces, and loud the Furnaces rebellow beneath

And these the Four in whom the twenty-four appeard four-fold:
Verulam. London. York. Edinburgh. mourning one towards another
Alas!———The time will come, when a mans worst enemies
Shall be those of his own house and family: in a Religion
Of Generation. to destroy by Sin and Atonement, happy Jerusalem.
The Bride and Wife of the Lamb. O God thou art Not an Avenger!

From *Jerusalem*

As I was walking among the fires of hell, delighted with the enjoyments of Genius, which to Angels look like torment and insanity, I collected some of their Proverbs . . . When I came home: on the abyss of the five senses, where a flat sided steep frowns over the present world, I saw a mighty Devil folded in black clouds, hovering on the sides of the rock: with corroding fires he wrote the following sentence . . .

'How do you know but ev'ry Bird that cuts the airy way,
Is an immense world of delight, clos'd by your senses five?'

It is into the succeeding 'Proverbs of Hell', however, that Blake has

packed his most explosive maxims. I have already noticed his resemblance
to Thomas Traherne. For the seventeenth-century mystic, this world was a
pomegranate, which 'containeth the seeds of grace and the seeds of glory.
All virtues lie in the World.' And he had suggested that the beauty of a
beautiful woman included 'infinite excellencies' that even a human lover
did not see. Similarly, far from neglecting and despising the world of
matter, Blake once declared that he could 'look at a knot in a piece of
wood till I am frightened at it', and held up the splendours of physical life
as so many manifestations of divine abundance:

> The pride of the peacock is the glory of God.
> The lust of the goat is the bounty of God.
> The wrath of the lion is the wisdom of God.
> The nakedness of woman is the work of God.

Like D. H. Lawrence, Blake was a strong believer in the sanctity of
human passion: 'The soul of sweet delight can never be defiled.' And, like
André Gide, he preached an emancipation of the body that would involve
a liberation of the mind. For 'The road of excess leads to the palace of
wisdom'; 'He who desires but acts not, breeds pestilence'; and 'If a fool
would persist in his folly he would become wise.' During the early days of
the French Revolution, Blake had worn the blood-red Cap of Liberty; and
in *The Marriage of Heaven and Hell* he re-emerges as a revolutionary writer.
'Prisons', he exclaims, 'are built with stones of Law, Brothels with bricks of

(*Below*) Two engravings
for *The Gates of Paradise*,
1793

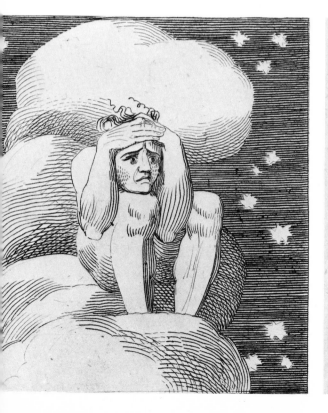
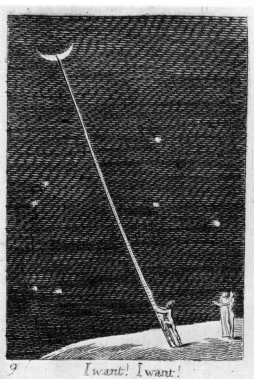

Religion.' His attack, however, is no longer directed against political and social tyranny, but against a system that supports Reason at the expense of the Imagination, and divides human activities into those which are sinful and those which bear the stamp of virtue. In the eighteen-twenties, his earnest young disciples, much as they loved and revered him, were often troubled by his views. Samuel Palmer, for example, regretted that 'he should sometimes have suffered fancy to trespass within sacred precincts', and suggested that 'erroneous spirits' might have tempted him to go astray.

Blake, he felt, was perhaps too much an artist, and 'would see nothing *but art* in anything he loved . . .' Here Palmer reveals the limitations of his disillusioned middle age. Blake cannot be judged, either as an artist who meddled in mysticism, or as a mystic who employed the imagery of art. His character was entirely homogeneous; each of his pursuits was closely linked up with all his other occupations, whether he were writing, engraving, etching, printing, illuminating his poems and Prophetic Books, making a pencil sketch of the vision that floated before his eyes, or, by a method of his own contrivance which he chose to call 'fresco', painting upon canvas, wood and copper. It is typical of Blake that, besides printing and colouring his songs, he should have sung them to music he had himself composed. As he lay dying, George Richmond relates, 'He burst out singing of the things he saw in Heaven . . .' Catherine Blake listened reverently; but, alas, she failed to take the poems down.

In the careers of most artists, we can trace a gradual ascent, followed very often by a slow decline. But, although Blake moved on from the marvellous lucidity of his early poems to the deep obscurity of the Prophetic Books, the central inspiration never flagged; in the murkiest passages of *Jerusalem*, we are still aware of his directing genius; while *The Everlasting Gospel*, written about 1818, is almost as bold and iconoclastic as the revolutionary *Marriage of Heaven and Hell*. Wordsworth, whom Blake, having read the *Ode on the Intimations of Immortality*, believed to be 'the greatest poet of the age',* was much impressed by his *Songs of Innocence* and *Songs of Experience*. 'There is no doubt', he observed, that 'this poor man was mad'; but there was something in his madness, he admitted, 'which interests me more than the sanity of Lord Byron and Walter Scott!'

It was during the eighteen-twenties that Blake first gathered around himself a circle of admiring young men – George Richmond, Frederick Tatham, Edward Calvert and Samuel Palmer, the last having been brought to his notice by the portrait-painter and engraver, John Linnell. Palmer and Linnell arrived at Blake's rooms in Fountain Court, between the river and the Strand, on 9 October 1824:

We found him lame in bed, of a scalded foot (or leg). There, not inactive,

* 'His delight in W's poetry was intense', records Crabb Robinson. 'Nor did it seem less notwithstanding . . . the reproaches he continually cast on W. for his imputed worship of nature, which in the mind of Blake constitutes Atheism.'

though sixty-seven years old, but hard-working on a bed covered with books sat
he up like one of the Antique patriarchs . . . Thus and thus was he making in the
leaves of a great book (folio) the sublimest designs from . . . Dante. He said he
began them with fear and trembling. I said 'O! I have enough of fear and
trembling.' 'Then', said he, 'you'll do' . . . There . . . did I show him some of
my first essays in design; and the sweet encouragement he gave me . . . made me
work harder and better that afternoon and night. And, after visiting him, the
scene recurs to me . . . and in this most false, corrupt, and genteely stupid town
my spirit sees his dwelling (the chariot of the sun), as it were an island in the
midst of the sea – such a place is it for primitive grandeur, whether in the persons
of Mr and Mrs Blake, or in the things hanging on the walls.

Other visitors were no less impressed by the fine simplicity of those
'enchanted rooms', where the old artist sat at a long engraver's table, 'a
pile of portfolios and drawings on Blake's right near the only cupboard',
and, on his left, 'a pile of books placed flatly one on another . . .' Palmer
and his friends called Blake's lodgings 'the House of the Interpreter'; and
Edward Calvert, when he himself was nearly eighty, would sometimes
undertake a pilgrimage to the quiet turning off the Strand, merely to look
up at the window behind which 'the blessed man' had done his work.

Of Blake's new friends, Palmer and Calvert were by far the most
original. Calvert had already seen the world and travelled, as a midship-
man, around the isles of Greece; but Palmer, the son of a London book-

Samuel Palmer; miniature by
George Richmond, 1829; 'O! I
have enough of fear and
trembling . . .'

seller, was a solitary and introspective youth, troubled by an asthmatic
complaint and prone to fits of deep religious gloom. This meeting with
Blake restored his faith; he felt that he had acquired a purpose; and,
during the year that followed Blake's death, he suddenly decided to leave
London and retire into the country. Accompanied by his father and his

Full Moon, by Samuel
Palmer

faithful old nurse, he settled down at the Kentish village of Shoreham, then a primitive and lonely hamlet, where he remained, painting, drawing and writing until the end of 1834.

Both Palmer and Calvert were subject to the kind of visionary experience I have mentioned in an earlier chapter; and both, like Wordsworth and Coleridge, were deeply indebted to their youthful recollections. The nurse who lived with Palmer at Shoreham was a devotee of the Bible and *Paradise Lost*; and

when less than four years old [Palmer related] as I was standing with her, watching the shadows on the wall from the branches of an elm behind which the moon had risen, she transformed and fixed the fleeting image in my memory by repeating the couplet:

> Vain man, the vision of a moment made,
> Dream of a dream and shadow of a shade.*

I never forgot those shadows, and am often trying to paint them.

Calvert had had an equally intense experience while sitting in his

* From a *Paraphrase of Job* by the eighteenth-century poet, Edward Young.

248

The Bright Cloud, by
Samuel Palmer; an
indefinable atmosphere
of calm and mystery and
breathless silence

parents' garden; but his disposition was much more cheerful and resolute; and the light of the setting sun, as it irradiated flowers and grass and leaves, had filled him with an ecstatic sense of the world's unearthly splendour.

At Shoreham, Palmer had found himself. Not only did he begin to cast off 'the load of horror which was wont so cruelly to scare my spirits on awaking'; but among those rounded chalk hills, steep meadows and richly wooded valleys, he discovered the Earthly Paradise, or celestial homeland, that he had already glimpsed through the eyes of William Blake. Among Blake's works, Palmer and Calvert had been especially impressed by his woodcut embellishments for Virgil's *Pastorals*. 'They are visions', wrote Palmer, 'of little dells, and nooks, and corners of Paradise; models of the exquisitest pitch of intense poetry. I thought of their light and shade, and ... I found no word to describe it ... There is in all such a mystic and dreamy glimmer as penetrates and kindles the inmost soul ...' Blake's miniature woodcuts, of course, are double impressive, since he had very seldom treated landscape, and, when he did so, was apt to depict it in a somewhat lifeless and schematic fashion. It was their lyrical, evocative quality that immediately attracted Palmer; and what he had learned

249

from Blake he strove to transfer to his own bosky Kentish hills and valleys.

In the few years he spent at Shoreham he created a vision of Nature quite unlike the vision of any other English artist. Kenneth Clark has compared him to the early-nineteenth-century German painter, Caspar David Friedrich,[28] who was also deeply enamoured of the moon and of the writhen trunks of ancient trees, and produced the same indefinable atmosphere of calm and mystery and breathless silence. In Friedrich's fantasies, as often in those of Palmer, we seem to be cut off from ordinary existence upon a single peak of time; everything around us is still and deadly quiet; we are the prisoners of that huge full moon, which looks down out of a crystalline sky through a network of distorted branches. But Friedrich's imagination had a certain Teutonic rigour; in the Englishman's idyllic landscape, all is warm and bland and gentle.

Once Palmer had said goodbye to Shoreham, married John Linnell's daughter and taken up domestic life in Surrey, he soon became a mediocre artist; but meanwhile he produced a long series of highly individual

Man and Woman Gazing at the Full Moon, by the Romantic German artist, Caspar David Friedrich, 1819

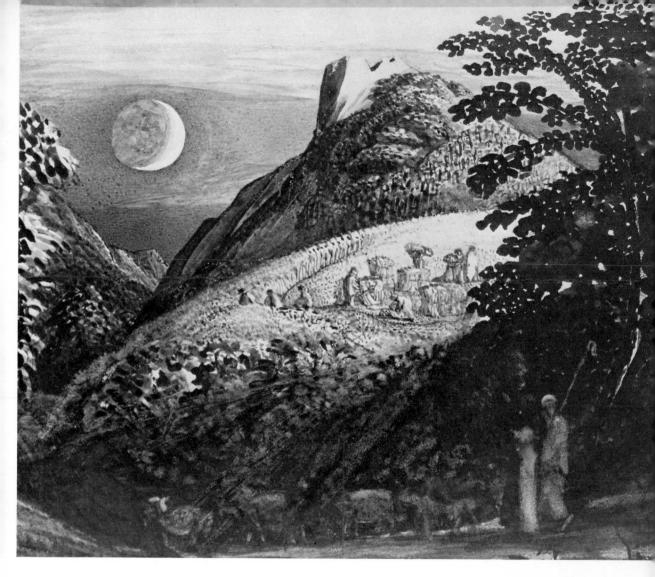

The Harvest Moon, by Samuel Palmer; 'the corn was orient and immortal wheat . . .'

pictures. Each appears to be the record of a dream – one of those miraculous rearrangements of the real world which occasionally creep into our sleeping minds. The subject is always Shoreham – but Shoreham magically enlarged and transformed. As we examine Palmer's cornfields, we remember Traherne's *Meditations*: 'The corn was orient and immortal wheat, which never should be reaped, nor was ever sown. I thought it had stood from everlasting to everlasting.' Palmer's pictures of corn give it a similarly everlasting air; his moons are enormous and immensely radiant; and, if his harvest-scenes recall Traherne, his cloudscapes bring back Wordsworth's line –

The solid mountains were as bright as clouds

– except that, in Palmer's world, the order is reversed; his 'Bright Clouds' are as large and glorious as mountains.

'Excess', wrote Blake's disciple, 'is the essential vivifying spirit . . . of the finest art'; and he longed to convey both the grandeur of Nature and its prodigious wealth of detail.

251

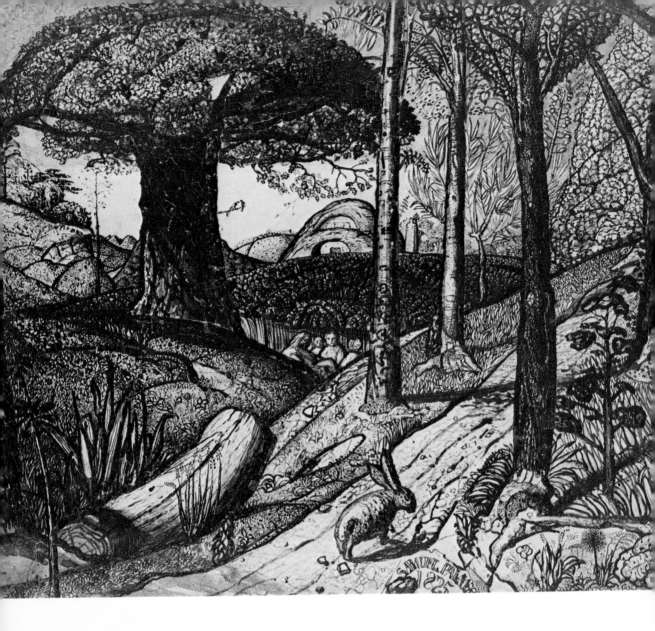

Nature [he asserted elsewhere], with mild reposing breadths of lawn and hill, shadowy glades and meadows, is sprinkled and showered with a thousand pretty eyes, and buds, and spires, and blossoms gemm'd with dew ... Nor must be forgotten the motley clouding; the fine meshes, the aerial tissues, that dapple the skies of spring; nor the rolling volumes and piled mountains of light ... Universal nature wears a lovely gentleness of mild attraction; but the leafy lightness, the thousand repetitions of little forms ... seem hard to be reconciled with the unwinning severity, the awfulness, the ponderous globosity of Art.

It was not, however, until he had left Shoreham and become an over-worked professional painter, that the awful severity of his task began at length to bear him down.

Edward Calvert was no less influenced by Blake's Virgilian illustrations; but they had a very different effect on his more masculine and sensuous

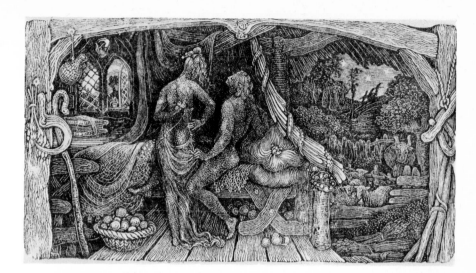

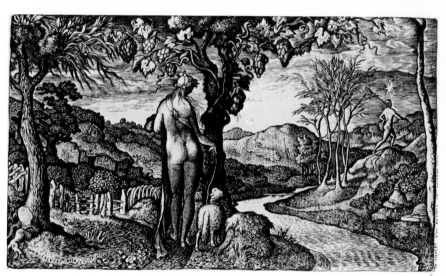

The Bride; engraving by
Edward Calvert

spirit. Perhaps because Blake had followed the engraver's trade, Calvert
taught himself to engrave on wood and copper. He had soon acquired
a rare proficiency, and turned out a succession of miniature plates,
each devoted to some aspect of what he conceived to be the Earthly
Paradise. In Palmer's work, human shapes are, for the most part, small
and rudimentary; in Calvert's, his protagonists are men and women
– desirable women and heroic men; and it is evident that, like his
master, Blake, he was strongly moved by the idea of passion. In *The
Chamber Idyll*, a beautiful girl is about to step into her marriage-bed;
Ideal Pastoral Life shows a naked shepherd and shepherdess amid a grove
of sturdy trees; *The Bride* depicts a callipygous figure, beneath the tendrils
of a vine, on the bank of a meandering brook. Calvert's greatest achieve-
ment, however, is not an engraving but a delicately coloured drawing. He

entitled it *A Primitive City*; and it contains a glimpse of some forgotten age when innocence and pleasure walked hand in hand, and 'the nakedness of woman' was the 'work of God'. Above a graceful girl who has just emerged from the stream bends a sensuous red-fruited tree; and the harvest moon, a massive, pallid sphere, is rising behind the city's grass-grown walls.

Both Blake and Samuel Palmer were deeply devoted to the genius of Gothic Art; and, under his earliest original engraving, a representation of Joseph of Arimathea, executed when he was sixteen years old, Blake announced that 'This is one of the Gothic Artists who Built the Cathedrals in what we call the Dark Ages, Wandering about in sheep skins & goat skins, of whom the World was not Worthy . . .' Blake's attitude towards Gothic architecture plainly anticipated that of Ruskin. 'Grecian', he asserted, 'is mathematic form . . . Gothic is living form.' Ruskin held exactly the same view. In his famous essay on *The Nature of Gothic*, he lays it down that, whereas classical forms were quiescent and static, the splendid ornamentation of medieval churches was always restless and dynamic:

It is the strange *disquietude* of the Gothic spirit that is its greatness; that restlessness of the dreaming mind, that wanders hither and thither among the niches, and flickers feverishly around the pinnacles, and frets and fades in labyrinthine knots and shadows along wall and roof . . . The Greek could stay in his triglyph furrow, and be at peace; but the work of the Gothic art . . . can neither rest in, nor from, its labour, but must pass on, sleeplessly . . .

Blake, like Ruskin, had exalted the Gothic ideal as a corrective to the horrors of the nineteenth-century industrial world, which for Ruskin were already an accomplished fact, and which Blake, at least in his later life, could see emerging all around him. Not only does he speak of the 'dark Satanic mills' that had begun to scar the English landscape; but much of the lurid imagery of the Prophetic Books – the anvils, the hammers, the cauldrons, the 'dread forges' and the 'red-hot wedges' – is clearly derived from his observations of some great industrial workshop. In *Milton*, Satan himself is 'Prince of the Starry Hosts and of the Wheels of Heaven', who turns the mills by night and day:

Get to thy Labours at the Mills and leave me to my wrath . . .
Thy work is Eternal Death . . .

Few other Englishmen suspected the magnitude of the change that was gradually overtaking them. Industrialism, they felt, was a lucrative addition to the pastoral English prospect; and, during the latter decades of the eighteenth century, England's industrial regions drew a series of enthusiastic sightseers.[29] It had been discovered that mines and factories and forges were equally profitable and picturesque; and the Cult of the Picturesque, epitomised in the popular books of the Reverend William Gilpin, who published a succession of picturesque tours between 1782 and 1804,* was conveniently extended to embrace industrial scenery. These

* These works were delightfully satirised by William Combe in the even more celebrated *Tours of Dr Syntax*.

(*Right*) *The Fairy-Feller's Masterstroke*, by Richard Dadd

(*Above*) *The Fiery Deeps of Hell*, by John Martin, whose imagery seems often to have been borrowed from contemporary industrial scenes. (*Right, above*) An example of ugliness in nature; 'perhaps no disposition of ground was ever more totally unpicturesque . . .' (*Below*) The same hill, bisected and adorned, becomes 'not wholly disagreeable'. From *Observations Relative to Picturesque Beauty*, by William Gilpin, 1772

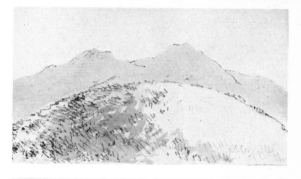

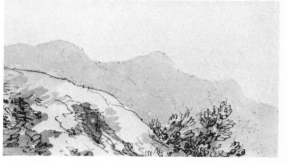

(*Left, above*) *Snowstorm: Hannibal and his Army crossing the Alps*, by Turner. (*Below*) *Coalbrookdale*, by P. de Loutherbourg

visitors were true Romantics. His experiences, reported a tourist who, on a visit to a Staffordshire lead-mine, had coasted down a subterranean river, had been 'exceedingly awful and sublime. The air rustled along in dreadful majesty . . .' Just as impressive were the copper-mines of North Wales, which, if the tourist dared to survey their depths, revealed 'an awful range of huge caverns, profound hollows, stupendous arches, gloomy passages'; or the Swansea smelting-houses which 'displayed such a glorious light' and threw out a wealth of multi-coloured ashes that shone beautifully beside the road.

Meanwhile, certain artists and poets – not, however, always the most distinguished – were doing their best to come to terms with industry. Erasmus Darwin, for instance, whose poem, *The Botanic Garden*, of which the two sections, *The Economy of Vegetation* (rapturously praised by Horace Walpole) and *The Loves of the Plants*, appeared in 1789 and 1791, had addressed an eloquent tribute to the power of the steam-engine:

> Soon shall thy arm, UNCONQUERED STEAM! afar
> Drag the slow barge, or drive the rapid car;
> Or on wide-waving wings expanded bear
> The flying-chariot through the fields of air

Even Wordsworth, though he dismissed the idea of 'enlisting the imagination under the banner of science', and pitied the victims with whom industrial civilisation strewed its path, found that there were times when he indeed exulted

> to see
> An intellectual mastery exercised
> O'er the blind elements; a purpose given,
> A perseverance fed; almost a soul
> Imparted – to brute matter.[30]

More successful were a number of gifted artists who, during the last decades of the eighteenth and the first years of the nineteenth century, set to work on the industrial landscape, among them being Paul Sandby and Beckford's old accomplice, Philip de Loutherbourg. Coalbrookdale Iron Works was the scene that Loutherbourg chose – a subject that always delighted the Romantics, since, built as it was in the depths of the country, it afforded them so many startling contrasts. The Dale itself, wrote Arthur Young in 1776, was 'a very romantic spot . . . a winding glen between two immense hills which break into various forms, and all thickly covered with wood . . . Too beautiful to be much in unison with that variety of horrors art has spread at the bottom; the noise of the forges, mills, etc., with all their vast machinery, the flames bursting from the furnaces . . . and the smoak of the lime-kilns, are altogether sublime . . .'

Turner, too, depicted Coalbrookdale; and, in 1844, he was to produce his extraordinary vision of a moving train, which he entitled *Rain, Steam and Speed – The Great Western Railway*. But the only artist whom industrialism inspired to produce his finest and most lasting work was the brilliant provincial painter, Joseph Wright of Derby, a romantic naturalist,

(*Right, above*) Copper-mine in Anglesey; water-colour drawing by J.C. Ibbetson, 1789. (*Below*) *Rain, Steam and Speed – The Great Western Railway*, by Turner, 1844

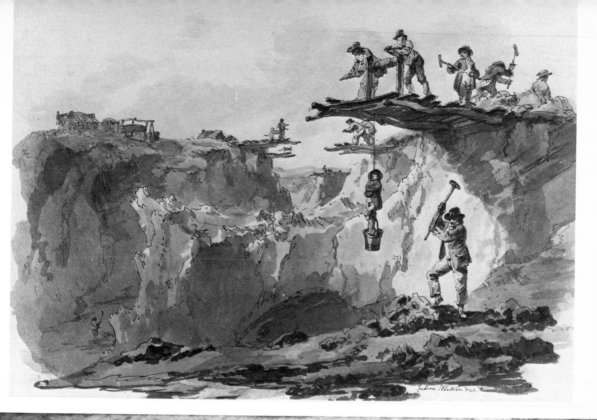

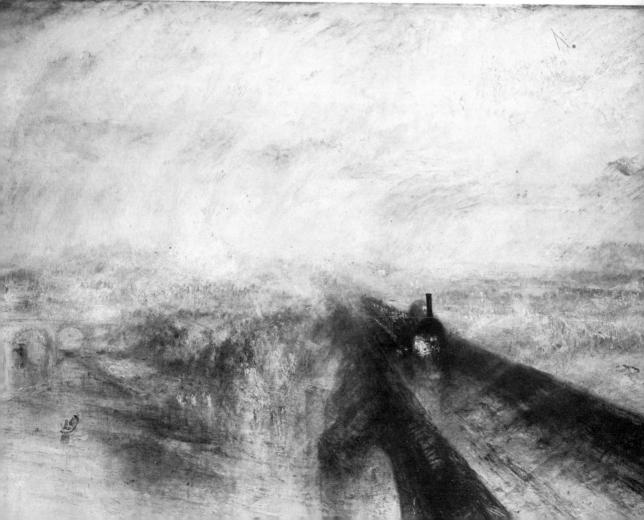

enamoured of chiaroscuro, which he achieved by the ingenious combination of many different forms of lighting; from the candlelight that shines on a little girl's face to the moonlight gleaming through a window; from the glow of the open sky to the ruddy reflection of a bar of a red-hot metal. While *The Orrery* and *The Experiment with the Air Pump*, painted in 1768 and 1769, show Wright's devotion to science and scientists, *The Blacksmith's Shop* and *The Iron Forge*, exhibited in 1771 and 1772, express his reverence for the world of labour. His workmen are sturdy demi-gods; their surroundings have a solid primitive dignity; and two or three handsome children have very often collected around the central source of warmth and light.

Never again was the decorative background of the Industrial Revolution to be portrayed with so much grace and spirit. After a brief attempt to arrange a workable alliance, the relationship between Art and Industry ended in complete estrangement; and more and more artists attacked the misery and squalor of the new industrial age. It was at this moment, during the eighteen-thirties, that the splendours of medieval art were rediscovered. Since the eighteenth century, most English architects, even the great neoclassicist Sir John Soane, had been prepared now and then, however reluctantly, to dabble in the Gothic mode. But the new exponent of the style was a high-minded young enthusiast, Augustus Welby Northmore Pugin, who regarded Gothic as the only form of Christian architecture, and who had decided he must devote his whole career to restoring the style upon a sound and systematic basis.

'Architecture', Sir Joshua Reynolds had announced in his thirteenth *Discourse*, '. . . applies itself like music (and I believe we may add poetry)

(*Left*) Augustus Welby Pugin; artist unknown. Pugin wished to pluck from his own age 'the mask of superior attainments so falsely assumed . . .' (*Right*) *The Blacksmith's Shop*, by Joseph Wright of Derby, *c.* 1770

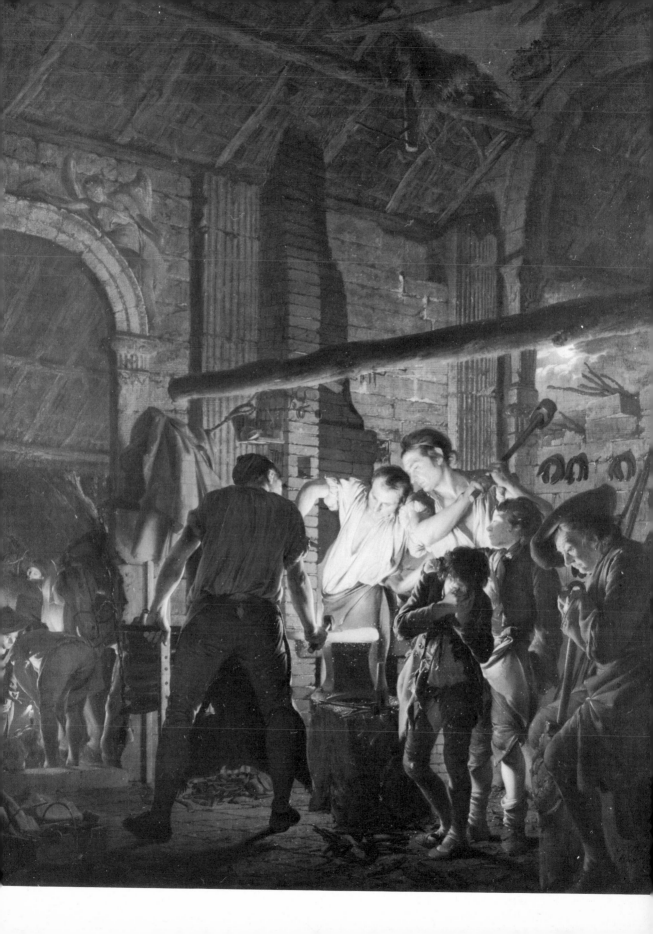

directly to the imagination ... In the hands of a man of genius it is capable of inspiring sentiment, and of filling the mind with great and sublime ideas.' This the architects of the Augustan Age had certainly set out to do. Their buildings expressed a view of life – their sense of human dignity, and of the supremacy that Man had established through the faithful use of Reason. The earliest chapter of the present survey related how the eighteenth-century Gothicists, who were beginning to distrust Reason, designed such edifices as Fonthill and Strawberry Hill to realise their own Romantic dreams. But their interest in medieval churches and abbeys had little to do with the building's religious purpose; they were literary unbelievers. Pugin, on the other hand, was a pious Catholic convert; and 'the sublime ideas' that his designs attempted to convey were those of the religious life, as opposed to the gross materialism and secular ugliness that disfigured the clouded hills of nineteenth-century Britain.

Pugin's celebrated volume of *Contrasts* appeared in 1836. He was then twenty-four; but, though not yet an experienced architect, he had already been employed, at the age of fifteen by Sir Jeffrey Wyatville, who had commissioned him to design suites of Gothic furniture for the rooms at Windsor Castle – a commission that Pugin afterwards much regretted. His father, too, was an expert Gothicist. Having escaped from France during the Revolution, the elder Pugin had become the assistant of John Nash, and supplied any Gothic details that Nash might wish to incorporate in an otherwise neo-classic scheme. But what the young Pugin saw of modern Gothic left him weary and dissatisfied. He detested the finicking elaboration of spiky Gothic chairs and tables, and envisaged a style that, besides being decorative, should be solid and completely functional.

(Above) A Catholic town in 1440. *(Below)* The same town rebuilt in 1840. From *Contrasts*

'The great test of architectural beauty', he wrote, 'is the fitness of the design to the purpose for which it is intended, and the style of a building should so correspond with its use that the spectator may at once perceive the purpose for which it was erected.' He anticipated Ruskin's belief that Gothic architecture was 'not only the best, but the *only rational* architecture, as being that which can fit itself most easily to all services, vulgar or noble'; and he dreamed of a new England, restored to its former faith, where, as in the Middle Ages, every urban skyline would be embellished, not with featureless smoke-stacks, but with finely fretted pinnacles and spires.

This was the vision that he unfolded in *Contrasts*. His intention, he admitted, was primarily polemical; he wished 'to pluck from the age the mask of superior attainments so falsely assumed, and ... to direct the attention of all back to the real merit of a past and better day'. Thus, in addition to his combative letterpress, Pugin published a series of thirty-two contrasted plates, each pair representing a medieval scene and its nineteenth-century equivalent. The first page, for example, shows us a 'Catholic town in 1440' and 'The Same Town in 1840'. The former is dominated by a group of splendid churches, encircled by castellated walls and towers, with a large chapel on the ancient bridge, and an 'Eleanor's Cross' at the end of the bridge, where the road runs into a pleasant suburb. In the modern metropolis, of course, all is grim and plain and wretched;

Catholic town in 1440.

St Michaels on the Hill. 2. Queens Cross. 3. St Thomas's Chapel. 4. St Maries Abbey. 5. All Saints. 6. St Johns. 7. St Peters. 8. St Alhmunds.
9. St Maries. 10. St Edmunds. 11. Grey Friars. 12. St Cuthberts. 13. Guild hall. 14. Trinity. 15. St Olavss. 16. St Botolphs.

THE SAME TOWN IN 1840

chaels Tower; rebuilt in 1750. 2. New Parsonage House & Pleasure Grounds. 3. The New Jail. 4. Gas Works. 5. Lunatic Asylum. 6. Iron Works & Ruins of
s Abbey. 7. Mr Evans Chapel. 8. Baptist Chapel. 9. Unitarian Chapel. 10. New Church. 11. New Town Hall & Concert Room. 12. Wesleyan Centenary
13. New Christian Society. 14. Quakers Meeting. 15. Socialist Hall of Science.

many of the churches have lost their spires; one has collapsed in abject ruin. A huge new model prison occupies the foreground; and a gaunt iron bridge has been thrown across the river.

Pugin's vision of the Middle Ages was not entirely realistic. In his picture of the 'Catholic town', where, we ask, is the customary array of gibbets; where are the skulls of traitors and felons stuck up above the city's gates; and where the middens and rubbish-heaps, that we should expect to find outside its walls? Pugin, however, was always a visionary rather than an archaeologist, and carried on into an industrial age something of the fiery spirit of the Romantic Revolution. His life was short; but, in forty years, he claimed that he had done the work of a century; and, though, as a young man, he had loved the theatre and had indulged a Shelleyean passion for the sea – 'there is nothing worth living for', he said, 'but Christian architecture and a boat' – latterly he divided up his time into alternate periods of work and prayer, rising at six o'clock and immediately entering his private chapel, where he dedicated his day's work to God.

He never lacked employment; the publication of *Contrasts* had brought him many interesting commissions; and, as early as 1832, he secured a magnificent patron in the sixteenth Earl of Shrewsbury, a pious nobleman reputed to spend some £20,000 a year on building churches. Pugin was a good deal less fortunate in his relations with his fellow architects. It may not be true that, after Pugin's death, Sir Charles Barry borrowed and destroyed the correspondence that revealed just how closely Pugin had collaborated with him when he was building the present Palace of Westminster. But the younger man proved a self-effacing aide, who gladly immersed himself in Barry's plan: and, between 1835 and the year of his death, he devoted endless labour, frequently working all night, to the decoration of the fabric. Its wall-paintings, stained glass and tiles, vaults, chimneypieces and woodwork were either designed by Pugin or produced beneath his eye; and he personally created such minor pieces of equipment as the umbrella-stands and bell-ropes.*

None of his achievements seems completely to have satisfied Pugin. He had passed his life, he said, 'thinking of fine things, studying fine things, designing fine things and realising very poor ones'. And, in his private existence, he showed all the restlessness, moodiness and inability to come to terms with his fellows that are an essential part of the Romantic nature. During his earlier manhood, he married twice, begot five offspring and, his biographer informs us, 'suffered the stress of three abortive engagements',[31] the last of which affected him so severely that he printed, for private circulation, an elaborate pamphlet explaining and justifying his own behaviour. Then, at thirty-six, he married again and, as he explained to a friend, 'got a first-rate Gothic woman at last, who perfectly delights in spires, chancels, screens, stained windows, brasses, vestments, etc.', besides bearing him another two children.

* A typical note from Barry to Pugin runs, in part, as follows: 'A little sketch for a hexagon pump in the cloisters will be welcome ... Inkstands of proper mediaeval character will undoubtedly be wanted, therefore send to me, when you can, one or two rough sketches for them.'

Pugin's dream of a
Gothic Revival

Although, by this time, Pugin's health had failed, when he was
appointed a Commissioner of Fine Art, charged with the organisation of
the Great Exhibition of 1851, he himself designed most of the objects
shown in the Medieval Court. Perhaps the sight of the Exhibition as a
whole, combined with his unending work on the Palace of Westminster,
helped to bring about his final breakdown. In 1852 he developed symptoms
of violent madness, and his family had him removed to Bedlam; but he
was presently well enough to return to the Grange, the bleak and cranky
little house, with chapel and cloisters attached, that, eleven years earlier,
he had built near Ramsgate. There Pugin died on 14 September 1852. To
the end he had moments of lucidity. During his first breakdown, a friend,
whose life he threatened, managed temporarily to divert his thoughts by
bringing up some architectural problem. At once Pugin's frenzy subsided.
'Give me a pencil!', he cried and, seizing a large envelope, produced a
brilliantly lucid sketch.

Notes

1 *Account of Architects.*
2 *Desciption of Strawberry Hill:* preface.
3 R.W.Ketton-Cremer, *Horace Walpole*, 1940.
4 *Dreams, Waking Thoughts, and Incidents*, published anonymously in 1783.
5 Emile Legouis, *William Wordsworth and Annette Vallon*, 1922.
6 *My First Acquaintance with Poets*, 1823.
7 Thomas De Quincey, *Reminiscences of the Lake Poets.*
8 Peter Burra, *Wordsworth*, 1936.
9 To Thomas Poole, 9 October 1797.
10 Peter Burra, *op. cit.*
11 *Ibid.*
12 *The Sign of the Fish*, 1960.
13 *In Allusion to Recent Histories and Notices of the French Revolution*, 1842.
14 See Leslie Marchand, *op. cit.*
15 See *To Lord Byron* by George Paston and Peter Quennell, 1939.
16 Newman Ivey White, *op. cit.*
17 *Moments of Vision*, Romanes Lecture, 1954.
18 *Appreciations.*
19 *Op. cit.*
20 *Chambers' Encyclopaedia*, 1966; *The Columbia Encyclopedia*, 1950.
21 Kenneth Clark, *op. cit.*
22 *Looking at Pictures*, 1960.
23 *Ibid.*
24 Quoted by A.J.Finberg, *The Life of J.M.W. Turner*, 1961.
25 *Narrative Pictures*, 1937.
26 *Fuseli Studies*, 1956.
27 See T.S.R.Boase, *English Art, 1800–1870.*
28 *Moments of Vision.*
29 See Esther Moir, 'The Industrial Revolution: A Romantic View', *History Today*, September 1959.
30 *The Excursion*, Book VI, 1814.
31 Michael Trappes-Lomax, *Pugin: A Medieval Victorian*, 1932.

Bibliography

Alexander, Boyd, *Life at Fonthill 1807–1822. From the Correspondence of William Beckford*, edited 1957.
Beckford's 1794 Journal, edited 1961.
England's Wealthiest Son, 1962.
Antal, F., *Fuseli Studies*, 1956.
Balston, Thomas, *John Martin: His Life and Works*, 1947.
Betjeman, John and Taylor, Geoffrey, *English, Scottish and Welsh Landscape, 1700 – c. 1860 an anthology*, 1944.
Bernbaum, Ernest, *Anthology of Romanticism*, 1948.
Binyon, Lawrence, *The Followers of William Blake*, 1925.
Buck, Ann, *A History of Children's Clothing*, 1965.
Boase, T. S. R., *English Art, 1800–1870*, 1959.
Burra, Peter, *Wordsworth*, 1936.
Chambers, E. K., *Samuel Taylor Coleridge*, 1950.
Chapman, Guy, *Beckford*, 1937.
Clark, Sir Kenneth, *Moments of Vision*, 1954.
Looking at Pictures, 1960.
The Gothic Revival (revised edition), 1962.
Crabbe, George, *The Life of George Crabbe*, with an introduction by Edmund Blunden, 1947.
Empson, William, *Seven Types of Ambiguity*, 1930.
Finberg, A. J., *The Life of J. M. W. Turner*, 1961.
Frith, W. P., *My Autobiography and Reminiscences*, 1888.
Gilchrist, Alexander, *The Life of William Blake*, 1863.
Gittings, Robert, *The Keats Inheritance*, 1964.
John Keats, 1968.
Grigson, Geoffrey, *The Romantics: An Anthology*, 1942.
Samuel Palmer: The Visionary Years, 1947.
Samuel Palmer's Valley of Vision, 1960.
Halsted, John B., *Romanticism, Selected documents*, 1969.
Harris, R. W., *Romanticism and the Social Order, 1780–1830*, 1969.
Hayter, Alethea, *A Sultry Month*, 1965.
Opium and the Romantic Imagination, 1968.
Harper, George McLean, *William Wordsworth, his Life, Works, and Influence*, 1916.

Haydon, Benjamin Robert, *Diaries*, edited by Willard Bissell Pope, 1960.
Hoskins, W. G., *The Making of the English Landscape*, 1955.
Honour, Hugh, *Chinoiserie*, 1961.
Huxley, Aldous, *Texts and Pretexts*, 1932.
Ketton-Cremer, R. W., *Horace Walpole*, 1940.
Klingender, Francis D., *Art and the Industrial Revolution*, 1947.
Legouis, Emile, *The Early Life of William Wordsworth*, 1921.
William Wordsworth and Annette Vallon, 1922.
Leslie, C. R., *Memoirs of the Life of John Constable*, edited by the Hon. Andrew Shirley, 1937.
Lindsay, Jack, *J. M. W. Turner: His Life and Work*, 1966.
Marchand, Leslie, *Byron: A Biography*, 1957.
Melville, Robert, *Samuel Palmer*, 1956.
Moorman, Mary, *William Wordsworth*, 1965.
Paston, George and Quennell, Peter, *To Lord Byron*, 1939.
Praz, Mario, *The Romantic Agony*, 1933.
Pugin, K. W. N., *Contrasts*, with an introduction by H. H. Hitchcock, 1969.
Read, Herbert, *Wordsworth*, 1930.
Richardson, Joanna, *The Everlasting Spell: a study of Keats and his Friends*, 1963.
Sitwell, Sacheverell, *Narrative Pictures*, 1937.
Steegman, John, *The Rule of Taste*, 1936.
Summers, Montagu, *The Gothic Quest*, 1938.
Talmon, J. L., *Romanticism and Revolt*, 1967.
Trappes-Lomax, Michael, *Pugin: A Medieval Victorian*, 1932.
Ward, Aileen, *John Keats, the Making of a Poet*, 1963.
White, Norman Ivey, *Shelley*, 1947.
Wilson, Mona, *The Life of William Blake*, 1948.

Figures in **bold** type indicate pages with colour illustrations; figures in *italic* type indicate pages with black and white illustrations.

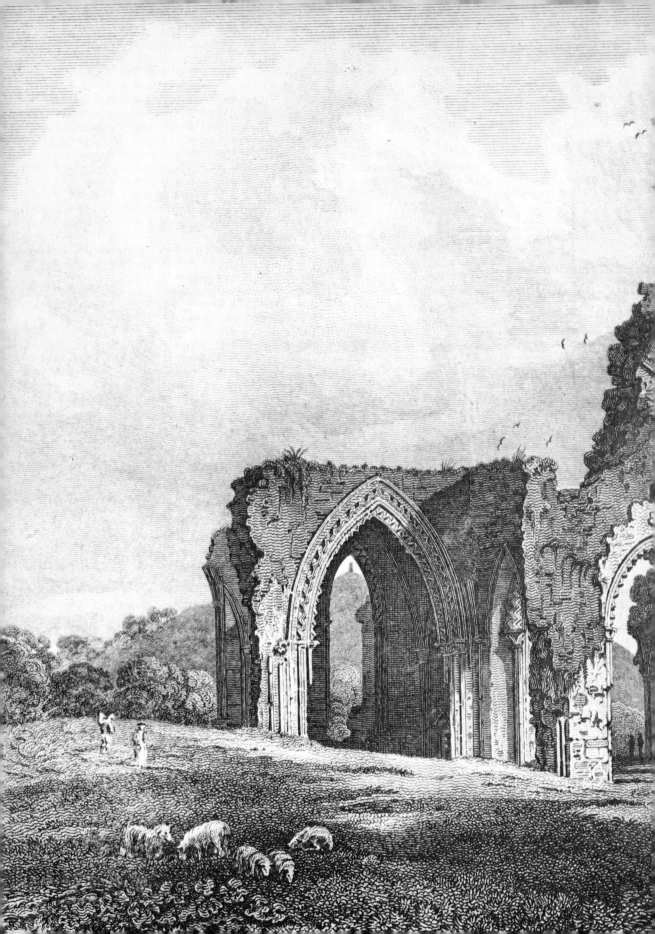